85-

SCULPTURE

From the Fifteenth to
the Eighteenth Century

SCULPTURE

THE GREAT TRADITION OF SCULPTURE FROM THE FIFTEENTH TO THE EIGHTEENTH CENTURY

by

Bernard Ceysson
Geneviève Bresc-Bautier
Maurizio Fagiolo dell'Arco
François Souchal

SKIRA

RIZZOLI
NEW YORK

© 1987 by Editions d'Art Albert Skira S.A., Geneva

Published in the United States of America in 1987 by
RIZZOLI INTERNATIONAL PUBLICATIONS, INC.
597 Fifth Avenue/New York 10017

Library of Congress Cataloging-in-Publication Data

Sculpture, English.
 Sculpture: the great tradition of sculpture
from the fifteenth to the eighteenth century.

 Translation of: La sculpture.
 1. Sculpture, Renaissance. 2. Sculpture, Modern —
17th-18th centuries. I. Ceysson, Bernard.
NB190.93913 1987 735'.21 87-61146
ISBN: 0-8478-0882-3

Printed in Switzerland

14,659

CONTENTS

BAROQUE 163

Maurizio Fagiolo dell'Arco,
translated from the Italian by James Emmons

ROCOCO 237

François Souchal,
translated from the French by Michael Taylor

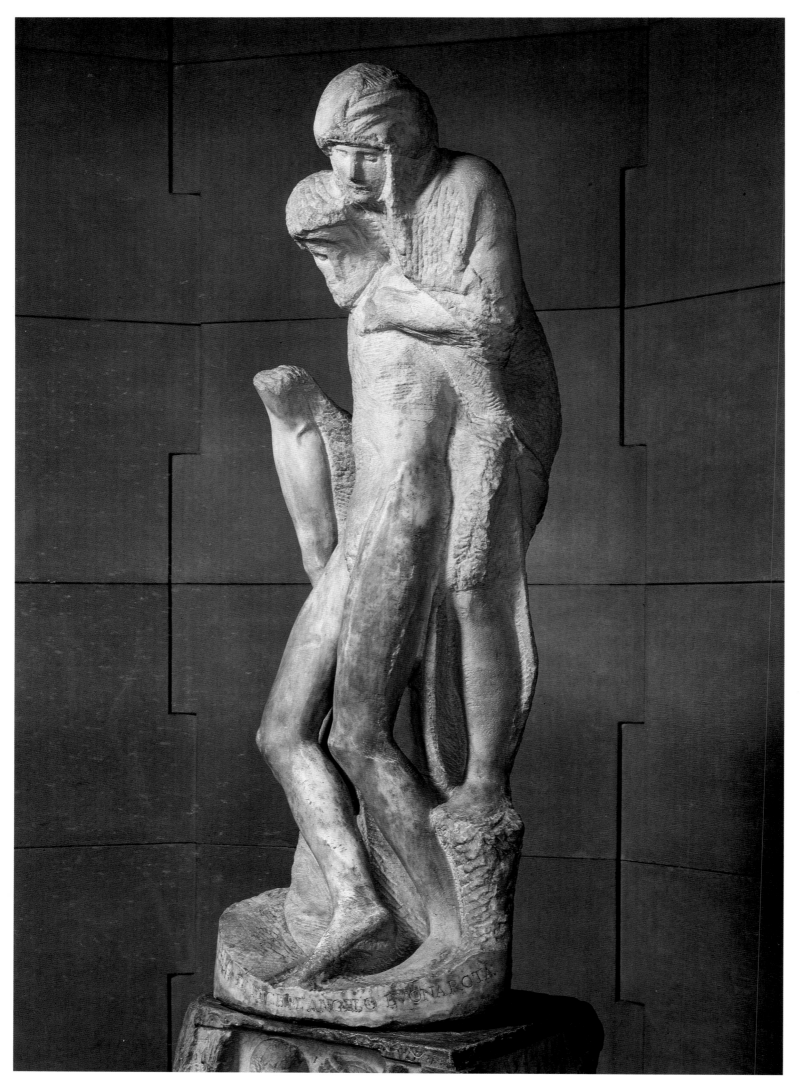

INTRODUCTION

From all the periods that have preceded our own, sculpture offers the most objective evidence we have of man's power over the world. While painting is apt to be travestied by time, sculpture more easily retains its original form and more often remains in the place for which it was made. Today, before a sculpture by Michelangelo, less so with his painting, one may still be sure of encountering, in full force, everything that he put into it. The shock of that encounter is unforgettable.

The period spanned by this book, from the fifteenth to the eighteenth century, produced some of the greatest sculptors of Western art. Their celebrity now is such that it is easy to lose sight of what was really new and challenging in their achievements. For it was they who, from the Renaissance to Rococo, decisively extended the scope of their art. They created new images of man, renewed the spatial setting and significance of public squares, embellished gardens, designed façades and interiors, in order to convey a fresh perception of space and time. They remodelled the form of tombs, invented the portrait, reactualized the monument. By moving sculpture away from architecture, they brought it under the sway of more subjective and symbolic necessities which completely transfigured its hitherto functional character.

Through a continual dialogue with the wonders of Antiquity which the archaeologists of this period were bringing to light, these sculptors were able to turn away from the past without repudiating it, and go on to set new aesthetic standards which are still a valued and admired possession of Western man. They also renewed their themes and subjects by a fresh reading of mythology.

But these outstanding sculptors, who were also practising architects and painters, were involved in the life and problems of their time. They did not hesitate to turn their hand to ephemeral works on one side and to aspire to total works of art on the other. And when they worked for history, they displayed an inventiveness and eager curiosity which enabled them to master all techniques. These they handled with unequalled virtuosity. The fertility and power of their output can only be grasped when one realizes the social and economic conditions, and the political and religious context, with which they had to cope. It was the creators of this period who first gave art a truly international dimension.

This history of sculpture singles out its finest moments as embodied in the greatest works, those in which the creative spirit expressed itself with vitality, humanity and purposefulness.

Jean-Luc DAVAL

Michelangelo (1475-1564):
The Rondanini Pietà, 1555-1564.
Marble, height 6′4¾″.

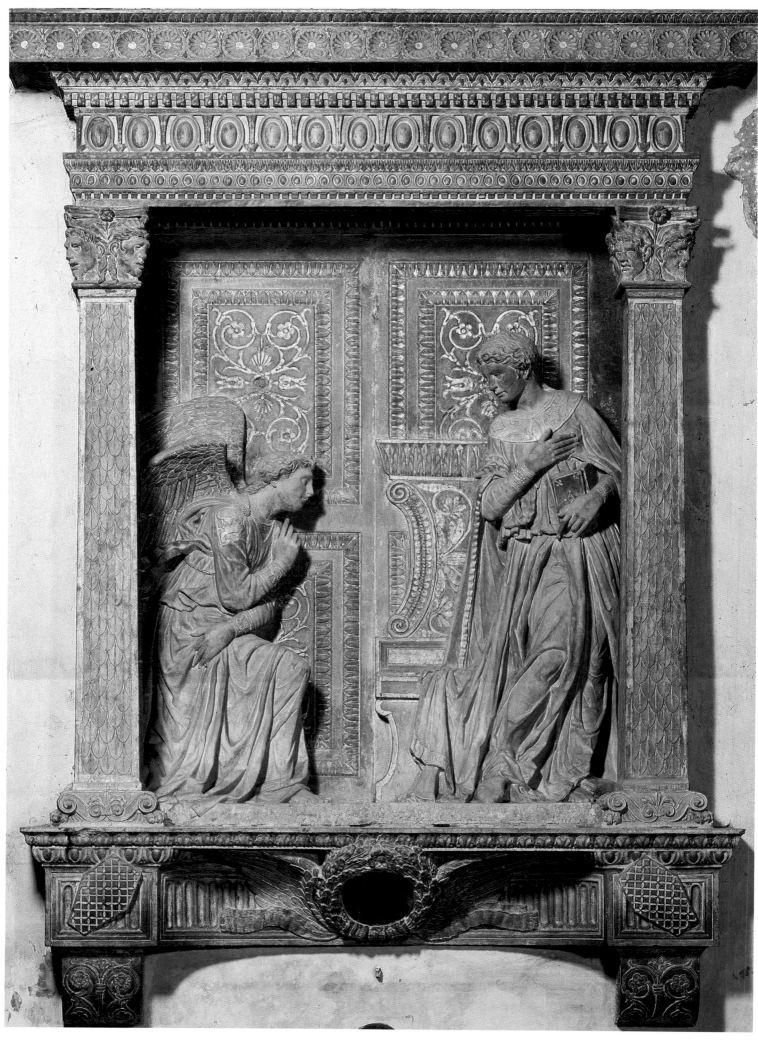

Donatello (1386?–1466): Tabernacle of the Annunciation, 1428–c. 1433.
Limestone and terracotta, height 13'9". Santa Croce, Florence.

THE RENAISSANCE

by Bernard Ceysson and Geneviève Bresc–Bautier

Is it possible to define the Renaissance without using clichés? The "springtime of the modern world" inevitably illustrated by reproductions of Botticelli's Primavera allegory has so perpetuated the myth of the "happy moment" and the "delicate dawn" that they still have their power to fascinate us. We still dream of mornings in Florence. We still want to believe in "that enchanting moment" when, as Hippolyte Taine says, "man discovered the poetry of real things for the first time." And we know that Walter Pater put the golden age of Florence, the time of Lorenzo the Magnificent, on the same plane as the age of Pericles.

Historians have rectified these idyllic interpretations which suggested a parallel with the Garden of Eden. We forget all too readily that this so-called happy moment was actually a period of confusion and tumult. A divided West, victim of endless wars and internecine strife, was exhausted and reeling from the aggressive Turkish drive against which it had organized no resistance. Pius II's exhortations at Mantua in 1459 had no effect on the Christian princes, who were indifferent to the peregrinations of the Palaeologus emperor.

The truth is that self-interest won the day over faith and morals. The fall of Constantinople in 1453 mainly affected commercial strategies. Political pragmatism, the theory of which was a Renaissance product, led Venetians, Genoese and Florentines to do business with the Ottomans. And artists were quick to seize their opportunities, too. Gentile Bellini painted a magnificent portrait of Mehmet II whom Bertoldo di Giovanni glorified with a celebrated medal.

Italy undoubtedly benefited by the disarray of an impoverished West whose squabbles and dissensions she financed, if we may put it that way. But in spite of her wealth, due to her mastery of banking techniques, she was not spared in her turn. Civil wars, clashes between clans and families, class and caste struggles against a background of the long-standing hatred of Guelph for Ghibelline, moulded everyday life. The history of Italian cities was marked by conspiracies and assassinations. And although the example of classical struggles against dictatorship fed the exaltation of "tyrant killers"–and justified their exactions–the "republican" ideal disappeared. There were good reasons why Pius II, as Burckhardt tells us, "cast an envious eye on the 'fortunate' imperial towns of Germany where existence was not poisoned by all kinds of confiscations and the violent actions of authorities and factions." And Garin reminds us that Leonardo Bruni was working on the writings of Plato "while the shock of civil war shook the walls of solemn palaces."

The Renaissance was a happy age only in the realm of culture. Perhaps in compensation, a new image of man was framed and confirmed a new audacious definition of his place in a universe of which he was no longer the plaything, but, in the words of Pico della Mirandola, the cen-

tre. Man, "that wonderful and beautiful thing," created in the image of his God, became master of his own destiny. A new awareness of time and space appeared in every human discipline and activity that led scholars to revise accepted ideas and outmoded knowledge. Humanism was primarily a wide-ranging and profound critical review of the *imago mundi*. André Chastel has rightly remarked on the "great desire to see the world" of an age which in every field was busy reorganizing space and reorienting the facts which made it possible to grasp, apprehend, measure and order it. Perhaps it was the discovery of nature and the human body, and their celebration, more than the imitation of antiquity, that characterized the art of the period. The plastic arts, architecture, painting and sculpture, are the strongest evidence of this need for new representations of the world in accordance with a visual order which would finally allow man to understand and organize it.

Executed in limestone and gilded polychrome terracotta, the *Tabernacle of the Annunciation* in Santa Croce made Donatello famous, or so Vasari tells us. In actual fact this work is usually dated to the 1430s. By placing it at the beginning of the artist's career, Vasari clearly recognized its novelty, which was the product of Donatello's thematic and formal invention. As in the *Tabernacle of the Sacrament* in St. Peter's and the *Cantoria*, Donatello manipulated motifs *all'antica* with a light touch, combining them as his fancy dictated, without attempting a slavish imitation of the architectural features he had seen (whether he studied them or not) in Rome. Here Donatello parted company with Brunelleschi and Michelozzo. The emphasis laid on the terracotta cornice ornamented with embracing *putti* holding festoons and the masks supporting the capitals anticipated the workshops' subsequent craze for bizarre constructions and surprising, enigmatic and complicated decorative repertories. Here Donatello juxtaposed the components of the new culture or rather integrated sacred history with the exciting order of a regenerative antiquity by demonstrating his ability to surpass it.

The polychromy, the gilding and the various techniques employed emphasize the "pictorial" quality of this work which established the new basic features of the expressive *mise en scène* of the representation of the Annunciation. Vasari clearly grasped the stylistic qualities of the *Tabernacle of the Annunciation*. He praised the drapery, the modelling and–an important factor according to his theory of the arts–the design. Lastly, his description paid tribute to the concentration and dramatic intensity which Donatello achieved by the "narrative" accuracy of the attitudes and gestures of the Virgin Mary and the angel. Here sculpture vies with painting. It makes the impalpable palpable and restores to us "by means of the gestures and movements of the limbs," as Leonardo required of the art of painting, "the state of mind of the personage," in other words the movements of his soul.

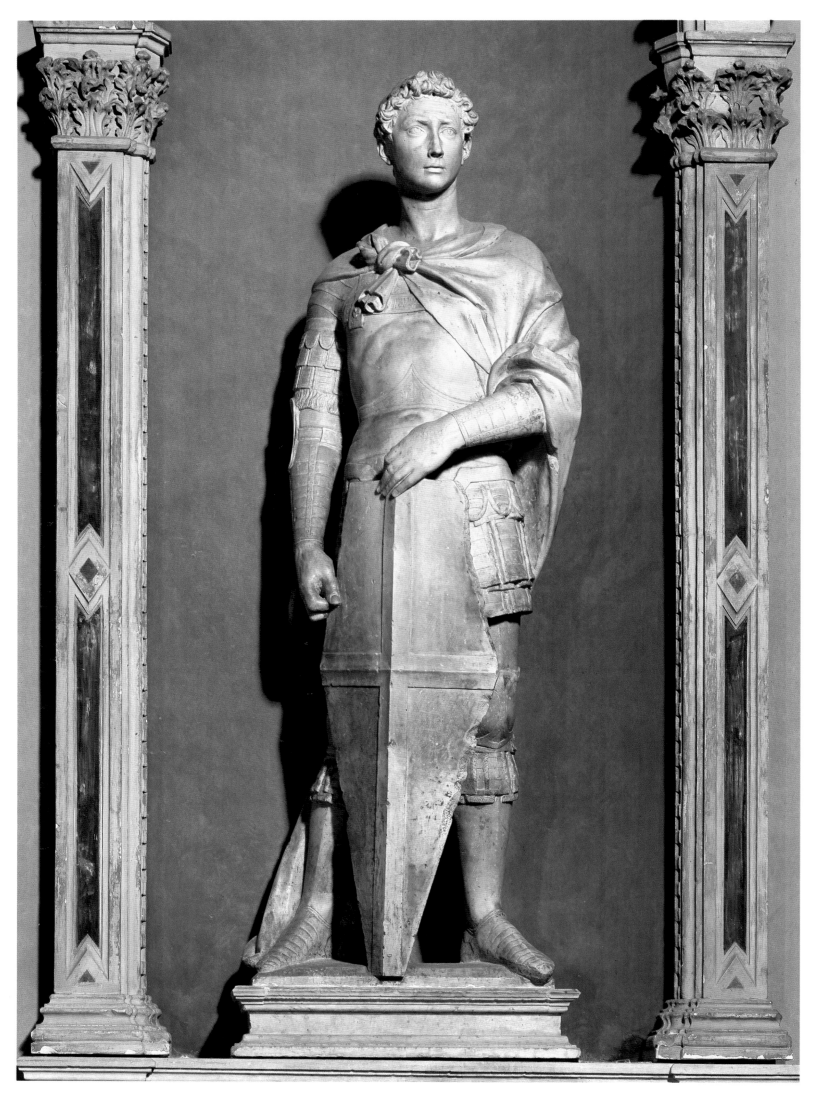

MODERN FREE-STANDING SCULPTURE BEGINS

Donatello has no equal except Michelangelo. That is the message of Vincenzo Borghini's famous phrase that was recalled by Vasari: "Either the spirit of Donato is at work in Buonarroti or the spirit of Buonarroti was already at work in Donato." Indeed Vasari felt that Donatello's work should be looked on as a premonition of Michelangelo's. It paved the way. Donatello was the initiator, "the inventor of the modern *bella maniera*" for sculpture, as Brunelleschi was for architecture and Masaccio for painting. Vasari influenced subsequent interpretations. The analysis of the *St. George* put forward by Janson was in no way fortuitous. He wrote that the saint's expression is not so much that of a warrior-saint depicted as a dragon-killer as of a victorious figure of David. Hence a figure that would take its place in the iconography of the biblical *hero* "between the previous version by Donatello and Michelangelo's famous giant." Some scholars have even recognized in the *St. George* the avatar of another sculpture representing David. Implausible though it may be, this hypothesis does take into account the radical novelty of Donatello's work and the strength of the conviction expressed and celebrated by Vasari of a seamless continuity of the Tuscan artistic tradition, masterfully accomplished by Michelangelo.

Sculpted at the request of the armourers' guild (Arte dei Corazzai e Spadai), for Or San Michele, the statue of the knightly saint *par excellence* (Macchioni), protector of the guild, was placed in a Gothic niche ornamented with a pediment showing God the Father and with a marble bas-relief on the base "where the saint kills the dragon" (Vasari). Originally the *St. George* may have been accoutred, as close study of the statue would lead us to believe, with a helmet, sword and lance (Janson) executed by one or more artisans from the guild. Even if attested, their presence would in no way gainsay the interpretations put forward of a work praised, as early as the sixteenth century, because it looked as if it could "roll down from the top of a mountain without breaking."

If the figure of *St. George* became symbolic of Quattrocento sculpture, it was precisely because it could not be compared with any other contemporary sculpture. The assertion of fullness of volume links up with the forgotten lesson of the stable, properly balanced forms of Giotto, which are here taken up again by the sculptor. The change which took place towards 1420 in the evolution of style at Florence, illustrated in Ghiberti's work by the transition from *St. John the Baptist* to *St. Matthew*, was exemplified by Donatello's *St. George*, which demonstrates it brilliantly. The statue strikes us by its *natural* appearance. Even if it implies a main point of view, it loses nothing of formal concentration and evidence when seen from another aspect. It embodies an exemplary, ideal human stature standing in a space to which it gives the measure and which includes in its order *the person observing it*. We should not forget that it was contemporaneous with Brunelleschi's experiments with perspective. It fits perfectly into the infinite, continuous and measurable space which the *legitimate construction* implies. It has all the aplomb and sovereign authority of the Christ placed in the centre of the fresco of the *Tribute Money* executed a few years later by Masaccio in Santa Maria del Carmine.

On the threshold of the Quattrocento Donatello invented a mode for the heroic representation of adolescence and grace which illustrates this new awareness of the dignity and excellence of man, of his *virtù*, which the humanists celebrated thenceforth. This representation had no precedent. Donatello's stay in Rome in Brunelleschi's company undoubtedly allowed him to discover the "antique" resources of the papal city, but searching for the precise formal sources of the youthful beardless saint in the representations of warrior saints found in Byzantine and Gothic art is not very informative. Following H.W. Janson, we may certainly admit the "influence" of the scenes on the north door of the Florentine Baptistery (some figures of the young armoured soldier are introduced in the "episodes" of the taking of Christ, the appearance before

Donatello (1386?-1466):

◁ St. George, c. 1415-1417.
Marble, height 6′10″.

St. George and the Dragon, c. 1415-1417, base of the niche with St. George.
Marble, 15⅜″ × 47¼″.

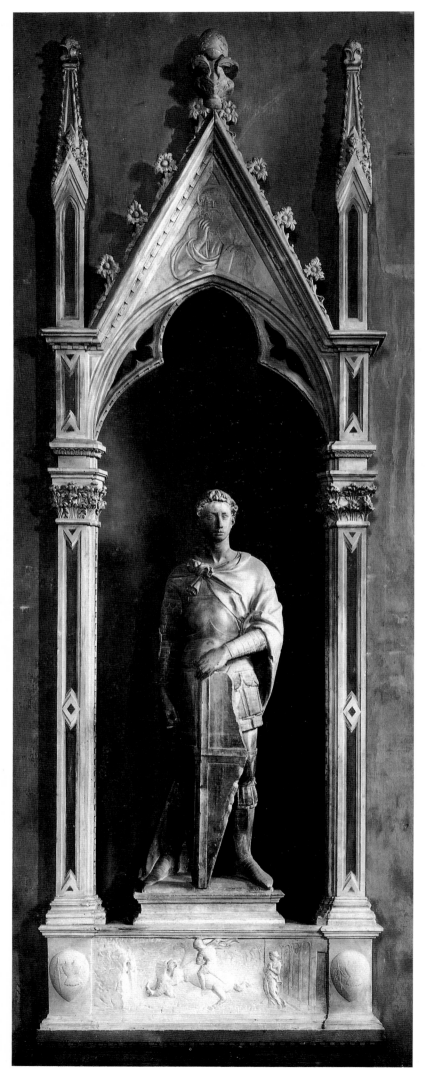

Donatello (1386?-1466):
St. George in the Gothic niche at Or San Michele,
Florence, c. 1415-1417. Below, the relief
with St. George and the Dragon.
Marble.

Pilate, and Pentecost), but they may have been executed after 1414. From that time on we cannot overlook the startling contemporaneousness of figurations of young knights, of whom the slim young standing king in Gentile da Fabriano's *Adoration of the Magi* was the "courtly" avatar. Vasari made no mistake: "It is certain," he wrote, "that among modern statues no one has yet found one whose marble is animated by a life, a soul, comparable to those which nature and art breathed into Donatello's *St. George.*" It is in his earlier works that we must look for the sources of Donatello's radical contribution to the *Renovatio*. His *David* and *St. Matthew*, which were also intended for Or San Michele, formed the still "Gothicizing precursors" of the history of modern sculpture in the round introduced so superbly by the *St. George*.

An "Apollonian" hero, the awe-inspiring proud *St. George* seems permanently detached from the combat in the bas-relief which concentrates on the serenity of the youthful knight and his calm assurance of victory rather than the tumult and ferocity. Nor is there any horrified fascination with the supernatural. Two conceptions of the world confront each other here: the idea of order and the idea of chaos. The bestiality of the dragon is opposed to the knight; the "Brunelleschian" architecture to the rock and the cave; the monster's fury to the adolescent grace of the saint and the princess, a frail distraught figure to be echoed later in the work of Ghiberti, Lippi and Botticelli. An empirical system of perspective which places the vanishing point high up gives the scene, unfolded like a panorama, its unity and dramatic force. The shallow relief work which barely cuts into the stone (*schiacciato*) and its sketch-like nature are modelled by light and shade. This "pictorial" play of values reinforces the illusionism of a representation which "recreates [reality] in such a way that it is equally convincing to the eye and to the mind" (John White). *St. George* thus determines the future programme for Tuscan sculpture in the round and in relief, whose Renaissance, as Vasari wrote, was entrusted to Donatello by the Florentines.

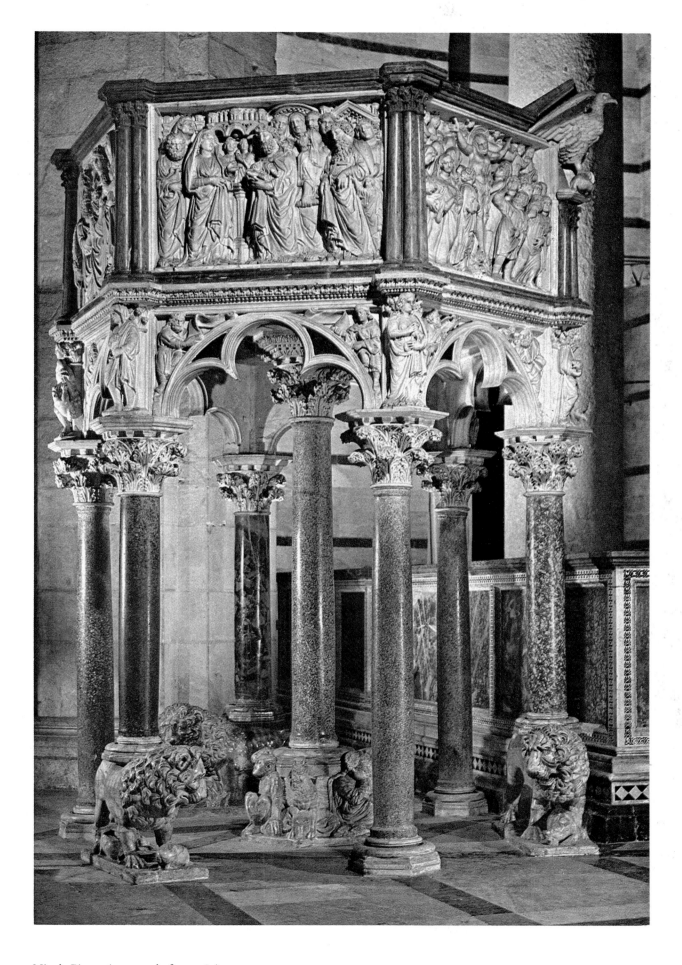

Nicola Pisano (c. 1220 – before 1284):
Pulpit, 1260.
Polychrome marbles, height 15′3″.
Baptistery, Pisa.

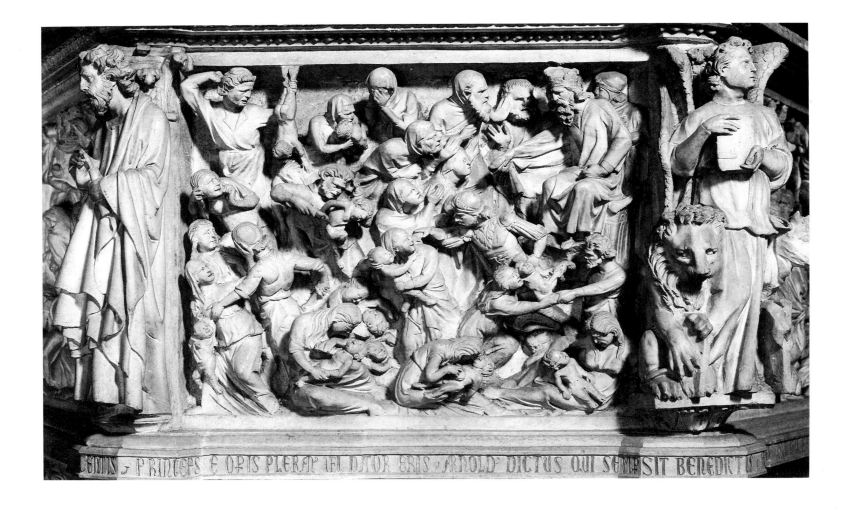

The sudden flowering of the *bella maniera* in Tuscany is a fascinating and enduring myth, although it was not without foundation, even if the "modern" seductions of courtly art prevailed over the severe and "antique" style in painting after 1450. After all, Benozzo Gozzoli was the artist chosen by the Medici to decorate their chapel. More naturally than painting, sculpture, like architecture, was able to appropriate the rediscovered remains of a forgotten antiquity. It was the quality of the Tuscan atmosphere and the hand of Providence which, "touched by the fine talents emerging daily from that land, restored their primordial skills to them." Thus, so Vasari says, the Pisani were able, around 1250, to make a clear distinction between the good and the bad, and once again set about "imitating antiques." Lastly, the Quattrocento saw the appearance of masters who could surpass the ancients. But although Cristoforo Landino praised Donatello for his skill in imitating antique models, the fame of the masters was not measured solely by the yardstick of the ancients. When writing about Donatello, it was Vasari who was careful to remind his readers that antiquities had not been exhumed in his time. And in the dedication of his book *Della Pittura* to Filippo Brunelleschi, Leon Battista Alberti observed in 1436 that, on returning to his homeland from exile, the works of Filippo, Donatello, Luca della Robbia and Masaccio were quite as meritorious and talented as those of the ancients. The ancients had examples to look at and ponder over, whereas the Tuscans succeeded in creating "arts and sciences never seen before," which only enhanced their glory. The humanists and artists of the day felt that they were the protagonists in an age of greatness.

That was how, as Gombrich remarked, a concept of art was born which claimed that every artist had a mission to contribute to the progress of art, and its rise to perfection. An acute historical awareness led practitioners to define themselves as superior to the very artists they encouraged each other to imitate.

The return to the *bella maniera* around 1250 was not of the same order. Nevertheless Nicola Pisano evinced a great fascination for the vestiges of antiquity and his mastery of "classical" technique showed that its "primordial skills" seemed to have been restored to him. The five large reliefs on the hexagonal pulpit in the Pisa Baptistery certainly owe their composition to the narrative motifs of Roman sarcophagi in the Campo Santo, but the composite architecture of the pulpit happily combines Byzantine, Gothic, Roman and Etruscan reminiscences. And we cannot help recalling, after John Pope-Hennessy, that Nicola Pisano's "simplified forms" recall the ivory figures of early Christian art.

The compositions of the five reliefs on the pulpit are indeed crowded, but they are clear and the personages are defined by the firm design of their outline and the luminous design of the folds of their drapery. Aspiration to the high style is equally remarkable in the solid sturdy figures placed above the capitals. The full modelling of Fortitude, its skilful *contrapposto*, far removed from the "sway" of Gothic statuary, demonstrates a careful observation of antiquity and obvious care in representing the human body. But this "Romanness" is less evident at Siena. This may be explained by the artist's recourse to the novelty of models supplied by the art of French cathedrals for which his son Giovanni showed a more resolute sensitivity.

Perhaps Giovanni Pisano travelled and worked in France. Or he may have known French sculpture from drawings and ivories. In any case, his work is clearly de-

THE AFFIRMATION OF THE ARTIST

One paramount innovation was that the artist was no longer content to be a mere craftsman, a person who executes an order or a commission (E.H. Gombrich). Now he felt that his mission was, as Cennino Cennini put it, to adorn with a jewel of his own the art and science of painting. Because, although Cennini still included the technical formulas and tricks of the workshop in his *Libro dell'Arte*, he also emphasized the painter's ability to invent under the stimulus of his own imagination, just as the poet does.

And although Filippo Villani had already observed that intelligent people did not look on painters as inferior to doctors of the liberal arts, Ghiberti and (more emphatically) Alberti, followed by Leonardo, were the first to put forward a modern definition of the artist's role and mission. Alberti and Leonardo proclaimed that the artist was a scholar and that art was an operation of inquiry into the mysteries of nature (Adolfo Venturi). The artist was primarily an intellectual: "The science of painting resides in the mind that conceives it." At the same time "the execution" that "is born as a result" is, Leonardo states, "much nobler than the said theory or science."

Comparisons of the different arts should be read in this context. The important thing still was to assert the "liberal" status of artists and the figurative arts. Leonardo's

Giovanni Pisano (c. 1245/50 – after 1314):
The Massacre of the Innocents, detail of the pulpit, 1297-1301.
Marble, 33″ × 40⅛″.
Sant'Andrea, Pistoia.

pendent on French examples. He assisted his father in the execution of the pulpit for the Pisa Baptistery, the pulpit of Siena Cathedral and the large fountain in Perugia. During the last two decades of the thirteenth century he was mainly active in Pisa and Siena where, for the cathedral façades, he undertook to sculpt large statues inspired by those on French portals. It is clearly the flexions and torsions of Gothic linearity that characterize works such as *Mary, Sister of Moses*, and the fragments of the tomb of Margaret of Luxemburg, but there they are combined with a wholly "Romanesque" monumentality and energy.

At Pistoia the pulpit reliefs are literally filled with figures which emerge dramatically from the background. The composition imbricates several "perspectives" connecting and isolating at one and the same time the different episodes depicted, as in the Annunciation, the Nativity, and the Annunciation to the Shepherds. In them, heedless of differences in scale, Giovanni arranges the figures around the Virgin, who is reclining in accordance with Byzantine tradition near the child she is tenderly swaddling.

The contrasting modelling of light and shade accentuates the violence of the relief representing the *Massacre of the Innocents* conceived as an antique battle scene. Dumb shows, gestures and intense pathetic looks are arranged by a play of diagonals that define the imperious gesture of a fearless Herod in the upper right of the relief and on the left that of a hardened old soldier preparing to massacre the child he holds by the ankles. At the bottom of the relief the frieze of wailing mothers clutching the bodies of their dead children endows the scene with a terrifying expressiveness unmatched by any other sculpture of the age.

Andrea Pisano (c. 1290-1348/49):
Hope, 1330-1338,
detail of the south door of the
Baptistery, Florence.
Bronze.

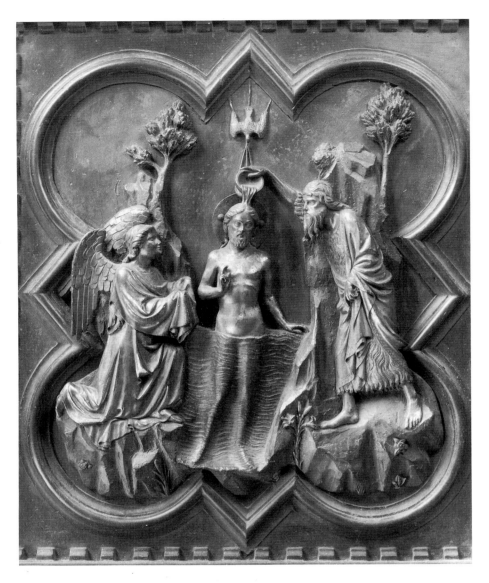

Andrea Pisano (c. 1290–1348/49):
The Baptism of Christ, 1330–1338,
detail of the south door of the
Baptistery, Florence.

ironic equation of the sculptor with the baker ought not to be read as a picturesque image. He cannot be accused of prejudice, practising as he did "the arts of the painter and sculptor in the same degree." So he should be listened to when he says that "sculpture is less intellectual than painting" because it confines itself to the appearance of things "by effortlessly revealing that which is."

That was not the opinion of Michelangelo, who gave a definition of sculpture that was restrictive, but radical and precise: "By sculpture I understand that which one does by removing (marble sculpture); that which ones does by adding (bronze sculpture) is like painting." Michelangelo held that discussions about the relative qualities and merits of painting and sculpture which "take more time than making the figures" were otiose. His insistence on practice is directly aimed at Leonardo, about whose "theoretical" activity Michelangelo had these malicious words to say: "If he who wrote that painting was nobler than sculpture was equally expert in the things he wrote, my servant would have written them better than he did." Later, Vasari called them sisters born of the same father "because they demonstrated the theory of design" without which no one could be a good painter or a good sculptor.

Consequently the two arts could not be dissociated or separated. That is why, Vasari wrote, heaven "has given us painter-sculptors and sculptor-painters in different ages." The signal example of these "universal" geniuses was, of course, Michelangelo Buonarotti "in whom these arts are equally resplendent" and whom nature had also endowed with the science of architecture, so that he could "provide his sculptures and paintings with a glorious framework that was worthy of them."

Florence commissioned a pair of bronze doors for the "glorious setting" of the Baptistery of San Giovanni from Andrea da Pontedera, known as Andrea Pisano. They were installed in the south portal of the Baptistery in 1336. Andrea Pisano divided each leaf of the double doors into fourteen rectangular panels in which scenes from the life of St. John the Baptist and figures of Virtues were inserted in a quatrefoil frame whose form did not decide the composition of the reliefs. Nevertheless, Andrea Pisano had a remarkable sense of *mise en scène*. He gave each of the reliefs its dramatic unity and coherence by arranging figures whose looks, gestures and attitudes express an interior concentration in relation to the action represented in front of an element of natural or architectural decoration. Giotto's influence is flagrant here. But Andrea's extremely beautiful figures do not possess the sturdiness of those of a painter anxious, as we know, to make the mass and weight of the personages and objects he painted tangible. The sculptor was more preoccupied with design than volume. His was a dry nervous design describing with keen precision hair, beards and above all the folds of clothes, thus allying to a mannered enthusiasm for the decorative a desire for "realistic" rendering which contains echoes of the meticulous representations and ornamented "naturalism" of Franco-Flemish illuminations.

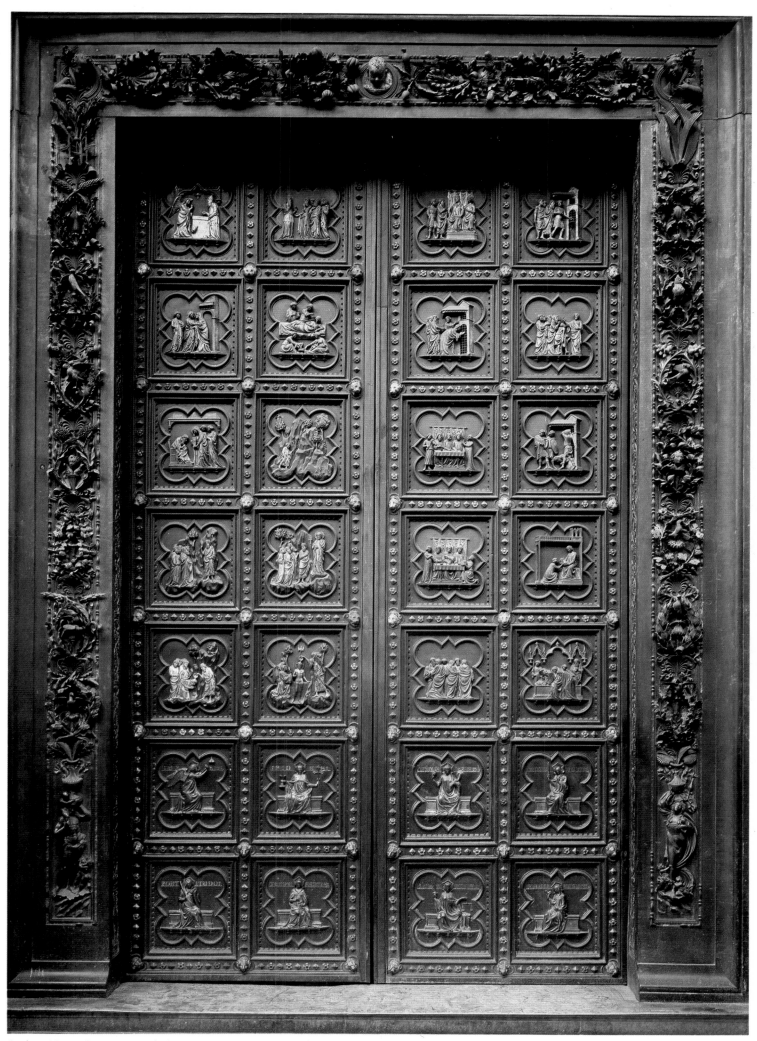

Andrea Pisano (c. 1290–1348/49):
South door of the Baptistery, Florence, 1330–1338.
Bronze.

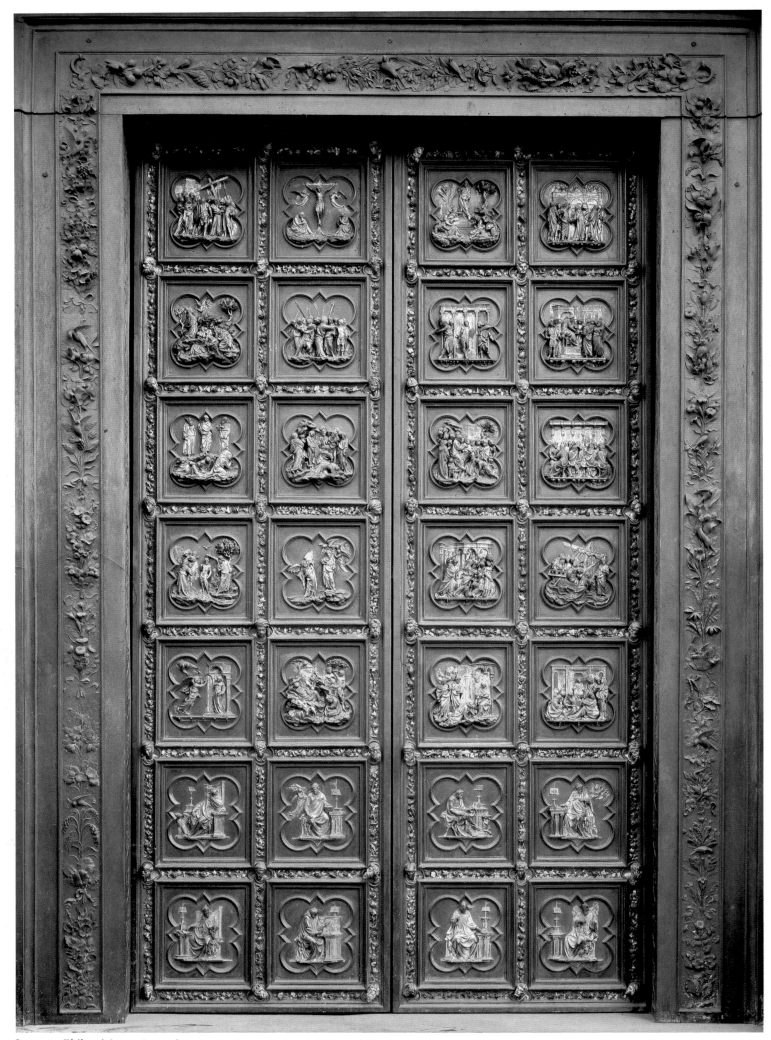

Lorenzo Ghiberti (c. 1378–1455):
North door of the Baptistery, Florence, 1402–1424.
Gilt bronze.

20

FLORENCE AND THE GREAT PROJECTS
THE BAPTISTERY DOORS: THE COMPETITION OF 1401

At the beginning of the Quattrocento Florence was strong and prosperous, in spite of the Milanese threat (which was relieved in September 1402 by the death of Gian Galeazzo Visconti whose troops had taken Bologna in June) and the devastating plague of 1399-1400. The opening of major worksites and the resumption of important artistic projects are evidence of this. At the Cathedral, which became an effervescent sculpture workshop, there was a firm decision in 1410 to execute the "grandiose" project of the dome, planned as early as 1367. And the competition for the second door of the Bel San Giovanni (Baptistery) was launched in 1401 by a powerful guild (the Arte dei Mercanti di Calimale). There is no need to revert here to the antique and Christian symbolism of this door, or its religious and civic significance. It should be remembered, however, that the commission for the first door awarded to Andrea Pisano in 1329 was an attempt to outdo Pisa, the rival city (it was conquered in 1406), which boasted of the bronze door that Bonanno Pisano executed for its cathedral.

Admittedly the competition of 1401 merely resumed the programme initiated by Andrea Pisano's door and interrupted in 1338 by the Great Plague, financial troubles and political disturbances. Around 1400, however, the speeding up of work on costly decorative and monumental projects in Florence was a challenge to Milanese ambitions, both military and "cultural" (the worksite of Milan cathedral was active at the time). To the inhabitants of the "home of San Giovanni" the Baptistery was the building which attested the city's antiquity and "Romanness." The publicity given to the project is evidence of the Florentines' intention to proclaim their city's inventive capacity and genius, ability to welcome "modernity" and confidence in remaining its centre.

The political and artistic importance of the competition, a capital event, notes Ludwig Heydenreich, in the history of western art, did not escape contemporary figures. In his *Commentarii* Lorenzo Ghiberti was at pains to recall that "skilful masters from all the regions of Italy" came to take part in it. And even if the choice of sculptors showed the clear pre-eminence of Tuscans and Florentines, they made an impressive list, as Richard Krautheimer writes. Apart from Ghiberti and Brunelleschi, it included Niccolò di Pietro Lamberti, Niccolò di Luca Spinelli, Jacopo della Quercia, Francesco di Valdambrino and Simone da Colle. So we can understand Ghiberti's obvious pride in reporting that he was chosen unanimously by the expert jury and with the approval of his rivals: "this glory," he exclaimed, "was universally recognized as mine." His reputation was now established and he could look forward to a commission for the third door, which he was given in January 1425. Nevertheless, if we are to believe Manetti, Brunelleschi's biographer, the decision of the jury of experts was disputed by the two finalists, because they were so undecided and so incapable of saying which surpassed the other in beauty that they proposed that the work be shared. (In Krautheimer's view, this would explain the preservation of panels by both Brunelleschi and Ghiberti.)

Brunelleschi's refusal to accept this proposal was a judicious one, according to Manetti, and Vasari tells us that Brunelleschi and Donatello agreed that Ghiberti should be given a chance to prove his talent. This ensured that he won the commission.

We can understand the experts' indecision. By retaining these two sculptors they had boldly taken the side of youth and novelty, and if they did hesitate it was because, unconsciously, they had to choose between two divergent forms of modernity. Ghiberti won the day because the experts rightly judged that he surpassed his rival in technical excellence. Ghiberti cast his *formella* all at once, whereas Brunelleschi soldered seven blocks cast separately on to a bronze plaque.

The specifications of the competition must have been very precise and examination of the two *formelle* confirms the accounts of the chroniclers. As the doors had to be devoted to the Old Testament, the *Sacrifice of Isaac*, a scene foretelling the sacrifice of Christ, was a natural choice. But the patrons carefully specified the number, nature and function of the figures, animals and elements of the decoration.

Filippo Brunelleschi (1377-1446):
The Sacrifice of Isaac, 1401, detail of the trial relief submitted in the competition for the doors of the Baptistery, Florence.
Gilt bronze.

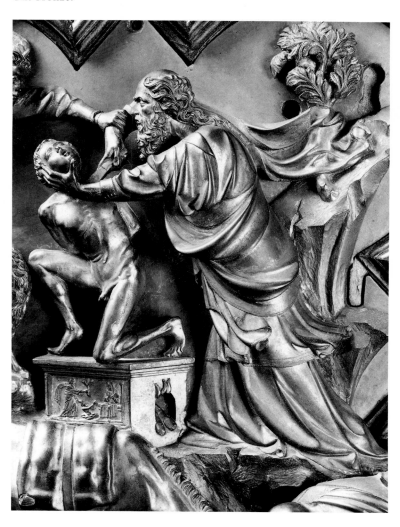

They also specified the form of the quatrefoil frame, repeated from the first door by Andrea Pisano.

On examination of the two works, we can see that Ghiberti was more skilful than Brunelleschi in reconciling the composition of the *storia* with the quatrefoil frame. The scene was constructed on two levels, in which Ghiberti's figures are distributed and modelled by playing skilfully with the luminous covering of forms. The reminiscence of antiquity in Isaac's torso is discreet but eloquent. But the elegant chasing of the drapery folds, the hair and facial features reveals an unparalleled skill in the goldsmith's craft and a knowledge, also indicated by the "realistic" intensity of certain landscape features, of the Gothic art of French courts.

Manetti's description of Brunelleschi's panel brings back for us clearly the dramatic tension born of attitudes and gestures: the vivacity of the angel restraining Abraham's arm, the terrified expression of the latter when he violently seizes his son's head. This accurate portrayal of the effective wild gesture is not seen again until much later in the painting of Caravaggio. The dispersion of figures, animals, trees, and rocks in an arrangement in two registers conforms to the "montage" of motifs adopted by the painting of the Trecento and still current in contemporary painting. It masks the attention paid to antiquity and Brunelleschi's obvious penchant for experi-

mentation, the foreshortenings, for example, to counterbalance the youth removing a thorn from his foot and the servant on the right. The austere and passionate naturalism of Brunelleschi may have seemed archaic, whereas Ghiberti exhibited a technical competence skilfully employed in the service of the undeniably modern decorative preciosity of courtly art.

The twenty-eight panels of the north door again followed Andrea Pisano's quatrefoil frame, stipulated by the competition of 1401. Eight reliefs depicted the Fathers of the Church and the Four Evangelists, and twenty the Life of Christ. The composition of the scenes followed the representational formulas used by contemporary painters. The figures are disposed on perspective stages in front of a landscape or architectural background which organizes the composition and enables the spectator to situate the personages in space. Each scene demonstrates Ghiberti's exceptional capacity for narrative invention. The sculptor had the ability to organize the flexions of the bodies and contrasting movements in a dramatic fashion, as the rhythmic actions of the *Flagellation of Christ* show. The expressive intensity of the attitudes seems to be reinforced by the skilfully constructed play of light and shade, and the chased delineation of drapery folds resulting from the artist's thorough mastery of the technical subtleties of French goldsmith's art.

Lorenzo Ghiberti (c. 1378-1455):
The Sacrifice of Isaac, 1401, trial relief submitted in the competition for the doors of the Baptistery, Florence.
Gilt bronze, 18½″ × 17¼″.

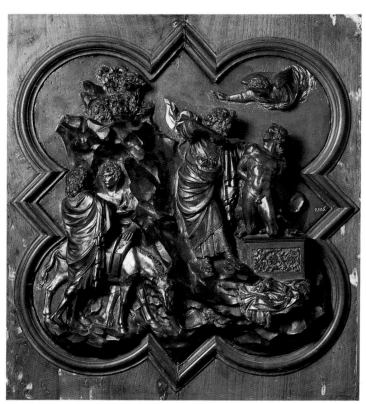

Filippo Brunelleschi (1377-1446):
The Sacrifice of Isaac, 1401, trial relief submitted in the competition for the doors of the Baptistery, Florence.
Gilt bronze, 16½″ × 15⅜″.

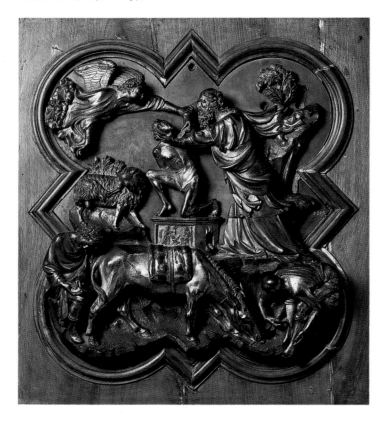

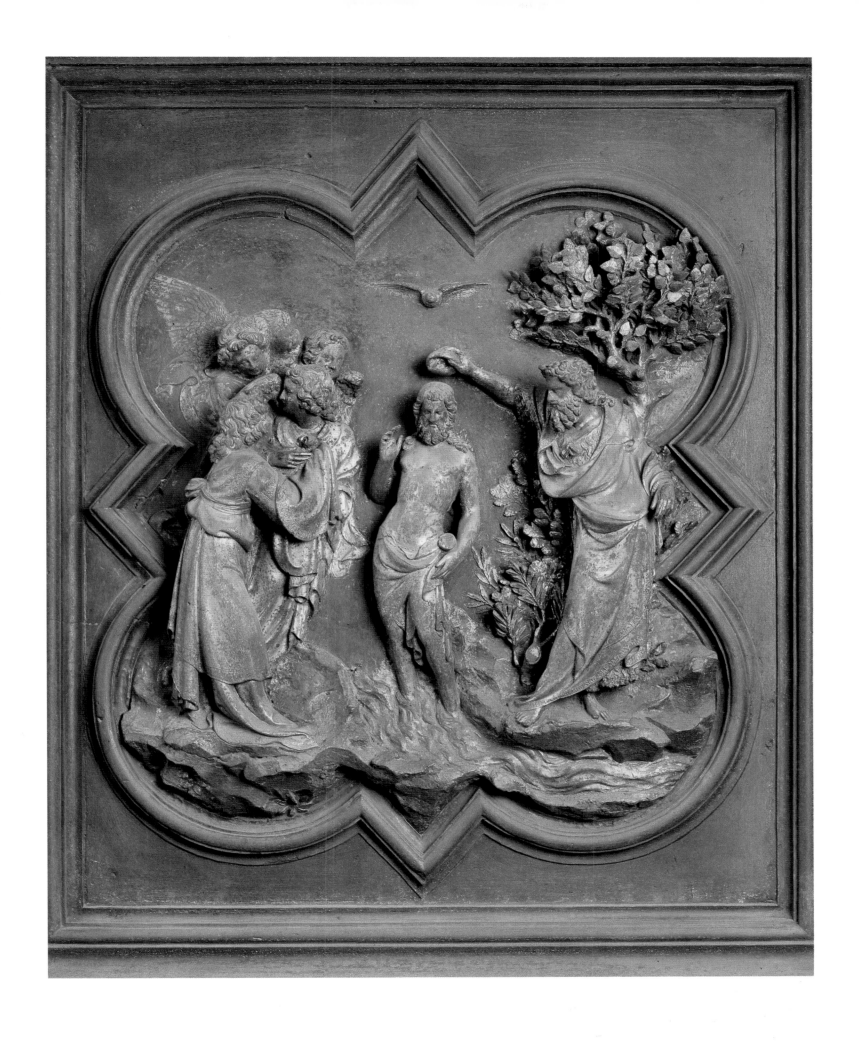

Lorenzo Ghiberti (c. 1378–1455):
The Baptism of Christ, 1403–1424, detail of the north door of the Baptistery, Florence.
Gilt bronze.

THE "GATE OF PARADISE"

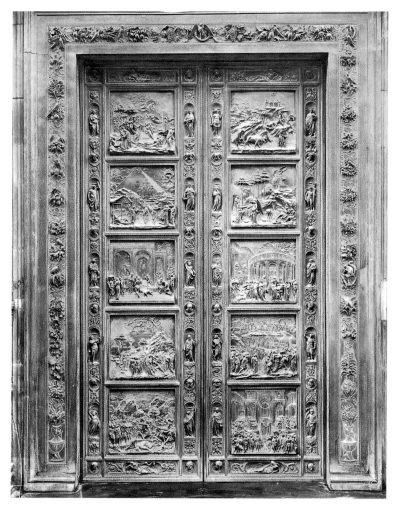

Lorenzo Ghiberti (c. 1378-1455):
East Door or "Gate of Paradise,"
Baptistery, Florence, 1425-1452.
Gilt bronze.

The competition of 1401 involved Ghiberti in an undertaking that took half a century to complete. It was not until July 1452 that the second pair of doors, which Michelangelo said were worthy to form the Gates of Paradise, were installed opposite the cathedral to replace Andrea Pisano's door which was transferred to the south portal of the Baptistery. The size of the site necessitated the setting up of a large workshop, because each relief needed a lengthy delicate finishing process, in addition to the arduous operations preparatory to casting. As a result, the Baptistery workshop became an exacting and effective centre of apprenticeship where Donatello, Paolo Uccello and Michelozzo, among others, were trained.

The first pair of doors occupied Ghiberti for more than twenty years, from 1402 to 1424, to be precise. That period coincided with a brilliant moment characterized in Florence by two trends. The first was the spread of a courtly art, a striking example of which was Gentile da Fabriano's *Adoration of the Magi* painted in 1423 for Palla Strozzi, the second the beginnings of an austere monumental art revealed by the experiments and early works of Brunelleschi, Donatello and Masaccio. Ghiberti's workshop virtu-

ally produced a synthesis of the two trends, leaving a deep and enduring mark on the development of Florentine art.

The Gate of Paradise owed its name to Michelangelo's respectful admiration. Vasari says of the ten large gilded reliefs executed between 1425 and 1452 which adorn it that "they are born of a breath rather than the finishing and preparatory touching up process." He means more of the inspiration of genius than of the talented handiwork of a craftsman.

The iconographic programme of the doors was considered with great care and the choice of scenes to be represented was the subject of discussions and controversies in which humanists such as Leonardo Bruni and Ambrogio Traversari took part. Although the programme worked out by Leonardo Bruni was not carried out, Krautheimer has shown that we have to thank Ambrogio Traversari's militant desire to see the Greek and Roman Churches reunited for inspiring the subject of the relief of the *Meeting of Solomon and the Queen of Sheba*. And we should not forget that this happened in the context of contemporary religious disputes, the Council of Basel and the threats hanging over an Eastern Empire that was breaking up.

The iconographic programme led Ghiberti to abandon the formal structure of the north door and divide the representation of the Old Testament into ten large reliefs, each of them condensing in a unified composition several "actions" of an episode in the scriptures. Vasari clearly perceived the narrative accuracy of Ghiberti's settings and emphasized the skill with which the sculptor linked the actions and attitudes of their interpreters by subtle transitions from high relief to *mezzo rilievo*, bas-relief and then to *rilievo schiacciato*. Vasari also observed the originality of the expressions and gestures of the protagonists appropriate to their sex and age. Indeed Ghiberti seems to have composed what amounts to a treatise on painting which could be compared with the aesthetic precepts and standards laid down by Alberti. Here comparisons with painting and contemporary handling of the scheme arranging the representations of biblical events would be illuminating. In the same way, it would be easy and fruitful to follow the fortunes of the various motifs and figures used by Ghiberti in the ten panels.

His obvious familiarity with the "science of optics" enabled him to produce a very clear perspective in all his reliefs and define a coherent spatial order in which the figures were arranged starting from a focal point firmly established against a landscape background or in the suggested but rigorous depth of an architectural structure. Study of the landscape of the reliefs, the scenes placed inside them and the elements of their decoration (designed with minute attention to detail) reveals the attraction Ghiberti felt for the precise imagery of the timeless frozen naturalism of International Gothic, but also invites comparison with the landscape temptations of contemporary painting, the work of Angelico, Lippi, Domenico Veneziano and of younger artists such as Baldovinetti and Piero. But it would also be necessary to draw up a list of deliberate borrowings from antiquity and, quoting Gombrich, to demonstrate how reading Pliny encouraged

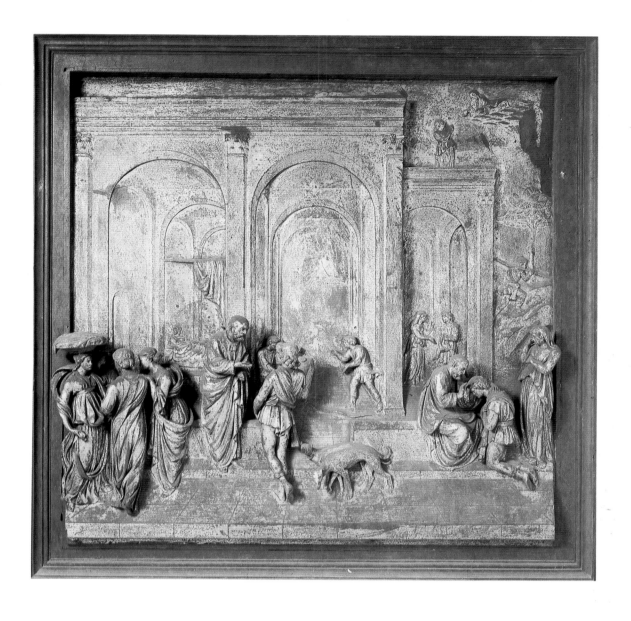

Lorenzo Ghiberti (c. 1378-1455):

△ The Story of Jacob and Esau, detail of the "Gate of Paradise,"
1430-1437.
Gilt bronze, 31″ × 31″.
Baptistery, Florence.

▷ Detail of the Story of Jacob and Esau on
the "Gate of Paradise," 1430-1437.
Gilt bronze.
Baptistery, Florence.

Ghiberti to "vie" with Lysippus by elongating his figures
in imitation of the latter. Lastly the buildings in the reliefs
are themselves worthy of lengthy analysis. They are signi-
ficant of the architectural preoccupations of the day and of
construction designs of an ideal spatial order, even though
Ghiberti's science of perspective is far too empirical.

The Gate of Paradise stood out in mid-century as the
exemplary model of a modern art which had the knowl-
edge and ability skilfully to combine aspirations to an
antiquizing "classicism" with the decorative seductions
of courtly art. The superb gilding of the doors which
Ghiberti apparently set great store by belongs to this regis-
ter, even though it was already outmoded by Masaccio's
austere frescoes in Santa Maria del Carmine and the emo-
tional intensity of Donatello's reliefs. But it does meet the
taste of the age and if, as Krautheimer has suggested, it has
a masterly aesthetic function, it also demonstrates the
power of the craft guild that commissioned it.

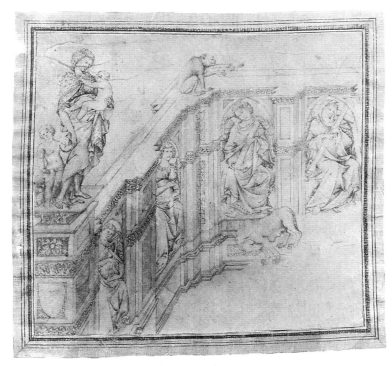

Jacopo della Quercia (c. 1374-1438):
Study for the Gaia Fountain at Siena, c. 1408-1409.
Pen and ink drawing, 7⅞″ × 8½″.

Jacopo della Quercia (c. 1374-1438):
Rhea Silvia, fragment of the Gaia Fountain, 1414-1419.
Marble, height 5′5″.
Loggia of the Palazzo Pubblico, Siena.

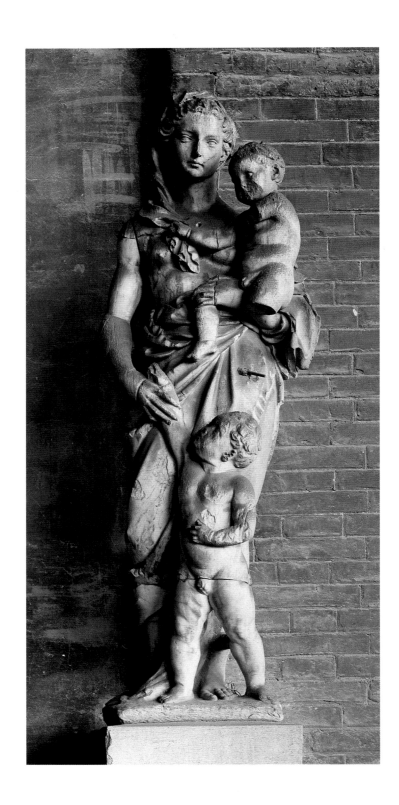

Jacopo della Quercia was one of the creators of the modern style. Yet we know very little about the training of this Sienese artist, whose first known masterpiece was the tomb of Ilaria del Carretto, which he executed in Lucca Cathedral about 1406 when he was over thirty. The second wife of Paolo Guinigi, ruler of Lucca, she is shown as a recumbent effigy with a dog lying at her feet on a sarcophagus ornamented with a frieze of *putti* carrying garlands. This tomb, with no architectural framework, was undoubtedly inspired by an antique sarcophagus preserved in the Campo Santo at Pisa. Vasari tells us that Jacopo executed the effigy with great care and all the subsequent commentators have praised the curves of the smooth polished *putti* and the dead woman. We cannot define Jacopo as strictly classical or strictly Gothic. Although the Madonna in Siena Cathedral has inflections and a charm we should not hesitate to qualify as "French," the Virgin and the Angel of the Annunciation in Florence

are evidently borrowed from Roman statuary. Unfortunately his major work is virtually destroyed. All that remains of the Gaia Fountain in Siena, on which he worked for more than twelve years (1408-1420), are a few admirable fragments. They include the lovely, sensual, mythological and pagan figures of Rhea Silvia and Acca Larentia, symbols of Siena's Roman antiquity. Jacopo's last years were occupied in modelling and casting reliefs for the doorway of San Petronio (1425-1435) at Bologna, characterized by the simple, precise outline of the figures whose intensity and epic quality were admired by Michelangelo.

But on the threshhold of the Quattrocento it fell to Florence to prescribe the decisive directions for art to follow. The town was one vast workshop. A large-scale programme of works was undertaken at the cathedral to adorn the façades, side doors, buttresses and niches of the campanile. And in 1404 the Signoria ordered every single guild to have a statue of its patron saint erected in its tabernacle in Or San Michele, under penalty of losing the privilege. Tuscan animation must be understood as a reply to Milanese effervescence, also crystallized around the Duomo, whose workshop attracted Italian and north European masters and journeymen. Perhaps these cultural "investments," as we should call them today, were made possible by a degree of economic recovery. But they can be more convincingly explained by the period of crisis which the peninsula, especially Florence, was experiencing. The hegemonic ambition which launched the Milanese on an expedition of conquest (temporarily halted by the death of Gian Galeazzo Visconti on 3 September 1402) was also expressed by the grandiose works at Milan cathedral. This in turn provoked a Florentine reaction attested by "the resurrection of Latin letters... the republican pathos of certain Latin authors... admirably suited to combat the 'tyrant' Gian Galeazzo Visconti" (Tenenti). Coluccio Salutati's *De tyranno* was published in 1400 and Leonardo Bruni's *Laudatio florentinae urbis* in 1403-1404. Later, in 1468, the celebration of the Tuscan city received its Milanese reply, the *De laudibus mediolanensium urbis* by Pier Candido Decembrio, but against the martial enterprise of the Milanese Bruni proclaimed the right of a *republic* founded to guarantee its independence by its antiquity and its ability, which Vasari insisted on in his *Vite*, and to be the centre of the restoration of a culture overthrown and destroyed by barbarism.

Knowledge became part and parcel of everyday preoccupations. The remains left by antiquity were no longer curiosities, but emblems of a history–a patrimony. The attraction exercised by what we call the art of International Gothic was countered at Florence, because it was a foreign, princely art, the art of the French and northern aristocracy appreciated by the courts of northern Italy and fashionable at Milan where Gian Galeazzo had received the title of duke from the emperor–countered by an austere "republican" art which did not so much imitate the art of antiquity as seek to incorporate it and surpass it. Thus the radical novelty and inventiveness of Brunelleschi's dome, built without buttresses or centering, proclaimed the "imperium" of Florentine "genius."

Sumptuary expenditure on the Cathedral, Or San Michele and the Baptistery certainly remained an act of faith, but it openly proclaimed the city's prestige and the munificence of its guilds of craftsmen and merchants in the ideal order of the architecture and the perennial figures of

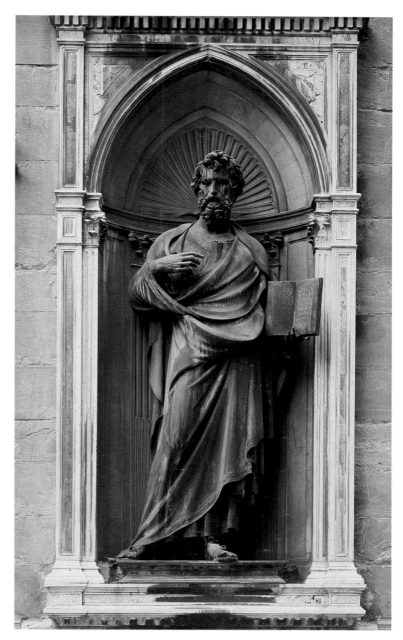

Lorenzo Ghiberti (c. 1378-1455)
and Michelozzo di Bartolommeo (1396-1472):
St. Matthew, 1419-1422.
Bronze.
Or San Michele, Florence.

the statuary. In Salutati's view, Florence, flower of Tuscany and mirror of Italy, was the daughter and heiress of Rome, but specifically of republican Rome, which, in Bruni's words, had lost its virtue when ruin entered the city under the name of Caesar.

So the defence of republican liberty, of the *respublica*, of *civitas*, of which Florence, fighting, as Rome once did, to safeguard Italy, was the incarnation, ought to be founded in law, justified by a critical re-examination of the ancient texts which entailed a new conception of history re-establishing the facts in space and time, in short which put history in *perspective*! "Historia sequi veritatem debet," wrote Bruni in his *Laudatio*.

When faced with reality, as well as the texts, in order to establish a just, rigorous and rational political order, the attitude changed. Henceforth, writes Garin, the authorities remained a dead-letter. To the Florentine scholars and humanists, eulogists of an exemplary republic of craftsmen and merchants, *civitas* could only be born of *knowledge* and

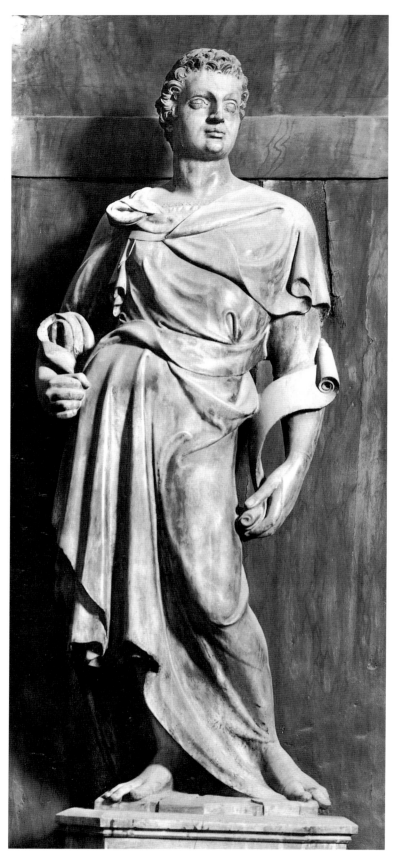

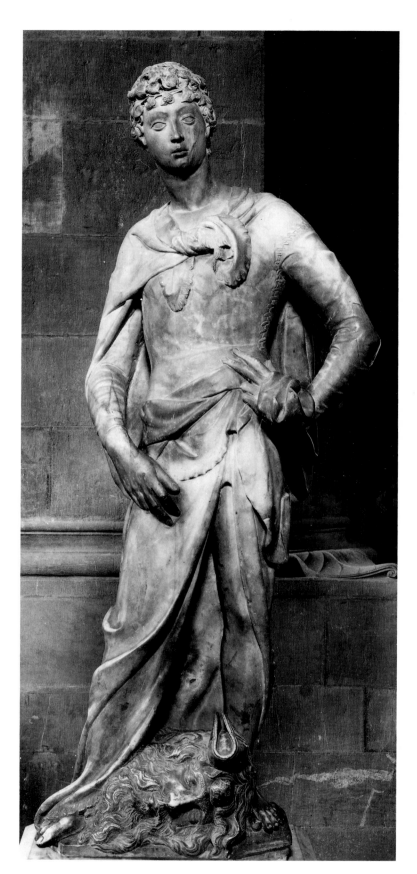

Nanni di Banco (c. 1380–1421):
Isaiah, 1408.
Marble, height 6′1″.
Cathedral, Florence.

Donatello (1386?–1466):
David, 1412?
Marble, height 6′3″.

action. The severe, *virtuous* humanist culture favoured by Salutati and Bruni required a rational organization of space. It implied the harmonious order of the *ideal city*. Thus the *pure, unornamented* art which the Florentine masters invented by effecting the rebirth of antiquity fitted in with humanist and political preoccupations. In other words, it was involved in topical, current events. So the

formal Florentine innovations which posited the rigour of a spatial order governed by the just (because mathematical) laws of divine perspective assumed a political and religious significance. They fixed and established formally and visually the universality of the laws governing the nature of the world and *civitas*, a second nature striving for *ideality*.

We understand more clearly why what characterizes this moment is its intention to define an idealized, perfect, but naturalistic representation of the human body. The novelty of the style goes hand in hand with a conception of beauty embodied by youth, whereas the gerontocracy in power strove to relegate the young and adolescent to the sidelines of social life (Richard C. Trexler). The major works inaugurating the Florentine golden age, Donatello's *St. George* and *David*, and Nanni di Banco's *Isaiah*, are representations of youth, of restrained force, of grace captured by the forms of a proud and hedonistic Beauty. Admittedly one could not claim that Donatello's *St. Mark* or Ghiberti's *St. John the Baptist* are juvenile figures, but they correspond to an optimistic, sovereign vision of the human figure which has been granted a central place in the universe.

There was undoubtedly a radical and decisive change of style in Florence at the beginning of the fifteenth century. But there coexisted several paths, several possible aesthetic orientations, that were equally "modern" and new. In her commentary on the niche statues at Or San Michele, Mina Bacci notes the presence "in the three masters at the beginning of the Quattrocento of the three elements which underlie Florentine culture: the Gothic tradition, the renewal of antiquity, and recourse to the single point of view which made it possible to confront reality." But these elements are by no means present for the same reason and in the same degree. The assertive frontality of early Quattrocento sculpture (which led Leonardo to say that a sculpture in the round amounted to the juxtaposition of two high reliefs, one showing the front of the figure, the other the back) did, however, contain the seeds of the sculpture's autonomy, its independence, by erecting it facing the spectator in what Focillon called limiting space, the space in which it is set out, and at the same time in environmental space, i.e. the space in which the spectator lives and acts. Donatello's anticipation and "illusionist" correction of the optical effects entailed by the elevated placement of *St. John the Evangelist* in the cathedral clearly took all that into account.

Donatello's activity in Florence cathedral is attested from 1406, the year in which he received ten florins for executing two marble statues of prophets for the Porta della Mandorla. When he finished that commission, the ecclesiastical authorities gave him an order for a *David* intended for the buttresses of the northern *tribuna*, for which an *Isaiah* was also commissioned from Nanni di Banco. Comparison between the two works is always inevitable but it is also significant. Nanni di Banco's *Isaiah* is a sturdy youthful figure with pronounced swaying, but there is nothing decorative about the tense flexion, which is still "Gothic." The assertive *contrapposto* and the drapery which emphasizes the clearly and firmly "modelled" volume of the body make this virile statue an image of strength and resolution. When sculpting his *David*, Donatello may have tried to vie with Nanni di Banco, as Janson suggests, and for that reason, breaking with the traditional representation of a bearded king playing the harp, invented a youthful victorious type of *David*, whose fortunes in Florentine art are well known. Perhaps he drew his inspiration from Taddeo di Bartolo. The meticulous finish of the execution, the scrupulous attention to detail, the light precise design of the leather jerkin and the cloak, and the chasing used to achieve the short, clustered curls, show Donatello still heedful of Ghiberti's fine technique, but the

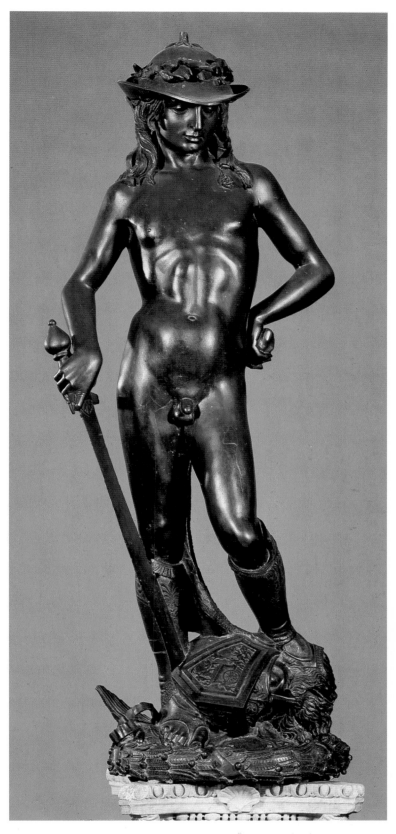

Donatello (1386?-1466):
David, c. 1440-1442.
Bronze, height 5'2¼".

flexibility and mobility given to the body by the indications of movements (some suggested, some concrete) and the heroic idealization of the representation are unprecedented. When the statue of *David*, judged too small for its intended location, was installed in the Hall of the Oriuolo in the Palazzo Vecchio by order of the Signoria in 1416, it was done with a purpose. For this steadfast, determined adolescent, "placing his raised foot" (Vasari) on the head of Goliath, symbolized liberty and intelligence triumphant over brute force and tyranny.

THE CATHEDRAL WORKSITE

Comparison of the monumental statues of the four Evangelists commissioned in 1408 from Niccolò di Pietro Lamberti, Nanni di Banco and Donatello, and from Bernardo Ciuffagni in 1410, exemplifies the Florentine artistic ambience and its aesthetic uncertainties. The antique manner has clearly not vanished overnight. The fluted decorative pleating of the drapery of Niccolò di Pietro Lamberti's *St. Mark* and its exaggerated flexion derive from a style whose obsolescence is demonstrated by the *St. Luke* and the *St. John*. As for Bernardo Ciuffagni's *St. Matthew*, its rigid frontality recalls the repetitive conventional art of the craftsmen maintained at Florence by the religious orders to counter the sumptuary excesses of International Gothic and which is well illustrated by the painting of Lorenzo Monaco.

John Pope-Hennessy has said of Nanni di Banco, who died prematurely in 1421, that he could be considered either as a Gothic sculptor in contact with the Renaissance style or as a Renaissance sculptor whose work retained certain features of Gothic craftmanship. To be sure, his *St. Luke* is not, as Heydenreich rightly says, animated by the inner force permeating Donatello's *St. John*, but it seems rich in a virtuous serenity that is wholly antique. The skilful *contrapposto*, the "natural" ease of the pose, the proud bearing of the head and the drapery free of pointless effects which defines and models the movement, seem to have purged the volume (in Adolf Hildebrandt's words) of "that which makes for violence in it." Nanni di Banco may still seem "Gothic" in comparison with Donatello. Nevertheless, he assimilated, more than any other contemporary artist, the essential features of the antique style, although his feeling for full, lucid, solid and monumental form links him more closely with Giotto. Like Donatello, he took the location allotted to his statue into account and

Bernardo Ciuffagni (1381-1457):
St. Matthew, 1410-1415.
Marble.

Nanni di Banco (c. 1380-1421):
St. Luke, between 1408 and 1413.
Marble.

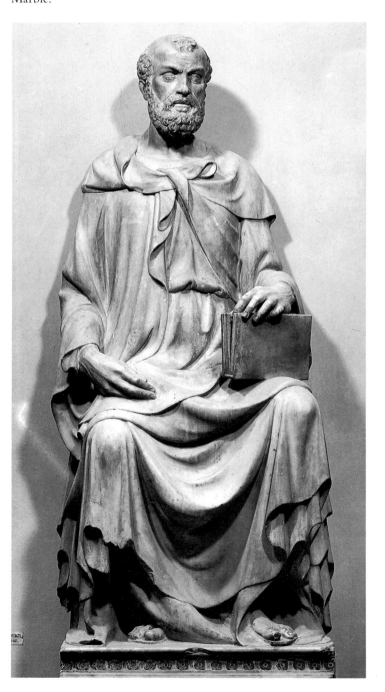

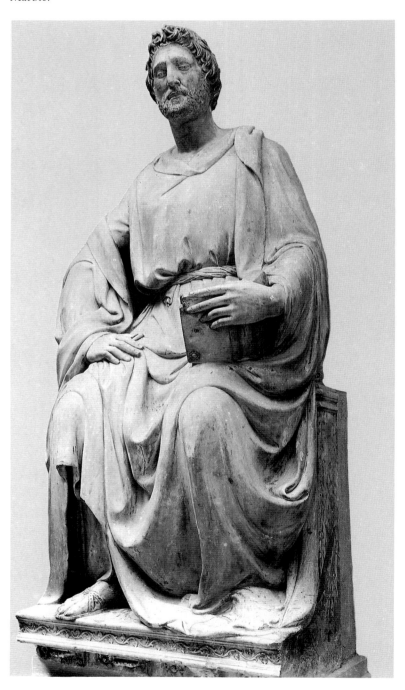

sculpted it to be seen from below. Like the *St. John*, which "has no back" and which Donatello "worked over," foreseeing the visual effects of distortions and foreshortenings caused by being viewed from below, the *St. Luke* was included from its inception in an order which put the sculpted figure and the spectator in perspective in a single coherent space, homogeneous and therefore measurable.

The serenity of St. John's rigid pose is belied by the muscular tension clearly emphasized by the enveloping folds of the Evangelist's cloak, hollowed out by light and shade, that demonstrate the artist's rejection "of the conventions of drapery in fashion" (André Chastel) by their romantic treatment. The restrained force and contemplative detachment of the meditative apostle are rendered by the pose of arms and hands, the intensity of his visionary gaze under knitted brows, and by a play of original attitudes which renew, to quote André Chastel again, the expressive repertory of the art of statuary. The classicism to which Nanni di Banco aspired was already opposed by

the concern with pathos which later led Donatello to a poignant *terribilità*, foreign, perhaps, to the optimistic aspirations of the Renaissance, but significant nevertheless of the melancholy engendered by man's humanist meditation over his destiny.

It was at Or San Michele that both Nanni di Banco and Donatello strove to erect a statue whose mass would fit naturally into the space that modelled it, thus inventing modern sculpture in the round. The richest and most powerful guilds called on Ghiberti to ornament their tabernacle and commissioned him to execute statues of bronze, an expensive and prestigious material. For the Arte di Calimala, Ghiberti accordingly cast and chased a *St. John the Baptist* (1413-1416), for the Arte del Cambio a *St. Matthew* and for the Arte della Lana a *St. Stephen*. This *St. John the Baptist* was thus the first great modern bronze statue. Delicately chased, it was praised by Vasari, but disparaged by Cellini. And it is true that in comparison with the works of Nanni and Donatello, we may look on it as "back-

Donatello (1386?-1466):
St. John the Evangelist, 1415.
Marble, height 6′10½″.

Niccolò di Pietro Lamberti (1370-1456):
St. Mark, 1410-1412.
Marble.

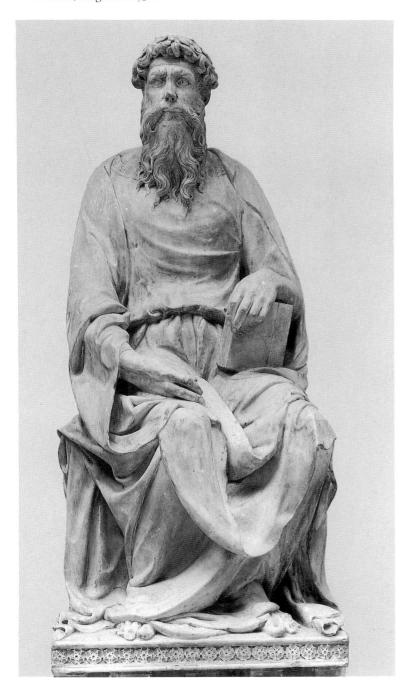

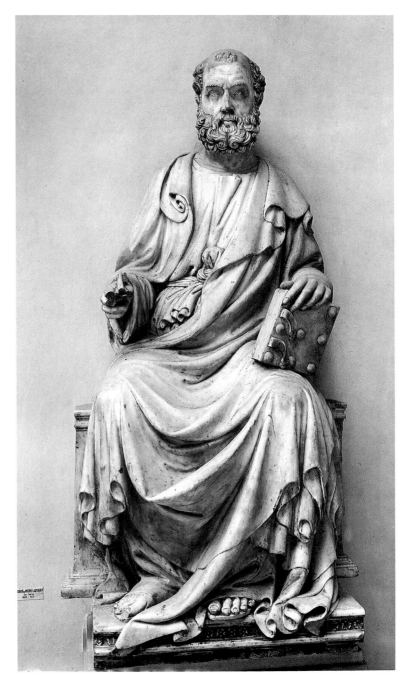

SCULPTURE BREAKS FREE OF ARCHITECTURE

Nanni di Banco (c. 1380-1421):
The Assumption of the Virgin,
over the Porta della Mandorla, 1414-1421.
Marble.
Cathedral, Florence.

ward.'' Donatello in his turn produced a gilt bronze statue of *St. Louis of Toulouse* (1423-1425), patron of the Guelph party. Wearing a heavy mitre and bundled up in a thick stiff cloak, his youthful saint is an imposing block fashioned by light and shade. Ghiberti's *St. Matthew* stems from a Gothic aesthetic, but like the *St. Stephen* it tends to a classicizing monumentality preoccupied with the proportions and harmonious relations between the statue and the niche containing it (D. Finiello-Zervas).

It is true that there had been the innovative works of Nanni di Banco and Donatello between *St. John the Baptist* and *St. Stephen*. Of Donatello's *St. Mark*, executed in 1411-1413 for the Arte dei Linaioli, Janson tells us that it was the first Renaissance statue and Artur Rosenauer that it was the first statue in the sense of an autonomous figure

in the history of modern art. Its truthful naturalism is wonderfully evoked by Michelangelo's remark that if the Evangelist was like the convincing honest man sculpted by Donatello, we should have to believe what he had written.

This obvious preoccupation with sculpture in the round, with a statue inscribing its mass in a space to which it gave order, was perfectly exemplified by Nanni di Banco with his group of the *Four Saints* (*Quattro Santi Coronati*) who were put to death on the orders of Emperor Diocletian for refusing to carve a stone idol. Nanni sculpted this group for Or San Michele at the request of the Stone and Woodworkers' Guild, of which he himself was a member. If we are to believe Vasari, Nanni was only able to fit his four finished statues into the niche thanks to Donatello who is supposed to have reorganized their grouping, thus re-establishing correct relations between the statues and their architectural frame. Although the anecdote is certainly untrue, it is significant. It shows that the novelty of this work stemmed from its harmonious natural relation with space and its unified composition which anticipated the coherence of the central group in the fresco of the *Tribute Money* so admirably effected by Masaccio in the Brancacci Chapel. Bertrand Jestaz writes that this work by Nanni di Banco came like a manifesto. Rightly so, for no other sculpture at the beginning of the Quattrocento so clearly proclaims the ambition to restore the style of Antiquity as this solemn group.

One of Nanni's notable works was the famous *Assumption* which gave its name to the Porta della Mandorla (1414-1421). Vasari attributes it to Jacopo della Quercia and praises him ''because the folds of the drapery are soft and beautiful, the clothes following the lines of the figure and while covering the limbs disclose every turn.'' Of the angels carrying the mandorla, Parronchi says that they constitute ''the first band of young immortals in Florentine art, the first certitude of a spring freed for all time in the marble and destined never to grow old.'' The error of attribution committed by Vasari is interesting. It lays emphasis on an art of modelling that Nanni had completely mastered and which Jacopo della Quercia possessed to the highest degree, if we are to believe the description of the technique employed to model the equestrian statue which he executed at Siena on the occasion of the funeral of Giovanni d'Azzo Ubaldini.

In fact the ''invention'' of sculpture freed from an architectural frame definitely belongs to Donatello. Mercury effortlessly victorious over Argus? David a moving victor over Goliath? The famous sculpture now in the Bargello, formerly standing in the court of the Medici Palace, still excites erudite polemics. Alessandro Parronchi's masterly commentary makes the first hypothesis more plausible. The mythological theme would explain the hat crowned with laurels and the pagan sensuality of this adolescent with an ambiguous beauty illustrating a subtle poetic Medicean symbolism. However that may be, this luminous representation of strength and grace demonstrates Donatello's matchless technique and forms a remarkable example of bronze statuary. In it we have the first modern nude. But Parronchi tells us that the first modern nude was not born of emulation of the antique. It was born as a ''canon of the perfect man.'' In that sense the first modern nude would be the Christ on the Crucifix in San Francesco al Bosco, attributed to Donatello by Parronchi, the same Christ of which Brunelleschi is reputed to have said to his sculptor friend: ''But you have crucified a peasant!''

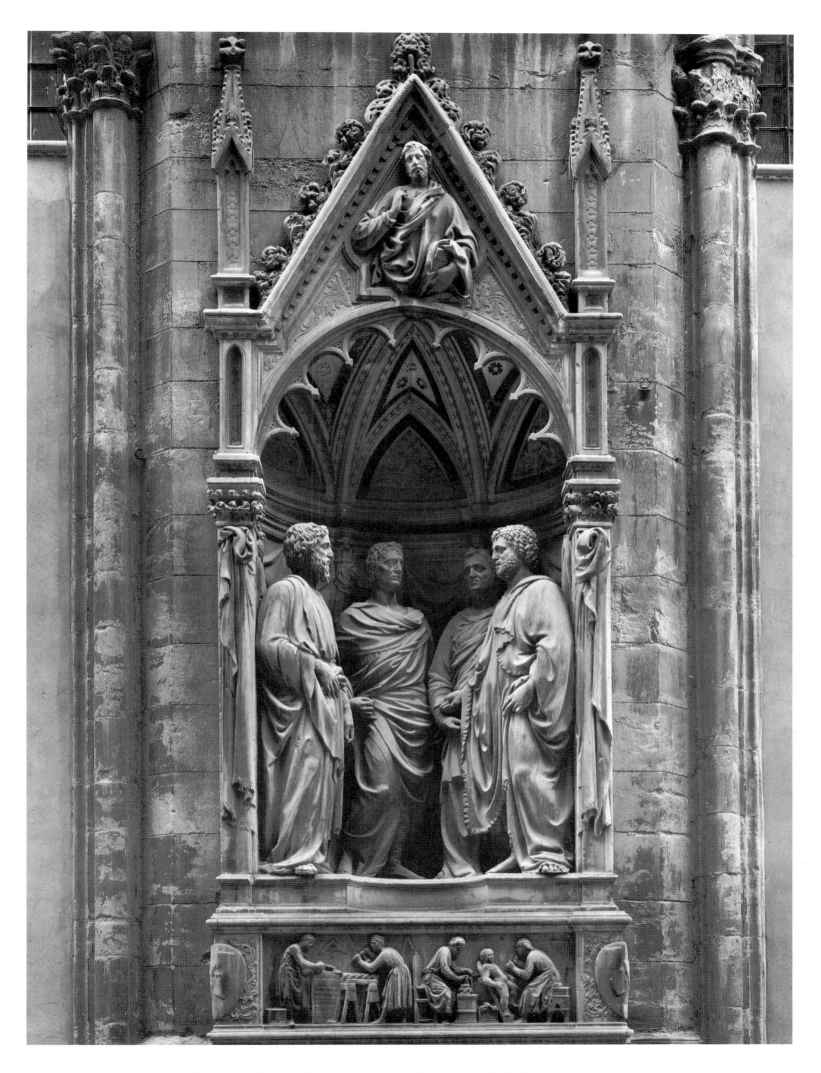

Nanni di Banco (c. 1380–1421): Four Saints (Quattro Santi Coronati) in the Tabernacolo dei Fabbri, c. 1410–1414.
Marble. Or San Michele, Florence.

DONATELLO
THE REBIRTH OF SCULPTURE

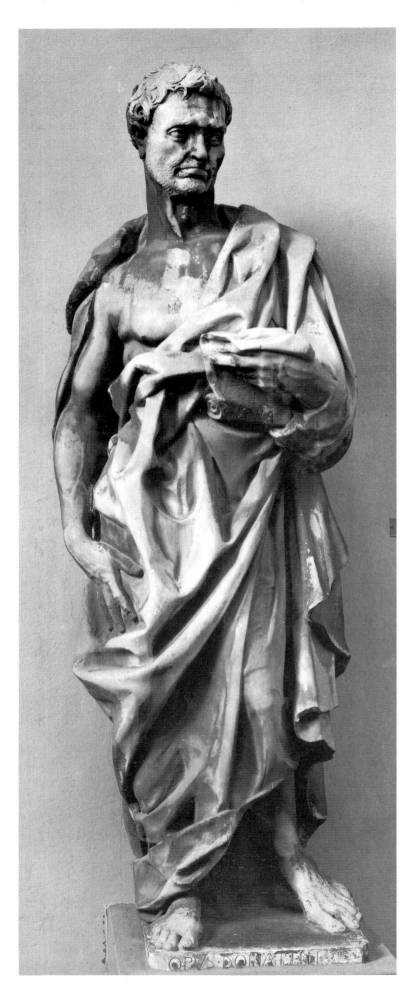

Donatello "left behind him so much work through the world that it may rightly be asserted that no artist worked so hard as he." He set his hand, adds Vasari, to everything, and an epitaph praises him for having done "alone today all that with a skilful hand numbers had once done for sculpture." And it is true that Donatello was an all-round sculptor; he was equally at home in low relief and figures in the round, in wood as well as marble and bronze. With him, in Florence, the art of sculpture was born anew. His figures ranged from the martial St. George to Mary Magdalene "consumed by fastings and abstinence," the arresting expressiveness of the latter being due in part at least, writes Vasari, "to his thorough knowledge of anatomy."

With the *David* in the Bargello and the group of *Judith and Holofernes*, he created the first free-standing statues of the Renaissance, independent of architecture or decoration. And from his first carvings for Florence Cathedral and Or San Michele he defined a type of monumental statuary whose concepts remained unquestioned till the appearance of "deconstructed" sculpture at the beginning of the twentieth century. The five statues of Prophets done between 1418 and 1435 fixed these concepts for good. The energy emanating from these grim and powerful figures is obtained by the contrast between the continuous modelling of the head and the visible parts of the body, and the shadow-broken modelling of the heavy drapery, whose firm volumes convey so keen an impression of weight and poise. From the first, Donatello was responsive to physiognomy. He has the knack of expressing emotions aptly and tellingly by a scowl, a puckering of the brows, a stare, a wondering gaze, by the slightest gesture or working of the muscles. Already his contemporaries were struck by the communicative uneasiness of his *Jeremiah*, by the meditative self-possession of his *Habakkuk*, and he was one of the most admired and respected artists of his day.

With his *St. George and the Dragon*, by enveloping the figures in space, he shaped a new definition of the relief, one that brought atmospheric values into play. The tactile sense of depth and recession was one of the constant features of Donatello's art. Illuminating in this respect is the *Pazzi Madonna*, which most students regard as an early work, preceding the *St. George*. Here the technique of flattened relief (*schiacciato*) is sketched out. True, the perspective is still stiff and unworked out, and the foreshortening of the Virgin's left hand is too forthright and bald, but the softened contouring and formal simplicity of this charming and tender group (reminiscent of Giotto's sober and limpid art) announces the austere monumentality of Masaccio's Virgins.

Donatello (1386?-1466):
The Prophet Jeremiah, 1427.
Marble, height 6'3".

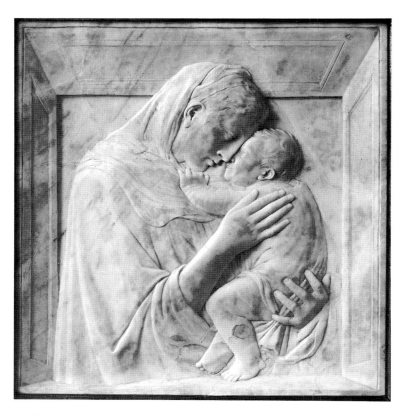

Donatello (1386?-1466):
The Pazzi Madonna, c. 1420-1422.
Marble relief, 29¼″ × 27⅜″.

In the later relief known as the *Madonna delle Nuvole* (Madonna of the Clouds) Donatello resorts, as in the St. George relief, to more pictorial effects. This image of the Virgin of Humility, seated in a halo of clouds, surrounded by cherubs, has a grandiose sobriety duly noted by Michelangelo. The relief is not so much cut and carved as drawn and incised in order to give scope for the sequence of planes within a skilful gradation of shadings and light values.

The relief of *Herod's Feast*, at Siena, was executed in 1425-1427; it is one of two panels originally ordered from Jacopo della Quercia for the baptismal fonts of Siena Cathedral. Here the architectural setting acts as one of the principal motifs of the scene. Possibly this setting was designed by Michelozzo. At any event it stands out in the history of art as the first relief to be built up in accordance with the rules of perspective. "Space here is suggested not only by the accurate proportions of the 'hall' but also by its extension on either side of the visual field," writes John White. And he points out that the successive planes of the

Donatello (1386?-1466):
Herod's Feast, detail: the Baptist's Head
Presented to Herod, 1425-1427.
Gilt bronze.
Baptistery, Siena.

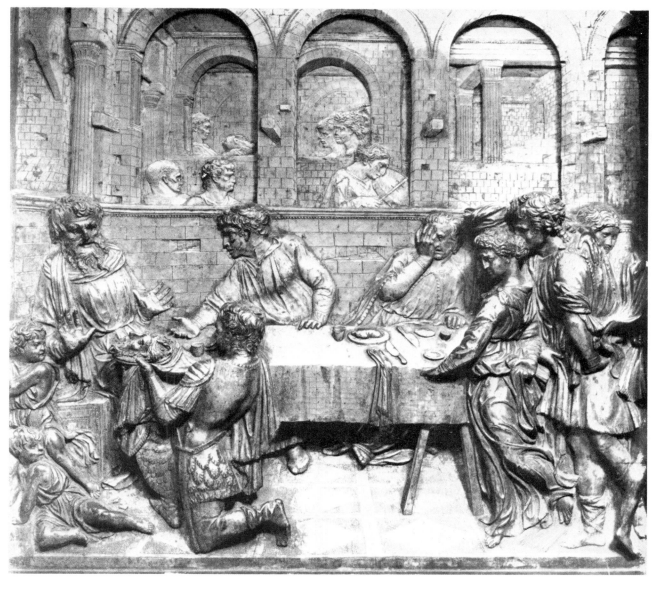

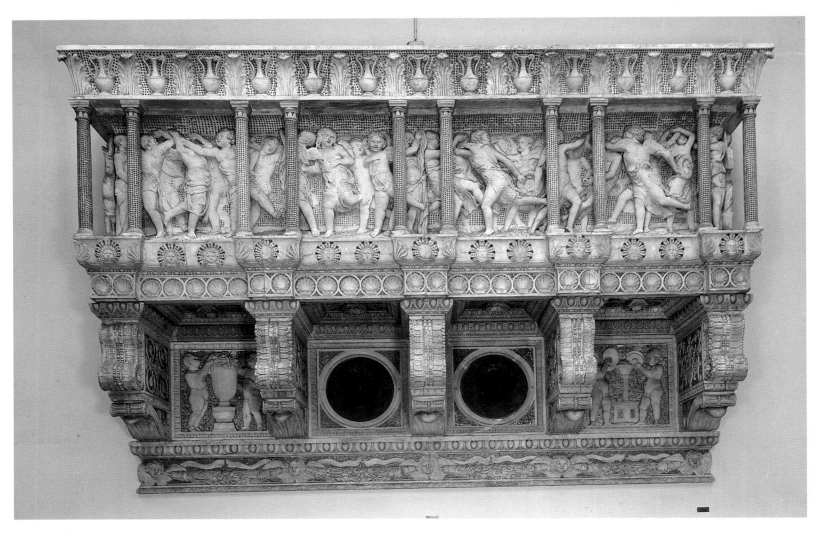

Donatello (1386?-1466):
The Cantoria or Singing Gallery, 1433-1439,
made for Florence Cathedral.
Marble and coloured glass, 11'5'' × 18'8''.

architecture weave a net which maintains the surface tension, while by its forms it creates the impression that a further sequence of airy spaces extend beyond the foreground. This strict perspective layout and the network of straight lines structuring it, heighten the dramatic effect of the scene. Starting from the Baptist's severed head presented on a salver to the horrified Herod, arises the crescendo of rhythmed gestures conveying the emotional response of the figures, expressed already by contorted or spirited movements, by the restless animation of the drapery. The upsweep of her dress shows us Salome still dancing. The memory of her slender, buoyant figure lingers on in Lippi and Botticelli.

Donatello owes his eager concern with perspective, his careful articulation of sculpture with architecture, to his friendship with Brunelleschi, but also to the collaboration of Michelozzo. It was with the latter that he conceived and executed the tomb of Cardinal Baldassare Coscia (the antipope John XXIII, deposed by the Council of Constance) and that of Cardinal Rinaldo Brancacci. The latter, carved at Pisa, was removed and set up at Naples in the church of Sant'Angelo a Nilo. The architectural setting of the Prato pulpit, too, was undoubtedly designed by Michelozzo. A rich ornamental vocabulary of antique motifs is deployed here with forcefulness and rigour, but it breaks up the joyful dance of *putti* by double pilasters separating the seven panels over which that dance extends.

In Florence the design and decoration of the Cantoria (Singing Gallery) was the work of Donatello. The combination of architecture, sculpture and polychrome mosaics went to create a total and expressive work of art. Here the dance of roguish and jubilant *putti* runs in a continuous frieze. Their full volumes are rendered by a subtle modelling of broad flat forms; and their figures, with incised hair, sinuous drapery and soft folds of flesh, are enveloped in colour and light by the background polychromy, which heightens the sacred buoyancy of their dance.

Donatello was fond of this motif of the antique *putto*, which he transposed from Dionysiac sarcophagi into Christian art. Much could be said about its appearance and development in his work, from the *putto* on the pastoral staff of St. Louis of Toulouse to the San Lorenzo ambos, by way of the "exuberant and shameless figure" (Chastel) in slashed breeches (inspired perhaps by an Etruscan vestige) of the Atys-Amorino which has given rise to divergent interpretations by learned scholars. Here we touch the intriguing question of Donatello's relations with Antiquity, memorably studied in some fine pages by André Chastel, who has shown "how attentive and accurate Donatello was in representing everything that brings out the allusion to antique mysteries": the nudity of the figures in the *Herod's Feast* relief, "the Dionysiac fillet and the fillet of the Eleusinian initiates on the brow of the musicians."

THE PADUA ALTAR

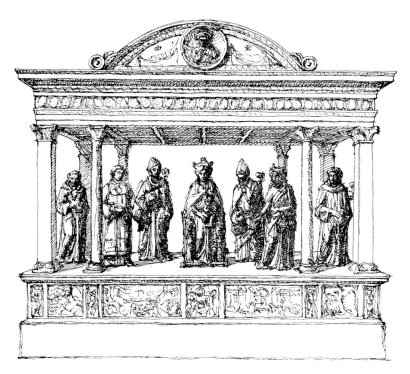

Camillo Boito (1836-1914):
Reconstruction of Donatello's High Altar of 1449 in the church of Sant'Antonio, Padua.
Drawing, 1895.

Donatello (1386?-1466):
St. Anthony of Padua performing the Miracle of the Mule, 1447.
Bronze relief, 22½″ × 48½″.
Detail of the High Altar, Sant'Antonio, Padua.

One of Donatello's major works is the large altar for the church of Sant'Antonio at Padua–an altar covering the bones of the great Franciscan, St. Anthony. Begun in 1446, it must have been completed by 1452. Unfortunately it was dismantled in 1579 and replaced by a new altar, for which some of Donatello's sculptures were taken over. A reconstruction of the original altar was made in 1895 by the Italian architect Camillo Boito, and it is this work that stands in the church today. In fact, however, it does not wholly correspond to the original state of the altar, and on the strength of early records and the description of it written about 1520 by Marcantonio Michiel, several scholars since Boito's time–Alessandro Parronchi, L. Planiscig, John White–have proposed more accurate reconstructions. This is not the place to compare and judge them, and we shall follow the reconstitution worked out by H.W. Janson.

Over the altar stood an aedicula in the form of a temple, with six bronze statues grouped on either side of the Virgin: those of St. Louis of Toulouse, St. Justina, St. Francis, then St. Anthony, St. Daniel, St. Prosdocimus. Four pillars and four columns, dividing the Virgin from the two groups of saints, supported a roofing with a heavy arched pediment. The stone predella below was adorned with four reliefs representing the miracles of St. Anthony of Padua: in front, the Miracle of the Repentant Son and the Miracle of the Miser's Heart; behind, the Miracle of the Mule and the Miracle of the Newborn Child. Further reliefs representing the four Evangelists, a Pietà, an Entombment, and twelve music-making angels or *putti* completed this complex iconographic layout, which has to be seen within the more general evolution of the theme of the *Sacra Conversazione*. While the connections with the *Sacra Conversazione* (Madonna with Four Saints) painted by Domenico Veneziano for the church of Santa Lucia de' Magnoli in Florence are difficult to establish, it is beyond question that the arrangement of figures within a prominent architectural setting in Mantegna's San Zeno triptych (Verona, 1459) presupposes a direct knowledge of the impressive structure invented by Donatello at Padua.

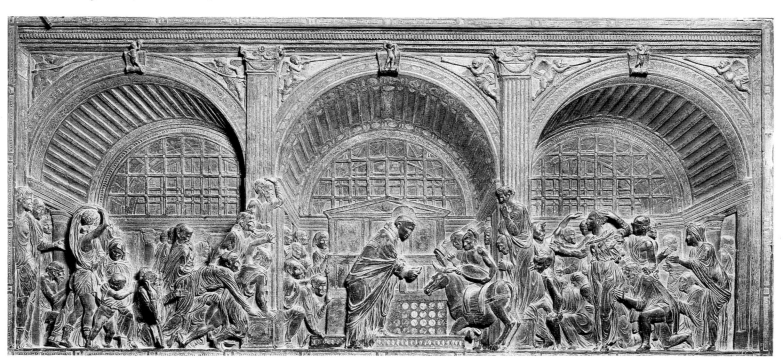

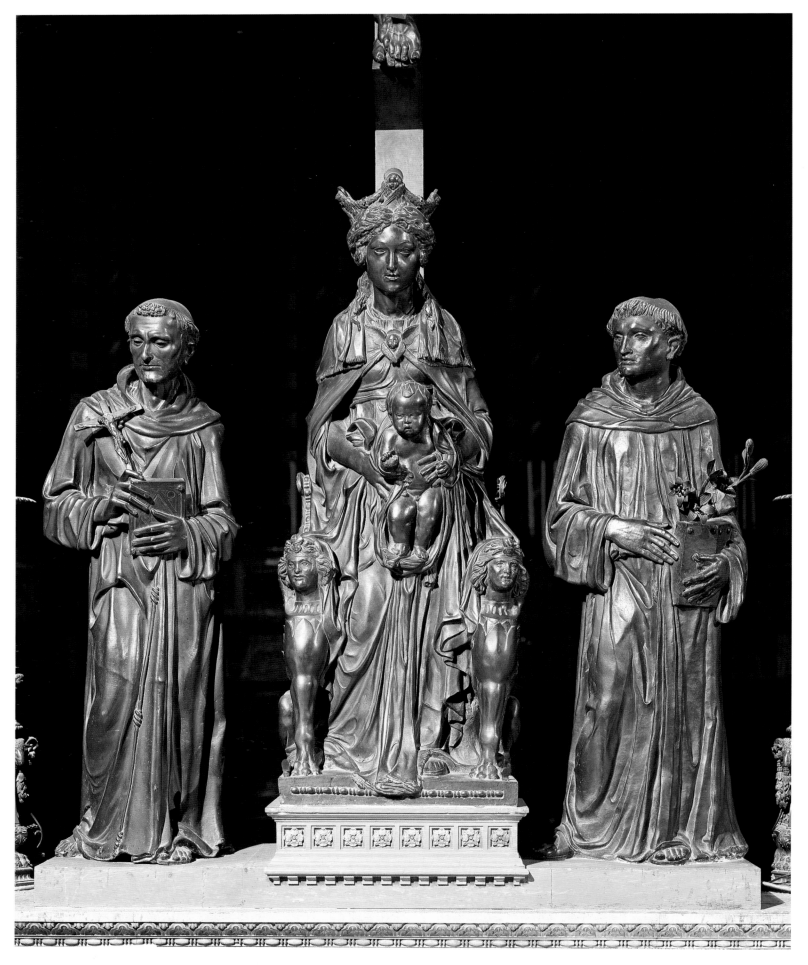

Donatello (1386?–1466):

△ Virgin and Child between St. Francis and St. Anthony, 1448.
Bronze, height of Virgin 5′2½″, of St. Francis 4′10″, of St. Anthony 4′9″.
Detail of the High Altar, Sant'Antonio, Padua.

▷ The Entombment of Christ, 1449.
Stone relief, 52¾″ × 74″.
Detail of the High Altar, Sant'Antonio, Padua.

The elevated presentation of the *Sacra Conversazione* carved in the round has something imposing and arresting about it. The more so because Donatello instilled these figures with an inner tension cunningly heightened by the contrast between the sharp-edged design of the draperies and the smooth, continuous modelling of the faces. The forthright frontality of the Virgin, its hieratic style, with an undertone of menace, evokes those archaic figures inspired by Etruscan art or more nearly the type of the Byzantine Nikopoia, such as Coppo di Marcovaldo's *Madonna* in Santa Maria Maggiore, Florence, with which Donatello was undoubtedly familiar. But he further introduced some unusual motifs which depart from the conventional iconography: the crenellated crown of cherubs, the sphinxes on the throne substituting for the traditional lions, perhaps in order to suggest the Divine Wisdom whose mysteries are not to be revealed. The strange "idol aspect" of the Virgin (Chastel) has been commented on by many historians, and indeed the figure has been seen as "the evocation of some sanguinary idol of paganism."

From the time they were finished and installed in the fifteenth century, the reliefs illustrating the miracles of St. Anthony of Padua have aroused surprise and wonder. "These are bas-reliefs designed with unerring judgment..., fine and varied compositions bringing together a large number of unusual figures, the whole conceived in accordance with the rules of perspective," writes Vasari, whose description of the Padua altar is almost confined to the reliefs. Perhaps because this part of the work has been

recognized from the beginning as the most important part. The records of the commission show in fact that for each of these reliefs Donatello was paid more than for the statue of the Virgin and Child.

The perspective of the reliefs is flawless. It is obtained by the outlining of broad architectural interiors; or, as in the Miracle of the Repentant Son, by the definition of a space rhythmed by a receding line of buildings and by two stairways which mark the tripartite division of the panel, in conformity with the composition of the other scenes. In the centre of each, the main action brings the protagonists together. Out, from this still centre, burst clusters of figures, convulsed and gesticulating crowds swept along by their excitement or fervour. This vivid expressionism is heightened by the contrast between, on the one hand, the spatial patterning of the architecture and its decoration, emphatic in the Miracle of the Mule, or overloaded in the Miracle of the Miser's Heart; and, on the other, the spare, incised design of the figures and the light-catching draperies.

But the rising pitch of excitement culminates in the relief of the *Entombment*. Behind the apostles, silent and pensive as they prepare to lay Christ in his tomb, the women give way to their despair with the vehemence of Maenads, tearing their hair, crying out, lifting their arms in frantic gestures of impotent grief and abandon—an emotional outburst whose course through European art thenceforward can be followed down to Picasso's *Guernica*.

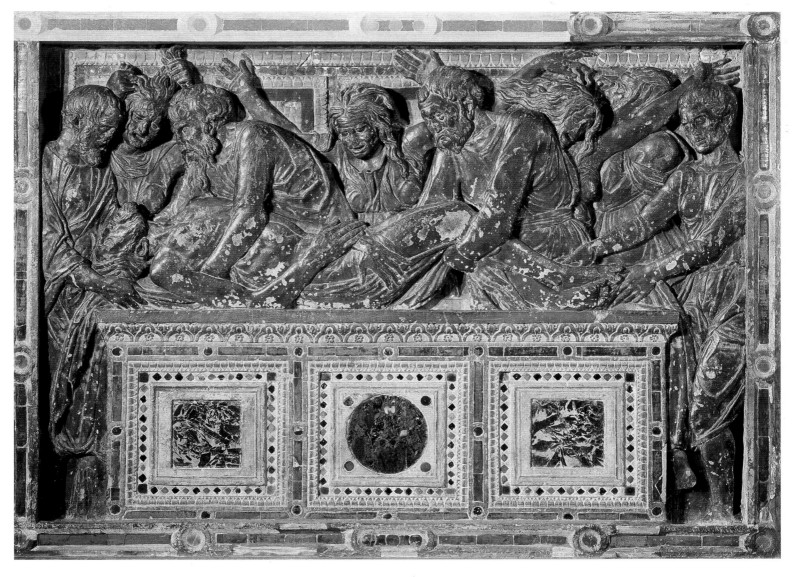

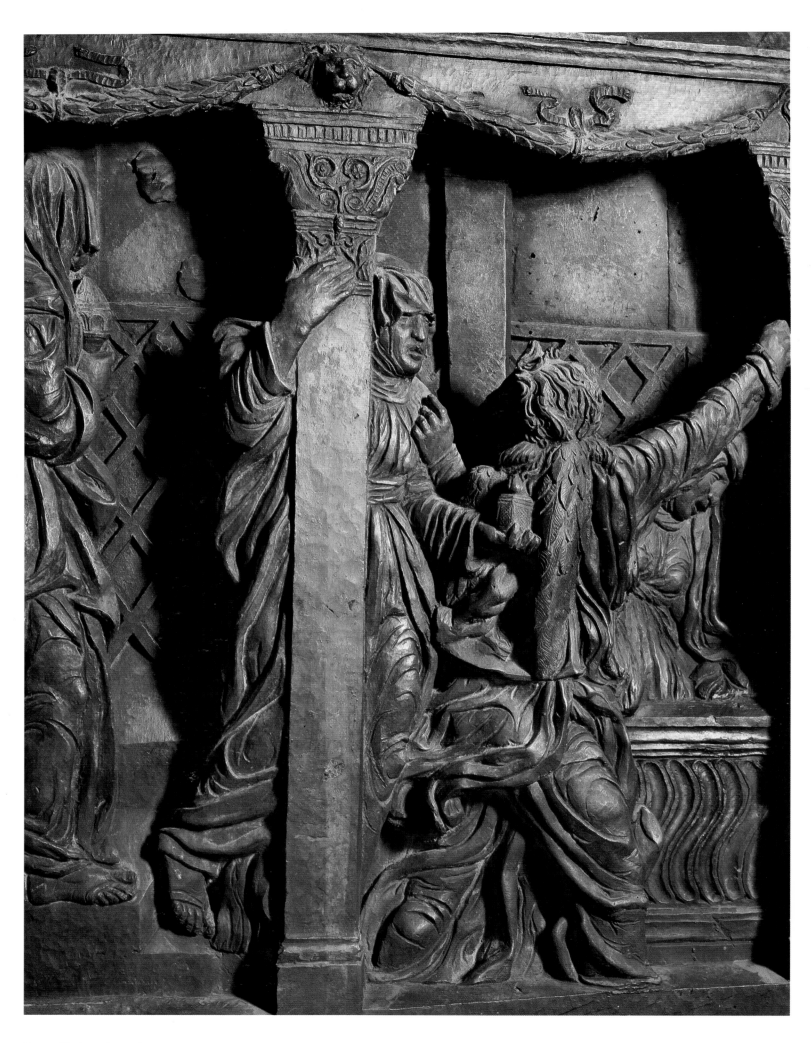

Donatello (1386?-1466):
The Maries at the Sepulchre, c. 1460-1470.
Bronze.
Detail of an ambo, San Lorenzo, Florence.

THE EXPRESSIONISM OF THE LATE WORKS

Donatello (1386?-1466):
Mary Magdalene, c. 1455.
Polychrome wood, height 6′2″.
Baptistery, Florence.

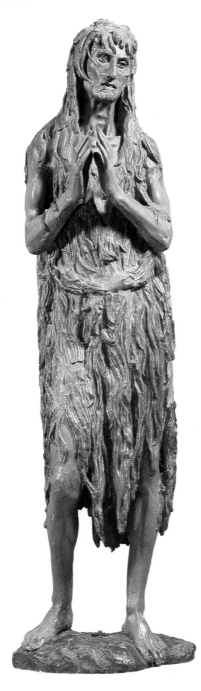

Donatello seems to have been the first to understand the suggestive power of the unfinished, the *non finito*. He found it a useful device for correcting the optical distortions caused by the spectator's distance from the work; above all, he valued it as a means of conveying in a few sharp strokes an idea that would have been weakened by aiming at "finish" for its own sake. For "the works inspired by the poetic frenzy are the only true ones, superior to those which are born laboriously."

This "frenzy of inspiration" appears at the outset in Donatello, beginning with the grim statues of prophets for the Campanile. In the last years of his life it assumes a feverish and moving tonality that one need not hesitate to describe as "romantic." At the same time it must be seen in the humanistic setting of his day. The restlessness and commotion of the figures in the last reliefs are carried to a point which, though extreme, is not amenable to an "expressionistic" interpretation in the present sense of the term. If Donatello enriched and extended the emotional range of art, he did so in perfect correspondence with the highest culture of his time–even though, at the end of his life, the contorted forms and convulsed expressiveness of his figures seem to look back to a medieval devoutness foreign to the spirit of the Renaissance. The dereliction, the inner torment, which these figures betray, is resolutely modern, and they have been rightly seen as a premonition of Michelangelo's sombre *terribilità*.

Although now (following Parronchi) it must be dated before his departure for Padua, the *St. John the Baptist* carved for Santa Maria dei Frari in Venice (dated by Janson to 1452-1454) can nevertheless be described as "the earliest late work." If then it is contemporary with the Cantoria, the change of style it evinces is all the more arresting. And even assuming that its style answered to a "political" necessity (to give no offence to the aesthetic convictions of the Venetians), it occupies a position "of pivotal importance" (Janson) in the artist's development. Possibly it was inspired by a Byzantine prototype, by a saint's figure in the Baptistery mosaics. It is a woodcarving, and the lean, emaciated body has a medieval spareness about it. The forthright gesture, meant to convince, belongs to the expressive repertory of preaching. But the intertwined hair and beard frame an inspired face which answers to no codified rule of expression.

Something of the same intensity enters later into the bronze *St. John* at Siena (1457). Out of the hairiness of the fur worn by the Baptist, looks a smooth, angular face devoured "to madness" (Maud Cruttwell) by its inner faith. This extreme concentration of the inner man is expressed by a play of features and muscular contractions so overwrought that Janson would describe them in terms of modern psychopathology. In thus conveying the stirrings of the soul by the movements of the body, Donatello refused–in accordance with Alberti's recommendations–to confine its expression to suave and graceful movements.

The *Mary Magdalene* carved for the Baptistery embodies, in paroxysmic terms, a mystical expression of faith and penitence remote from Neoplatonist speculations. It urges the beholder on to a religious fervour not far short of St. Francis of Assisi's burning faith. After Donatello there is no equivalent in Italy of this moving vision of the body's decay and downfall.

41

In contrast, the roughly contemporary *Judith* (1456-1460?) is instinct with a classical serenity. But clad in the pleated folds of her veil and dress, this blood-shedding heroine expresses in her tense features an uncommon doggedness and resolve as she lifts her scimitar, about to cut off the head of a "wine-besotted Holofernes" (Vasari), sitting strangely erect on his cushion. This figure group, said to illustrate an orison of St. Antoninus (Parronchi), has something awe-inspiring about it, carried over into the turbulent bacchanal of *putti* on the three sides of the triangular base.

Ordered by Cosimo de' Medici in 1461 and still incomplete on Donatello's death in 1466, the ambos for San Lorenzo were finished by Bertoldo and Bellano (the latter perpetuating with some awkwardness the rough manner of his master). These ambo reliefs bring Donatello's work to a close on a note of unrest and tumult. Their complex structure has been analysed in a remarkable article by Alessandro Parronchi. It is enough here to say that in them Donatello represented a cycle of New Testament scenes whose newly devised iconography comes as a reaction against all the Quattrocento conventions of religious symbolism. The design of the two ambos is dissimilar. In one, the scenes are figured on panels set between pilasters; in the other, they are separated by walls cut out of the bronze and thrown forward from the relief plane. This arrangement produces diorama effects which reinforce the expressive veracity of the *mise en scène*, most conspicuously in the *Maries at the Sepulchre*. Relief technique rises here to a point of rare complexity. The fusion of planes is obtained by a play of light and shade over the ridges of masses barely sketched out. The result is an incised pattern of luminous streakings. This pictorial concern with depth accounts for the strict architecture of the places where the action is set. In the *Lamentation over the Dead Christ* the off-centre arrangement of the three crosses and the ladder involves the scene in the network of an unemphasized perspective layout which securely orders the apparently confused figure groups, whose agitation verges on tumult. Here and there one notes the convulsed and terrified figures of women, Christianized maenads moving in an outburst of cries and tears, a pure manifestation of frantic emotion.

Donatello (1386?-1466):
The Martyrdom of St. Lawrence, after 1460.
Bronze bas-relief.
Back of the ambo, San Lorenzo, Florence.

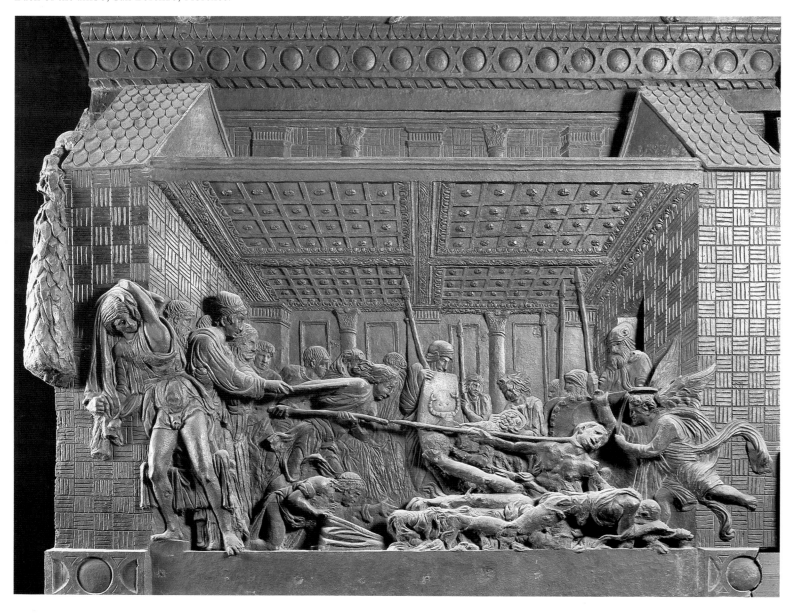

SCULPTURE-PAINTING: LUCA DELLA ROBBIA

Luca della Robbia
(1399/1400-1482):
Virgin and Child Enthroned
between Lilies, c. 1455-1460.
Polychrome enamelled terracotta,
diameter 5′11″.
Or San Michele, Florence.

Donatello's expressive style fascinated his contemporaries. But sometimes in Florence a preference was felt for a more ingratiating and less intellectual style, whose vogue is attested by the work of two younger artists: Bernardo Rossellino, inventor of a new type of funerary architecture; and Luca della Robbia.

Apprenticed in Florence to a master goldsmith, Luca was probably trained as a sculptor in the studio of Nanni di Banco, whose rounded modelling and clear strict spatial settings (so different from the more emphatic art of Donatello) Luca perpetuated. Witness the ten bronze door reliefs for the new sacristy of the cathedral, each adorned with a figure from the Scriptures or Church history: the Virgin, the Baptist, four Doctors of the Church, the four Evangelists, each of them flanked by two angels. Their deliberately simple, frontal composition is set off by the rigorous moulding of the frame, punctuated at the corners of the relief by heads of Prophets, whose variety is praised by Vasari.

It is the Cantoria or Singing Gallery made for Florence Cathedral, about the same time as Donatello's, which best

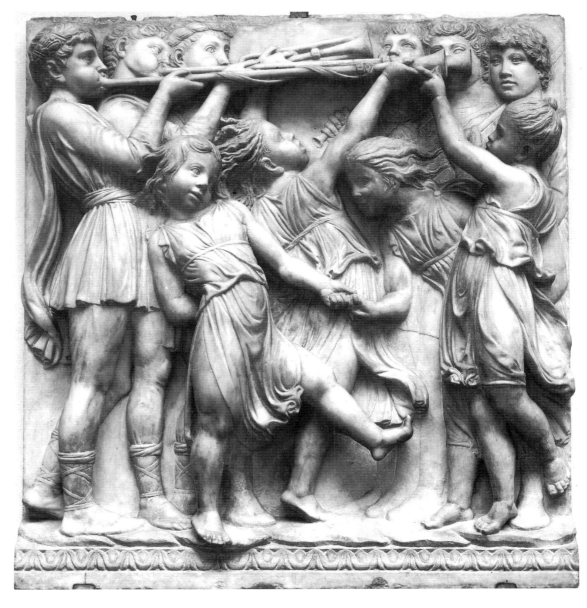

Luca della Robbia
(1399/1400-1482):
Trumpeters, 1431-1438.
Marble, 42″ × 41″.
Detail of a Cantoria
formerly in Florence Cathedral.

43

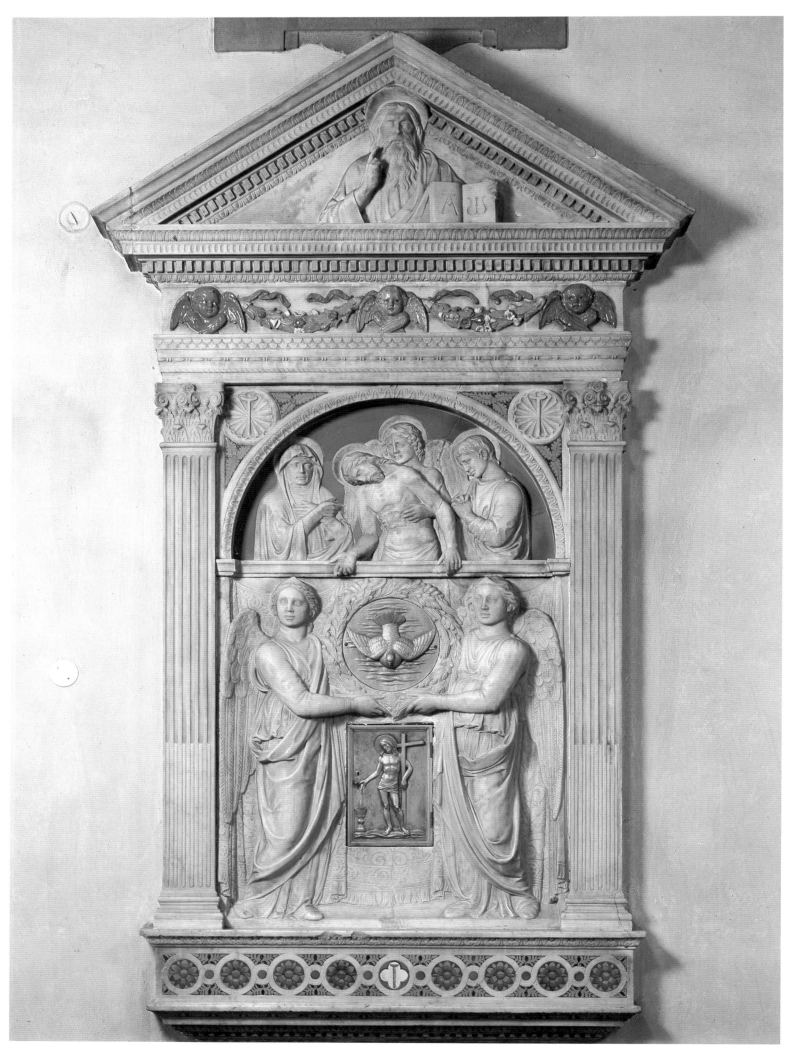

Luca della Robbia (1399/1400–1482): Tabernacle with Pietà and Two Victory Angels, 1441–1443.
Marble and enamelled terracotta. Church of Santa Maria, Peretola, near Florence.

illustrates Luca della Robbia's "classicizing" opposition to the romanticism of Donatello. And it is the inevitable comparison between the two works which prompts Vasari, intent on justifying the incompleteness of Michelangelo's sculptures, to speak so highly of the suggestive power of the inspired sketch. The architectural structure of Luca's Cantoria is not impaired, like Donatello's, by the profusion of ornament and the luminous play of colours intensifying the rhythm of the dancing *putti*. Twin pilasters sharply separate the ten relief panels illustrating Psalm CL (*Laudate Dominum*). Their careful polishing and finish enhance and indeed idealize the realism of the lovely faces of these harmoniously grouped angel singers and musicians. This balanced classicism, accurately defining the sober and limpid perspective of the reliefs, is manifest again in the tomb of Benozzo Federighi; also in the Tabernacle now at Peretola (but here more insipidly), where the banal and stiffened disposition of figures is handicapped by the heavy architectural frame *all'antica* which encloses them.

Like the Federighi tomb, with its fine surrounding frieze of floral motifs, the Peretola Tabernacle is ornamented with enamelled terracotta, a technique whose invention Luca della Robbia is credited with, but which he may owe to the initiative and prompting of Brunelleschi, who employed him about 1440 to do thirteen terracotta *tondi* in blue and white for the Pazzi Chapel in Santa Croce. According to Vasari, Luca turned away from bronze and marble sculpture, for which he had originally been trained, when he found that he could earn more money from terracotta work, a technique he perfected and one that stood up extremely well to time and weather. Though Luca and his followers did indeed make the most of glazed terracotta as a durable medium for polychrome reliefs in positions where oil paintings would soon have deteriorated, Vasari's explanation is hardly good enough.

It would seem, rather, that Luca simply wished in the first instance to add colour to marble sculpture, and glazed terracotta proved the readiest way of doing so. That it was not taken up originally for its durability is shown by the fact, noted by Pope-Hennessy, that his terracottas were not necessarily made for positions exposed to inclement weather. Giulio Carlo Argan has pointed out that the appearance of terracotta coincides with the adding of colour to statuary and with the taste in painting for simulated sculpture. Luca, then, would have offered the Florentine workshops an original and attractive solution to the problem of a synthesis of the arts. And it is true that the invention of this coloured terracotta medium, whether actually his or not, appeared at a time when the question of the pre-eminence of one art over the others turned attention to their fusion or anyhow their integration in architecture. A signal example of these preoccupations is the Chapel of the Cardinal of Portugal in San Miniato, where Luca and his workshop adorned the ceiling with five large medallions in patterns of blue.

This art proved to be a profitable one, as Luca himself states in his will. The ingredients were inexpensive and it was admirably suited to rendering, with all the seduction of smooth forms and bright colours, the standard subjects of religious art and the ornamentation of building structures and of statuary in marble and bronze. The demand for it was such that Luca's business was carried on by his nephew Andrea della Robbia (1435-1525) and later by Andrea's five sons, of whom the most important were Giovanni (1469-1529) and Girolamo (1488-1566), who multiplied and diffused an endless variety of washing fountains, lunettes and *tondi*.

Luca della Robbia (1399/1400-1482) and his workshop:
Virgin and Child with Two Angels, c. 1475.
Enamelled terracotta relief.

IN SEARCH OF NEW FUNCTIONS
TOMB SCULPTURE

The desire for eternity in this world as well as the next had always driven great men and their close family to erect prestigious monuments on their tombs. Ancient funerary themes, enlivened and varied by new experiments, continued during the Renaissance.

The antique sarcophagus as a sepulchral coffer persisted throughout the Middle Ages. Rejuvenated by archaeological knowledge of ancient Rome, it sometimes served as a funerary monument on its own. Examples of this are the tomb executed by Bernardo Rossellino in honour of Neri Capponi in Santa Croce at Florence and Verrocchio's tomb for Giovanni and Piero de' Medici in San Lorenzo.

The marble or bronze slab inserted into the stone floors of churches dates back to the Middle Ages. It represented the deceased in a recumbent position by a silhouette in shallow relief in Italy, and more simply in Gothic countries by incised outlines and features which the footsteps of the faithful wore down over the centuries. Although some outstanding sculptors (Jacopo della Quercia at San Frediano in Lucca, Ghiberti in Santa Maria Novella in Florence, Donatello in Siena Cathedral) raised the figural tomb slab to the level of great tragic portraiture, its traditional structure was retained. Only the architectural decoration and the ornamental grammar marked the transition to a new age.

Donatello surrounded the recumbent effigy of Pope Martin V in St. John Lateran with arches ornamented with ovoli, foliage and a cartouche showing cherubs carrying a wreath of laurels.

The recumbent effigy in the round, isolated on its sarcophagus, was the other medieval formula. It was most common outside Italy, although examples were also known there. In 1406 Jacopo della Quercia adopted it for his marble sculpture of the beautiful *Ilaria del Carretto* reposing peacefully on a high base punctuated by *putti* playing with garlands. Pollaiolo, the artist of the *Tomb of Sixtus IV*, again used the theme of the sarcophagus, admittedly with sloping faces, thus turning it into what was virtually a raised tomb slab. The pope, reclining on a funeral bier with tiers of the liberal arts in relief, was visible from all sides in the Grotte Vaticane.

Nevertheless, this type of structure was rare in Italian churches, which were crammed with individual and family sepulchres. The isolated tomb that attracted the observer's attention was more successful abroad. It was used by the Florentine Pietro Torrigiani in Westminster Abbey and Domenico Fancelli in Spain, in accordance with local custom. A more structured version in which the effigy was surmounted by an ornamental canopy also had its origin in medieval tradition. Covered in antiquizing ornaments, as in the tomb for Gian Galeazzo Visconti by Gian Cristoforo Romano in the Charterhouse of Pavia, the canopied monument later inspired the Giusti brothers to adopt the form for the tomb of Louis XII and introduced a princely model to sixteenth-century Europe.

Previously, when he drew up the initial project for the tomb of Julius II, Michelangelo had also adopted the formula of the tiered monument, isolated like a chapel; but, steeped in antique architecture and the humanist ideal, he imagined a symbolic structure with powerful rhythms in which the ancient ciborium became a triumphal arch, animated by a structure recalling papal and spiritual grandeur.

Jacopo della Quercia (1374?-1438):
Tomb of Ilaria del Carretto, 1406.
Marble, length of figure 6'10".
Cathedral, Lucca.

Nevertheless, the wall tomb was the favourite framework used by Renaissance sculpture as its field for experimentation. The weight of medieval tradition was applied to the simple attached relief where the recumbent effigy in profile reposed in a minimal setting. The Blessed Villanova, framed by curtains, sculpted by Bernardo Rossellino at Fiesole, and the delicate Sicilia Aprile by an unknown artist in Palermo Museum, are examples. The medieval heritage also dominated the recess tomb, deriving from the antique arcosolium, as well as the sarcophagus supported by columns or caryatids which was developed in sumptuous fashion in Angevin Naples. Tino di Camaino, Arnolfo di Cambio and the Pisani had laid the foundations of a funerary art at Naples, Rome, Orvieto, Pisa and Florence. It consisted of several statuettes in relief or in the round evoking life and death (Virtues, angels holding curtains), which surrounded the sleeping *gisant*, while the divine image above, often that of the Virgin, bore witness to eternal life.

Donatello, in company with Michelozzo, continued these traditional themes. *John XXIII* reposes in the Baptistery at Florence on a bed for lying in state with fringed curtains (1425-1427). At Naples *Cardinal Brancacci*, resting on a sarcophagus with rigid compartments, is framed by two angels holding the funeral drapes. Three Virtues, placed in niches at Florence, and caryatids at Naples gaze out at the spectator. The tympanum above frames a relief of the Virgin and Child. But a new conception ousted the traditional iconography. The architecture became classical, enlivened at Florence by a garlanded base composed of fluted columns and pilasters, and sober rational motifs. The amply modelled Virtues are clad in soft pliable draperies. Lively dimpled naked *putti* sound the trumpet from on high, while other, more pensive angels, in symmetrical *contrapposto*, keep vigil over the deceased.

The tomb backed against a wall then became the norm for the ambitious monument. At Florence, the recess, framed by fluted pilasters surmounted by a semi-circular tympanum and placed on a base with garlands in the antique fashion, was used by all the sculptors. Thus Bernardo Rossellino erected the prototype of the large wall tomb for the humanist *Leonardo Bruni*; Desiderio da Settignano made that of the secretary of state *Carlo Marsuppini*, and Matteo Civitali that of *Pietro Noceto* at Lucca. Pietro Lombardo also used the arrangement for the tomb of the *Doge Pasquale Malipiero* in Venice. The tomb of the *Cardinal of Portugal* at San Miniato was the highpoint of this art, the product of rhythm and restraint. Antonio Rossellino enlarged the recess in depth in the axis of a funerary chapel. He played on the polychromy of the marbles, frescoes and the glazed terracotta work by Della Robbia. He mingled archaeological elements, such as the sarcophagus copied from an antique porphyry model, and the enjoyment of life embodied by smiling cherubs. He superimposed the long flexible curtains and the compartments with rosettes on the intrados of the recess.

Each region adapted the structure of the tomb backed against a wall to suit artistic temperaments and fashions. At first the pilaster with candelabra and foliage outshone the fluted pilaster at Bergamo and in northern Italy. At Venice large triumphal arches replaced tombs with a Gothic structure, such as the tomb of the *Doge Francesco Foscari* by Antonio Bregno and those showing Florentine influence, such as that of the *Doge Pasquale Malipiero* by Pietro Lombardo, which were characterized by curtains in the form

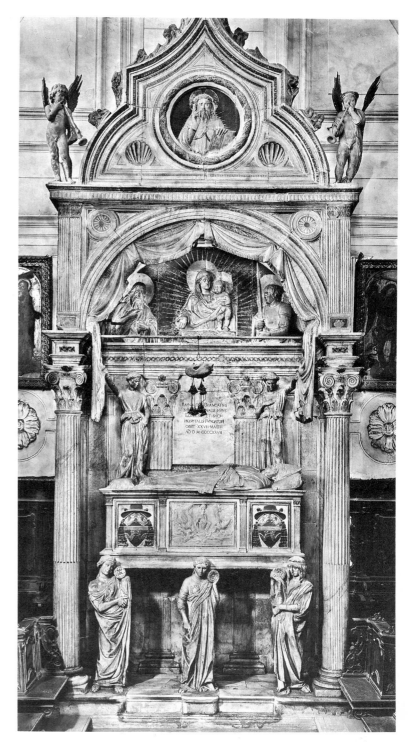

Donatello (1386?-1466) and Michelozzo di Bartolommeo (1396-1472):
Tomb of Cardinal Rinaldo Brancacci, 1426-1428.
Marble.
Sant'Angelo a Nilo, Naples.

of a tent. Antonio Rizzo erected the tomb of the *Doge Niccolò Tron*, a gigantic triumphal arch with simple articulations, on which statues of saints occupy the lateral pilasters in the manner of an altarpiece. The recumbent effigy on the sarcophagus is matched below by the standing figure of the doge framed by Virtues. The idea of the altarpiece was also used by Pietro Lombardo, who made skilful use of borrowings from past experiments. The great tombs he executed were composed in a more dynamic and grandiose fashion. Three atlantes support the sarcophagus of the *Doge Pietro Mocenigo*, whose standing figure is framed in the centre of the arcade. Erected behind the façade of San Zanipolo (i.e. Giovanni e Paolo) at Venice, this monument was a counterpart to the tomb of the *Doge Andrea Vendramin*, the work of Pietro Lombardo and his

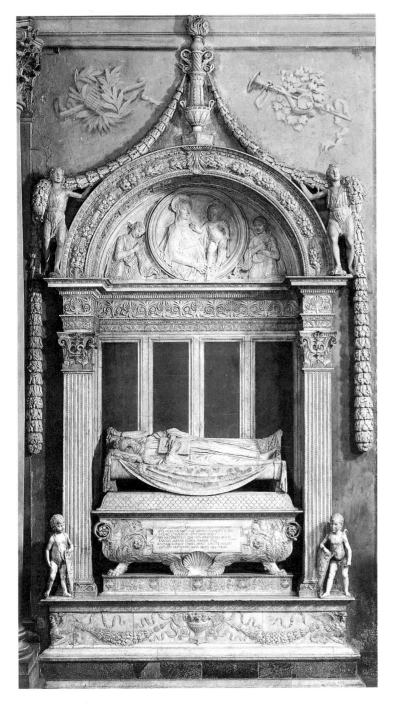

Desiderio da Settignano (1429/30-1464):
Tomb of Carlo Marsuppini, 1453-1455.
Marble and porphyry, height 19'9''.
Santa Croce, Florence.

arcade, which emphasized the image of the deceased, with lateral niches containing statues of saints or Virtues. Andrea Sansovino, Peruzzi and Jacopo Sansovino all used this arrangement which lasted until the sixteenth century.

There were very few artists who tried to liberate themselves from architectural formulas. When Verrocchio executed the tomb of *Cardinal Forteguerri* at Pistoia and Gian Cristoforo Romano that of *Cardinal Cibo* in Santa Maria del Popolo, they laid the emphasis on large pictorial mystic reliefs. But as usual it was Michelangelo who could not be confined to the calm orderly development of mortuary art. The tomb of Julius II and the Medici monuments with their pyramidal structure overturned the order of the recess to become the source of funerary baroque.

These monuments contain every field for sculptural experimentation. Statuary is favoured and the place of honour is reserved for the funeral effigy surrounded by *putti*, Virtues or saints. The relief, originally strictly ornamental and antiquizing, later developed until it was favoured by Bambaia who carved the marble reliefs in the antique manner for the monument to the youthful Gaston de Foix, and by Riccio, who enclosed the *arca*, the coffer mounted on columns, of the physician Marcantonio della Torre in bronze plaques.

The development of the representation of the dead denoted a new conception of the portrait. The traditional Italian *gisant* had its eyes closed and hands crossed on the chest. Depiction of faces was often dictated by the concept

Antonio Rossellino (1427-1479) and Bernardo Rossellino (1409-1464):
Tomb of the Cardinal of Portugal, 1461-1466.
Marble, height 18'6''.
San Miniato al Monte, Florence.

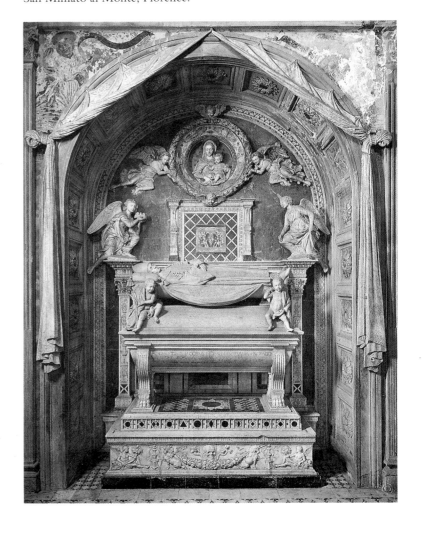

son Tullio, a veritable triumphal arch punctuated by columns. The classicism of the figures, Adam and Eve (now dispersed) and two soldiers standing at either side of the central zone, did not preclude a decoration exhibiting accurate and scrupulous detail. In the next generation Jacopo Sansovino made economical use of these elements to assert at the height of his powers a rigorous architecture and a powerful statuary of exceptional merit.

In Rome, too, the backed tomb was contaminated by the successive forms taken by altarpieces. The recess was surrounded by statuettes aligned vertically on the pilasters. That was the arrangement adopted by Andrea Bregno and Giovanni Dalmata for the tomb of *Cardinal Raffaello Riario* in the Santi Apostoli, and by Dalmata in collaboration with Mino da Fiesole for a monument to Paul II in the Vatican that was later dismantled. Subsequently artists adopted a tripartite structure, contrasting the central

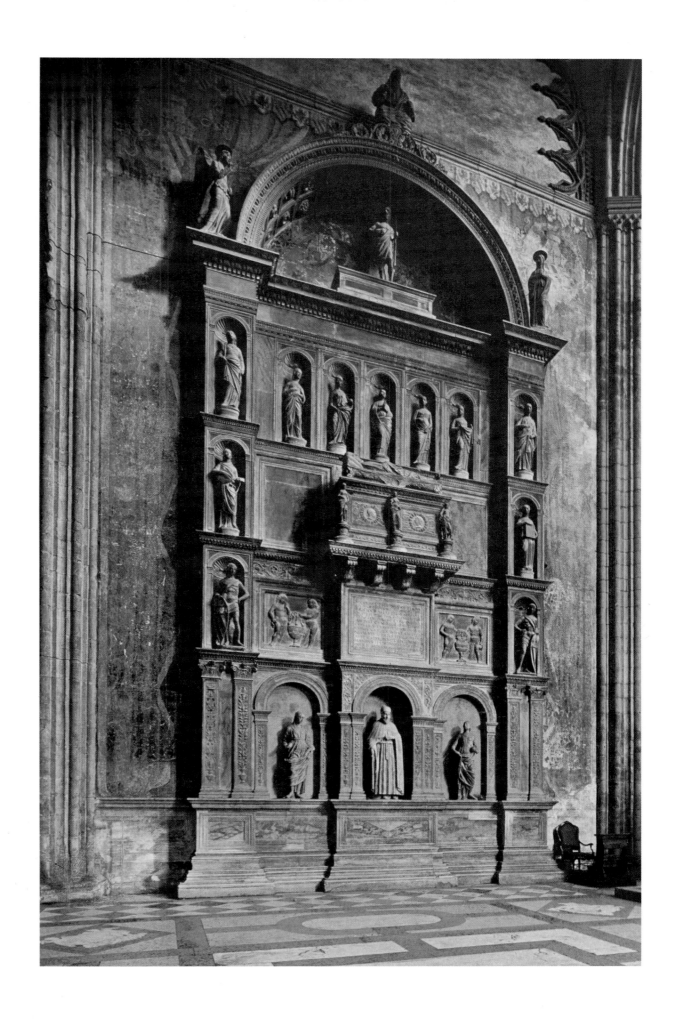

Antonio Rizzo (c. 1440-1499/1500):
Tomb of Doge Niccolò Tron, begun 1476.
At the top, the Risen Christ between the Annunciatory Angel and the Virgin Annunciate.
At the bottom, the Doge between Charity (left) and Prudence (right).
Marble.
Santa Maria Gloriosa dei Frari, Venice.

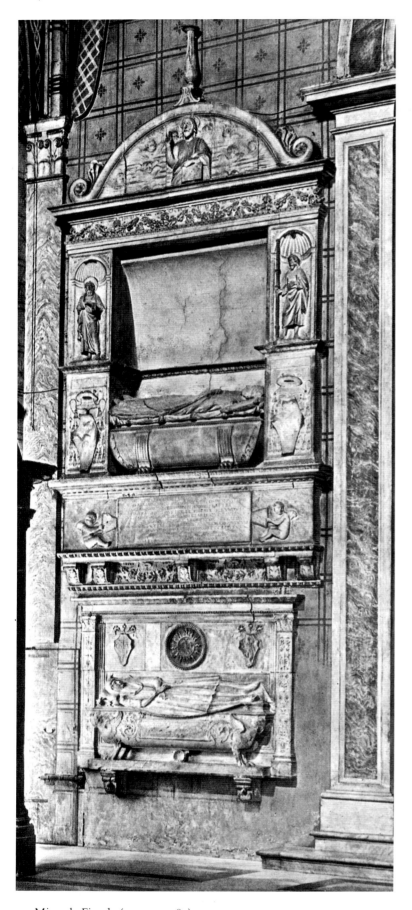

Mino da Fiesole (c. 1429-1484):
Tomb of Francesco Tornabuoni, c. 1481.
Marble.
Santa Maria sopra Minerva, Rome.

of the ideal. *Ilaria del Carretto*, serenely asleep for all eternity, announced a series of calm images in which softness of the features and purity of volumes were deployed accurately and sumptuously. The Lombards, Amadeo for the effigy of *Medea Colleoni* at Bergamo, Solari for the effigies of *Ludovico il Moro* and Bambaia for that of *Gaston*

de Foix, favoured a synthetic frontal vision with stylized geometry and quasi-metallic rendering. The bowed withdrawn face of the young *Antonio Speciale*, the work of Francesco Laurana or Domenico Gagini at Palermo, or, by way of contrast, the energetic smooth visage of the condottiere *Guidarello Guidarelli* by Tullio Lombardo at Ravenna, show a more flexible, suggestive aesthetic.

But idealization went hand in hand with the individuality of features which had made itself felt from the fourteenth century onwards. It was often based on the use of the death mask, as attested by the sculpture of the *Cardinal of Portugal* by Antonio Rossellino. The naturalists, on the other hand, made their faces even truer to life, omitting none of the morbid details. Thus Pollaiolo modelled the face of *Sixtus IV*, showing him seamed and ravaged by the passage of the years and death.

Italian art was too much concerned with life to confine itself to effigies withdrawn in the sleep of death. A variation of the *gisant* was to represent it, still asleep, but lying on its side, resting on one elbow. That was the form adopted by Andrea Sansovino in Rome. There was also a continuation of the two medieval types in which the deceased was shown as he was when alive: the professor teaching in a classroom, the condottiere on horseback. The Della Scalas at Verona, including the fierce Can Grande, had themselves represented on horseback on their open-air tombs. During the fifteenth century equestrian funerary statues, mostly of wood, continued to be made. The Colleoni tomb at Bergamo and Leonardo's abandoned project for the monument to Trivulzio, Louis XII's condottiere, are the most striking examples of this type.

Then it was the turn of the isolated, standing, seated or reclining figure of the deceased, depicted alive, to embark on a long career. On his gigantic *Innocent VIII* Pollaiolo superimposed the seated statue of the pope in the act of benediction, presenting the relic of the Holy Lance, the point of departure for the series of great Vatican tombs. In Venice the doge on horseback was replaced by the image of the doge standing, as in the monuments to *Niccolò Tron* and *Pietro Mocenigo*, the former still with the bed for lying in state, the latter triumphant on his sarcophagus. Nevertheless, it was in Spain that the figure lying on one side, reading and meditating, appeared for the first time on the tomb of the Doncel, but Romans and Florentines quickly adopted the theme, which is reminiscent of Etruscan and Roman tombs. In the tombs in San Lorenzo Michelangelo asserted the spiritual force of the seated meditating figure.

In France Guido Mazzoni created the second royal tomb showing the deceased kneeling at prayer, the monument to Charles VIII, but the theme of the *orant* struggled to gain a foothold in Italy. It spread throughout Europe, but in Italy it was confined to Naples, on Spanish territory. The praying effigy was reserved for the mystical presentation of the deceased in Paradise. Examples are *Cardinal Forteguerri* by Verrocchio, *Cardinal Cibo* by Gian Cristoforo Romano, and the doges of Venice on the upper part of their tombs. These crowded compositions differed widely from the isolated statues of *orants* in Spain and France.

Renaissance Italy, repelled by the naked effigy (*transi*), the wretched emaciated corpse of the Gothic countries which lasted until the sixteenth century, hesitant before the *orant* in a suppliant position, preferred to extol eternal life in the colours of life on earth, a body with fleshly humanity, and asserted the eternity of personal glory by the dramatic setting.

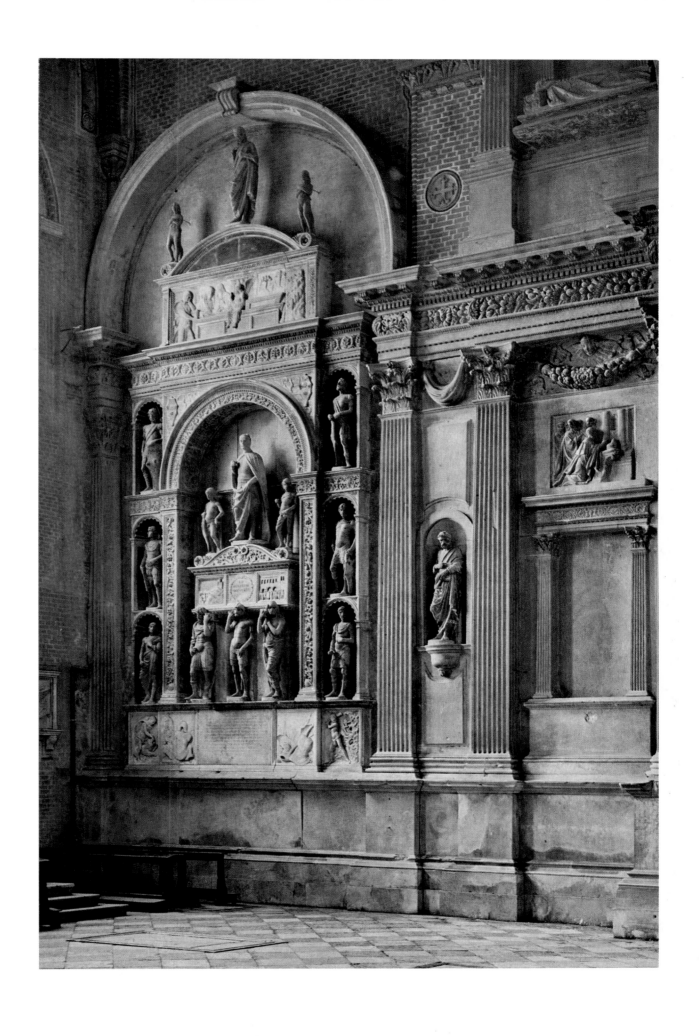

Pietro Lombardo (c. 1435–1515):
Tomb of Doge Pietro Mocenigo, 1476–1478.
Marble and Istrian stone.
Santi Giovanni e Paolo, Venice.

REVIVAL OF
THE EQUESTRIAN STATUE

Paolo Uccello (1397–1475):
Equestrian Portrait of Sir John Hawkwood, 1436.
Fresco transferred to canvas, 26′10″ × 16′10″.
Cathedral, Florence.

Fifteenth-century Italian art was signposted by a remarkable number of equestrian statues. The horse, to which Leon Battista Alberti devoted an essay, seemed to fascinate painters and sculptors. The theme of St. George, the less common one of the battle scene so masterfully treated by Paolo Uccello and Piero della Francesca, and the theme of the Adoration of the Magi in particular, were so many pretexts for drawing up a repertory of horses and riders with vivid attitudes and postures. The *Adoration of the Magi* (1481), left unfinished by Leonardo, constitutes a veritable "treatise on the horse," as André Chastel has said.

So the life-size representation of a horse and rider was an attractive subject for sculptors, but did not become possible until the second half of the century. The cost of execution and inability to master the techniques of casting may explain a time lapse which left the task of working out the problems to the first half of the century.

The adaptation of the equestrian monument, originally reserved for the celebration of the ruler's glory, to the commemoration of the civic and secular virtues of "illustrious men" was not accepted as a matter of course, in spite of the existence of famous antique examples such as the *Marcus Aurelius* in Rome (then in the Lateran, later moved by Michelangelo to the Capitol), the *Regisole* in Pavia (since destroyed, but much admired for its movement, as Leonardo tells us), and of course the horses on the pediment of the Basilica of St. Mark's at Venice, undoubtedly the equestrian ideal.

Nevertheless, there was no lack of contemporary or Trecento equestrian representations, but they were incorporated into the architecture of tombs and limited in size by the materials used (stone, marble). Cement, stucco and wood (as for the statue of *Paolo Savelli*, in the Frari, Venice, carved about 1405), shortlived materials that soon deteriorated, did not satisfy the desire to immortalize, in imitation of antiquity, the memory of "illustrious men." This explains why Florence resorted to the painted representation of equestrian figures of which the fresco commissioned in 1436 from Paolo Uccello with the effigy of *Sir John Hawkwood*, victor at the Battle of Cascina, is the masterpiece.

Uccello conceived a large complicated monument which, if sculptured, would have fitted naturally into the spatial environment of the piazza. In so doing he virtually perfected the formula which led directly to Donatello's

Donatello (1386?–1466):
Equestrian Statue of the Condottiere Gattamelata, 1446–1450.
Bronze, height 11′2″.
Piazza del Santo, Padua.

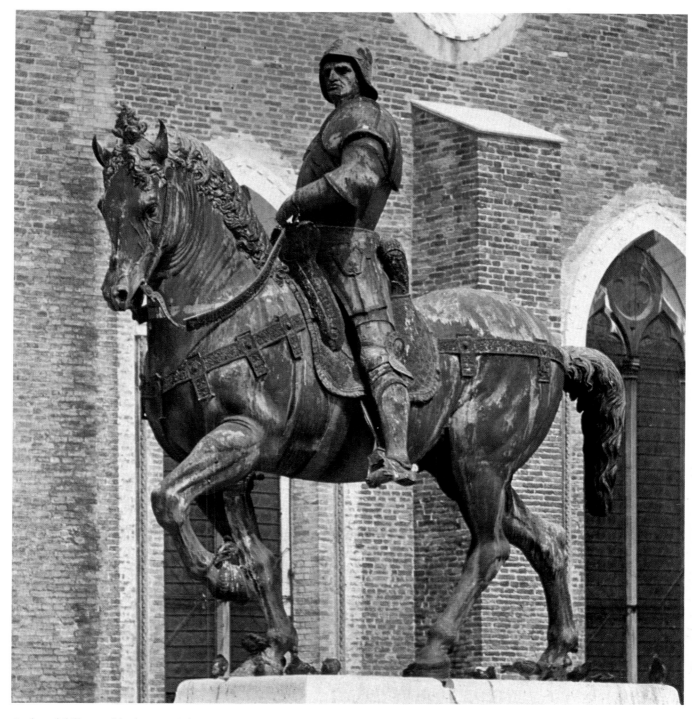

Andrea del Verrocchio (1435-1488):
Equestrian Statue of the Condottiere Bartolommeo Colleoni, 1482-1488.
Bronze, height 13′. Campo Santi Giovanni e Paolo, Venice.

Gattamelata and Verrocchio's *Bartolommeo Colleoni*. (The bronze statue of Niccolò d'Este cast about 1441-1442 by Antonio di Cristoforo and Niccolò Baroncelli, both Florentines, apparently had no memorable following.) Here we shall confine ourselves to emphasizing Uccello's brilliant intuition (disregarding the problems raised by the errors of design mentioned by Vasari, especially the contradictory perspectives). Paradoxically it fell to him (to whom Vasari, as Damisch suggests, opposed Donatello, as the guarantor of a pictorial order which Uccello's mania for perspective would disturb) to define the "norms" for sculptural representations of the "hero." Donatello was to remember Uccello's ideal impassive image of *virtù* and the power to command captured within the clear-cut setting of an impeccable formal geometry when he was commissioned to execute at Padua the monument to Erasmo da Narni, nicknamed Gattamelata, captain of the Venetian armies (died 1443) and faithful servant, so it seems, of Cosimo de' Medici.

But Donatello changed the original formula, departing abruptly from the painted Florentine imitation sculptures by renouncing the modern costume still worn by Niccolò da Tolentino in the almost contemporary fresco by Andrea del Castagno. The bare-headed *Gattamelata* irresistibly recalls the *Marcus Aurelius* on the Capitol. Donatello transformed the Venetian captain into a triumphant Caesar, casting him for all eternity in an ideal glorification of resolute *virtù* expressed by the marked concentration of the prominent facial features, knitted brow, tensed mouth and chin, etc. The emphasis is on the soldier's intellectuality and inner nature. Indeed, the condottiere seems to be immortalized at the crucial moment of setting some carefully planned strategy in motion, not when engaging in actual combat.

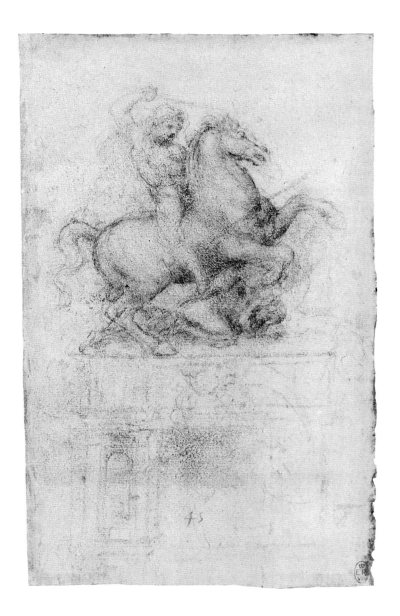

Milan, for Ludovico Sforza. Vasari possessed two versions of the project in his portfolio of drawings: "In one the equestrian statue surmounts Verona; in the other, on a base decorated with battles, the duke in armour leaps his horse over a warrior." So the design with the terse line we associate with Pollaiolo is roughly contemporary with Verrocchio's commission and shows a desire to break with the type of equestrian monument embodied by Verrocchio's *Colleoni*, which came after the "imitation sculptures" by Uccello and Castagno, and Donatello's *Gattamelata*. Pollaiolo seems to have dreamt of a virtuoso *tour de force* demonstrating his ability to surpass his contemporaries, especially the Tuscan masters. The sources of his radical innovation are to be sought, as Pope-Hennessy suggests, in reliefs on antique sarcophagi, but the idea of the rearing or prancing horse may have been borrowed from the numerous representations of St. George's horse trampling the dragon underfoot or the battle scenes of Uccello and Piero della Francesca.

Leonardo adopted the idea of the rearing horse for the same monument. In an astonishing letter which listed his talents complacently and at length, he offered his services to Ludovico Il Moro to "undertake the execution of a bronze horse which shall endue with immortal glory and eternal honours the auspicious memory of the Prince your father and of the illustrious house of Sforza." Apparently the project was rejected as impracticable, although Leonardo had envisaged supporting his rearing horse by resting one of its front feet on the shield of a dead soldier or a fallen treetrunk. Did Leonardo's plan diverge too radically from the traditional equestrian portrait? He certainly

△▷ Leonardo da Vinci (1452-1519):
Studies for the Equestrian Monument to Gian Giacomo Trivulzio,
c. 1508-1511.
Pen and bistre (right), black chalk or black lead (above).

The *Gattamelata*, as Bertrand Jestaz points out, was the first public monument to appear. It was repeated only once in the fifteenth century by a second equestrian statue, erected in Venice to celebrate Bartolommeo Colleoni, another condottiere. Commissioned from Verrocchio in 1479, who worked on it at Venice from 1482, it was unfinished when he died in 1488. And it was not, as Verrocchio had wished, Lorenzo di Credi who cast it, but Alessandro Leopardi, who also signed it! Although the horse follows the pattern of the horses of St. Mark's and the horse of Marcus Aurelius, its musculature is emphasized and drawn more nervously, and there is a sense of movement. As for the condottiere, he seems to be animated by a fierce restrained energy. This armoured and helmeted image of *furia* makes a striking powerful figure, a perfect emblem of the *vir bellicus*.

In those days the equestrian statue was looked on as the indispensable public monument for "preserving the memory of those who have accomplished some great action" and delivering man from his "mortal condition" (Pomponius Gauricus). Antonio Pollaiolo wrote to Vittorio Orsini: "I would have made a statue of you on a bronze horse in order to immortalize you." He appears to have designed an equestrian statue of Francesco Sforza, Duke of

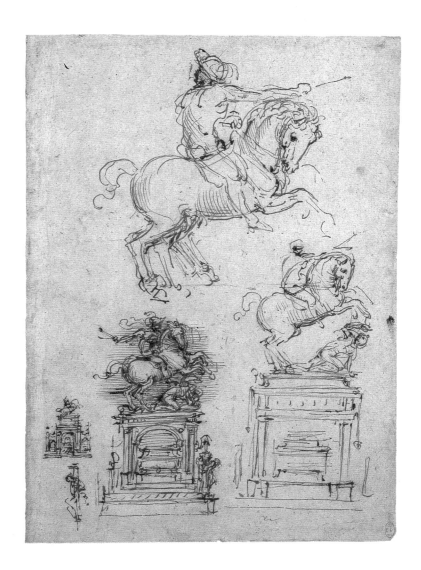

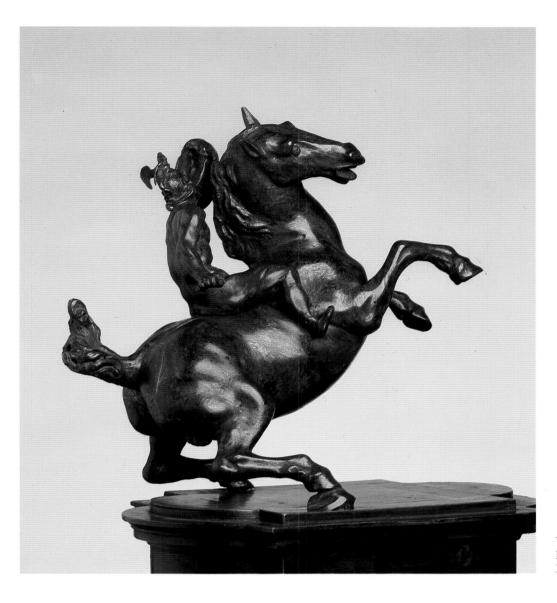

Workshop of Leonardo da Vinci (1452-1519):
Rearing Horse and Rider, c. 1506-1508.
Bronze, height 9¼".

dreamt of a colossal statue and we know drawings of his second project which show his ambition to formulate an ideal equestrian canon of some kind. A clay model of the horse (not the rider) was actually made, but the invading French prevented the model being cast and destroyed it into the bargain. Thereupon Leonardo returned to Florence.

In 1506 he was recalled to Milan by Charles d'Amboise and stayed there until the French left in 1513. During those seven years he worked on another equestrian statue, the *Monument to Gian Giacomo Trivulzio*, actually a tomb with complicated architecture, a sort of *tempietto* housing a sarcophagus and serving as a base for the statue. It seems that Leonardo again used the daring motif of the rearing horse, but this extraordinary project never came to fruition. The bronze statuette in Budapest suggests a reduced version of it, but the equestrian statue of Cosimo I de' Medici (1581-1594) that Giambologna erected in the Piazza della Signoria at Florence was inspired by the *Colleoni* and the *Gattamelata* and fitted into the direct line of monumental statuary manifesting the stability and imperious authority of power.

Andrea Riccio (c. 1470-1532):
Shouting Warrior on Horseback, early 16th century.
Bronze, height 13½".

55

THE PORTRAIT

Antonio Pisanello (before 1395-1455):
Two medals: Sigismondo Pandolfo Malatesta (left) and
Filippo Maria Visconti (right).
Bronze.

Florentine master:
Bust of Giovanni Antonio da Narni, son of Gattamelata, c. 1470-1475.
Bronze.

The revival of the ancient notion of *fama*, renown, gave a fresh stimulus to the art of the medallist. Pisanello is the creator of the Renaissance medal, and after him it was practised with ability and profit by Matteo de' Pasti, Pietro da Milano, Niccolò Fiorentino and others. The medal was in effect a monument simplified and miniaturized. It perpetuated in bronze the *virtù* of "famous men." On the obverse a profile likeness established the ideal outline of the face, and this memorable image was commented on by a motto; on the reverse, an emblematic scene associating the portrait with some allusion to the subject's life or character.

The invention and vogue of the Renaissance medal take their place in the more general evolution of the art of portraiture, which is inseparable from the evolution of tomb art. The point in all cases was to answer to the insistent, all too human desire to commemorate one's life and deeds. The demand for such work is evidenced by the abundant output, especially in the latter half of the fifteenth century, of votive masks in wax, moulded on either the living or the dead; the mask was then laid over the head of a manikin bust prepared in advance—a procedure made into a speciality by the Benintendi, who were pupils of Verrocchio. With the decline of antique art, the bust portrait had by no means disappeared, for in the Middle Ages it took the form of the reliquary bust. And well before the Quattrocento it was still being used for the decoration of pulpits and façades. Its conspicuous revival now stemmed from the new conception of man put forward by the humanists. The questioning of the "legitimate powers," the cult of *virtù*, that is the moral and aesthetic affirmation of the human personality in its utter distinctiveness, called for a lifelike portrayal of the human face but also for its "idealized" portrayal. Ghiberti's turbaned self-portrait in the Florentine Baptistery may be judged as realistic and ex-

pressive; it seems nevertheless to have been prompted by a Roman example. In his treatise *De Statua* Leon Battista Alberti urged the portraitist to single out that which distinguishes one individual from another; but he also recommended the measuring of those details to which it is fitting that average proportions should be given. The artist had to characterize, yes, but he also had to establish harmonious relations. The indispensable tension towards *virtù* required an ideal formulation. It is true that Alberti's recommendations spring from his scholarly knowledge of antiquity and the example of Zeuxis. As for the characterization intended to specify and define the natural features of an individual, it implied on the one hand a "modern" attention to physiognomy and its psychological bearings; and on the other it inscribed man in the inexorable course of time. Such were the contradictions of the Renaissance.

Now that the terracotta *Bust of Niccolò da Uzzano* has been withdrawn from the corpus of Donatello's work, it is no longer possible to see him as the inventor of the Renaissance portrait bust. The *Reliquary Bust of San Rossore*, which is now frequently attributed to him, is not actually a portrait, in spite of its distinctive features. As for the meditative adolescent in the Bargello, which Chastel refuses to leave in his catalogue, it embodies an idealized representation whose meanings, figured on the cameo adorning his breast (a chariot drawn by two horses led by a winged genius), have their source in Neoplatonist speculations. The *Young Warrior* bust in the Bargello, attributed to the workshop of Antonio Pollaiolo, is a similar venture in idealization, as borne out by the heroic and exalted decoration of his breastplate.

Benedetto da Maiano (1442-1497):
Bust of Pietro Mellini, 1474.
Marble, height 21″.

Antonio Rossellino (1427-1479):
Bust of Giovanni Chellini, 1456.
Marble, height 20″.

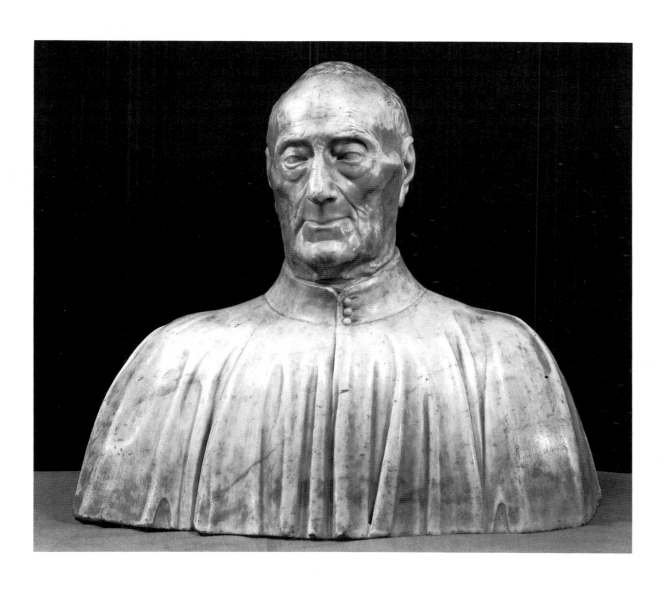

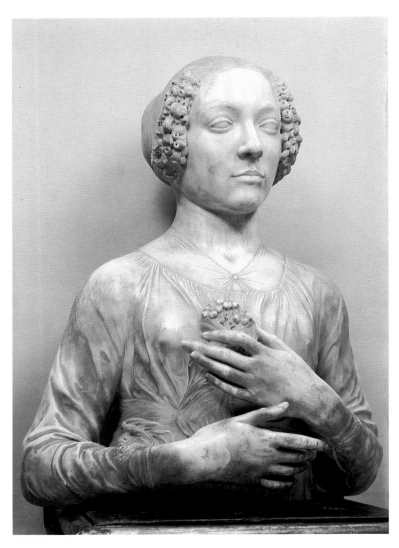

Andrea del Verrocchio (1435-1488):
Bust of a Lady with a Bunch of Violets, 1470s.
Marble, height 24″.

To these strong and stoic images quickened by a pent-up energy (which call for comparison with the studied realism of Ghirlandaio and the meticulous delineations of northern portraiture), answers the somewhat conventional simplification of the bust of *Niccolò Strozzi* by Mino da Fiesole, who gives his preference to the side view, as does Verrocchio even more emphatically. The latter's bust of *Giuliano de' Medici* is seen most rewardingly in side view, the profile contour cutting through space and inscribing there, as if on the obverse of a medal, the man's handsome and memorable features. In contrast with this "harsher" manner, Francesco Laurana crystallizes the essentials of a face in the ordered calm of pure and mellow geometric forms, as in the *Bust of a Lady*.

Female portraits naturally implied a searching focus on the beauty of woman, and inspired the artist to a celebration of beauty. The different approach meant a softer, tenderer treatment. The face of Desiderio da Settignano's unknown lady is inscribed in a form contoured by a continuous line–a line smoothed and softened by the polishing of the marble that fuses the planes and envelopes the masses in a *sfumato* which seems to arise from the milky and luminous transparency of the marble. The suave and refined art

Desiderio da Settignano (1429/30-1464):
Bust of a Lady, c. 1460-1464.
Marble, height 18″.

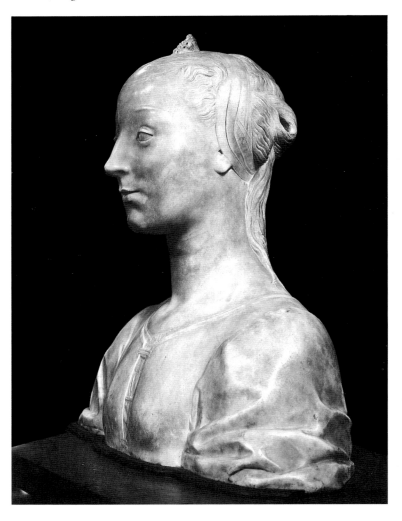

The first lifelike portrait of the Quattrocento, according to Pope-Hennessy, is the bust of *Piero de' Medici* carved in 1453 by Mino da Fiesole, a sculptor not of the greatest but a good portraitist, who also left us a vigorous likeness of *Diotisalvi Neroni*. The renewed use, about 1460, of plaster casts taken from the living face had a transforming effect on portraiture. This procedure was the starting point from which Antonio Rossellino carved his imperious bust of *Giovanni Chellini*. The direct "copy" thus made of the living face ensured a closer accuracy. An even more faithful rendering of facial features, with all their wrinkles, creases, veins and flesh marks, was achieved by Benedetto da Maiano in his *Pietro Mellini*, dated 1474. But the purpose of this hyperrealism was not merely to achieve an outward resemblance. The lifelikeness of both of these works, and of many other portrait sculptures, can only be understood by reference to Antiquity, to the naturalism of the Roman portrait. The axial and frontal vision which they impose condenses individual peculiarities, summing them up in a formal order which brings out not so much the effects of time as the vigour of a character answering to a typology which regulates the way of portraying each class according to age and social standing.

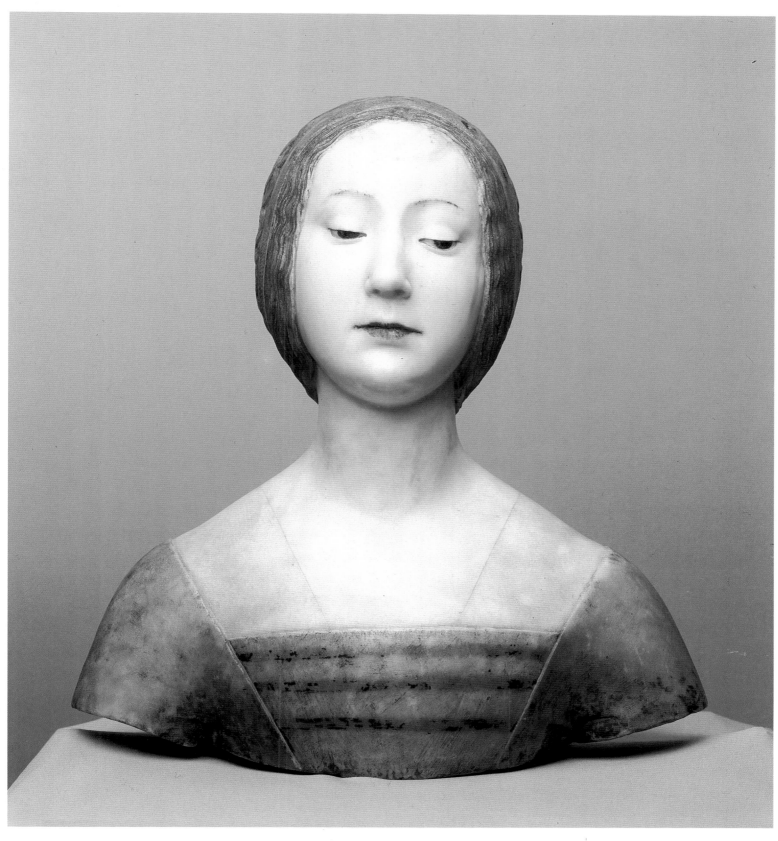

Francesco Laurana (c. 1430 - before 1502):
Bust of a Lady (Isabella of Aragon?), c. 1487-1488?
Coloured marble.

of Desiderio da Settignano was admirably suited to the portrayal of women and children, whose smiling grace still stands as a classic definition of their human appeal.

It was left to Verrocchio to alter the formula. He does so in the *Portrait of a Lady with a Bunch of Violets* (who resembles Ginevra de' Benci in her portrait by Leonardo da Vinci now in Washington). Verrocchio's attention to decorative detail and the serried design of folds, contrasting with the firm and limpid modelling of the face, animate what is at once a real and an ideal image of woman. The prominence given to the hands adds an expressive note to the solemnity of the traditional bust. But this nostalgic vision of beauty is still in harmony with the amatory lyricism of contemporary poetry.

DRAMATIC SETTINGS

For a long time dramatic religious theatre, as opposed to the serene polished marbles of humanism, was looked on as popular art of minor importance, simply because it was expressive. Nevertheless, it was produced by cultivated artists and accepted by contemporaries on the same level as the great altarpieces.

The spiritual movement that first stirred the Rhineland in the fourteenth century spread throughout France and Italy in the fifteenth century. This impassioned current of religious thought laid great emphasis on Christ's sufferings. Stations of the Cross, devotions to Christ's wounds and liturgical theatre formed the new outlets for religious expression. In sculpture, the emergence of the theme of the dead Christ, either with the Virgin of Mercy or in the Entombment, met the demands of this religious feeling. Large sculptural groups were reproduced in Germany. At first they portrayed the Lamentation over Christ and later the Entombment. Northern Italy, especially Emilia, a region sensitive to influences from northern Europe, gave a warm welcome to this grandiose theatrical art. Polychrome terracotta scenes with life-size figures abounded in the dim interiors of churches. The dead Christ, lying on the ground and sometimes in the Sepulchre, was in the centre; around him the Virgin, St. John, Mary Magdalene and the two Maries gave vent to their grief; at his head and feet were Nicodemus and Joseph of Arimathea, usually shown as kneeling donors. Every degree of grief was depicted, from silent sorrow to the quasi-hysterical keening of female weepers.

Niccolò dell'Arca, a native of Apulia, executed the *Lamentation over the Dead Christ* for Santa Maria della Vita in Bologna. Was it done after 1464, the date of a letter of indulgence which mentions the "Sepulchre of Christ" in the church, or around 1485 when the Ferrarese painter Ercole de' Roberti had made his dynamism and intense expressiveness felt in Bologna? In the absence of documentary evidence, critics who measure sculpture by the yardstick of painting have been tentative in their judgments, detecting contradictory influences from Burgundy, Na-

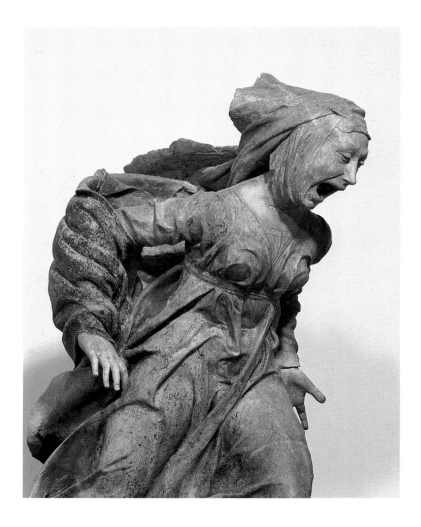

Niccolò dell'Arca (c. 1435-1494):
Mary Magdalene, detail of the Lamentation over the Dead Christ, after 1464 or c. 1485.

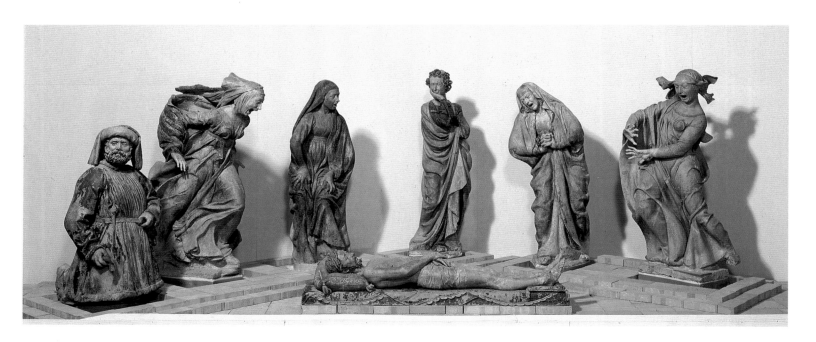

Niccolò dell'Arca (c. 1435-1494):
Lamentation over the Dead Christ, after 1464 or c. 1485.
Polychrome terracotta.
Santa Maria della Vita, Bologna.

ples, Ferrara and Florence. But this sculptor, who was described as *fantasticus* and *barbarus*, cannot be pinned down to local provincial categories. The earlier dating fits in with the innovative vigour of the style, which became the archetype of Emilian *tableaux vivants*. Emotions and figures are equally represented in his settings. We find an astonished stalwart donor, an emaciated St. John holding his face as if at the foot of a Calvary, the Virgin with bowed head and clasped hands uttering an anguished shriek and two holy women, one hurling herself forward, screaming in despair, the other recoiling in terror.

We find this modulated religious terror again in the works of Guido Mazzoni of Modena. He gained his knowledge of theatrical design during the entertainments for the marriage of Ercole d'Este in which he had a hand and by modelling papier-mâché masks. He went on to specialize in terracotta groups of Nativities and Lamentations. His crowded compact personages in the Franciscan monastery of Busseto include a dishevelled Mary Magdalene advancing with arms crossed. In Ferrara, Venice and then Naples in 1492, and at Modena at a date varying between 1476 (according to a document) and 1516-1518 (if we are to believe a stylistic analysis), he developed a powerful, evocative art in which the individualization of faces, attitudes and feelings was meant to match every conceivable state of mind in the spectator. To the sinuous, precise style which sometimes overlaps Niccolò dell'Arca's Gothic manner, Mazzoni replied with a denser naturalism.

They inaugurated the tradition of *tableaux vivants*, which, like the sacred theatre, came close to the popular image of the life of Christ. Then groups of the *sacri monti*, mounts meant to represent the Holy Land, which were disseminated in northern Italy and even in Tuscany at San Vivaldo, as well as those by the Emilian modellers Vincenzo Onofri, Alfonso Lombardi and later Antonio Begarelli, forged the link between Rhineland mysticism as revised by humanist individualism and Baroque expressiveness.

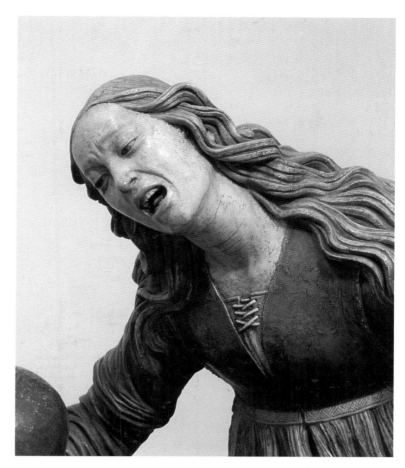

Guido Mazzoni (c. 1450-1518):
Mary Magdalene, detail of the Lamentation over the Dead Christ,
c. 1476 or 1516-1518.

Guido Mazzoni (c. 1450-1518):
Lamentation over the Dead Christ, c. 1476 or 1516-1518.
Polychrome terracotta.
San Giovanni Battista, Modena.

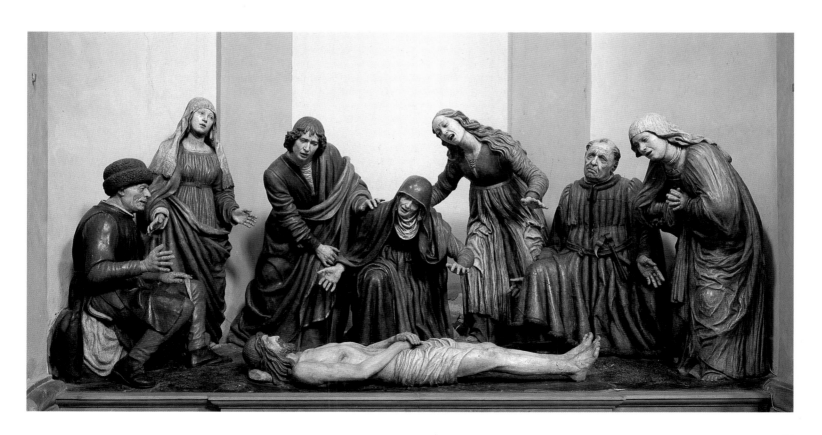

MASTERS AND PROBLEMS
VERROCCHIO AND POLLAIOLO

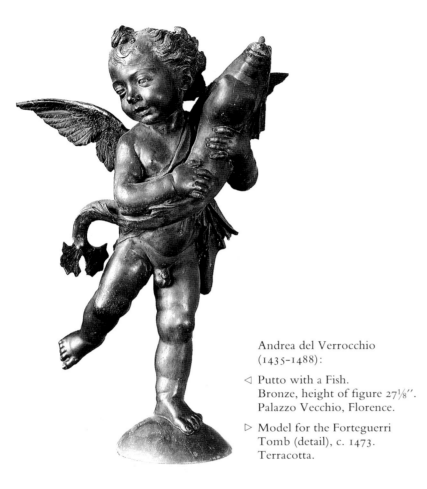

Andrea del Verrocchio
(1435-1488):

◁ Putto with a Fish.
Bronze, height of figure 27⅛″.
Palazzo Vecchio, Florence.

▷ Model for the Forteguerri
Tomb (detail), c. 1473.
Terracotta.

charm. But the sharp dry contour, together with the stiff patterning of the drapery folds, show him moving towards the limits of that harsher style whose masters are obviously Antonio Pollaiolo and Andrea del Verrocchio.

Vasari has some critical words to say about Verrocchio. To begin with, in opening his life of him, he duly enumerates his many talents, as goldsmith, metalworker, sculptor, painter, and commends him as a steady and strenuous worker; but finds his work harsh and crude, devoid of natural grace. For Vasari, Verrocchio has talent and diligence, but no genius; he never rises to the level of true inspiration. Yet, as his contemporaries saw and commented on, Verrocchio was a master under whom some very famous artists were trained, first among them Leonardo da Vinci, but also Perugino and Lorenzo di Credi. His workshop was important and ceaselessly active in meeting a demand that never flagged. Following on from Donatello and several others, he contributed to the continuing prestige of Florentine art formulas and values at home and abroad. Singling out several themes, André Chastel has written some now classic pages on the significant rehandling of them by Verrocchio and his pupils and assistants. Particularly acute is his commentary on the metal relief of the *Beheading of John the Baptist*, with its confrontation of smiling youthful grace and ruffianly furore. Verrocchio was fond of clearcut ornamentation, of

The contrast between the harsher and the softer manner fails to render an adequate account of the style of Florentine sculpture in the closing decades of the fifteenth century. But while Piero della Francesca's broad modelling and clear daylight had a definite influence on the trend of painting outside Tuscany, it was Donatello's pathos and incisive design which fixed the main orientations of style in sculpture. It would be a mistake however to disregard the departures from them. A mistake to overlook the extraordinary ornamental inventiveness of Amadeo at Bergamo and the Carthusian monastery of Pavia; or that of the Lombard workshops and their varied output of candelabra, scrollwork and *putti*. Their charm lies less in their skill than in their naïveté, but their highly wrought orchestrations of decorative motifs, in a Gothic profusion indicative of their *horror vacui*, are pleasing and apposite.

A Florentine sculptor of fine talent is Agostino di Duccio. His characteristic style owes much to the practice of the *schiacciato* relief, which he turned to account with distinctive originality. His sculptures are like drawn carvings, their forms contoured with a flexible line clinging to the supple shapes which define the light folds and overfolds in their graceful flow. This graphic linearism, often redundant, sometimes ventures out into mannered and sophisticated stylizations for which there is no comparable example in the statuary of this period.

The work of two other masters, Desiderio da Settignano and Mino da Fiesole, is steeped in Gothic reminiscences. Mino's figure of *Charity* on the tomb of Count Hugo of Tuscany has mannerist proportions and a mannerist

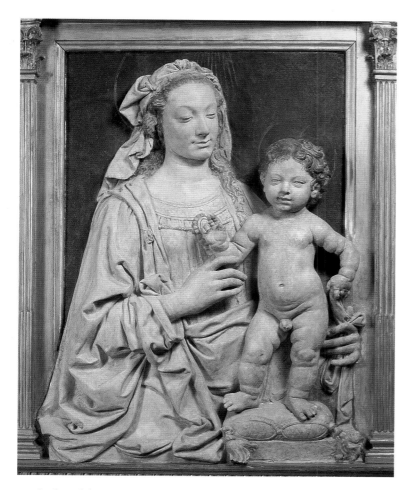

Andrea del Verrocchio (1435-1488):
The Virgin and Child, c. 1470-1480.
Terracotta.

of pathos, and by the contained intensity of the two men's meeting gaze. Here again drapery effects play a key role. They set off and carry on the turning movement of St. Thomas, whose artful and symbolic position outside the niche underscores the naturalism of this figure group. The decorative effect of the falling locks of hair likewise sets off the smooth envelope of the faces, where slight muscular tensions arise from the tender and severe expression of Christ and the "disappointed" smile of the youthful apostle.

Andrea del Verrocchio (1435-1488):
David, before 1476.
Bronze, height 49½".

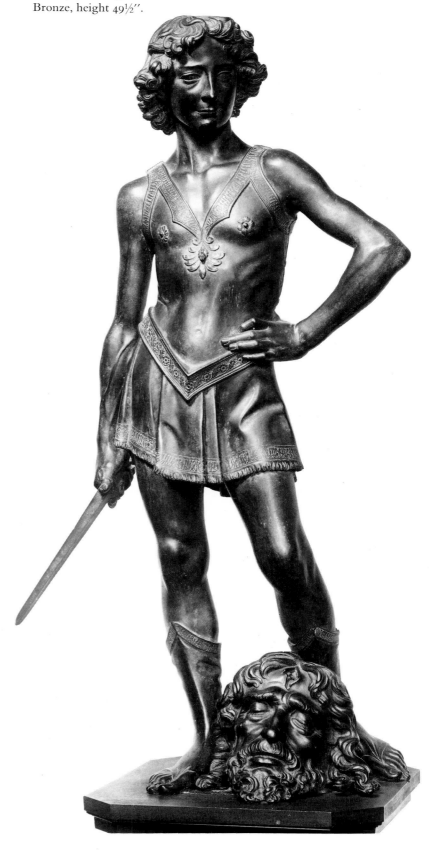

strange and hybrid forms. He knew how to make the most of the antique repertory in working out his own vocabulary of decoration. He shaped a distinctive type of Madonna, firm-featured, round-faced, full-lipped, with a thoughtful, distant gaze; it was quickly taken over by others. Verrocchio, in short, was much more than the able, hard-working craftsman described by Vasari.

His bronze *David* is a slender, unprettified youth vividly rendered by modelling that both sharpens the contours and enhances the smoothly enveloping surfaces. Here he established a pattern of slim and delicate male beauty, in keeping with the dissertations of Renaissance scholars on that type of angelic and androgynous beauty which Leonardo, in his angel figures, carried to a smiling and ambiguous perfection. Verrocchio seems to have devoted special attention to those bodily workings which so subtly convey the "stirrings of the soul." Thus the frail grace of the winged *Putto with a Fish* in the Palazzo Vecchio is expressed not only by its unstable position, poised on one leg, but also by the faint and seemingly timorous smile, almost as elusive as the one that plays about the set lips of his *David*. The unspoken play of inner emotions is admirably suggested by the sensitive rendering of the faces of the Christ, angels and Virtues on the unfinished *Monument to Cardinal Niccolò Forteguerri*—emotions re-echoed by the restless swirling of the drapery with its broken folds and "Gothic" upsweep.

Verrocchio's *Christ and St. Thomas* at Or San Michele is his masterpiece and one of the cardinal works of the later fifteenth century. The dramatic concentration that unites the two figures, the incredulous apostle and the majestic Saviour, is obtained by natural, restrained gestures devoid

The competing workshop in Florence, equally capable of meeting orders of the most varied kind, was that of Antonio and Piero Pollaiolo. Antonio came late to sculpture. He first received a thorough training as a goldsmith, followed by an apprenticeship under Ghiberti. His two major works as a sculptor are the *Tomb of Pope Sixtus IV* (Grotte Vaticane) and the *Tomb of Pope Innocent VIII* (St. Peter's). The animation of the figures and tension of the decoration inevitably evoke the style of his rival, Verrocchio. Having himself practised dissection on dead bodies, Antonio Pollaiolo gave due attention to muscles and veins, to the play of features, to gestures and all the body movements which display the natural workings of the human organism. The Medici inventories permit the attribution to him of several bronze statuettes of antique inspiration, but the only one unquestionably his is the *Hercules and Antaeus*, to which no certain date can be attached. The side view gives the keenest impression of Hercules' strenuous effort as he lifts Antaeus off the ground, in the iron grip of his powerful arms. Antonio treated the same subject in a painting no longer extant, but described by Vasari in terms that apply equally well to his statuette: "From the stretch of muscles and nerves one realizes how strong is the grip in which Antaeus is held. The latter's gasping mouth is in perfect harmony with the other parts of the body, even to the toes clenched in the strain of violent effort."

Antonio Pollaiolo (1431/32-1498):
Hercules and Antaeus, c. 1475-1480.
Bronze, height with base 17¾".

Antonio Pollaiolo (1431/32–1498):
The Pope Blessing, detail of the Tomb of Innocent VIII, 1493–1497.
Bronze.
St. Peter's, Rome.

◁ Antonio Pollaiolo (1431/32–1498):
Allegorical figure of Philosophy, detail of the Tomb of Sixtus IV, 1484–1492.
Bronze.
Grotte Vaticane, Rome.

THE EMERGENCE
OF MICHELANGELO

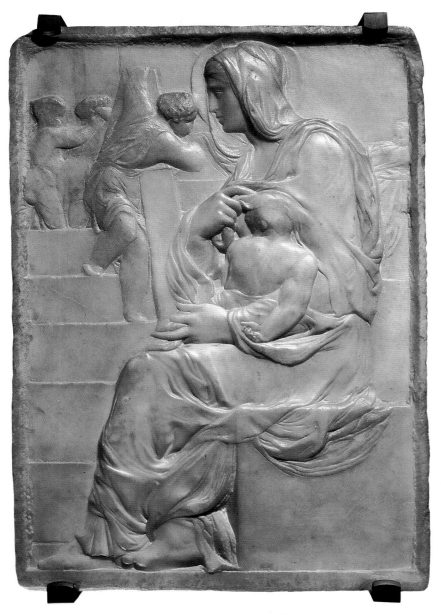

Michelangelo (1475-1564):
The Virgin and Child (Madonna of the Stairs), 1490-1492.
Marble relief, 21⅞″ × 15¾″.
Casa Buonarroti, Florence.

Michelangelo was born in 1475 and died in 1564. During his long life thirteen popes succeeded each other on the throne of St. Peter. He saw the Medici driven out of Florence and then return, he saw the line of Lorenzo die out and the Grand Duchy of Tuscany set up. He lived through a period torn by religious troubles: the rabid preaching of Savonarola, the just changes, but also the intransigent dogmatism, of the Reformation and the crushed hopes of the Catholics seeking revival. We must not forget that he was only twenty when Savonarola's sermons shook Florence and fifty-two when Rome was sacked by the Imperials. When he died, the Council of Trent had done its work, the Jesuit order had been approved and the Inquisition established. Christianity had spread far afield. Cortés had ravaged Mexico and Pizarro had overthrown the Inca Empire–for the greater glory of God! The Bible had been translated into the vernacular and the posthumously published *The Prince* by his compa-

triot Machiavelli had, alas, grasped only too well the reality of wielding power in a Europe turned into a Gehenna by wars, rebellions, revolts and massacres.

From the beginning Michelangelo was looked on as the perfect example of the genius transported by the uncontrollable *furia* of individuals dominated by the black bile of *homo melancholicus* (R. and M. Wittkower). If he called himself "mad," it was only because he believed that his art could not be lowered to the level of an ordinary stone-carver's work. In his lifetime, Michelangelo appeared as the archetype of the saturnine man subject in turn to exaltation and doubt, the man who slaves and sweats at a Herculean task demanding asceticism and solitude in order to conquer Beauty. Michelangelo was worlds away from the virtuoso, the talented courtier, described by Baldassare Castiglione, the friend of Raphael who, in his fresco *The School of Athens*, gave the severe troubled features of Michelangelo to his Heraclitus, meditating sombrely in the "melancholy" pose disseminated after 1516 by Dürer's celebrated print.

In hindsight, his first known works seem premonitory. They at once reveal the outstanding aptitudes of a brilliant adolescent and above all the coherence, in their very contradictions, of the moving creations of an artist torn between his obsession to complete, and his inability to finish, his work.

Michelangelo executed his only bas-relief, the *Madonna of the Stairs*, before he was seventeen and while he was still studying in the Medici gardens under the tutelage of Bertoldo di Giovanni. It represents the Madonna as a humble Virgin, sitting on a simple stone cube, gently covering the Child with her cloak. He is asleep on her breast in a twisted pose, with his back to the spectator. The background of the panel is filled by a flight of stairs on top of which two *putti* are playing, while a child stands near them, leaning over the balustrade. Another child (perceptible behind the Madonna) helps him to hold an outstretched drape. This little scene, symbolically repeating the Madonna's gesture, seems to foretell Christ's future death. Mary, serene and stoic, seems to be lost in resigned contemplation of the Sacrifice of her Son. Described by Tolnay as a vision of the primordial Mother, simultaneously creator of life and keeper of death, this relief by the youthful sculptor undoubtedly owes some of its inspiration to antique examples, reliefs or gems, but the influence of Donatellian models must have been decisive.

This first example of the cult of the finished was countered almost immediately by the *non finito*, the expressive unfinished state of a relief executed with great intensity, also about 1492. It depicts the battle between the Lapiths and the Centaurs when the Centaur Eurythion had tried to carry off Hippodamia, the Lapith bride, during a wedding feast. Politian may have suggested this subject from Ovid's *Metamorphoses* to the sculptor. The humanist culture of the Medicean entourage was combined with the influence of the reliefs on Roman and Etruscan sarcophagi, and undoubtedly with that of Bertoldo, one of whose major works was the battle scene sculpted shortly before 1491 to imitate and surpass a Roman sarcophagus preserved in the Campo Santo at Pisa. Michelangelo retained the impact of the central figure in Bertoldo's relief, but the composition differs radically. Structured by the directions of looks and actions, it generates violent whirling movements from the background of raw stone. It is hard to distinguish Centaurs from Lapiths in this tangle of bodies

striving to escape from the chaos of the battle and the rough raw material.

Obsession with the nude, that desire to exalt beauty by the animation of the body (Kenneth Clark), is already expressed during his formative years and poses the question of the "finished" and the "unfinished" at the outset of his career. Following Hartt, we may ask ourselves what the *Battle of the Centaurs* would have been like if Michelangelo had carried it to completion. Only the backs and torsos have received an initial polish, whereas faces, hands and feet are still roughed out and are marked by traces of the *gradina*. The technique of relief practised here is the kind of high relief which Ghiberti tried out and perfected on the Florentine Baptistery. So that Michelangelo is really recapitulating the Tuscan techniques in these two reliefs.

Impressed by a series of events which were bound to trouble a mind ever ready to believe in portents and prophetic dreams (the death of Lorenzo de' Medici,

Savonarola's sermons and eschatological predictions, etc.), Michelangelo fled to Venice and then settled in Bologna. Protected by Gian Francesco Aldovrandi, he received a commission for three statuettes, an angel, a St. Proculus and a St. Petronius. These were intended for the tomb of the last-named which had been successively worked on by Nicola Pisano, his pupil Fra Guglielmo da Pisa, and as from 1469 Niccolò dell'Arca, who left it incomplete when he died in March 1494. In the Bolognese work of Jacopo della Quercia, Michelangelo had found confirmation of his aesthetic intuitions: the example of a robust monumental humanity with little regard for the rules and canons laid down by the theorists. The influence of the Sienese artist and his liking for full modelled forms encircled by a precise line are discernible in the heavy flowing drapery enveloping St. Petronius. But the most striking statuette is that of the young St. Proculus, which is thought to be a self-portrait.

Michelangelo (1475-1564):
The Battle of the Centaurs, 1492.
Unfinished marble relief, 35⅝″ × 35⅝″.
Casa Buonarroti, Florence.

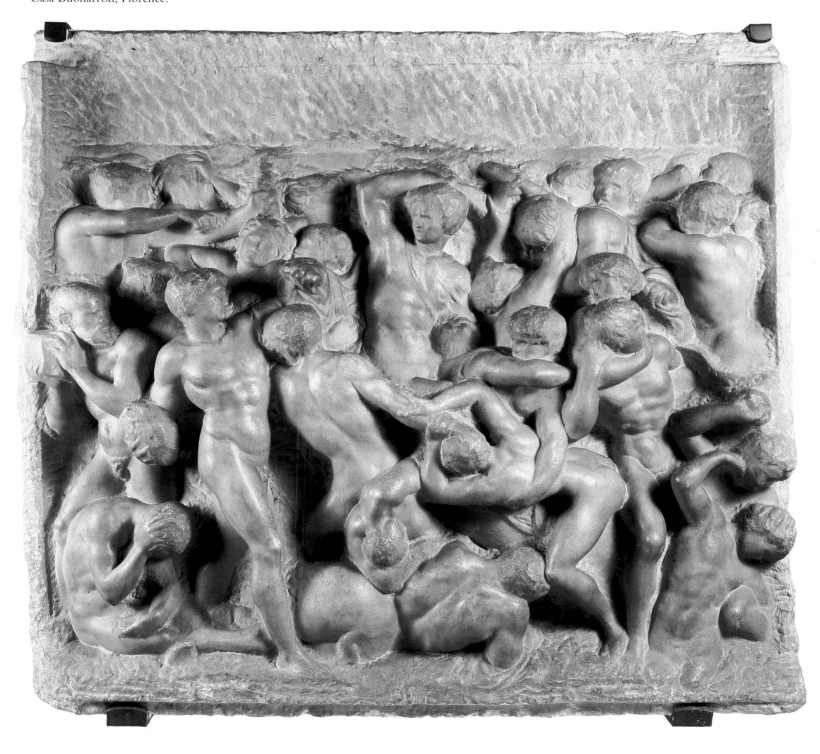

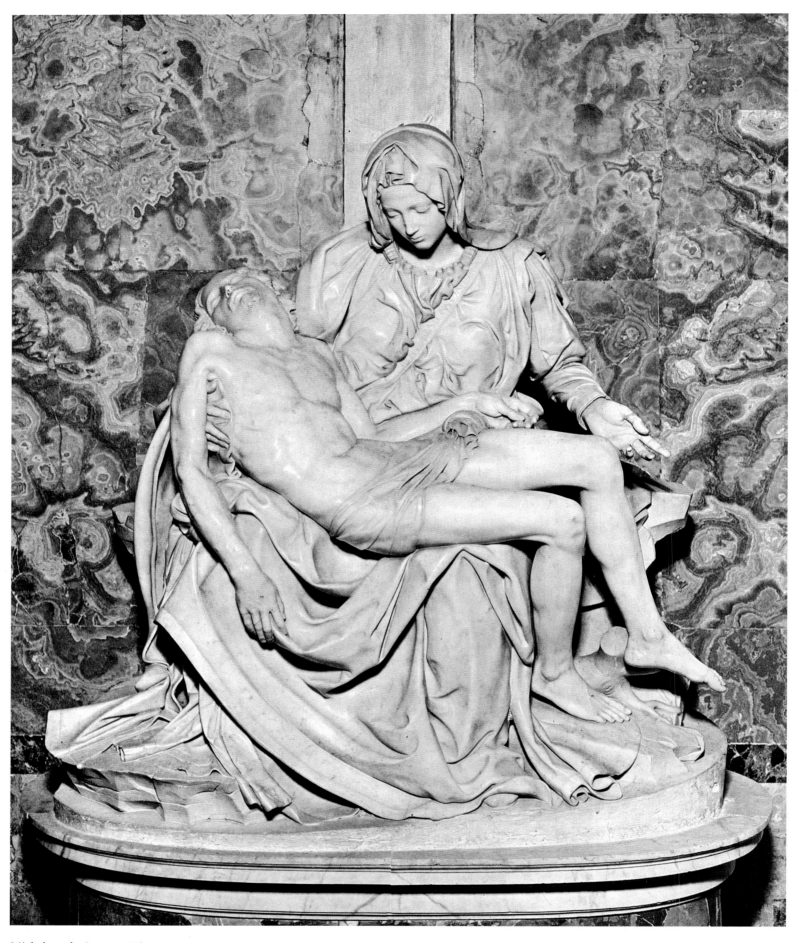

Michelangelo (1475–1564):
Pietà, 1498–1499.
Marble, height 5′8½″.
Chapel of the Pietà, St. Peter's, Rome.

At the end of 1495 Michelangelo was back in Florence, where he did not linger, quickly making his way to Rome. Two major works of widely differing types have come down to us from his stay in that city. They are the *Bacchus* and the *Pietà*, now in St. Peter's, commissioned by the French Cardinal Jean Bilhères de Lagraulas. As usual, Michelangelo broke with the conventions for representing the theme. To begin with, the grouping is clearly of ultra-montane inspiration, but above all the Virgin is depicted as younger than her Son. Did Michelangelo, a remarkable connoisseur of the work of Dante, to whom he dedicated two sonnets, transcribe in marble the poet's invocation to Mary, "Virgin mother, daughter of thy son" (Hartt)? Pensive and compassionate as if transfixed by an inexpressible grief, the Virgin contemplates the limp body of Christ, lying across her ample cloak. The virtuous verist accuracy of the rendering of the bone structure and inert stiffened muscles of Jesus defies commentary. Here the finish attains an unsurpassable perfection. The surface of the marble is so exquisitely polished that one almost has tactile experience of the texture of his luminous skin. No other work by Michelangelo has been brought to such a state of completion. The design of the draperies recalls the refined drapery studies done in Verrocchio's workshop, and their clearcut delineation contrasts with a "malleable" modelling borrowed from Jacopo della Quercia. It is as if the work is animated by the contrast between this smooth silky modelling and the firm design of the forms. One cannot help comparing the *Pietà* with the Bruges *Virgin and Child* executed four years later and bought by a Flemish merchant, Alexander Mouscheron. The pronounced frontality of the compact group of Mary and Jesus whom his mother holds as if grafted between her knees, caught in the folds of her cloak, seems to be accentuated by the contrast between the meticulous working of the front, paying the utmost attention to detail, and the back of the statue defined by large unpolished areas (Hartt).

These two works could be contrasted with two *tondi*, the *Taddei Madonna* and the *Pitti Madonna*, which would also have to be compared with the *Doni Madonna* which puts forward the finished "Michelangelesque" version of the representation of the Child and his Mother in a biblical evangelical vision of the ages of humanity anticipating the cosmic order on the ceiling of the Sistine Chapel. The presence in the *Taddei Madonna* of John the Baptist offering a goldfinch, symbol of his sufferings to come, to a frightened Jesus throwing himself into his mother's lap and Jesus resting one elbow on a book in the *Pitti Madonna*, are in keeping with the contemporary iconography of the Virgin and Child. Painting shows many examples of this. As for the Madonna in the Pitti *tondo*, she seems to announce the proud figures of the Sibyls. In these two works the figures seem to be constrained by the mass and form of the marble support. They look as if they want to overflow it as a prerequisite to achieving their liberation from the original material.

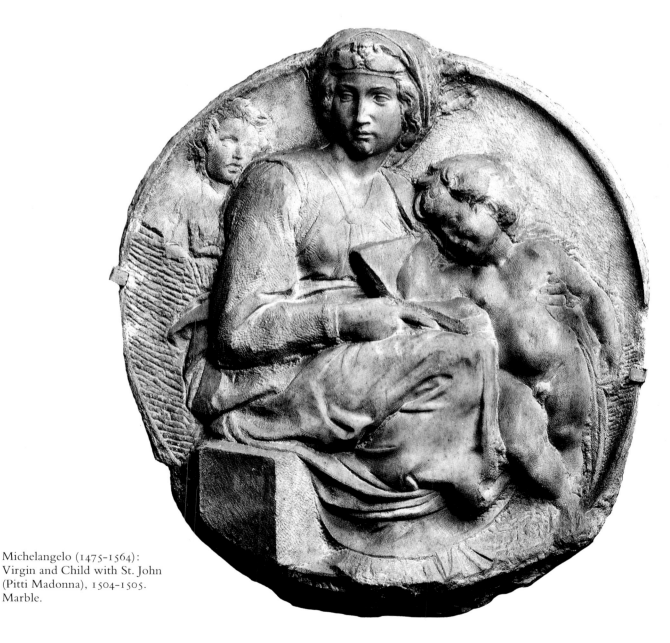

Michelangelo (1475-1564):
Virgin and Child with St. John
(Pitti Madonna), 1504-1505.
Marble.

REPRESENTING THE NUDE

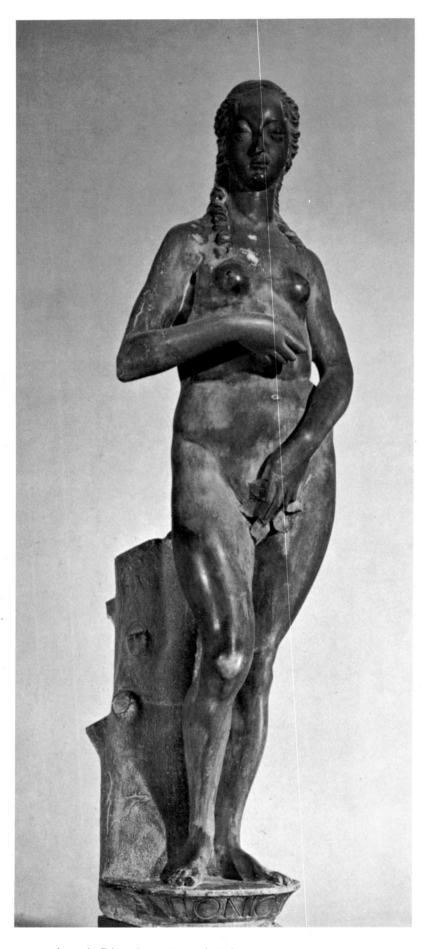

Antonio Rizzo (c. 1440-1499/1500):
Eve, 1485?
Marble, height 6'8¼".
Ducal Palace, Venice.

According to Michelet's and Burckhardt's superb pages, it was the "discovery of man" that primarily characterized the Renaissance. The dignity ascribed to him by humanists such as Giannozzo Manetti and Pico della Mirandola made the human being into a demiurge capable of transforming nature and at the same time a condensed version of that very nature, in short a world in himself. This conception was pregnant with consequences that may be called "revolutionary," because thenceforth the individual was defined as a being who was free to decide for himself. Since he was now able to unbalance the order of the universe, at least the fixed hierarchical order of the medieval cosmos, he became aware at the same time, in his persona as microcosm, of a superior mode of organization in his own body. Therefore the human figure was the tangible manifestation of a higher Beauty, that of divine splendour. Thus the perfect harmonious representation of the human body was evidence of the image of God. That is why Ficino tells us that Beauty resides in the obvious resemblance of bodies to *ideas* (Blunt).

The age loved erudite and poetic speculations about Beauty bound up with the vogue for Neoplatonism and the resultant amorous "theories" (André Chastel). But artists and authors of practical treatises were also engaged in defining and enumerating the practical means for attaining Beauty and stating the rules which establish it. And of course in establishing a canon, following the art of Antiquity. To Alberti, Beauty could only be attained by "a kind of harmony and concord of all the parts to form a whole which is constructed to a fixed number, and a certain relation and order, as symmetry, the highest and most perfect law of nature, demands" (Alberti, quoted by Blunt). The mathematical correspondence between the parts and the whole could give birth to the ideal law governing, as it were, the creation of Beauty. But Alberti is still vague when it comes to defining it. Admittedly artists may attain it by the just definition of proportions, but also by choosing the most beautiful things scattered and dispersed in nature in many different bodies and recomposing them into a whole. Thus Alberti invites artists, in contradictory fashion, to imitate nature, but also to correct and surpass it. He takes care to add that the artist should concern himself with rendering the inner emotions of the figures he is depicting by means of gestures and by the expression of the face.

In his own writings, Leonardo showed himself to be simultaneously close to and worlds apart from Alberti's aesthetic precepts. He favoured the indispensable imitation of nature even more strongly than Alberti, but he was less insistent on a theory of ideal proportions. Rather than a universal canon, he preferred the mastery of the harmonious relations peculiar to each variety of the natural species (Blunt). It is true that Leonardo always based his knowledge on the observation of nature.

Indeed, throughout what we call the Renaissance, we find a dual tendency (particularly noticeable in the artistic field) which combines knowledge with experience and virtually undertakes to articulate them dialectically. Aspiration to perfect Beauty led artists to imitate and study antiques, but also to construct harmonious systems of ideal proportions. As we know, Leonardo depicted Vitruvian man (c. 1490-1492) which was matched by Dürer's imperious canon. And Francesco di Giorgio defines the proportions of a basilica starting from the perfect symmetry and proportions of the human body. As depicted

around 1480, the emblem implies reciprocity and can establish a theory of correspondences. The passion for mathematical analysis and the exegesis of the Vitruvian and Varronian canons were backed up by intense Neoplatonist philosophical speculation. At the same time, people studied the organic functioning and constitution of the human body in its reality. This was especially true of artists, who needed practical schemas and models at the same time that they were trying to grasp the fundamentals behind antique perfection. So much so, that the study of anatomy linked with that of physiognomy, especially during the so-called classical period of the Renaissance, was virtually "in the hands of the artists" (André Chastel). Leonardo and Michelangelo practised dissection, Michelangelo with such stubborn concentration that his stomach became disordered, according to Condivi. In another connection, we should remember that even if this "impassioned love for physical Beauty" fitted in with philosophical and aesthetic reflection and cleared the way for scientific medical experience, it also corresponded to a physical attraction peculiar to the period and the mores of the workshops, to the beauty of adolescents, an attraction which Neoplatonist erudition and amatory literature would back with their scholarly humanist prestige.

The predominance of representations of the male nude in painting and sculpture throughout the Quattrocento and even during the high Renaissance is an undeniable fact, in spite of the numerous and often ambiguous representations of Adam's sinful doom-bearing companion. One could cite many Italian and northern works which do not show her in any way remorseful. The most beautiful Venetian sculpture of the fifteenth century (Chastel), together with the Adam accompanying her on the Arca dei Foscari in the Ducal Palace, is surely the moving *Eve* carved by Antonio Rizzo. Indeed, it is one of the most beautiful female figures in Renaissance statuary. She could easily be confused with a representation of Venus. Tall and elongated, but still with a fine figure, she seems to belong to the Gothic tradition and announce the chill beauties of Mannerism.

But it was in the field of small bronze statuary at the end of the fifteenth century that female nudes imitated from antique statuary and reduced to the state of delectable curios for collectors of antiques were produced in abundance. It is true that Agostino di Duccio, or one of his assistants, had already depicted a Venus rising from the waves (c. 1454-1457) in a relief for the Tempio Malatestiano at Rimini, long before Botticelli's unforgettable image, but it was the specialists in this type of small statuary, the goldsmiths and bronze-workers, Adriano Fiorentino, Pier Jacopo Alari Bonacolsi, called Antico, Andrea Brisco, called Il Riccio, and Maffeo Olivieri, who, among others, diffused representations of Venus inspired by the *Venus Felix*.

Tullio Lombardo (c. 1455-1532):
Adam, c. 1490-1495?
Marble, height 6'4".

Michelangelo (1475-1564):
Bacchus and Young Satyr, 1497-1498.
Marble, height with base 6'8".

Jacopo Sansovino (1486-1570):
Bacchus, 1511.
Marble, height 4'9½".

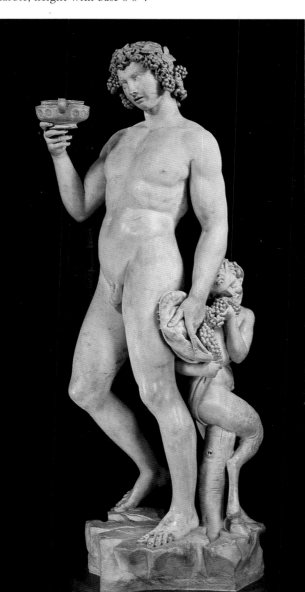

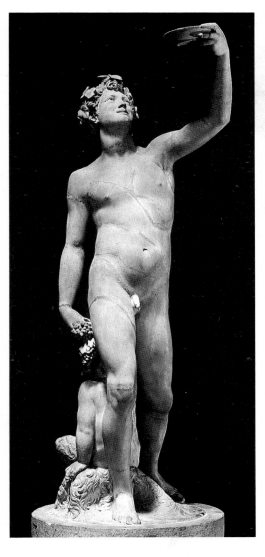

Yet it was the male nude which kept the workshops busy, especially around 1460 at Florence, which became "the capital of the nude" (Chastel). And although it was in Verrocchio's workshop that the type of androgynous angelic ephebe was perfected and later flourished in Florence, it was Donatello, with his luminous statue of *David*, who produced the first representation of virile naked beauty, a somewhat equivocal beauty, if we follow Mary McCarthy, who called it "a provocative coquette of a body... a transvestite's and fetishist's dream of alluring ambiguity." As Panofsky observed, the fact remains that Donatello's most classical nude does not depict an Apollo but a David, and even if it was really a Mercury, the rapid transformation of its title would in no way invalidate the historian's remark. At first, diffusion of antique forms was effected through the filter of traditional representations and subjects. Antonio Pollaiolo, together with Luca Signorelli, was the great anatomical artist of the Quattrocento. He was the creator of the first modern, pagan and mythological representations of the male nude–a motif rapidly spread by his famous line engraving, the *Battle of the Naked Men* (1470). Pollaiolo and his workshop also made bronze statuettes in the antique taste, as did Donatello and Bertoldo.

But the first great "post-antique" work depicting naked male divinity destined, like the small bronzes, solely for display in a private collection, was the *Bacchus* commissioned from Michelangelo (Hartt), during his first stay in Rome, by the wealthy banker and collector Jacopo Galli. Michelangelo had acquired a reputation as an imitator of antiques. During his schooling under Bertoldo he had already attracted the attention of Lorenzo de' Medici while copying the head of a faun in the Medici collections; so that the execution of a *Cupid* sold as a genuine antique, the ostensible reason for his being summoned to Rome and introduced into the circle of Cardinal Riario to which Galli belonged, was superfluous. A drawing by Maerten van Heemskerck, reproduced by Edgar Wind, shows this *Bacchus* in the gardens of the Casa Galli amongst the chimeras, sphinxes, reliefs and scattered broken torsos of a collection of antiquities. The *Bacchus* is mutilated, its right hand broken off. It seems to have been restored before Condivi's description, perhaps by Michelangelo himself, something which Wind queries. In his analysis of the *Bacchus*, he recalls the cruel ritual of destruction and death to which the drunken god invites, also evoked by the grinning satyr greedily devouring the grapes in an animal skin held by the god in his left hand. Hartt comments on this work in which antique and Christian traditions meet. The drunkenness of Bacchus suggests the drunkenness of Noah, his nudity the naked state of the prophet discovered after a drinking bout and of course the nudity of Christ on the cross. For Tolnay the muzzle of the lion (?) expresses the death aspect of his being and the joyous satyr the reawakening of his vital forces. Tolnay points out that satyr, skin, and god are bound together in a spiral movement, their outline forming a serpentine line impelling the spectator to walk round the statue. The extremely free pose given by the uncertain *contrapposto*, which puts the body out of alignment, and the toe of the right foot barely touching the base also demand to be seen from different angles. Anticipating the twistings of Mannerist statuary, Michelangelo did not conceive his statue from a "principal point of view," as was his practice. The portrayal of the flaccid body of the young god implies a mastery of anatomy and a self-confident knowledge of muscular functioning. Here Michelangelo showed his virtuosity, soon to be confirmed by the *Pietà* carved for the Cardinal of Santa Sabina at the instigation of Jacopo Galli.

This smooth effeminate representation was to remain without an equivalent, even if a source for it could be found in the suave delicate *St. Sebastian* by Benedetto da Maiano. As for the *Bacchus* carved in 1511 by Jacopo Sansovino, it represents a jubilant adolescent eagerly calling for drunkenness. This radiant and charming figure implies none of the formal "connotations" and ambiguous symbolism aroused by Michelangelo's equivocal *Bacchus*.

A few years later Michelangelo replied to the limp body of Bacchus with another masterpiece, his carving of *David*. His clearly antiquizing inspiration is in no way comparable to the tense impeccable formulations of Tullio Lombardo's cold neoclassicism, some of whose smooth, almost milky figures have a Giorgionesque charm, or to the somewhat insipid grace of Sansovino's *Apollo*, sculpted soon after the *Bacchus* and like it destined for the collection of an antique-lover. Actually the *David* ended a line of Florentine male statues inaugurated by Donatello's *St. George* and marble *David*. Here male nudity no longer expresses erudite concerns or more or less conscious sensual drives, but it does correspond deeply both to actuality and a cultural tradition.

Michelangelo returned to Florence in the spring of 1501, either because his family had asked for his help or because he had learnt that the Signoria had decided on the completion of the *David* which Agostino di Duccio had unsuccessfully tried to extract from an enormous block of hard marble and which was later "ruined" by Antonio Rossellino. Some scholars have claimed to see an "inexpressive cliché" in the result of Michelangelo's work (Marcel Marnat). They say that his *David* is too much the embodiment of "republican and civic" virtues. The official illustration of an idea of the Florentine *res publica*, it would thus ideally accomplish what was already suggested by Donatello's *St. George*, the pattern of courage, according to Mary McCarthy. Michelangelo's *David* has no trace of the provocative sensuality of Donatello's *David*, nor of the seductive androgynous strangeness of Verrocchio's slender epicene *David*. With his knitted brows and lined forehead, he is the perfect incarnation of *fortezza*, the just wrath of the brave man so sorely needed by the threatened Florentine republic. Michelangelo has made masterly use of the over-narrow block to extract from it a figure whose pose, attitudes and facial features suggest concentrated energy ready to express itself in action.

The emplacement chosen to erect the *David* was significant of the symbolic function assigned to it by the Signoria. To decide on it a commission of thirty was set up, including Leonardo da Vinci, Giuliano da Sangallo and Andrea Sansovino. But their opinions were completely disregarded and, undoubtedly with Michelangelo's agreement, the Signoria installed the statue on the terrace in front of the entrance to the Palazzo Vecchio. As a counterpart to it, Michelangelo was commissioned to execute a group of *Hercules and Antaeus*. A clay sketch indicates his conception, but when the Medici returned to Florence, the commission was given to Baccio Bandinelli. As for Michelangelo, he was later able to express his passion for the male nude and physical Beauty on the ceiling and walls of the Sistine Chapel, in spite of all the tragic vicissitudes involved in his commission for the *Tomb of Julius II*.

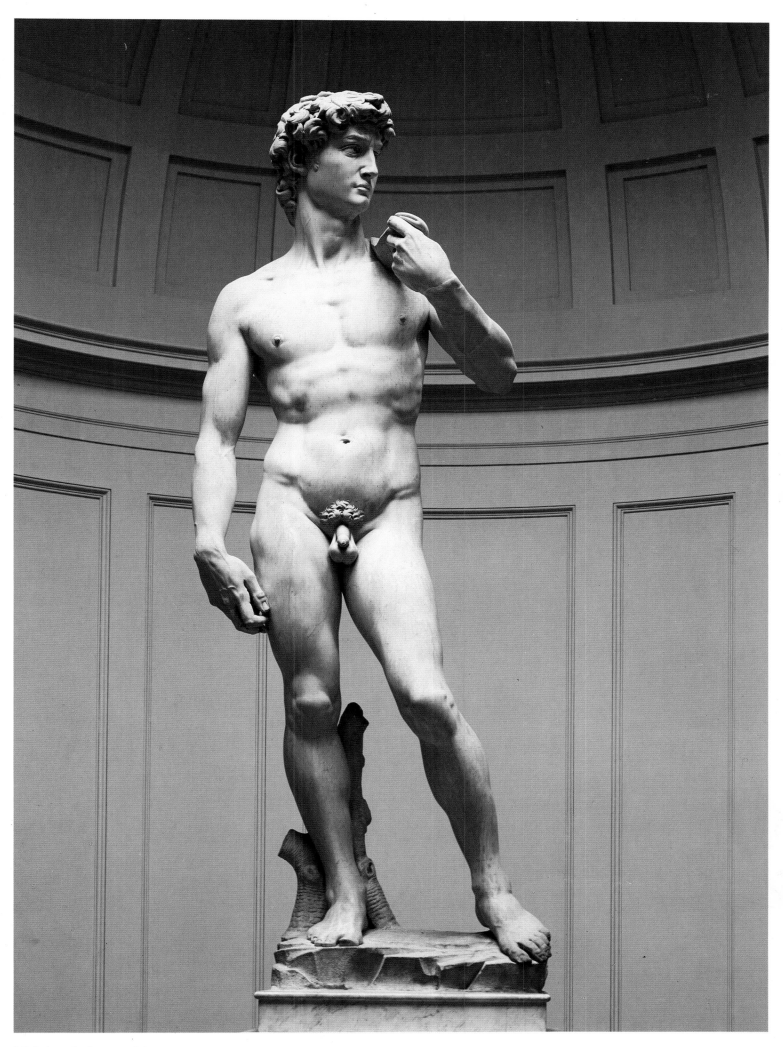

Michelangelo (1475-1564):
David, 1501-1504.
Marble, height 13′5″.

STATUETTES AND THE DIFFUSION OF THE ANTIQUE

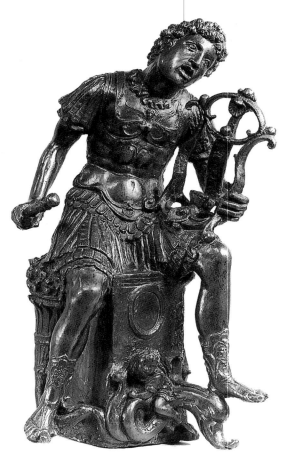

Andrea Riccio (c. 1470-1532):
Arion, early 16th century.
Bronze, height 9⅞".

To the humanist, antiquity was not merely a model to look at and admire. The sculptor's task was to study it in practice, i.e. by copying it. In the first stage, the slavish copy taught the practitioner values and techniques. Then the interpretative copy sought to correct the "errors" of the models as judged by an aesthetic standard. The final result was a new creation faithful to the antique spirit and form.

The needs of collectors, eager to possess a wide choice of "antiques," both genuine classical objects and faithful copies (the notions of forgery and plagiary were both foreign to the spirit of the age), and the creative energy of sculptors joined forces. A specific type, the small bronze, was born. A collector's object, it did not play with space, like great sculpture. Its purpose lay solely in the personal pleasure it gave, a private enjoyment which depended equally on the volumes revolving in the hand and the details visible from close up—the surface on which traces of fusion and chasing by the bronze-founder played, and the patina with bright shimmering tints.

The lavish production of small bronzes in the specialized centres, Florence, Venice, Mantua and Padua, made them a field for specialists in *objets d'art*. Unlike statuary, which is comparatively well dated by documents, the biographical details of contemporaries are vague and incomplete, the inventories of collections often inaccurate. Hence attributions to different artists are fluctuating and flimsy, and complicated by the abundance of examples.

Because the antique heritage took many forms, it embraced small cameos, intaglios and medals, as well as clay and bronze figurines, not to mention bas-reliefs and statuary. The sculptors of the fifteenth century drew freely on all these sources.

The reduction of large antiques to the scale of small bronzes was a common approach. One of the first examples was the bronze statuette after the equestrian statue of Marcus Aurelius realized by Antonio Averlino, known as Filarete (Dresden). An inscription says that the work was given to Piero de' Medici in 1465 and suggests that it was executed at Rome and therefore when Filarete was working on the doors of St. Peter's (1433-1445). The variations in comparison with the original, then erected in front of the Lateran, were minimal—a few decorations demonstrating the chaser's skill.

Pier Jacopo Alari Bonacolsi, known as Antico, also drew on the antique, showing it meticulous respect. Attached to the humanist court of the Gonzagas at Mantua, dominated by the personality of Mantegna and an archaeological interest in decoration, he went to Rome to study the great marbles. The *Apollo Belvedere* inspired him to make an extremely faithful reduction of it, whereas the somewhat stiff and heavy Belvedere *Venus Felix* gave him

Bertoldo di Giovanni (c. 1420-1491):
Hercules with the Apples of the Hesperides, c. 1470-1475.
Bronze, height with base 19¼".

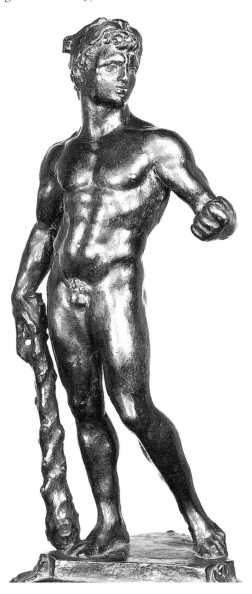

an opportunity to correct the antique, transforming the drapery, softening the attitude and suppressing the genius which accompanied her. He changed an imperial Roman portrait into a cool luxury statuette. These great antiques, as well as the *Meleager* (Victoria and Albert Museum, London), were transcribed as curios, cast in bronze with an impeccable surface, virtuoso finishing touches and coloured with gold highlights. Antico also executed for the court of Mantua large bronze busts of emperors, in a clear, full style, a type which became fashionable at humanist courts.

The majority of sculptors departed from the model in order to assimilate it and then transpose it into their own idiom. That was the case with Bertoldo di Giovanni, who formed the link in Florence between his master Donatello and his pupil Michelangelo. A friend of Lorenzo the Magnificent, whose gems he preserved, and well known for his small-scale works, Bertoldo drew his inspiration from the antique. His relief of the *Battle of the Horsemen* (Bargello) is similar to a sarcophagus in the Campo Santo at Pisa. His *Hercules with the Apples of the Hesperides* has the tranquil pose and monumentality of a classical marble. But *Bellerophon and Pegasus*, one of the rare signed statuettes, differs widely from the antique models.

At Padua the tradition of Mantegna imposed the double trend of nature and archaeological culture on the art of bronze. Sculptors preserved the antique iconography without clinging too closely to the forms. Admittedly, the foremost representative of Paduan art, Andrea Briosco, known as Riccio ("curly-haired"), author of the great candelabrum in Sant'Antonio at Padua, made use of elements from the *Sacrifice of Marcus Aurelius* (Palazzo dei Conservatori, Rome) in his relief of the *Sacrifice after Death* (Louvre) from the tomb of Marcantonio della Torre. But his abundant production, whether attributed or resulting from his models, borrows no more from the antique than a costume and themes, transposed by a rapid nervous sensitive personal style. The *Shouting Horseman* (Victoria and Albert Museum) and *Arion* are antique warriors in whom dramatic expression and movement take pride of place. A similar dynamism, this time of *joie de vivre* (a sometimes shameless vitality), animates the games of nymphs and satyrs. The artist's archaeological interest gives birth to a poetic recreation of antiquity. This tendency, which appeared in soberer guise at Venice in the hands of Alessandro Leopardi and Vittore Gambello, known as il Camelio, combined an artistic desire to achieve personal creation with antique reminiscences.

Antico (Pier Jacopo Alari Bonacolsi, c. 1460-1528):
Apollo, late 15th century?
Bronze, height with base 15¾″.
Ca' d'Oro, Venice.

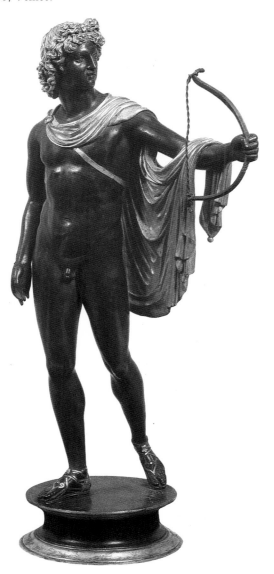

Antico (Pier Jacopo Alari Bonacolsi, c. 1460-1528):
Venus Felix, c. 1495.
Bronze, height with base 12½″.

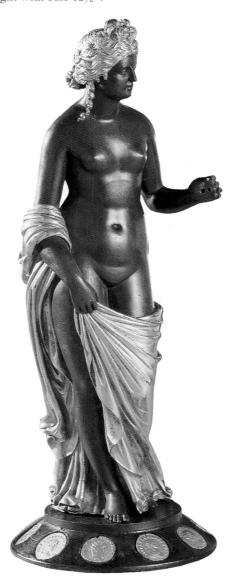

THE CLASSICAL SCULPTORS

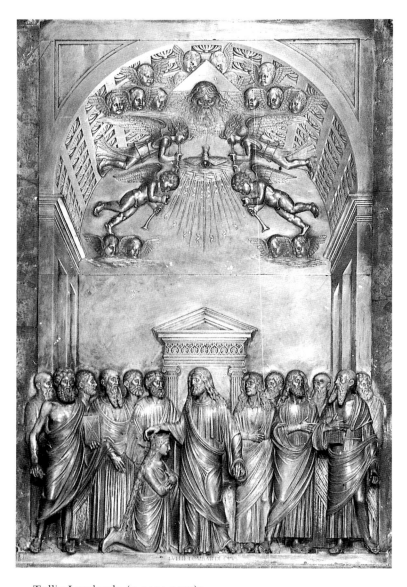

Tullio Lombardo (c. 1455-1532):
The Coronation of the Virgin, 1501.
Marble relief.
Altarpiece, Cappella degli Apostoli,
San Giovanni Crisostomo, Venice.

The return to the antique allied to a desire for clarity, breadth and unity gave birth to a classical art. In painting, the personality of Raphael summed up this trend, in which serenity and passion were constructed harmoniously in balanced rhythms which did not exclude energy and expression. In sculpture, artistic centres were animated by different forms of classicism. In the north of Italy, Antiquity was mostly interpreted in archaeological terms. Artists were not looking for justification in ancient works of art; they sought to become deeply imbued with them, to rediscover their spirit as well as their form. So the aim of artistic creation was to reincarnate the antique ideal. Archaeological discoveries, the study of great collections, the taste of patrons, humanists such as the Estes and the Gonzagas, and theorists such as Pomponius Gauricus, author of the *De sculptura* (1504) which lavished praise on the new classics, prescribed an antiquizing art which sometimes meant that the artist had to subordinate his own personality to the new aesthetic.

Antico, a specialist in bronze, who took his name from his special skill in recreating the antique, dominated sculpture at the Gonzaga court in Mantua. Bronze busts after the antique, *Hadrian Crowned with Laurels* (New York, Louvre), *Bacchus* and *Ariadne* (Vienna), adorned the halls of the ducal palace. Immobile frontal life-size busts, their austere perfection nevertheless evokes a subdued subtle melancholy.

Marble, on the other hand, was the domain of the Lombardo family, whose activity centred on Venice. Trained in the art of the great Venetian tombs in the workshop of his father Pietro, Tullio Lombardo asserted his personality in subtle variations on antique themes. His portraits of young couples in high relief (Ca' d'Oro and Vienna) were inspired by antique funerary busts, but the sculptor completely rejected naturalism. The simplicity of the volumes and the sobriety of expression are set off by decorative refinements which depart from the antique schema. They include embroidered hairnets in the hair and meticulously designed sinuous locks.

The *Coronation of the Virgin*, the large relief executed by Tullio Lombardo for the altar of San Giovanni Crisostomo in Venice, attests the complete abandonment of medieval formulas. This theme, lyrical and supernatural in Florentine painting, here becomes terrestrial and philosophical. The heavens, the Trinity and cherubs are superimposed on a coffered vault. The area is confined by a perspective and closed by a door with a pediment and palmettes. The figures are grouped, or more accurately aligned, in the foreground with their heads not rising above a strict horizontal line. They consist of Christ, clearly framed in the axial door, and the apostles as antique philosophers draped in their togas, hands on chest. The long-haired Virgin kneeling humbly in the foreground is almost lost in this composition, which is so clear and articulated that it rejects any sort of vibration or emotion.

This classical impassiveness was gradually modified until it attained the grandeur of antique tragedy in the great marble reliefs which Tullio and Antonio Lombardo created between 1501 and 1525 for the chapel of Sant'Antonio in Padua. Conceived as a place of memory and exaltation, it is a side chapel in the basilica of the Santo lined with gigantic marble reliefs recounting St. Anthony's miracles. Whereas Donatello had given an epic, vigorous and unsentimental vision of them on the high altar and Titian later waxed poetic and lyrical in the neighbouring Scuola, the Lombardi emphasized a monumental fullness in which feelings and tenderness sometimes showed through.

The younger son Antonio Lombardo, more sensitive to the poetic climate of Venice, entered the service of Alfonso I d'Este, Duke of Ferrara, in 1506. In 1508 he carved a sequence of marble bas-reliefs probably intended for the *camerino d'alabastro* in the ducal palace (unless it was another *studio di marmo*). Twenty-eight reliefs from that humanist's elegant retreat are now in the Hermitage Museum, Leningrad, and one relief in the Louvre. Although the majority are essentially composed of ornamental foliage peopled with fabulous monsters and a whole flexible decorative grammar in which the highly wrought refinement of the material predominated, some storied reliefs witness to the desire fully to integrate the expressive force and structured suppleness of great antique statues.

One relief represents *Vulcan's Forge*: it shows a personage, probably Jupiter suffering from the pangs preced-

ing the birth of Minerva, in the unstable dramatic stance of the *Laocoön*, which had just been discovered. Another is the *Dispute between Minerva and Neptune*: it contrasts a chiselled background of architecture and scrollwork pilasters with three figures in strong relief standing out from a scenic wall like statuettes. A frontal view of a calm, slender, nude Neptune shows a wholly classical musculature; Minerva escapes from the bounds of traditional representations and the sculptor chose to create a peaceful image of the young goddess, fully draped in a garment with small serried folds. They offer their gifts to Attica to assure their domination over her. Neptune's horse is inspired by one of the horses of St. Mark's, whereas the goddess's simply stylized olive tree blends with the background. Victory of wisdom or allegory of the peace between Ferrara and Venice, the relief of the *Dispute* (whose iconography may have been inspired by Pausanias' description of the pediments on the Parthenon, known at the time by Pomponius Gauricus) is the perfect illustration of a humanist art with an eye to the latest finds transcribing a miniaturized Antiquity in scrupulous and luxurious fashion.

This sometimes studied, sometimes poetic sensibility recurs in other marble carvers. In Lombardy, Bambaia specialized in reliefs with delicate figurines. In Venetia, Mosca, author of the *Portia* killing herself on hearing about the death of her husband Brutus (Ca' d'Oro) and the *Judgment of Solomon* (Louvre), introduces a tragic feeling, an icy horror, into the subtle refinement of the delicately wrought figurines.

Further south, in Tuscany and Rome, classicism acquired a broad monumental character with Andrea Sansovino, who was praised, like the Lombardi, by Pomponius Gauricus in 1504. Sansovino's culture was nurtured by varied experiences. At the court of Lorenzo de' Medici in Florence, contact with the Laurentian Academy and prevailing sculpture gave him a solid classical training and a knowledge of the earlier masters (Donatello) and contemporary ones (Pollaiolo, Benedetto da

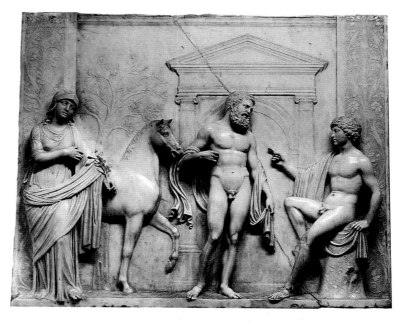

Antonio Lombardo (c. 1458-1516?):
The Dispute between Minerva and Neptune, c. 1510.
Marble, 33⅞″ × 42⅛″.

Maiano). A journey to the court of Portugal enabled him to escape such influences and establish a more personal style dominated by antique largeness. Beginning in 1504, a long stay in Rome at a time when Julius II was assembling artists in the busiest art centre in Italy, definitively established his reputation, somewhat overshadowed in contemporary criticism by the major role then played by Michelangelo.

Andrea Sansovino preferred austere, powerful monumental figures. His *Virgin* and *St. John the Baptist* in the chapel for the Baptist's relics in Genoa Cathedral (a creation whose marbles and arrangement vie with that in the Santo at Padua) already imposed their impassive character (1502). His great tombs of the Roman cardinals Ascanio Sforza and Girolamo Basso commissioned by Julius II for

Andrea Sansovino (c. 1470-1529):
The Annunciation, 1518-1524.
Marble.
Relief on the Holy House in the Chiesa della Santa Casa, Loreto.

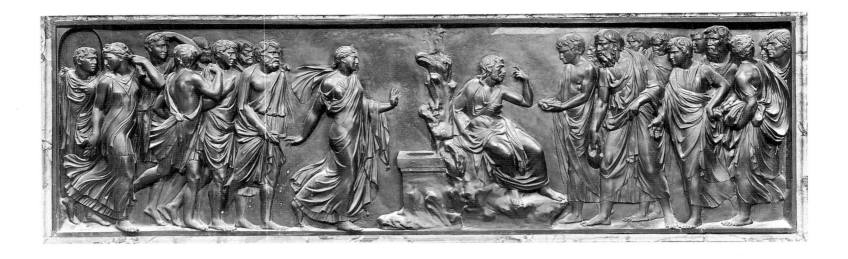

Lorenzetti (Lorenzo Lotti, 1490-1541), after Raphael:
Christ and the Woman taken in Adultery, 1520.
Bronze altar frontal, 24⅜″ × 82¾″.
Chigi Chapel, Santa Maria del Popolo, Rome.

Santa Maria del Popolo (1505-1510) are triumphal arches framing, in the centre, the effigies of the deceased reclining on one elbow. Standing cardinal Virtues in the niches and theological Virtues seated in prayer in the upper parts are represented by full-figured women in the antique manner, wearing wavy bandeaux. The broad impassive faces, with straight noses, fleshy mouths and wide open eyes, are those of the classical Muses. This broad facture which recurs in the full drapery is emphasized by highly decorated frameworks. The ornamental vocabulary swarms up the columns and insinuates itself into friezes, pilasters and spandrels. Garlands and grotesque masks, ornamental foliage and acanthus patterns in which lissome ephebes sometimes play derive from a knowledge of the antique based on Roman stuccoes.

Antonio Begarelli (c. 1499-1565):
The Adoration of the Shepherds, c. 1526-1527.
Terracotta.
Cathedral, Modena.

In 1510 Andrea Sansovino received a commission from Jean Goritz, the apostolic protonotary, for an unusual funerary monument on a pillar in the Roman church of Sant'Agostino. In a niche surmounting an altar Sansovino placed a group of the *Virgin and Child with St. Anne*, a compact monolithic marble where the two seated women smile sweetly at the restless Child. Above, a fresco by Raphael, the *Prophet Isaiah* presenting the text of the prophecy of the Incarnation, drives home the idea of divine force. A humanist monument which Jean Goritz induced the best poets to praise, it represents the sober balanced Roman classicism in which Sansovino's moderation does not lend itself to any deviation, anguish or fantasy.

This solemn art culminated in the decoration of the shrine of the House of the Virgin inside the basilica at Loreto, where Sansovino was appointed master of works by Leo X Medici in 1513. He devoted his last years to casing, together with his team of sculptors, the exterior of the Santa Casa, the House of the Virgin miraculously transported to Loreto by the angels. The walls, punctuated by engaged columns and niches housing statuettes, are covered with marble reliefs recounting episodes in the life of the Virgin. The *Marriage* was completed by Tribolo; the *Annunciation* and the *Nativity* integrate classical personages in a pictorial perspective. The scene of the *Annunciation* is divided into three sections by slanting walls whose vanishing lines stop short. To the right, the symbolic area unites the Tree of the Knowledge of Good and Evil (which

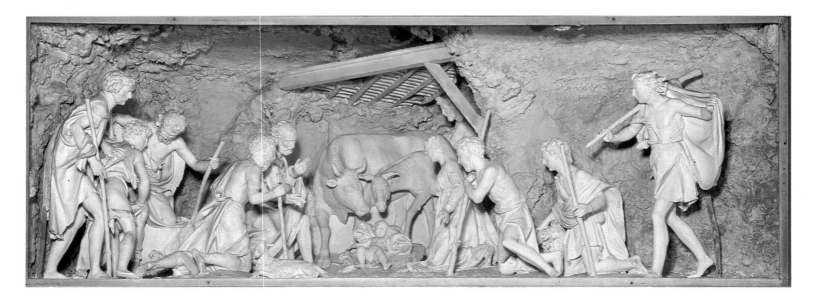

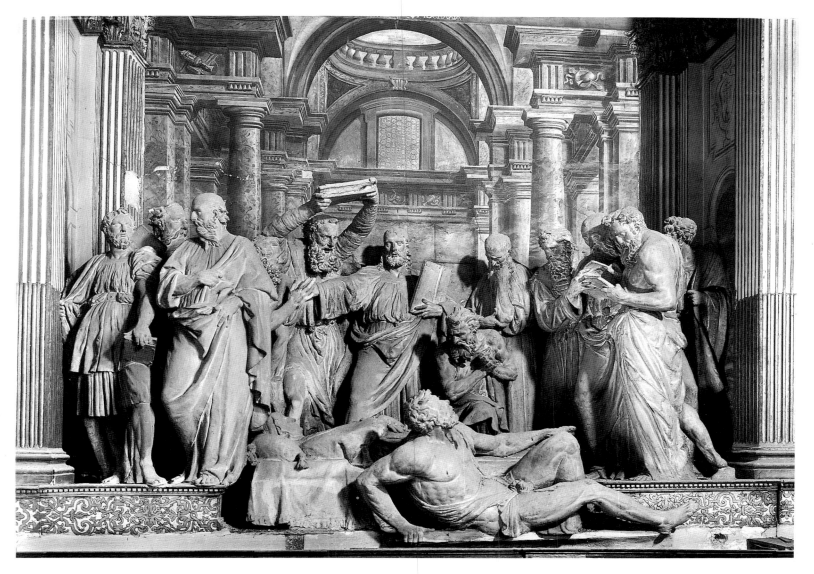

Alfonso Lombardi (1487-1536):
Death Scene of the Virgin, 1519-1521.
Life-size terracotta.
Santa Maria della Vita, Bologna.

the Incarnation transformed into a Tree of Redemption thanks to the "new Eve," Mary) with the bouquet of lilies and roses of purity and grief, while a cat inserts its familiar or maleficent silhouette. The massive pensive Virgin is seated in her room with a curtained canopy. The monumentality of this figure is reinforced by the attitude, that of certain Virtues on Roman tombs by Sansovino, with legs apart, emphasized by the linear folds of flowing draperies knotted together at one side to enhance the natural authority of the Virgin. Lastly, on the left, the supernatural vision depicts a slanting tapering shaft, the divine ray emanating from a Jupiter-like God the Father surrounded by carefree *putti*, above a kneeling angel with floating draperies similar to the one painted by the youthful Leonardo. The monumental background of this scene, the pillars of the atrium, contrasts with the intimacy of the alcove containing the Virgin. The tranquil serenity of the latter is contrasted with the movements of the angels. Contact with this well balanced art helped the next generation, Niccolò Tribolo and Jacopo Sansovino, who took his name from his master Andrea, to reinforce a sense of structure and introduce movement.

While Sansovino was occupied at Loreto, Lorenzo Lotti, called Lorenzetti, a Florentine, arrived at Rome and became Raphael's assistant. From the painter's designs he executed the decoration of the Chigi Chapel in Santa Maria del Popolo consisting of two statues, *Elijah*, in which the schema of the celebrated antique *Torso* in the Belvedere is recognizable, and *Jonah*, an adolescent with refined forms, exhibiting Raphael's sense of harmony. The relief on the altar, a long bronze frieze, betrays references to the best known Roman reliefs, the *Ara pacis* and the Borghese *Dancers*. The composition, due to Raphael, is more sculptural than Sansovino's. There is no ground; the figures stand out from the bronze plaque. The depth of the planes is given by variations in the relief. The flexibility of the women's clinging drapery and the togas with small angular folds emphasize the respect for Antiquity, that omnipresent artistic matrix.

The impact of Raphael on the artistic life of his time was such that sculptors introduced references to his work. Alfonso Lombardi, trained in clay modelling by following in the footsteps of Emilian craftsmen, sought to rediscover the breadth of *The School of Athens* in scenes framed by an uncompromisingly classical architecture (Bologna, churches of San Domenico and Santa Maria della Vita). Another modeller, Antonio Begarelli, attains Raphaelesque accents in his *Madonnas*, in which the spirit of Correggio is also present, and in the naturalistic frieze of the *Adoration of the Shepherds* in Modena Cathedral. Here it is the shadow of Raphael which contributes a grain of classicism to a resolutely naturalistic art.

THE TRIUMPH OF MICHELANGELO

THE TOMB OF JULIUS II

Visual and tactile responses are vividly aroused by the *St. Matthew*, the only vestige of an unfulfilled order given to Michelangelo in 1503 for twelve Apostle statues for Florence Cathedral. He had the contract cancelled in 1505 when he entered on the arduous and chequered enterprise of the *Tomb of Julius II*. The rough-hewn figure of the saint strains forward from the rough block of marble still imprisoning it. Vasari's interpretation, supported by one of Michelangelo's poems, would have us see this incompleteness as a "romantic" failure, a strenuous inability to embody in stone the sublime grandeur of the Idea. True, Michelangelo knew how to make the most of the suggestive power of the *abbozzato*. But that was not the case here: the *St. Matthew* was simply left unfinished, under the pressure of other work.

"The great mausoleum of Julius II is lost forever to the sixteenth century" (André Chastel). Commissioned from Michelangelo in 1505 by the Pope, the tomb was never finished and the contract of 20 August 1542 which specified its present state put an end to a "great tragedy," to use Condivi's words, which involved a grandiose conception and forty years of anguish–a tragedy whose causes are hard to understand and whose convoluted episodes are not easily summarized.

Although there is no shortage of documents dealing with the tomb, they have little to tell us about Michelangelo's monumental dream. Two drawings, copies of workshop studies (?), do give us some idea of the project of 1513, but the initial design is known only from the descriptions of Vasari and Condivi which do not always tally. This makes attempts at reconstruction hazardous. Nevertheless, we know that Michelangelo, dissatisfied with the Florentine formula of the wall tomb, had envisaged a mausoleum with a pyramidal structure enclosing an oval funerary chamber in the centre of which a sarcophagus was to house the Pope's remains. Victories flanked by slaves or captives adorned the lower storey. Above, on a platform, were four large seated statues, behind which "the construction rose by degrees." The work was crowned by two statues carrying what Condivi calls a casket (*arca*) and Vasari a bier or litter (*barca*), and which Panofsky simply interprets as a *sella gestatoria* with a seated statue of the Pope.

After the Pope's death in 1513, the project was modified and its architectural amplitude reduced to a compromise between wall tomb and mausoleum. The iconographic programme was changed and the number of seated statues increased to six. A *cappelletta*, a vast niche or apse, rose behind the catafalque supported by four figures on which the effigy of the Pope could be seen. A Virgin and Child were depicted in its mandorla and on either side of two monumental columns niches probably housed four statues of saints.

Michelangelo (1475-1564):
St. Matthew, c. 1505-1506.
Marble, height 8'7".

Jacomo Rocchetti (active c. 1594), after Michelangelo:
Second project, 1513, for the Tomb of Julius II.
Pen and ink drawing, 20⅝″ × 13⅜″.

However, disputes between Michelangelo and the Pope's heirs soon flared up and were so fierce that in July 1516 a third contract reduced the mausoleum to a simple wall tomb! In October 1526 and again in 1532, the project was modified still further. Thenceforth it consisted of a simple structured façade, although the effigy of the Pope, recumbent on a sarcophagus, was retained. Six statues were to be added to it: a Sibyl, a Prophet, a Madonna, Moses and the two Slaves now in the Louvre, because as Panofsky observes "they were finished." The contract of 1532 also provided for the Tomb being placed in San Pietro in Vincoli. Lastly Michelangelo undertook to finish it in three years. It seems that at the time he did not want to incorporate the two Louvre statues into the new project and that he had envisioned introducing two sculptures of Rachel and Leah, personifications of the Active Life and the Contemplative Life. Perhaps he dreamt of a more monumental tomb, "a last desperate effort," Panofsky thinks, "to compensate for the loss of architectural magnificence by plastic power... an effort doomed to failure."

To Tolnay, these successive projects summed up "the artistic and spiritual development of Michelangelo from the heroic ideal of his youth to his religious conversion in old age." Tolnay emphasizes the symbolical significance of funerary edifices on a central plan and with a dome deriving from an ancient tradition, that of the martyriums and mausoleums of the imperial epoch evoking the Beyond and Heaven itself. Thus the Slaves and the Victories represent the triumph of the Apostolic Church over the pagan peoples; the seated statues "the instauration and diffusion of the true faith" and the elevation of the Pope the apotheosis of the Holy Church. To Panofsky, the Slaves personify the human soul as prisoner of the raw material and the Victories the human soul capable of overcoming base feelings by reason. Panofsky sees the deeper meaning of the Tomb as a "spiritual triumph," immortalizing the Pope, by eternal salvation, as the representative of humanity. In spite of their differences, these erudite interpreta-

Michelangelo (1475-1564):
The Captive from the Boboli Gardens, called Atlas, c. 1519.
Marble, height 9′1½″.

Michelangelo (1475-1564):
Prisoner intended for the Tomb of Julius II, known as
The Dying Slave (unfinished), 1513-1515.
Marble, height 7′5¾″.

tions are not mutually exclusive. They are complementary or combine to emphasize the religious and philosophical symbolism of the Tomb which, whether or not of Neoplatonic inspiration, seeks to express the aspiration of the soul to Beauty, to pure contemplation, the passage by successive stages from profane love to the Love of God. On this point a remark by André Chastel forms a fitting conclusion: "These symbolical values are not necessarily mutually exclusive and the practice of ambiguity familiar to Michelangelo invites us to merge the opposing interpretations rather than choose between them." This is confirmed by the commonplace "formalist" description of and commentary on the remaining works.

The Louvre Slaves (with the proviso that the little roughly carved monkey behind the Dying Slave, an allusion, it has been said, to painting, admits of other interpretative derivations), the Slaves in the Accademia at Florence and Moses seem to be carried away in the terrible effort to rise to spiritual spheres. The unstable pose of the Louvre Slaves, the impotent protraction of the waking state of the Dying Slave emphasized by the muscular palpitation, perceptible beneath the softly polished luminous marble skin, and the violent twistings of the Rebellious Slave enclosed in the spiral of an infrangible outline which multiplies the view of the body and restores its complicated anatomical functioning, obviously express the torment and anguish of unfulfilment. The faces, especially that of the Rebellious Slave, have not been brought to the purity of the smooth finished form. Deliberately or not, the contrast between the carefully polished parts and those where the passage of the toothed chisel is still visible reinforce, somewhat in the manner of chiaroscuro, the expressive capacity of the forms. But it is the four great Accademia statues which most explicitly reveal to us a process of highly symbolic direct carving which consists in freeing from the dead stone, the raw inert material, the Beauty it imprisons. As Michelangelo says in one of his sonnets:

"The marble not yet carved can hold the form
Of every thought the greatest artist has,
And no conception can yet come to pass
Unless the hand obeys the intellect."

Thus these giant figures are still caught in the prison of the material of which they are made, inexorably enclosed in the *carcer terreno* from which they are desperately trying to free themselves. The slave called Atlas seems to be striving to free his face from the heavy shapeless crushing mass which grasps him and prevents his accession to Humanity.

The brutal expressive tension arising from the contrast between the finished and the unfinished whose symbolic and suggestive capacity Michelangelo appears clearly to have understood is demonstrated at its strongest in *St. Matthew* and these Slaves. Nevertheless, we must guard against a "romantic" interpretation of these sculptures, because there may be some perfectly ordinary reason for their unfinished state. Yet we may be tempted to read in them the failure of the artist, a prey to doubt, unable to extract from the matrix of the rough-hewn block the form incarnating his *concetto*, the Idea of the Beauty to which he aspires. One senses there a Neoplatonic inspiration which would account for the intense concentration of Moses even better. The Prophet's pose may owe a great deal to that of Donatello's *St. John*, but Michelangelo, while maintaining a fixed point of view which imposes a frontal vision of the statue, throws the movements out of alignment. Moses

seems to be on the point of standing up, but to be stopped in the act. And the contrary directions of head and arms, the opposition between the firmly posed right leg and the tensed withdrawn left leg, the play of the heavy folds of the drapery and the swirling undulant tangle of his beard well express the violence of a constraint, the inner conflict represented by this petrification of the prophet who seems to contain his righteous wrath. But we must be careful not to misconstrue and reduce to the level of anecdote possibilities suggested by the attitude of Moses. The arrested tension of the Prophet is that of a being lost in contemplation, as Condivi rightly pointed out. And we should see in

the tense concentrated attitude of Moses not so much that of the leader of the Hebrews in a fit of rage as that of the Prophet petrified and ravished by the vision of "the splendour of the light divine" (Panofsky).

On 20 August 1542 a final contract stipulated that Michelangelo should have the statues of the Virgin, the Prophet, the Sibyl, Leah and Rachel finished at his own expense by Raffaello da Montelupo. But Michelangelo, yielding perhaps to the insistence of the Pope's heirs, made himself partly responsible for the last two statues. And in the end it was Tommaso di Pietro Boscoli who executed the statue of Julius II.

Michelangelo (1475-1564):
Moses, central figure of the Tomb of Julius II, 1513-1515.
Marble, height 7′8½″.
San Pietro in Vincoli, Rome.

THE MEDICI CHAPEL

Michelangelo (1475-1564): The Medici Chapel, partial view with the Tomb
of Giuliano de' Medici (left) and the Virgin and Child group (at the back), 1520-1534.
New Sacristy, San Lorenzo, Florence.

In 1520 Leo X and his cousin Cardinal Giulio de' Medici, the future Pope Clement VII, decided to employ Michelangelo to build a funerary chapel in San Lorenzo, Florence, to enshrine the tombs of the *Magnifici*, Giuliano, assassinated in 1478 during the Pazzi conspiracy, and Lorenzo, who died in 1492, and the Dukes, Giuliano II, Duke of Nemours (1478-1516) and Lorenzo, Duke of Urbino (1492-1519), son and grandson of Il Magnifico respectively. The project was planned comparatively quickly, but work on it did not begin until 1526, because of delay in quarrying the marbles at Carrara. And now began hostilities between Clement VII and Charles V which caused the devastation of Rome (1527). When the Medici were expelled from Florence the restored "Republic" made Michelangelo responsible for work on the fortifications. He carried it out enthusiastically at first until, having an accurate premonition of Malatesta Baglioni's treason and what he saw as the inevitable fall of the Republic against which the Emperor and Clement VII were in league, he fled from Florence in September 1529. He returned when the siege of the town began, obtained his pardon and resumed his work as a military engineer. After the fall

of the city, he went into hiding, but the Pope, on the advice of Sebastiano del Piombo, gave orders that he should be spared on condition that he resumed work on the Medici Chapel. He set about the task with expedition, "moved," so Condivi tells us, "more by fear than by love." But when Clement VII summoned him to Rome in 1534, he left Florence for ever, leaving the site unfinished and in great disorder, with the abandoned marbles scattered in the chapel. It was not until 1545, after the installation of the statues by Niccolò Tribolo and Raffaelo da Montelupo, that the monumental dominant grandeur of this ensemble, which is undoubtedly his most significant sculptured work, could be properly assessed.

The incompletion of the project is admittedly attributable to the events we have just summarized, but critics have rightly seen in it the consequence of the fatigue of the artist entangled in his own contradictions, torn between his artistic and "political" commitment and the need to obey the demands of his patron, the symptom also of a personality problem characteristic of a melancholy temperament unable to reconcile a sexuality he considered "guilty" with his religious and spiritual convictions.

Michelangelo (1475-1564): The Medici Chapel: Lorenzo de' Medici, Duke of Urbino, 1524-1531?
Marble, height 5′10″.
New Sacristy, San Lorenzo, Florence.

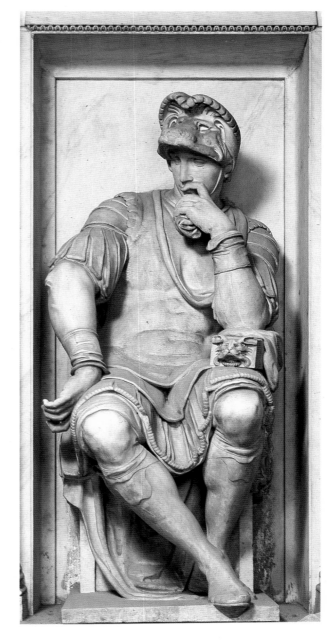

Michelangelo (1475-1564):
The Medici Chapel: Night, on the Tomb of Giuliano de' Medici, 1526-1531.
Marble, length 6′4⅜″.
New Sacristy, San Lorenzo, Florence.

▷ Michelangelo (1475-1564):
Pietà, 1548-1555.
Marble, height 7′5″.

◁ Michelangelo (1475-1564):
The Medici Chapel: Dawn (detail),
on the Tomb of Lorenzo de' Medici,
1524-1531?
Marble.
New Sacristy, San Lorenzo, Florence.

At first, Michelangelo apparently dreamt of erecting a sort of four-sided triumphal arch (*quadrifons*) inspired by the Arch of Janus in Rome. The solution chosen reserved the entrance wall for the tombs of the *Magnifici* and the side walls for those of the Dukes. According to Hartt, allegories of Rivers, the Tiber and the Arno, were to have been placed at the foot of the Dukes' tombs. They were the Rivers of Hades to upholders of the Neoplatonic interpretation! In the niches on either side of Dukes Giuliano and Lorenzo, the programme envisaged representations of Heaven and Earth, Truth and Justice or Justice and Religion. Lunettes and dome were to be frescoed. Today we should say that the Medici Chapel constitutes a remarkable example of the total work of art (*Gesamtkunstwerk*) because Michelangelo dreamt of employing and uniting in it architecture, sculpture and painting, and it is understandable why fascinated critics have interpreted this ensemble as an "epitome of the cosmos," "an abbreviated image of the universe," illustrating the Neoplatonic doctrines of death and the immortality of the soul then in vogue. In

their view the finished chapel would have embodied a sublime vision of the Universe and Time elevating the spirit by degrees from the domain of the departed to the celestial sphere. But we can equally well accept it as a celebration of the temporal and spiritual power of the Medici, superhuman victors over destructive and devouring time (Hartt).

Here we can assess the power and at the same time the impotence of erudition and, incidentally, of the impressionist grasp of the forms (to which not enough credit is given). It is true that everything that could be said about this grandiose fascinating ensemble has already been said. The orthogonal grid of the ribs of *pietra serena* articulating the stucco and white marble façades of the chapel, like the clear spatial structurations of Brunelleschi, contrast with the curves of the volutes, stretched like the leaves of a spring, which surmount the sarcophagi. The latter bear the unstable cramped bodies and torsos of four allegories of the Times of Day, which have rightly been called "disturbing" and "downcast." They look as if their extraction

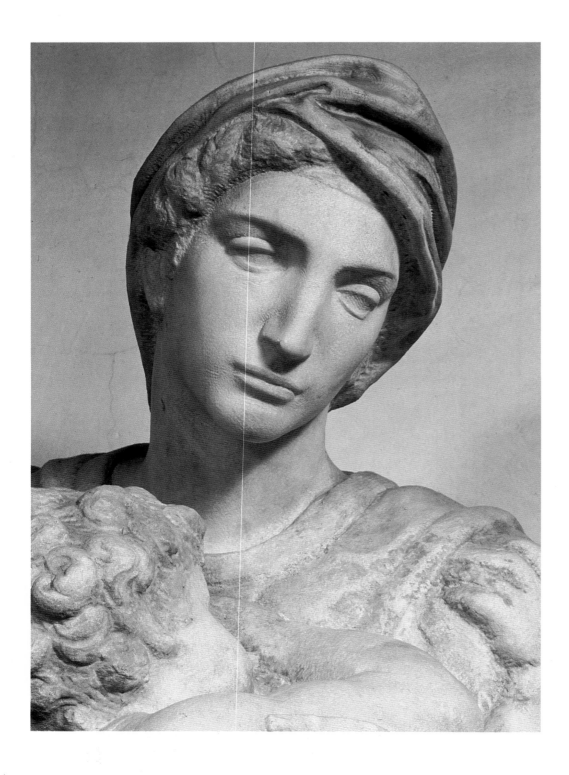

Michelangelo (1475-1564):
The Medici Chapel: The Virgin
and Child (Medici Madonna),
detail, c. 1532.
Marble.
New Sacristy, San Lorenzo, Florence.

from the inert matrix of the raw material was a cause for regret. Victim of an abandonment with no redress, Day extricates itself painfully from a protective consoling "foetal" night. The noble pose of the Dukes, whose Roman cuirasses recall their patrician status, seems to be belied by their gestures. The bizarre helmeted melancholy figure of *Il Penserioso* is lost in sombre silent meditation. And Giuliano's inordinately long neck, his dreamy look, the extreme retraction of his left leg betraying indecision of movement and the relaxation of the musculature of his torso, proclaim the unavoidable exhaustion of the *vir activus*. The twisting, the elongation, the stretching of the bodies imprisoned in the material and apparently emerging with reluctance from a state of preconsciousness, the dissonances of lines and masses with contradictory tensions–all this expresses doubt, anguish and terror.

The death of Vittoria Colonna in 1547, which shattered Michelangelo, may have been the inspiration for the Florence *Pietà* in which Michelangelo is represented in the guise of Joseph of Arimathea, accompanying the burial of

the mortal body of Christ making the Redeeming Sacrifice. The just definition of the masses drawn as if naturally from the blocks shows a peerless mastery confirmed by the adumbration of the Saviour's torso. As for the Milan *Pietà*, which seems to conclude the sculpted works, it grips us, in its very incompletion, by an austere religiosity which conforms with the recommendations of the Council of Trent. The pathetic image of Mary carrying the lifeless body of her Son, to which, in mystical fervour, Michelangelo has given his own features, does away with all speculations about Beauty. Only Faith, abandonment in God, guarantees Salvation. Thus the Renaissance comes to an end. The human optimism opened up for us in the field of sculpture by the youthful Apollonian serenity of Donatello's *St. George* terminates in pessimism and the melancholic *terribilità* of the saturnine genius. The exalted discovery of Man and his powers leads, as if by predestination, to awareness of the insignificance of the earthly vanities and the happy assertion of the power of style to transcend experience and suffering.

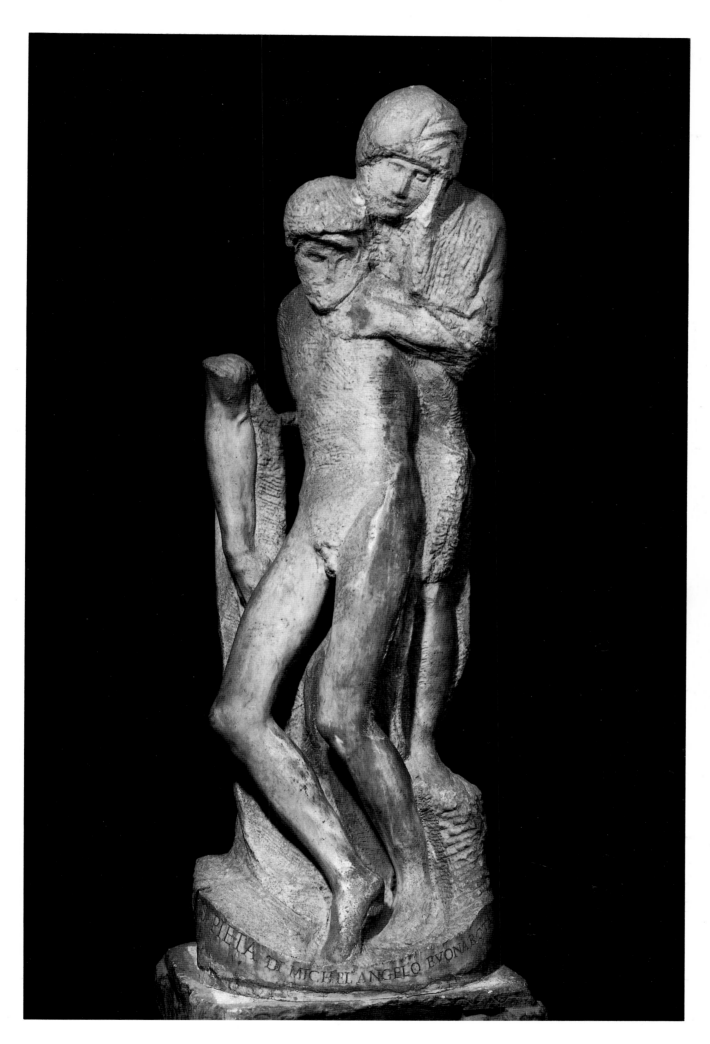

Michelangelo (1475-1564):
The Rondanini Pietà, 1555-1564.
Marble, height 6'4¾".
Castello Sforzesco, Milan.

Niccolò Tribolo (1500–1558):
Fountain of the Labyrinth, with the figure
of Fiorenza by Giambologna, 1555–1560.
Marble fountain, height of bronze figure 49¼″.
Villa of Petraia, Castello, near Florence.

MANNERISM by Geneviève Bresc-Bautier

To an unprecedented extent, sixteenth-century aesthetic theory conceived of art as a global activity employing every available technique in order to achieve the symphony of Ideal Beauty. This makes it hard to separate sculpture from an artistic whole in which the sculptor was usually bound by the restrictions imposed by his patron, the directives of the supervisor, painter or architect, and the overall programme.

The sculptor's autonomy within this basic unity was mainly technical. After the *De statua* by Leon Battista Alberti (1464) and the *De sculptura* by Pomponius Gauricus (1504) preceding the treatise on proportions by the Florentine sculptor Vincenzo Danti, the specific nature of sculpture was recognized as the art of the basic material expressed in volume. It was also assumed to have assimilated the rules of painting, proportions and perspective, as well as its precious adjuncts, line and colour.

The experience acquired in Quattrocento Italy (rediscovery of the classical rules, the truth of the body, unity and rhythm) helped to introduce a new dimension into the sculpture of other countries where the Gothic tradition still lingered. The Renaissance took the stage at the beginning of the sixteenth century. The reality of the body replaced graphic representation; unified composition gradually ousted the lavish use of scenes and personages. Decoration in the antique style, trophies and candelabra, ornamental foliage and *putti*, coexisted with the acanthus and other motifs of Flamboyant Gothic before supplanting them. The humanist courts of northern Europe, eager to vie with the Italian courts, and the scholarly prelates, for whom Rome was once again a magnet, attracted Italians who brought new ideas with them. This was a fashion for some, a deliberate break for others who saw the victory of the modern mind over the scholastic mind in the new forms and a return to the civic, legal, literary and even philosophical values of antiquity.

The "Early Renaissance" outside Italy (from the late fifteenth century to 1525) was the gestation period for the new sculpture. During this period of contacts, the discovery of Italy by the subjects of the kings of France, the visits of Dürer and Peter Vischer the Younger to Venice, the diaspora of Italian sculptors (the Giusti to France, Torrigiani to England and Spain, Domenico Fancelli, Jacopo l'Indaco and his brother to Spain), Italians and indigenous nationals worked side by side on major artistic projects, Gothic and Renaissance decorations were juxtaposed and *contrapposto* and flowing drapery were used for figures. Was there a conflict between the opposing tendencies? A generation quarrel? Although historians of Gothic have believed that the national style was then swept away, artists seem to have adopted the new forms unreservedly. To the extent that the Gothic traditions were revitalized by fifteenth-century trends (the Germanic "weicher Stil," French "détente," realism), it was a creative sculpture that prepared itself unobtrusively for the conversion, not as the slave of foreign forms, but consciously assimilating them, while preserving its originality.

Europe was shaken by cataclysmic events between 1525 and 1530. They included the rise of Protestantism, the wars of the Emperor Charles V, the Sack of Rome (1527), the second Florentine revolution and the capture of the king of France (1525). It was goodbye to the certainties of the Renaissance, the peaceful balance between Beauty and Reason, and unified Faith. The progress of despotism in Italy, the Wars of Religion and the rise of the Inquisition left only a few protected islets such as Venice and spread pessimism and scepticism. Art became refuge and evasion, as exemplified by the poems of chivalry, Ariosto's *Orlando furioso* (1532) and Tasso's *Gerusalemme liberata* (1575), while the Church, reassured after the Council of Trent (1563), inspired a mystical and liturgical renewal of sculpture.

Artistic circles were shaken. The confused and visionary unconscious, inhibited by the imperial order and the contradictory dogmas of the churches which confronted each other, was expressed during the sixteenth century within the framework of Mannerism.

This style oscillated in opposite directions between the fantastic and the *maniera*, the great ideal genre drawn from the example of the masters, the ancients, Raphael and above all Michelangelo, who expressed the spirit of Italy. Sometimes the ideal took precedence. Powerful figures of Hercules with exaggerated muscular development were opposed to elongated weightless bodies. Undulating spirals animated groups and twisted sinuous bodies. Elsewhere expression exaggerated to the point of morbidity and the bizarre was preferred, contrasting with mysterious faces rapt in some inner reverie. Research into body structure caused a clash between symbolism, anatomical study as revealed by Vesalius, classical continuity (an essential bow to the masters), realism of detail and an oneiric atmosphere. An international sculpture, dominant to be sure, but diffused between its practitioners, arose in Florence, the cradle of Mannerism, in Venice, Mantua, Fontainebleau and Augsburg. Artists moved freely all over Europe. Northerners became Florentines, Florentines emigrated to the French court, Milanese to Spain, Spaniards to Italy, Dutch to the Empire, not to mention a host of travellers eager for contacts or commissions. Sculptors ransacked Europe, bringing back disparate themes, allying the decorative and the dreamlike to the German realist tradition. Rustic peasants and classical goddesses, royal statues, Pietàs and dead Christs, saints in ecstasy, all formed the incongruous repertory of the sculpture whose practitioners also insisted on an excess of decoration in their search for effect.

Far from being a sign of decadence as was thought for a long time, this diversity exemplified an art in search of itself. After the serene self-assurance of the Renaissance, the troubled complexity of Mannerism was not exhaustion, but creation. Once peace returned, the Florence of the Medici, the Fontainebleau of Henry IV, the Rome of the late sixteenth century and the Prague of Rudolf II were to witness the triumphant flowering of Mannerism.

IN SEARCH OF EFFECT:
THE LIGHTNESS OF STUCCO...

The rediscovery of the Domus Aurea built by Nero on the slopes of the Esquiline Hill and its halls covered with fanciful delicate stucco work started a craze for the decorative motifs known as "grotesques" from the name of the so-called "crypto-porticus" grottoes, but it also reinstated stucco as a material. The decorations of the Coliseum and Hadrian's Villa at Tivoli still clearly visible at the time spread familiarity with their motifs: festoons, garlands, mouldings, bas-reliefs, figurines, networks of interlacing figures, coffers, candelabra and grotesque masks.

Stucco, a malleable mixture of plaster, lime and sometimes powdered marble, is well suited for modelling. It can be used to embellish walls and ceilings, and makes all kinds of surface effects possible. Naturally white, it acquires a brilliant gleam when mixed with powdered marble. When polished and sometimes waxed, it actually looks like marble. An air of richness emanates from the lively shining surfaces which often form part of the composition along with frescoes and gold highlights. Raphael, his favourite stucco worker (*stuccatore*) Giovanni da Udine, and his pupil Giulio Romano brought the classical technique up to date and used it for the most prestigious decorations of papal Rome: the Vatican Loggie, the Farnesina and the Villa Madama, giving the grotesque style a place of honour in the classical architectural strictness.

Giulio Romano and Giovanni da Udine left to spread the technique in Venice where they decorated the Fondaco dei Tedeschi. At Mantua, Giulio Romano in collaboration with the young Primaticcio decorated the ceilings of the Palazzo del Tè, the pleasure residence of Federico Gonzaga, which was a veritable laboratory of Mannerism. Small rooms with "grotesque" stucco work inspired by the Vatican Loggie alternated with halls with ambitious decorations, such as the *Triumph of Sigismund* in which long white friezes evoke the reliefs on Trajan's Column.

Primaticcio left Mantua for the court of Francis I in 1531. There he became the successful rival of Rosso Fiorentino who had arrived at Fontainebleau the year before. The two artists and their teams of stucco workers introduced the stucco technique at different levels. Rosso, in the Gallery of Francis I, and Primaticcio in the Salon of the Duchesse d'Etampes, transformed the purely decorative motifs of the fresco frames into genuine sculptures. In their designs the modelled stuccoes were still volutes, strapwork and festoons, but there were also large figures in strong relief projecting well beyond the architectural framework. Primaticcio's slender elongated nymphs form a languorous circle around the walls of the royal mistress's room. The more ambitious project in Rosso's gallery varies the frames of each fresco, alternating reliefs in the classical style and fantastic figures, and changing canon, relief and style. Stucco becomes the favourite instrument to achieve effect. Its limpid whiteness subtly brings out the vibrant colours of the frescos. The vigorous modelling of the large ephebes with twisting bodies enables the sculpture to take possession of the space far outside the architectural framework.

In France stucco was short-lived. Jean Goujon already chose to carve the interior decoration of the Louvre in stone, but a new contact with Italy around 1640 was to relaunch stucco and bring back the Italian stucco workers.

In Italy, on the other hand, stucco became widespread. Cheap, quickly modelled and moulded, a substitute for marble, it was used for the ceilings of palaces and churches, rustic grottoes and even for the large statues of galleries and ecclesiastical and civic monuments (such as the Teatro Olimpico by Palladio at Vicenza).

Under the direction of Francesco Primaticcio (1504-1570):
Venus, 1536.
Stucco and fresco.
Gallery of Francis I, Château de Fontainebleau.

Pirro Ligorio (c. 1500-1583):
Casina or Summer House of Pius IV, 1558-1561.
Vatican Gardens, Rome.

Venice became one of the capitals of stucco, because of the brilliant work of Alessandro Vittoria, Palladio's assistant at the Palazzo Thiene in Vicenza, in villas, and as the great decorator of the Ducal Palace. There he modelled the stuccoes of the sloping vaults of the Scala d'Oro, where square medallions, busts in relief, genii and volutes alternate on a ground of gold mosaics.

Rome was the other pole of the art of stucco. It was there that Perino del Vaga, responsible for the decorations of Trinità dei Monti, trained Daniele da Volterra before he left to spread his art in Genoa. In the Cabinet of Bacchus of the Palazzo Farnese (c. 1550) and the Sala Regia of the Vatican, Daniele created a broad style, with a strong tendency towards classical antiquity, to be sure, but drawing on reliefs rather than grotesques. The interior decorations of palaces and villas (Palazzo Spada, the Villa d'Este, the Villa Caprarola and the villa of Pope Julius III), and of chapels and oratories (San Giovanni Decollato) relied primarily on frescoes. They were a theme the Carracci were to take up again in the Farnese Gallery, when they used real stucco for the walls, but imitated it in *trompe l'œil* on the ceiling, a recognition of the role this technique played in the architecture.

The large number of commissions also entailed the adoption of stucco for executing sculpture in the round, such as the statues by Camillo Mariani in San Bernardo alle Terme and Ambrogio Bonvicino in the Lateran and San Giacomo degli Spagnuoli.

The spread of stucco was general throughout Italy. We find it in Florence, in Milan (where Pellegrino Tibaldi and Francesco Brambilla worked on the Duomo), in Genoa and Urbino (where Federico Brandani modelled the walls of the ducal chapel). Even on the exterior, architects made use of this solid material which created effects thanks to motifs that could be renewed ad infinitum. In France we sometimes find a kind of reconstituted stone, as at the Château d'Assier. A moulded medallion of this material from the Château is housed in the Louvre.

Palladio employed stucco workers on some façades. The Loggia di Capitano in the main square at Vicenza and the Palazzo Barbarano exhibit an abundant decoration consisting of trophies.

The façades of Roman palaces, villas and "casinos" were given stucco ornaments sometimes used so lavishly as to be excessive. At the Palazzo Spada, festoons and "grotesque" atlantes surmount large figures in the round (1540). On the façade of the Villa Medici (1540), antique reliefs, including the remains of the *Ara pietatis* of Augustus, are surrounded by stucco friezes and medallions in elaborate compositions which later served as a model for the Villa Massimo and Prince Doria Pamphily's Villa. The architect Pirro Ligorio, a productive Neapolitan who was a successful archaeologist at Hadrian's Villa and an inventive decorator at the Villa d'Este, raised the art of exterior stucco work to its apogee on the Casina of Pius IV in the Vatican Gardens (1558-1561). Large reliefs and supple female figures modelled by Rocco da Montefiascone and the Cassignolas were framed in architectural motifs borrowed from antique sarcophagi, forming a light sculptural façade among the greenery.

... AND VARIETY OF COLOURS

Anonymous Master:
Bust Portrait of Francesco della Rovere, Duke of Urbino,
16th century.
Wax, diameter 29½".

The search for effect was often concentrated on polychrome sculpture and the play of materials. The contrasting of the plain colours of marble, bronze or gold, as appropriate, brought out the whiteness of the volumes of statuary marble or the shining patina of bronze. Skilful mixtures of marble and bronze are seen on the Medici tomb by Leoni in Milan, the tomb of Henry II at Saint-Denis, the tomb of Paul III Farnese in Rome, as well as in Munich and Delft.

The exploitation of quarries yielding coloured marbles (portor from Portovenere, green from Seravezza, red from Verona, yellow from Siena in Italy; mottled red from Rance and Belgian black from Dinant near Namur; seams from the Pyrenees and Dauphiné) made it possible to vary the colours of altarpieces and tombs. Thus in France Barthélemy Prieur pushed this search for chromatic effects to the limit. For the heart monument of Anne de Montmorency (Louvre), he erected a square pedestal and a twisted column of pink marble inlaid with decorative white reliefs on which black marble epitaphs, bronze statues of Virtues and white marble attributes (gauntlets, helmet) stood out vigorously. He used the formula again for the tomb of Christophe de Thou (Louvre) where the bust of the deceased, composed of pink drapery and a white marble head, is surrounded by white marble Virtues and green marble columns surmounting a black marble sarcophagus on which two bronze genii are seated.

Juan de Juní (1506-1577):
Entombment, 1541-1544.
Painted wood, height 6'1", length 10'7".

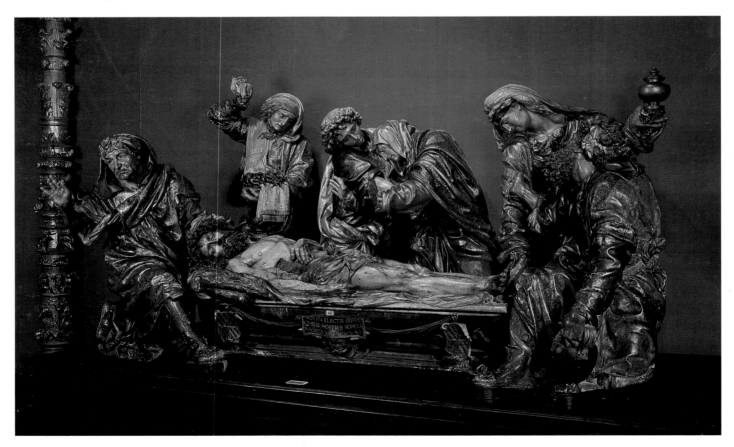

This predilection for marble inlays culminated at Rome around 1600 in coloured symphonies such as the *Moor* executed by Nicolas Cordier for the Villa Borghese (Versailles) in imitation of classical polychrome marbles such as the putative *Cato* or the *Barbarian Captives*.

No colour, apart from gold highlights, was added to rich materials such as marble, alabaster and bronze. Stone, wood and terracotta were the favourite materials for artists employing polychromy. These materials were mostly painted or gilded on top of a thin preparatory layer. Maintenance repainting in religious edifices and art market methods of cleaning have caused the loss of too many original polychromies that were once an integral part of the objects and gave them their meaning. Brabantine and German altarpieces, Spanish groups such as those by Juan de Juní and great religious scenes of the "Sacri Monti" (Mounts of the Passion) from Northern Italy still exhibit the colours which gave life to the volumes, although they are now softened by time. Facial flesh of delicate pink with prominent cheek bones, red lips, brightly coloured clothes gleaming with vermilion and azurite, orphreys heightened with gold or other metals, and frequently in the North and Spain the widespread brilliance of gold leaf prolonged the medieval art of colour in church choirs.

Using a different colour scale, white, blue and sometimes yellow and green, the last productions of the Della Robbias brought the art of smooth brilliant glazed terracotta to its apogee.

The appearance of life was mainly given in the productions of ceroplastics (modelling in wax) which developed in the two centres of Italy and Germany. Nothing remains of great sculpture in wax, such as the deer modelled by Antonio Giusti. But there still exist miniature compositions, small mythological reliefs and medallions, in which first Italian and then French modellers excelled, although they were faced with competition from the hyper-productive German workshops of Augsburg and Nuremberg. The profiles of the great of this world formed portrait galleries at the courts on equal terms with miniatures and drawings. Flesh subtly coloured in the mass and the richness of clothing often heightened with jewels and pearls give the illusion of life, rather like a miniature Madame Tussaud's.

Midway between architecture and sculpture, the art of fountain-making began to flourish. It was no longer solely the fountain of dreams of the Christian mystique or the court of love depicted in paintings or tapestries. It materialized in gardens and the heart of towns. Admittedly monastic lavabos and the first civic fountains, like the one at Perugia, or even the playful *jets d'eau* of aristocratic gardens, had paved the way since the Middle Ages. But during the sixteenth century the fountain, a simple, primarily architectural aedicula, became a sculpture in itself in which the spouting water and the figures defined the whole flashing flowing space reflected by the shining shifting mirrors of the expanses of water.

Barthélemy Prieur (1536-1611):
Monument for the Heart of the Constable Anne de Montmorency,
with Peace between Justice and Abundance,
originally in the Church of the Celestines, Paris, 1571-1573.
Bronze, overall height 10'7".

... AND THE SPARKLE OF FOUNTAINS

Bartolomeo Ammanati (1511-1592):
Fountain of Neptune (detail), 1560-1575.
Bronze and marble.
Piazza della Signoria, Florence.

The early sixteenth-century fountain of the kind Genoese marble cutters exported to France and Spain was still a set piece of figures and superimposed basins with water falling from one to another. Soon the structure became more sophisticated: vertical jets, mouths spitting thin spurts, water bubbling up and mirrors of water animate the fountains *ad infinitum*. Grottoes (at Boboli, in Venetian and Genoese villas, e.g. Sampierdarena, at the Tuileries, Meudon and Munich) and theatres of water (Maser, the Villa d'Este) gave the fountain-makers' art a new orientation that was sometimes wild and mysterious, sometimes architectural and scenographic.

An essential garden decoration, the fountain adorned the centre of the great estates in Italy (Boboli, Petraia, the Villa Lante at Bagnaia, the Villa d'Este at Tivoli) and France. After the Italianate gardens of Gaillon and Blois came the gardens of the Tuileries for Catherine de' Medici and especially Fontainebleau under Henry IV who called in those Florentine fountain-makers, the Francini.

Except in Venice, city of sleeping waters and wells, the urban fountain was also an indispensable ornament of civil life. Although fountains were sometimes the gift of a benefactor, such as Jacques de Beaune at Tours (1511) or Jacques d'Amboise at Clermont, they were mostly municipal. The towns, which ensured their maintenance, vied with each other in erecting splendid fashionable fountains in their main squares, either by ordering the separate elements, or inviting a celebrated sculptor like Montorsoli, who sculpted the two fountains at Messina, or more simply by buying them secondhand, like the Senate of Palermo who virtually filled the Piazza della Pretoria in front of the Town Hall with the concentric circles of a fountain animated by a large number of marble statues that was originally intended for a Florentine villa.

The majority of large-scale urban fountains had a central plan, displayed for a vast public. Examples are the fountains in the Piazza della Signoria in Florence, in Augsburg, Munich, Messina and the Tortoise Fountain in Rome. The fountain backed against a building also permitted architectural effects, from simple mouths spitting water to the fountain-loggias like Jean Goujon's in the Rue Saint-Denis, Paris.

Sometimes reclining nymphs and rivers underline with their presence the hymn to the indispensable living waters, signs of fecundity and abundance. Often the play of coats of arms and emblems, and even certain allegories (*Genius of Palermo* at the Fiera Vecchia, *Neptune* and *Orion* at Messina, *Augustus Caesar* at Augsburg) emphasize the mythical origins or the glory of the city. Commemorating victories such as Charles V's on the fountain of Albert of Brandenburg at Mainz (1526), royal entries or civic events, the fountain, together with the statue of the sovereign, was the public monument *par excellence*.

Taddeo Landini (c. 1550-1596):
The Tortoise Fountain, 1581-1585.
Bronze and marble.
Piazza Mattei, Rome.

MATERIALS FOR ETERNITY:
MARBLE AND BRONZE

Marble is the favourite material for sculpture. Sumptuous because it is costly and brilliant; eternal because of its hard grain; beautiful because its whiteness does not tolerate mediocrity, nor its power, technical incompetence. Whereas alabaster, a warm soft saline rock, supplied only the markets close to the deposits in England, Franche-Comté, Volterra, Sicily and the Ebro, in the same way as the marble quarries with a local market (pink marbles from Verona and Hungary, Istrian stone, white marble from Candoglia for Milan), the great centre of Carrara exported its marble to all the European statue-making centres. Exploited since the Middle Ages, the Apuan Alps, heirs of antique Luni, had supplied Tuscany with marble. Michelangelo's predilection for Carrara marble ensured its lasting success. (He went there to carve the *Pietà* of 1498 and also to choose his blocks.) It was adopted throughout Italy, including Venice, and became the indispensable material for great sculpture, in spite of a few cases of local protectionism.

Foreign courts, who sent royal agents and sculptors such as Antonio Giusti to Carrara to choose the best blocks, procured the material for the great funerary monuments there: the tombs of the Duke of Brittany and the Dauphins, erected by Anne of Brittany, those of Philibert of Savoy and Margaret of Austria at Brou, of Louis XII, Francis I, the Catholic Kings, Don Juan, Philip the Handsome and Joanna the Mad, and Maximilian II.

Jean Juste (Giovanni Giusti, 1485-1549):
Tomb of Louis XII and Anne of Brittany, 1516-1531.
Marble.
Basilica of Saint-Denis, Paris.

Hendrik De Keyser (1565-1621):
Mausoleum of William I the Silent, 1614-1622.
Bronze and marble, height 25'.
Nieuwe Kerk, Delft.

Unlike a block of marble which is massive and broad-based, bronze, a light metal, permitted all kinds of balancing tricks around a pivot. Whereas Florence and Venice produced small art bronzes for connoisseurs, copies after the antique and mythological statuettes, technical progress made it possible to use these volumes enlarged to the human scale for fountains and palaces. The skilful alchemy of molten metal stabilized for eternity mastered by Quattro-

cento sculptors linked up with the imperial Rome of Constantine and Marcus Aurelius. Bronze, the "antique" material for royal statues, competed with marble for the great tombs. Examples are the tombs of Henry VII and Charles VIII, the silent cohort of Maximilian's Mausoleum, the allegories and kneeling figures at prayer on Henry II's tomb, the groups at prayer on the tombs of Charles V and Philip II, and the seated figure of William the Silent, that impassive commander, surrounded by Virtues. As a result the courts quickly enlisted the casters of large bronzes: the Germanic heirs of a long tradition, Krafft, Vischer, Gerhard, De Vries and the Italians Torrigiani, Rustici, Cellini and Leoni.

MOBILE AND EPHEMERAL SCULPTURE

Sculpture was indeed mobile on occasion in the sixteenth century. We find Jack-o'-the-clocks from belfries and animated figures on clocks, weathervanes on castles and churches, the *giraldillo* which dominated the Giralda at Seville from 1568, for example. Not to mention the sculpture of royal means of transport, the litters and carriages, and especially the sumptuous galleys with gilded castles of the kind that Venice and Spain launched at Lepanto.

Too often we think of sculpture as the art of the durable. Yet from the Middle Ages onwards the sculptor, like the painter, was considered as a decorator, or even a producer of feasts and entertainments. A whole stratum of artistic life has disappeared. A few accounts, some rare drawings and collections of engravings give but a vague idea of the decorations prepared for great events. Papal, imperial and royal entries (the entry of the sovereign into his capital at the time of his coronation, of his spouse on the occasion of his marriage or into towns when provincial tournaments were being held) gave rise to the lavish use of pomp and display in which sculpture made of cardboard and papier mâché played a great part. The course taken by the procession was punctuated by triumphal arches, the iconography of which referred to the virtues of the personage honoured and the town. Treatises narrated in detail the liturgy of the entry and the triumphal themes which illustrated it. Thus on the occasion of Henry II's entry into Paris (1549) a booklet with woodcuts described triumphal arches adorned with statues and the ephemeral fountain of Ponceau decorated with nymphs by Jean Goujon. Collections of engravings were intended to preserve the memory of sumptuous but transient decorations. Examples come from Brussels (entry of Archduke Matthias, 1578), Bologna (entry of Clement VIII, 1598), Munich (nuptials of William of Bavaria, 1568), Florence (marriage of Ferdinand, 1589), London (James I, 1604) and provincial towns. Although painters and architects conceived them and in spite of the large numbers of painted *trompe l'œil* canvases, sculpture was the preferred medium for arches and pediments.

The entry was the occasion for pageantry, theatre and pantomime, with a procession of carnival-like floats, like that which celebrated the marriage of Francesco de' Medici and Joanna of Austria in Florence (1566), and even galleys like those embellished by Francesco Scibec de Carpi in honour of Henry II in Paris. In these circumstances the sculptor could model works of his imagination. Michel Colombe used clay to make the model of the cuirass of the giant Turmus, legendary founder of Tours, which welcomed Louis XII (1500). Michel Colombe was the artist who in his youth had used wire, cardboard and goatskin to make the elephants which were a conspicuous feature at the marriage of the Duke of Bourbon.

Theatre decors, public and private masquerades and religious ornaments for great feasts were so many occasions for sculptors to execute cheaply and quickly a showy sculpture in which new experiments could be tried out.

Funerals should be allotted a special place among ephemeral sculptures. Catafalques standing in the centre of churches, lit by candles, marked out by funerary or triumphal allegories, were light but sumptuous structures. Florentine catafalques supported by caryatids wrapped in shrouds and the great pyramidal machines constructed for Henry IV's funeral were works of sculpture, as was the decoration applied between the heavy funeral hangings around them.

Bernardo Buontalenti (1536-1608) and his workshop:
Catafalque of Cosimo I in San Lorenzo,
Florence, 1574.
Drawing.

Jean Goujon (c. 1510-c. 1566):
Gate of St. Denis erected for the Entry
of Henry II into Paris on 16 June 1549.
Woodcut.

Alessandro Allori (1535-1607):
Float symbolizing Heaven, for the wedding procession of
Francesco de' Medici and Joanna of Austria, Florence, 1566.
Pencil and watercolour, 31½″ × 22½″.

EVOLUTION AND INTERNATIONALIZATION
PAINTERS AND SCULPTORS

Francesco Primaticcio (1504-1570):
Design for the Tomb of Claude of Lorraine, Duke of Guise,
executed by Dominique Florentin, c. 1550.
Pen drawing, 12⅜″ × 12⅜″.

The ideal of the complete artist, who was architect, painter and sculptor, was mainly inspired by the example of Michelangelo, although Leonardo, preoccupied with rendering the volumes he studied on the Sforza monument, and Raphael, who conceived the prophets of Santa Maria del Popolo, also influenced it. Few artists achieved this goal. Some painters, such as Domenico Beccafumi, creator of the models of the angels on the high altar of Siena Cathedral, were modellers; some sculptors, e.g. Dominique Florentin (Domenico del Barbiere) of the School of Fontainebleau, were engravers; some (mostly Florentine) artists–Ammanati, Caccini, Francesco Sangallo and Jacopo Sansovino–successfully combined architecture and sculpture. Peter Flötner and Jean Goujon illustrated Vitruvius' *Treatise on Architecture*.

The genuine painter-sculptors, employing the two techniques required by their commissions, came from the circle of Michelangelo's pupils. Daniele da Volterra, trained in the art of stucco by Perino del Vaga, was primarily a painter and modeller, but in addition to his stuccoed decorations, he made busts of Michelangelo and Orazio Pratesi, of almost tragic melancholy, the great marbles of Sts. Peter and Paul at San Pietro in Montorio which reveal the predominant role of the assistant, and he modelled the bronze horse for an equestrian statue of Henry II, which only arrived in France under Louis XIII.

Alonso Berruguete was also trained in the school of Michelangelo. He painted in Florence and on his return to Spain became Charles V's official painter, devoting him-

self to large altarpieces of polychrome woodcarving in which he could combine the two techniques closely.

Nevertheless, the actual role played by other painters in the sculptured works attributed to them is questionable. Did Jean Cousin, painter, but carver of images as well, execute the marble and alabaster of Admiral Chabot's tomb, now in the Louvre? Painter of cartoons for tapestries and stained-glass windows, did he provide the model or the design? Or did he actually possess the technical ability that some documents seem to credit him with? The same question could be asked about the sculptured works attributed to Rosso, the Gallery of Francis I at Fontainebleau and the *gisant* supported on one elbow of the Prince of Carpi in the Louvre. What part did collaborators play? Not to mention Pietro Candido, who had tombs and fountains at the court of Bavaria executed after his models.

The complexity of the problem appears clearly with the personality of Primaticcio. There is no doubt that he was a stucco worker under the orders of Giulio Romano in the Palazzo del Tè at Mantua. But what was his part in the execution of works of art during his long career as art director at Fontainebleau under Francis I? He designed projects in profusion: frescoes and stuccoes for the Porte Dorée, the bathroom, the Ulysses Gallery, the Ballroom and the Salon of the Duchesse d'Etampes. Surrounded by a team of collaborators who carried out most of the work,

Domenico del Barbiere,
known as Dominique Florentin
(c. 1506 – c. 1570):
Temperance, figure for the
Tomb of Claude of Lorraine,
Duke of Guise,
1550-1552.
Marble, height 6½′.
Town Hall, Joinville
(Haute-Marne).

Under the direction of El Greco (c. 1541–1614):
St. Ildefonsus receiving the Chasuble from the Virgin, 1585.
Painted wood.
Sacristy of Toledo Cathedral.

Primaticcio definitely reserved part of it for himself. But which part? In the same way, when he went to Rome taking the king the moulds for casting the finest antiques in the Vatican in bronze, he made his choice as a sculptor, but surrounded himself with technicians: Vignola, who did the mouldings, and sculptors, among them Pierre Bontemps, to put the finishing touches to the waxes and then chase the bronzes. Primaticcio was the supervisor. He was the author of the drawing (and the design because the words were more or less synonymous at the time), responsible for the execution by his directives and his choice of collaborators. He was a connoisseur of sculpture by experience, but it was as a painter imposing the pre-eminence of his idea that he directed the painting, sculpture and sometimes the architecture of the court of Fontainebleau.

Primaticcio's role, comparable to that of Le Brun in the next century, was to ensure the consistency of both team and style. Nevertheless, the sculptors under his direction could express their own personalities and develop their own special qualities. Thus Primaticcio prepared the project for the tomb of the Duke of Guise in the church of Joinville, two drawings of which are preserved in the Louvre, but the sculptors Dominique Florentin and Jean Picart demonstrated their freedom when actually carrying out the work. One of them, probably Picart, takes up the composition designed by Primaticcio in the bas-relief of the *Triumph of the Duke*, whereas the other endows the figures of the Virtues with a suppleness expressed in the soft drapery, the firm canon and the warm flesh which are evident in his other realizations. In the same way one could analyse the tomb of Henry II, for which Primaticcio made the architectural project, although it is definitely the work of Ponce Jacquiot and Germain Pilon, whose hands are clearly recognizable.

The role of supervisor, however, was dominant on the scene of the great worksites. Sometimes a painter provided the design, as Jean Perréal did for the tomb of the Dukes of Brittany sculpted by Michel Colombe. Sometimes it was the architect who directed the work. The collaboration between Pierre Lescot and Jean Goujon on the roodscreen of Saint-Germain-l'Auxerrois, the Fountain of the Innocents and the Louvre Palace was not fortuitous. Elsewhere, Pirro Ligorio in Rome and Bernardo Buontalenti in Florence were the technical and aesthetic directors of artistic life.

It was also El Greco's role to be in sole charge during the execution of the great altarpieces whose architecture and sculpture he decided on at the same time that he executed the painting. Notarized contracts attest El Greco's acceptance of overall responsibility for the altarpiece in Santo Domingo el Antiguo at Toledo, for the Church of Talavera (1591), the College of Doña Maria d'Aragon (1596), the Charity Hospital of Illescas (1603) and above all the Talavera Hospital at Toledo, sculptured reliefs of which have survived.

THE EXAMPLE OF ANTIQUITY

Federico Zuccari (c. 1540-1609):
The Artist's Brother Taddeo copying the Laocoön
and other pieces of ancient statuary in Rome.
Drawing.

In the fifteenth century, antiquity, never forgotten, it is true, was discovered in all its archaeological dimensions. In the next century, as knowledge of its remains increased, it became the dominant influence, the compulsory point of reference for all creative work, even when watered down, travestied or distorted.

Sixteenth-century man's vision of antique history and arts was not the same as ours. Greek art re-elaborated by the Romans and Egyptian art travestied at Hadrian's Villa were no more than faint echoes distorted by copies made so much later. On the other hand, artists did study many facets of Roman art. They include decorative stucco, the realistic portrait, point of departure for many busts, the funerary statue supported on one elbow transforming the medieval *gisant* and the imperial statue which may have inspired the antique-style cuirasses as exemplified by the torso of Louis XII sculpted by Lorenzo da Mugiano for the Château de Gaillon in Normandy, on the model of the *Caesar* in the Capitol.

Cameos and intaglios, and especially medals, which had a wider circulation among collectors, offered a rich repertory of forms, emblems and mythological decorations. These small reliefs, enlarged by sculptors, served as models for large medallions adorned with busts or profiles, an obligatory decoration for the castles and town houses of the early Italian and later the French Renaissance.

Another rediscovery was the great antique relief as seen on the triumphal arches of Rome and Provence, Trajan's Column, sarcophagi with marine, Bacchic or mythological decorations, isolated reliefs in the great Roman collections (the Medici *Sacrifices*, the Borghese *Dancers*, the *Weeping Dacia*) and the *Marcus Aurelius* reliefs of the Palazzo dei Conservatori. The summary perspective, the expressive modelling of this Roman art, the effects of crowd and movement enabled the technique of relief to abandon *schiacciato* with its subtle illusionist flattened surfaces for strong compositions.

Artists primarily turned to major sculpture to study its proportions, expressions and the rendering of volumes. The equestrian statue of Marcus Aurelius installed by Michelangelo in the new square of the Capitol (the Campidoglio) became the prototype of royal statuary,

together with the horses of St. Mark's in Venice. Animal groups, the *Wolf* on the Capitol, the *Lion* in the Florence Loggia, the *Lion Attacking a Horse* from the Capitol, the Medici *Porcellino* and a few statuettes were the sources of small bronzes of the kind made by Giambologna.

Large Hellenistic statues and groups mainly housed in Roman collections, but also in those of some sculptors like Leone Leoni in Milan, formed the corpus of the most copied and admired examples. The Vatican Belvedere contains the most beautiful examples, although the papal collection of the Capitol is earlier. In the Belvedere the popes set out the most famous classical marbles: *Apollo*, the *Torso* and *Antinoüs*, peaceful heroes embodying masculine beauty in all its plenitude; *Commodus as Hercules*, illustrating the power of the athletic body; the sleeping *Cleopatra* and the *Venus of Cnidus*, contrasting two aspects of the female body, one draped, chaste and abandoned by her lover, the other naked, desirable and disturbing; lastly and above all *Laocoön and his Children*, a drama of human destiny, powerless against the wrath of the gods, a group of a dynamic contrasting struggle between man and snakes, twisted in a tangle of lines and spirals uniting in the centre of the old man's immense body, a strong diagonal of violence and suffering. The *Lacocoön* was universally praised and studied by the "antiquarians." The addition of the missing arm by Montorsoli gave rise to a heated debate on the principles of restoration, the after-effects of which continue down to our own day. Already copied in wax by four sculptors, including Jacopo Sansovino who made a large cast of it in 1510, the *Laocoön* was copied in marble

Baccio Bandinelli (1488/93-1560):
Copy of the Laocoön, 1525.
Marble.

by Bandinelli in 1525, possibly so that he could offer it to Francis I. Subsequently Francis I, who was anxious to acquire the most beautiful antiques, sent Primaticcio to Italy in 1540 to mould statues, in the absence of prestigious examples. (The first great antique to reach France was *Diana the Huntress* in the Louvre.) Naturally the *Laocoön* was chosen, along with the principal pieces in the Belvedere, *Venus*, *Apollo*, *Commodus as Hercules*, *Cleopatra* and the reclining *Tiber*, as well as the *Satyrs* in the Palazzo della Valle and the horse of Marcus Aurelius. The moulds were used to cast large bronzes which were installed at Fontainebleau.

Other collections attracted visitors: the Palazzo Valle-Capranica with a courtyard full of statues offered its tortured *Marsyas* and the *Satyrs*; the Palazzo Farnese where the roguish *Callipygian Venus* lived alongside philosophers and the two enormous monumental marbles, the *Bull* and *Hercules*; the Villa Medici and its group of *Niobids*; the Capitol with the *Spinario*. Collectors snatched up the most beautiful pieces as soon as excavations brought them to light or by dint of politico-economic transactions.

That was how Cosimo and then Francesco I de' Medici were able to turn the Uffizi at Florence into a veritable museum, acquiring the youthful *Mercury*, the *Medici Venus*, the violent group of *Wrestlers*, the *Porcellino* and the *Scythian Slave*, whose crouching pose inspired many artists. The construction of the Tribuna in 1584 confirmed the major place that Florence henceforth held in the study of antique art.

Hieronymus Cock (c. 1510-1570):
Courtyard of the Palazzo Valle-Capranica, Rome, with its collection of antique statuary, 1553.
Print.

Drawn by artists, including Federico Zuccari and Maerten van Heemskerck, the great antiques were the subject of numerous engravings, and even of specialized collections, such as the anthologies of Antoine Lafreri and Giambattista de' Cavalieri. Plaster casts of them were sent to the four corners of Europe. They served as an apprenticeship to drawing and modelling. This dissemination by image helped to make a knowledge of antiquity and the academic ideal universally available.

Under the direction of Francesco Primaticcio (1504-1570):
Copy of the Laocoön, 1542-1543.
Bronze, height 6'3", length 4'11".
Château de Fontainebleau.

103

THE TRANSMISSION OF MODELS

Invention, creation, innovation, are the key words of sixteenth-century art. But wanting to create is not enough. Sculptors such as François Marchand, over-dependent on the masters of works in charge of artistic projects, simply reproduced the works they admired when left to themselves, refusing to undertake the risky adventure of creation. Some used Italian plaquettes to reproduce them in large format, as on the façade of the "Loges" at the Château de Blois or the roodscreen of Limoges Cathedral (1533).

Others, anxious to respect the *maniera*, punctuated their work with a reference to the sculptures of Michelangelo, the outstanding examples. Whether they knew them directly, through drawings, engravings, sculpted reductions or even casts, like the *Pietà* installed at Fontainebleau by Francis I, their copying was not slavish. Thus Vittoria places two statues on the pediment of the hall of the Ante-

colegio of the Ducal Palace, Venice. They were *Prudence* and *Justice*, adopting the (slightly altered) pose of the allegorical figures on the Medici tombs, but enveloped in stiff draperies. Prospero Sogari took up these schemas again in the Duomo of Reggio Emilia, but he made them heavy in the extreme (1552-1557), whereas Leoni evokes them more subtly in his reliefs, *Evening* and *Dawn* (1560), on the tomb of Gian Giacomo de' Medici in Milan. Barthélemy Prieur transformed them into tense, bitterly grieving, almost savage funerary genii for the tomb of Christophe de Thou (1585). The more allusive Rosso placed a noble old man and an ephebe reminiscent of *Moses* and *David* around a fresco at Fontainebleau.

Parallel to the humanist reference to Michelangelo's work, the old medieval system of reproducing a statue for religious reasons still continued. The *Virgin* of Trapani, a

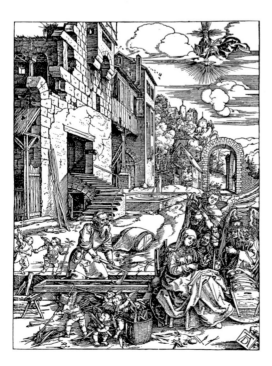

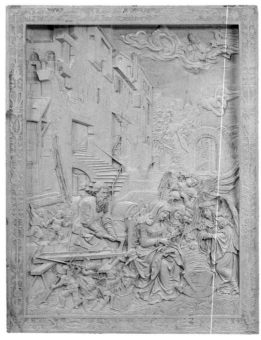

marble by Nino Pisano in the convent of the Annunziata, inspired such devotion that reproductions of it either by celebrated sculptors or by craftsmen using alabaster with gold highlights spread throughout the Western Mediterranean, Spain and Provence. This was evidence of an extension of devotion rather than an artistic preference.

Beginning in the Middle Ages, French Marian sculpture experienced a diffusion of types (sometimes bastardized) inspired by a key work with nothing especially spiritual about it. The *Virgin* of the church of La Couture at Le Mans, sculpted by Germain Pilon in 1570, assumed this role for a long time, as attested by statues from the Ile-de-France and Le Mans workshops, including that of Mathieu Dionise, which supplied the Loire valley area with large terracottas. As from 1675 this role was taken over by the *Virgin* of Lyons by Coysevox, and as from 1775 by that of Félix Lecomte at Rouen.

The models for reference might also be a painting or an engraving, vehicle of the Renaissance and unifier of styles which spread the new creations abroad: Raphael's classicism, Parmigianino's mannerism, Dürer's oneirism, northern picturesqueness. One could multiply the number of borrowings. At the Château de Gaillon the relief of *Triumph* was sculpted by Antonio Giusti after Mantegna and the arabesques of the panelling derive from the Venetian collection of Zoan Andrea. At the abbey of Saint-Père at Chartres the reliefs of the roodscreen (Louvre) and the *Descent from the Cross* (Ecole des Beaux-Arts, Paris) were executed by François Marchand after engravings by Marcantonio Raimondi. The alabaster *Charity*, close to the art of Germain Pilon (Louvre), was the transposition of a fresco by Andrea del Sarto. Dürer's engravings were the fountainhead of art in the North. One sculptor, Hans Daucher, made it his speciality to transcribe Dürer's style of drawing. In Champagne, the roodscreen of Villemaur (1528) and the Lirey altarpiece (London), also the tomb of Jean de Langeac at Limoges (1544), were literal copies of the cycles of Dürer and Schongauer, as the roodscreen of Hertogenbosch (London) was in relation to engravings after Martin de Vos and Stradanus.

Working virtually as craftsmen, the alabaster-cutters of Malines and the woodcarvers turning out armoires, stalls and panelling borrowed their motifs from many engraved sources, as did the painters of enamels and majolicas.

Mathieu Dionise (early 17th century):
The Virgin and Child, 1613.
Terracotta, 56″.
Church of Parigné-l'Evêque, near Le Mans (Sarthe).

Germain Pilon (1528-1590):
The Virgin and Child, 1570.
Marble, height 37¾″.
Church of Notre-Dame-de-la-Couture,
Le Mans (Sarthe).

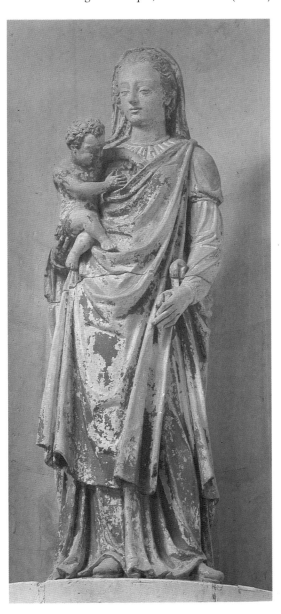

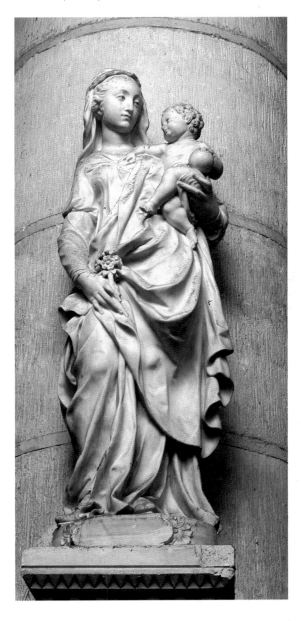

FROM THE SINGLE PIECE TO STANDARDIZED PRODUCTION

Guillaume Dupré (c. 1574-1642):
Henry IV entrusting the Regency to Marie de' Medici,
with the Dauphin between them, 1603.
Gold medal, diameter 7⅜″.

The idea that the work of art is a unique piece is firmly rooted in people's minds. Nevertheless, during the sixteenth century when the concept of an original was still vague, serial production of copies starting from a basic model had a wide field of application.

The craft and commercial structure of the northern countries predisposed sculptors to organize production on an almost industrial scale. English alabaster relief plaques, the juxtaposition of which could create whole altarpieces, had a wide market at home and on the continent in the fifteenth century. Later, Flanders and Brabant dominated the market for gilded polychrome wooden altarpieces. Executed by sculptors, decorated by painters, exported by the big merchants to Champagne, Picardy and Brittany, as well as Germany, Sweden, Spain and even its colonies, these works were assembled in workshops. A label of quality stamped in iron on the wood (a severed hand at Antwerp, four vertical lines representing the *pals* of the arms of Malines, and a mallet at Brussels) authenticated the provenance of the sculpture. Then it was painted and gilded by another corporation which applied a second mark. Although the large pieces commissioned from celebrated sculptors for a specific destination were unique, the craftsmen of the Netherlands, especially at Antwerp, also prepared complete altarpieces of ordinary quality ready for export. Malines, which welcomed the Renaissance under pressure from the court of Margaret of Austria, exported its "dolls," statuettes of the Virgin and saints of a stereotyped elegance, throughout Europe.

In the same region the development of sculpture using alabaster for high altars and roodscreens resulted in a large output of small portable alabaster altarpieces, with gold highlights. These reliefs, sometimes mounted in complicated altarpieces set in Italianate frames, sometimes simple plaquettes set in decorated stamped papier mâché mouldings, reflect the compositions then in fashion which were familiar owing to the wide circulation of collections of engravings. It seems likely that they were made at Malines. Sometimes they were signed with a monogram and given what were probably commercial marks.

When this phenomenon of works of art being distributed commercially appeared, Florence did not lag behind. Devotional images, especially Madonnas, were "mass-produced" with the help of stucco, *cartapesta* and glazed terracotta.

Much appreciated by connoisseurs, the small bronzes that were the speciality of Venice and Florence were in great demand. The need to keep one copy of the work in case it was irreparably damaged during casting made it

Workshops of Malines, Belgium:
Portable Altar, with central relief
of the Communion of Judas, c. 1550.
Alabaster, 48″ × 32″.

The art of medals, on the other hand, as distinct from sculpture proper, called for multiple copies struck from one die and sometimes of different alloys. Some sculptors practised this art, producing models which were then engraved by specialists. Thus Leone Leoni was the creator of many medals bearing the effigy of the Emperor Charles V. Michel Colombe made the model of the medal struck for Louis XII's royal entry into Tours (1500). Subsequently, Germain Pilon obtained the post of Controller General of Effigies, producing official images of Henry II and his sons. Guillaume Dupré, a medallist rather than a sculptor, assumed this post under Henry IV, executing small medals and large medallions with no reverses, representing the king, his family, his ministers, the Gonzaga and the Medici or celebrating the events of his reign. These medallions, struck in large numbers, reflect the art of the realistic portrait and sometimes provide evidence of Mannerist influence on the art of the medal. The scene showing Henry IV entrusting the regency to Marie de' Medici in the presence of the Dauphin with the epigraph *Propago imperii* (1603) exhibits plumed actors dressed like antique gods characteristic of the Second School of Fontainebleau, in a bright airy centred composition.

Avon Workshops near Fontainebleau:
Woman Suckling a Child, early 17th century.
Terracotta, height 9½".

Giambologna (1529–1608):
Bird-Catcher.
Bronze, height 12½".

possible to build up stocks of original models. Consequently the structure of the workshop where the master employed casters, pupils and journeymen meant that replicas of the model could be produced. Better still, transmission of the stock after the master's death to his heirs or pupils meant that bronze replicas could be cast long after the original artist's disappearance from the scene. This happened in Giambologna's studio, which was taken over by Pietro Tacca and then by Susini. But casting by the lost wax process involved putting the final touches to the wax prior to casting, and chasing the metal afterwards. As a result every bronze was slightly different, as regards both the alloy used and the chasing, and classifying models from the original work of art to later replicas is a tricky business.

Lastly terracotta, easy to mould or stamp, was a possible material for easy reproduction. Nevertheless, the workshops, which often used similar techniques to potters, mainly resorted to modelling to execute sculptures that were certainly repetitive, but original. Series of terracottas produced by craftsmen, reliefs and statues by the Della Robbias in Florence, statuary from Le Mans and dishes and decorations by Bernard Palissy attest the creativity of craftsmen's workshops.

The wood pieces from the Netherlands and Italian bronzes and terracottas were all original creations, varying from piece to piece, although the method of fabrication involved the formation of series that were homogeneous in style and workmanship.

ITINERANT ARTISTS...

Wandering was the sculptor's lot. There were not many artists as fortunate as Guillaume Regnault of Tours, who inherited a family studio and continued a peaceful career there, although he was still able to travel if he wished.

Artists' training often consisted of a journey ending in an initiatory stay with a celebrated master who was usually established in Italy, at Rome or Florence. Artists who followed this path include Alonso Berruguete, who worked with Michelangelo, Bartolomé Ordóñez, Nicolas Bachelier from Toulouse, Ponce Jacquiot (so Italianized, as Ponzio Jaquio, that later generations took him for an Italian), Pierre Jacques from Reims, Pierre Biard, Jacques Dubroeucq from Mons, Van der Schardt and Adriaen De Vries, a pupil of Giambologna. The youthful heirs of the

Pietro Torrigiani (1472-1528):
Tomb of Henry VII and Elizabeth of York, 1512-1518.
Gilt bronze, black and white marble.
The Henry VII Chapel, Westminster Abbey, London.

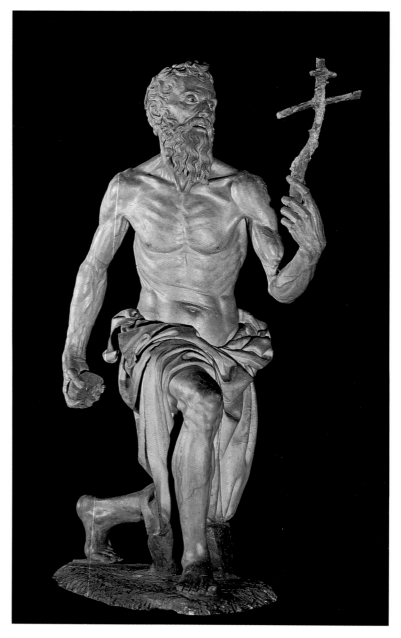

Pietro Torrigiani (1472-1528):
St. Jerome, c. 1523-1524.
Terracotta, height 5'3".

techniques of the Lombard Antelami and the marble cutters left the Como region and the Apuan Alps, where so many sculptors were trained, in search of new ideas. Pietro Tacca went to work with Giambologna, Danese Cattaneo moved to Rome, and Calamacca first to Florence and then Venice, abandoning their homeland, Carrara, as did the masters from Como, who were scattered through Italy.

Sometimes a sculptor's departure from his home town, or at least the one where he worked, was forced on him by the vagaries of politics or religion. The Sack of Rome (1527) set many artists on the move, not only Benvenuto Cellini, who boasted that he had killed the Constable de Bourbon during the fighting, but more pacific men such as Jacopo Sansovino and Danese Cattaneo, who went to Venice, and Rosso Fiorentino, who travelled to Perugia, Arezzo, Venice and finally France. The Florentine revolution, followed by the re-establishment of the Medici (1530), emptied the town for a time, in the same way that wars forced artists to seek more hospitable regions. The prevailing religion drove men of minority faiths into exile (the Protestants in France, for example). Pierre Bontemps

sought refuge in Verneuil-sur-Avre (1562), Jean Goujon in Bologna (1562) and Ligier Richier in Geneva (1567).

Artists' movements generally depended on their commissions, the summons from a patron or the attraction of a busy artistic site. Some wandered from one contract to another, like Martin Cloître, of Grenoble, whom we find at Orléans, later in Berry to carve the tomb of Cesare Borgia's wife, then at Rambouillet and Paris. Others found a temporary clientele in medium-sized towns before they returned to an artistic capital. This was the path followed by Dominique Florentin at Troyes, by Montorsoli at Genoa (1540-1546) and Messina (1547-1557).

Yet others, coming from afar, settled and put down roots in an adoptive town, sometimes in minor centres, preferring pre-eminence there to vegetating in the capital cities. Thus Nicolas Chantereine and Jean de Rouen, who came from a Normandy background, brought the Renaissance to Portugal on the royal site of the Jéronimos Monastery in Lisbon and at Coimbra. Nicolas Halins, a Fleming, dominated art at Troyes when it welcomed the Renaissance (1494-1544). The Bacheliers, Florentine by origin, took root in Toulouse. Calamacca, a native of Carrara, settled in Messina, as did the Florentine Naccherino in Naples.

Domenico del Barbiere, known as Dominique Florentin
(c. 1506 - c. 1570):
Charity.
Stone, height 5′1½″.
Church of Saint-Pantaléon, Troyes.

Jean de Rouen (c. 1495-1580):
Pulpit, c. 1520.
Stone.
Church of the Santa Cruz Monastery, Coimbra, Portugal.

Fundamental to this vast movement was the part played by rulers eager to attract to their courts the sculptors best able to enliven the artistic scene. The Florentine Pietro Torrigiani made lengthy visits to England, executing Henry VII's tomb at Westminster, and to Malines working for Margaret of Austria, Regent of the Netherlands. He finally died in Spain. Conrad Meit of Worms entered the service of the same ruler at Malines and Brou, where he collaborated with a mysterious Florentine, Honoffre Campidoglio, propagating the elegant canon of Cranach's figures mingled with precocious Italianisms. Later, calls from the German courts and imperial free towns led to a large-scale artistic diaspora. From the Netherlands Van der Schardt went to Nuremberg, Adriaen De Vries to Augsburg and Prague, Hubert Gerhard to Augsburg and Munich. The Italians Carlo de Cesare and Jacopo del Duca left for Dresden and Innsbruck respectively. Originally from Flanders, Pieter De Witte, Italianized by a stay in Florence to Pietro Candido, moved to Munich and Alexander Colin to Prague and Innsbruck.

Thus, in spite of the artists' diverse origins and the dispersal of their artistic careers, the predominant role played by initial, especially Tuscan, training and systematic intermingling on major projects for royalty and the aristocracy, made the establishment of a genuinely European art possible.

... AND THE CENTRES THEY WERE ATTRACTED TO:
THE FRENCH COURT

In the sixteenth century the King of France continued the royal tradition of enlisting the best native artists and the top Italian creators, who were attracted by lucrative commissions. Charles VIII's adventurous expedition to Florence and Naples was not simply military. It was also a revelation to the king and his nobility of Mediterranean luxury which, although castigated by Savonarola, carried within it the seeds of a new humanism. When he returned to the Château d'Amboise on the banks of the Loire, Charles VIII brought back with him a team of Italian "building designers" (Fra Giocondo, Domenico da Cortona), landscape gardeners in the Italian style (Pacello da Mercogliano, known as Mercolienne), perfumers and dressmakers, not to mention Guido Mazzoni (known as il Paganino) of Modena, fertile producer of dramatic and expressive terracotta entombments, and Jérôme Pacherot, who introduced ornamental foliage and arabesques into decorative reliefs.

The team at Amboise was still a modest one. Louis XII, successfully pursuing the Italian dream and taking possession of Lombardy, expanded his predecessor's artistic policy, supported by his minister and mentor, the Cardinal of Amboise. A court art centred on the Loire valley took shape, with extensions to Gaillon, the Normandy re-

Francesco Primaticcio (1504-1570):
Fresco with Apelles painting Alexander and Campaspe,
flanked by stucco figures, 1541-1544.
Former Chamber of the Duchesse d'Etampes,
Château de Fontainebleau.

110

Benvenuto Cellini (1500-1571):
The Nymph of Fontainebleau, 1542-1545.
Bronze, height 6'8½", length 13'4".

sidence of Georges d'Amboise, Archbishop of Rouen. Queen Anne of Brittany's official sculptors were French: Michel Colombe and his nephew Guillaume Regnault, who settled at Tours after working at Bourges and the court of the Dukes of Bourbon. The king's sculptors were Italians: Guido Mazzoni, creator of the tomb of Charles VIII and the equestrian statue of Louis XII on the pediment of the portal of the Château de Blois, and the Giusti brothers (di Giusto Betti), Antonio and Giovanni, who left Florence for Tours where they carved the tomb of Louis XII.

Francis I's accession to power (1515) did not change royalty's artistic preferences. The king, who was also fascinated by the Italian mirage which vanished when he was taken prisoner at Pavia, pursued a twofold policy. In Italy he waged war against the towns, the Pope and the Emperor, and went to great lengths to procure works of art (such as Michelangelo's *Hercules*) and court artists.

Visits by Leonardo da Vinci (1516-1519) and Andrea del Sarto (1518) had no repercussions on French sculpture. It was only on his return from captivity (1526) that Francis I really organized an innovative art introducing new blood. Girolamo della Robbia, resident in France from 1527, introduced glazed terracotta sculpture which he used to decorate the Château de Madrid, built near Paris and subsequently destroyed. Gian Francesco Rustici left Florence in 1528 and stayed in Paris until the king's death, pursuing the chimera of casting an equestrian statue for him. Rosso and Primaticcio, arriving in 1532 and 1534 respectively, created the School of Fontainebleau, surrounded by a group of collaborators. Artists of Italian origin, Francesco Scibec de Carpi, who introduced cabinet-making "in the antique style," Lorenzo Naldini, gallicized

as Laurent Regnaudin, and Domenico del Barbiere, known as Dominique Florentin, combined with their French colleagues Jean Leroux, Pierre Bontemps, Jean Cousin and François Marchand to form a cosmopolitan artistic society. Later in France, Benvenuto Cellini disputed Primaticcio's major role. Lodged for five years (1540-1545) in the Hôtel du Petit-Nesles opposite the Louvre, he cast the immense bronze relief of the *Nymph of Fontainebleau*, helped by a Roman goldsmith, French casters and sculptors, and produced the sumptuous saltcellar now in the Kunsthistorisches Museum in Vienna.

Henry II reverted to a more nationalist policy. His court sculptors were French: Ponce Jacquiot, Jean Goujon, Germain Pilon and Barthélemy Prieur. There were no more foreign collaborators, because the Wars of Religion were a powerful disincentive to travel.

After the storm, the advent of Henry IV (1589) marked the progressive return of court art. The French still formed the majority of the king's workaday sculptors: Matthieu Jacquet, Barthélemy Prieur and his son-in-law Dupré, Barthélemy Tremblay and his son-in-law Gissey, an ageing Pilon and his sons, Pierre Biard, and Thomas Boudin. But direction of the arts passed into the hands of Italian specialists. From Florence the king summoned Pierre Franqueville, a native of Cambrai, Italianized for fifteen years, accompanied by his pupil Francesco Bordoni, a native Florentine, who became his son-in-law. Franqueville, housed in the Louvre and bearing the title of the king's first sculptor, was the official artist, treated royally on condition that he worked for the king without remuneration. This Florentine presence was further increased by the arrival of the Francini, who were appointed as royal fountain-makers and hydraulic engineers.

...THE SPANISH COURT

Foreigners were much in demand for royal artistic projects in Spain. Ferdinand of Aragon, widower of Isabella the Catholic, engaged the services of Domenico Fancelli from Settignano for his funerary monuments and inundated him with work. Fancelli was the artist of the tomb of the Archbishop of Seville, Diego Hurtado de Mendoza, in 1509. No sooner had he erected the marble monument to the infante Don Juan, the only son of the Catholic Kings, in the Dominican Church of Santo Tomás in Avila (1513) than he undertook the tomb of the Catholic Kings in the Capilla Real at Granada, the new royal pantheon of a united Spain. These marbles were barely finished in 1517 when he made the drawings for the tomb of Cardinal Cisneros, the Regent of Castile, at Alcalá de Henares, but Fancelli died suddenly at Saragossa in 1519 after a decade of ceaseless journeys fetching marble blocks from Carrara, carving them at Genoa and erecting the finished products in Spain.

Granada Cathedral then became the "laboratory" of royal art, both the Capilla Real, which was still Plateresque, and the cathedral proper, erected in the Roman classical style under the direction of Diego de Siloé. Several sculptors in succession worked there. Charles V commissioned Bartolomé Ordóñez to execute the tomb of Joanna the Mad and Philip the Handsome (1510-1520). Jacopo l'Indaco, a Florentine friend of Michelangelo, sculpted an *Annunciation* above the door of the sacristy.

Alonso Berruguete saw his projects come to nothing (1520-1521). Diego de Siloé executed the altarpiece of the Catholic Kings.

But Charles V was not genuinely interested in art. The new imperial palace in Granada conceived by Pedro Machuca opposite the Nasrid Alhambra was more of a political manifesto than an artistic centre.

Charles V's journey to Italy from 1541 to 1545 finally revealed to him the art of Northern Italy. Fascinated by the painting of Titian, he engaged the services of the Milanese artist Leone Leoni in 1545, but although this Lombard accompanied the infante Philip to Brussels in 1548, he was loath to cross the sea. He actually executed the imperial commissions with their wholly political imagery in Milan, where he turned out endless medals, busts, reliefs and statues portraying the emperor and his relations. Leone's son, Pompeo Leoni, left for Spain in 1556. In spite of clashing with the Inquisition which incarcerated him in a monastery for six months because of his Lutheranism, he became Philip II's court sculptor. Towards the end of his life (1597-1598), he cast ten large bronzes for the Capilla Mayor in the Escorial where the kneeling figures of Charles V, his wife, daughter and two sisters faced Philip II, three of his successive wives and his son Don Carlos. This solemn group at prayer with carved court vestments, hunched up stiffly in their ruffs, is dominated by the individual expression of the faces–the candour of Doña Maria, the radiant purity of Isabella of Portugal, the disenchantment of the emperor and the disdainful aloofness of Philip II.

Pompeo Leoni (c . 1533-1608):
Monument to the Emperor
Charles V, c. 1597.
Bronze.
Capilla Mayor, Church of
the Escorial, near Madrid.

... AND THE MEDICI COURT

Pierre Franqueville
(Pietro Francavilla, c. 1548-1615):
Spring, 1593.
Stone.
Bridge of Santa Trinità, Florence.

Florence, the home of sculpture, was always able to attract artists, although more as a training centre than to offer them work, because the award of artistic commissions was heavily biassed in favour of the Florentines. The re-establishment of the Medici (1530) and the artistic policy of Cosimo I, crowned Grand Duke in 1565, Francesco I and Ferdinand opened up the city to foreigners by engaging them as court sculptors. The Medici family's move to the Palazzo Vecchio (1540) marked the beginning of state patronage in official residences. Tuscan sculptors who had left their homeland were recalled. In 1537 Tribolo returned to work on the Villa Medici of Castello and the Medici Chapel. Bandinelli came back from Rome to decorate the Palazzo Vecchio in 1540. In 1545 Benvenuto Cellini left the court of the French king Francis I to cast his *Perseus* and the bust of his patron in bronze. The young pupils of these Florentine repatriates, Pierino da Vinci, Giovanni Bandini, Valerio Cioli and later the Ammanati, were also Tuscans.

The influx of foreign artists did not become effective until after 1556. Vincenzo Danti, a native of Perugia trained in Rome, lived in Florence from 1557 to 1573

sculpting the statue of Cosimo, to whom he dedicated his treatise on proportions. Jean Bologne (Giambologna), a Fleming born at Douai, arrived around 1556 and toppled the Florentine hegemony. Official Medici sculptor until his death (1608), he executed garden decorations and political statues.

Giambologna's pupils were often foreigners. Pietro Candido from Bruges worked with him between 1569 and 1586. Pierre Franqueville (Pietro Francavilla), a native of Cambrai, came to study in 1571, after a visit to Innsbruck, and also won commissions for such dynastic works as the statues of Ferdinand at Pisa and Arezzo. Twenty years later Pietro Tacca, a native of Carrara, established himself with Giambologna. After the departure of Franqueville, summoned to France by Henry IV in 1606, Tacca inherited the studio and commissions of his master.

Giambologna (1529-1608):
Florence Triumphant Over Pisa, 1565-1570.
Marble, height 8½′.

113

LATE GOTHIC IN THE GERMANIC LANDS

Veit Stoss (c. 1438/47-1533):
The Annunciation (or Angelic Salutation), 1517-1518.
Painted woodcarving, height 16½′.
Church of St. Lorenz, Nuremberg.

The flowering of Flamboyant Gothic, at times harsh, with sharp folds and tense faces, at times florid with swirling draperies and feminine prettiness, at others burgeoning on large altarpieces, is called *Spätgothik*, i.e. Late Gothic. The masters of carved wood (mostly lime, but sometimes boxwood) made skilful use of polychromy or left it to the natural material to bring out the subtlety of polished reliefs. This style, which appeared around 1475, was comparatively uniform within a primarily Southern Germanic mould, from the Rhineland and Swabia to Franconia, Bavaria and the Tyrol. Inside this little world sculptors travelled freely and workshops exported their products, so we should not be surprised at obvious connections between Austrian works and the Brisach altarpiece.

Some creators of this style prolonged their activity into the sixteenth century. After a long stay in Cracow, Veit Stoss, restless, passionate and irascible, settled in Nuremberg. There he purified his style and reached his apogee about 1517-1518 in monumental compositions such as the larger than life *Annunciation* surrounded by a paternoster rosary of sixty pearls and the seven joys of the Virgin in the Church of St. Lorenz.

Tilman Riemenschneider, a citizen of Würzburg, where he was burgomaster in 1520, ran a large workshop whose sensitive and lyrical art produced altarpieces, reliefs, statues and tombs, such as that of Bishop Rudolf von Scherenberg (1499). His personages, with a powerful plastic density, can be recognized by their uniform expression, whether gentle or tormented, the creased folds and the faces with vigorously contrasted planes.

There were many Gothic workshops in the great centres before the Reformation convulsed religious and political

Tilman Riemenschneider (c. 1460-1531):
Tomb of the Prince-Bishop Rudolf von Scherenberg, 1499.
Würzburg Cathedral.

scientific research, and the home of Dürer, also welcomed the southern Renaissance. Admittedly the new stylistic features were not particularly apparent in the work of Veit Stoss, a sculptor in wood, nor in that of Adam Krafft, sculptor in stone. But the art of metal underwent a profound transformation in the workshop of Peter Vischer and his sons Hermann and Peter II, both Italianized. The tomb of St. Sebaldus, a brass baldacchino with high blind arcades, is still Gothic in its architectonic arrangement, but the whole ornamentation of cheerful *putti* and sphinxes is Italian and the statuettes of Virtues and the statues of the Apostles wear majestic and elegant classical drapery (1507-1519). The workshop of Vischer and his sons supplied the whole of Germany with sepulchral plaques and mythological plaquettes. The commission of two statues for the Imperial Mausoleum of Maximilian at Innsbruck was the culmination of their art (1513-1514). *Theodoric* and *King Arthur*, the knight of medieval dreams, are large and noble testimonies to their pre-eminence. Although the decoration and armour evoke an almost anachronistic medieval romanticism, the impassive *contrapposto* is that of an antique hero.

◁ Peter Vischer the Elder (1460-1529) and his workshop: King Arthur, detail of the Tomb of Maximilian I, 1513-1514. Bronze. Hofkirche, Innsbruck.

Hans Leinberger (c. 1480 - c. 1531/35): Resting Christ, 1525-1528. Limewood, height 29½″.

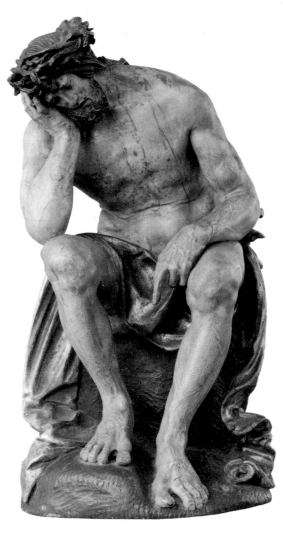

life. The Renaissance gradually penetrated this religious art whose sweet/sour ardours matched the twin aspects of Rhineland mysticism. Sometimes antique elements were introduced. Leinberger's *Resting Christ* meditates while awaiting the Crucifixion and the perfection of the nude inspired by the Belvedere *Torso* confers a divine aspect on Our Lord's almost human despair.

The two cities of Augsburg and Nuremberg, commercial and banking centres keenly interested in trading with Italy, were particularly receptive to the Renaissance. At Augsburg the powerful Fugger brothers built their family chapel in the Carmelite Church of St. Anne (1512-1518). Marble paving, stained-glass windows, organs, funerary tablets and a balustrade on which dimpled dreaming *putti* lean all form part of a setting dominated by a central marble group, the *Mourning over the Body of Christ*. The first great Renaissance decoration inspired by patrons mainly resident in Italy, the sculpted ensemble borrowed its themes from Dürer and its effects from Venice.

Nuremberg, another commercial centre between the North and Venice, the cradle of German humanism and

115

THE EARLY RENAISSANCE IN THE LOW COUNTRIES

Lancelot Blondeel (1498-1561) and Guyot Beaugrant (?-1557): Fireplace known as the Cheminée du Franc de Bruges, 1528-1531. Marble, alabaster, oak, height of figure 59''.

The Low Countries found it hard to make the transition from the Gothic which also dominated architecture and tapestry. The workshops of the chest-makers of Brussels, Malines and Antwerp continued to produce Gothic altarpieces in which scenes and statuettes were mounted inside Flamboyant frames until the middle of the sixteenth century. The regulations governing corporative work permitted production on an almost industrial scale, with the work passing through the hands of various trade groups, sculptors, painters and gilders, before it was put on the market through the international network of the merchants of Antwerp. The weight of tradition which delayed the introduction of Renaissance decoration until 1520 imposed intricate compositions and a certain "overloading" which the best sculptors such as Jan Borman enlivened with a genuinely inventive verve.

In 1507 Margaret of Austria, daughter of Maximilian and Mary of Burgundy, became Regent of the Nether-

lands in the name of her nephew, the young Charles V. She was a cultivated princess and poetess and until her death in 1531 she maintained at Malines a cosmopolitan court in the tradition of the court of Burgundy, helping artists to escape from the grip of the cities, the necessary condition for a genuine intellectual and artistic revival. The enlightened protectress of Erasmus, that "prince of humanists," and a collector of gems, medals and antique statues, she took into her service poets, musicians, painters (Bernaert Van Orley) and the sculptor and woodcarver Conrad Meit. Born at Worms, with an aesthetic close to Cranach, Conrad knew Dürer, who visisted him at Malines. He developed the art of the portrait and a new conception of the nude in boxwood, alabaster and bronze statuettes. *Adam* and *Eve* (Gotha Museum) and *Judith* have smooth bodies whose proportions are in keeping with a flexible line and a sensitive modelling which do not exclude certain realistic features, bulging stomachs and blemishes. Margaret's major architectural undertaking was the construction of the abbey of Brou, in her crownland of Bresse, in memory of her husband Philibert the Fair, the Duke of Savoy. To

ornament the three tombs of the Duke, his mother and herself, Margaret at first commissioned a project from the aged sculptor Michel Colombe, of Touraine, but entrusted the actual execution of the Gothic decoration to the team of the master of works Van Boghem. The anonymous sculptors, some of them Italianizing, others French or Flemish, produced elegant alabaster statuettes (1516-1522). Margaret commissioned Conrad Meit to execute "from life" the *gisants* and the recumbent effigies of Carrara marble and Jura alabaster (1522-1531). The sculpture expresses a noble elegance in a broad style. Collaborators, including a Florentine, executed most of the large cherubs which bear emblems. Master Conrad reserved for himself the *putti* on the tomb of Margaret of Bourbon, with plump dimpled flesh and stylized hair in large loops. We find this detail again in the child held by the *Virgin* in the church of St. Gudule in Brussels. This bust with clinging drapery which leaves her firm round breasts visible marks a new conception in Marian art, with a wholly classical ideal, animated by a human tenderness.

Renaissance decoration was introduced by Lancelot Blondeel in his designs for the fireplace in the Greffe du Franc at Bruges (1528-1531), sculpted by a native of Lorraine, Guyot Beaugrant, who later left for Burgos. Ornamental foliage, columns, coats of arms, *putti* and medallions served as a backdrop for large sculptures in the round exalting Charles V surrounded by his grandparents, Mary of Burgundy, the emperor and the Catholic Kings.

Under Charles V the court sculptor was Jean Mone, of Metz, fertile creator of calm alabaster *gisants*. On the altarpieces of St. Martin at Hal (1533) and St. Gudule at Brussels (1538-1541), he carved meticulous reliefs in superimposed registers with delicate neatly arranged figures.

Conrad Meit (c. 1475 – after 1536):
Judith with the Head of Holofernes, c. 1508.
Alabaster partly painted and gilt, height 11⅝″.

Jacques Dubroeucq (c. 1505-1584):
Temperance, c. 1545.
Alabaster, height 5′3″.
Church of Sainte-Waudru, Mons, Belgium.

Jacques Dubroeucq, who taught Giambologna, adopted a more powerful kind of art. The roodscreen of St. Waudru at Mons, although dismantled, is evidence of the richness of his interests (1540-1545). An architect, he renounced niches and blind arcades for a clear organization of reliefs and alabaster statues. The cardinal Virtues in the round linked up with the classical ideal by the emphasis on proportions and the serene *contrapposto* animated by skilful drapery in the antique manner. The largest reliefs, such as the *Resurrection*, and the multi-figure narrow friezes, exhibit long silhouettes in strong relief which the depth of the planes allows to play in space.

117

FRANCE DRAWS AWAY FROM THE GOTHIC TRADITION

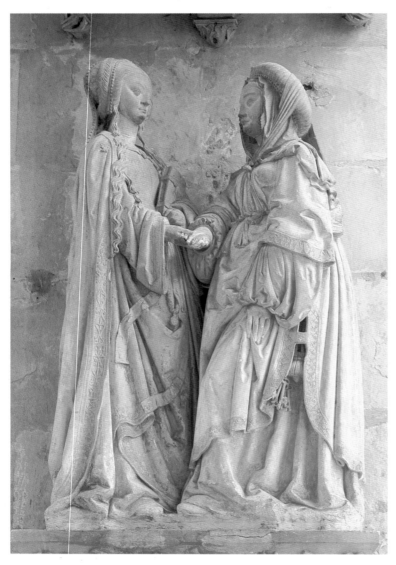

Master of the Visitation of Troyes:
The Visitation.
Stone with traces of painting and gilding, height 51½".
Church of Saint-Jean-au-Marché, Troyes.

The broad movement of fifteenth-century realism was modified by the relaxation of the more sober graceful sculpture of the end of the century. Early contacts with Italy (the sculptor Francesco Laurana's move to Provence, visits by Fouquet to Rome and Naples, for example) strengthened the desire for clarity and serenity opposed in the North by picturesque tendencies. So it was a Gothic art in full bloom that made the acquaintance of the latest Italian creations on the occasion of Charles VIII's expedition (1494) and then came into more direct contact with Italian sculptors when they were installed at the court of France (Mazzoni, the Giusti brothers).

The Italian Renaissance was distinguished at first by the adoption of a new decorative language in the field of architecture. It included mouldings in the antique style, pilasters, arabesques, candelabra, medallions and *putti*. The ornamentation of royal châteaux (Blois, the first Chambord), aristocratic residences (Azay-le-Rideau, Chenonceaux, Ussé, Gaillon, Bury, Montal, Oiron) and town houses (Alluye at Blois, Pincé at Angers, Beaune at Tours, Lallemand at Bourges, Dupré-la-Tour at Valence, not for-

getting the centres of Riom, Lyons and Rouen), borrowed widely from a decorative repertory much in fashion in Lombardy, the duchy administered by Louis XII, where the brand new Charterhouse of Pavia so much admired by the French was the shining example. The new decoration was also introduced into religious architecture for choir screens (Vendôme), cloisters (Tours) and cathedral façades (Troyes, Rouen, Bourges, Beauvais). In funerary art, the pilaster with antique ornamental foliage framing a shell-shaped niche became the leitmotiv of the ornamented bases of statuettes. Once Michel Colombe had employed this kind of decoration for the tomb of Francis of Brittany at Nantes (c. 1500), other sculptors made systematic use of it until around 1530.

The introduction of this easily distinguishable Renaissance decoration of obvious Italian inspiration led nineteenth-century art historians to contrast in a systematic and Manichean way the new foreign, pagan and mannered decorative tendencies with contemporary Gothic sculpture in the natural Christian national tradition. The contrast was reinforced by the negative judgment they made on the rare works executed by Italians that were still extant (tomb of the Dauphins at Tours, tomb of Louis XII at Saint-Denis), although they were not even given credit for executing the most remarkable features, the *gisants* and the praying figures.

Three large centres animated French sculpture under Charles VIII, Louis XII and the early reign of Francis I. They were the Loire valley, Champagne and the South-West. The region of the Loire valley from Moulins to Nantes, with an extension to Normandy, had its focal point at Tours, cradle of a Franco-Italian Renaissance dominated by a serene lyricism expressed in powerful volumes. Like the French sculptors Colombe and Regnault, the Italians, the Giusti and Pacherot, lived in the same town. They collaborated on the same projects and established a sculpture which now included Italianate decoration, although it was dominated by a composite statuary combining Gothic monumentality with new corporeal values and flowing drapery. Far from being in conflict, the Gothic tradition and the lesson of the Quattrocento found a point of equilibrium, a good example of which is the *Virgin of Olivet* attributed to Guillaume Regnault (Louvre). The art of the Loire valley expressed its ideal of beauty and tenderness by creating dense and rhythmic volumes which did not seek movement.

There were contrasting tendencies in Champagne, where the Master of Chaource, the last Gothic sculptor, lived and worked. His artistic career was highlighted by the *Virgin of Pity* at Bayel, the *St. Martha* at Troyes and the entombments at Chaource (1515) and Villeneuve-l'Archevêque (1528). This imperturbable artist, who was also known as the Master of Sad Faces, depicted silent grief without passion or violence. The unity of the expressions and the construction of his faces represent a sombre simple drama without flourishes or pathos. The feelings of his personages are interiorized, but a spiritual presence emanates from them.

In parallel, Champagne produced an elegant, almost worldly sculpture. It exhibited decorative tendencies, and

complicated clothing, belts with knotted ribbons, embroidered orphreys and jewels were added to personages who still maintained Gothic attitudes. The studios produced numerous saints and Virgins with high bulging foreheads and half-closed eyes, looking gently hieratic beneath the long wavy hair framing their faces. Sometimes the decoration became complicated, as in the statues that emanated from the workshop of Saint-Léger.

The South-West (Périgord, Rouergue, the Bordeaux region, Languedoc) was animated by the same contradictory sentiments. The charm of the female figures with broad enigmatic foreheads prolonged the "détente" of Languedoc sculpture, epitomized by the delicate *Our Lady of Mercy* (Toulouse), and sometimes enlivened tragic scenes, Virgins of Pity and Entombments, such as those in the cathedrals of Rodez and Monestiés. But there was an unknown master who expressed similar feelings to the Master of Chaource, using a serene simplification that heightened the volumes and the dramatic but unified expressions. The Entombments from Biron (New York) and Carcenac-Salmiech show figures with regular facial features comparable to the decorative busts of the Château de Montal. The Master of Biron's artistic activities included the portraits of the Montal family which punctuate the upper parts of that Périgord château. Their serenely idealized melancholy expression and the simple volumes defining them are combined with an iconographic system—the decorative bust borrowed from the Italian Renaissance.

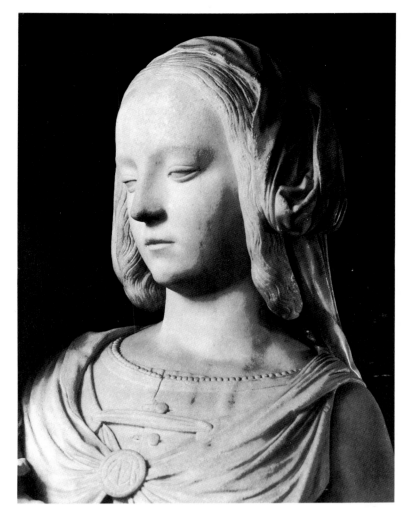

Attributed to Guillaume Regnault (1450/55 – c. 1532):
The Virgin of Olivet (detail).
Marble, whole figure 6′ high.

Michel Colombe (1430–1512):
St. George Slaying the Dragon, after 1508.
from the Château de Gaillon, with frame by Jérôme Pacherot.
Marble, 8′11″ × 13′8″.

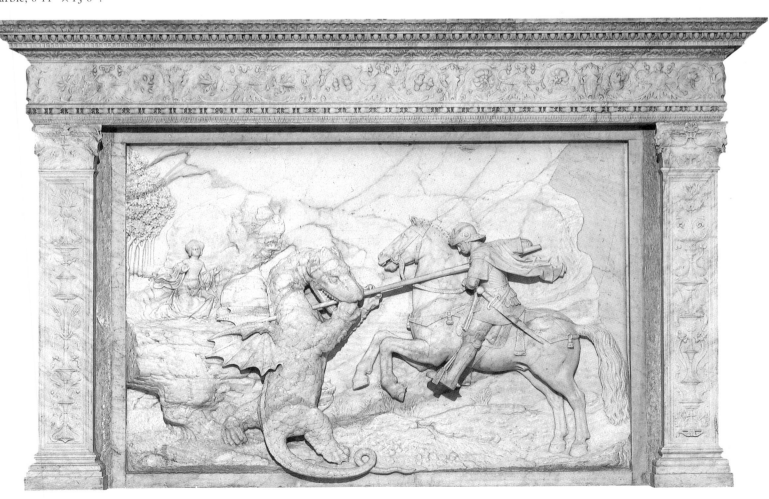

SPAIN: THE STIMULUS
OF ITALIAN ART

Damián Forment (c. 1480–1540):
Self-Portrait, detail of the main altarpiece, 1520–1533.
Alabaster.
Huesca Cathedral.

Catalonia, Aragon, Majorca and Valencia had long formed part of the land of the Crown of Aragon, which extended along the two shores of the Western Mediterranean. A fruitful exchange of artists and their works between Italy and the Peninsula stimulated artistic life and was complemented by the southbound movement of French, Flemish and German artists. The unification of Spain by the Catholic Kings parallel to the development of the transatlantic commercial route opened the doors of the New World and its riches to Andalusia, moving the political and financial centre westwards and stimulating a new artistic vitality to the detriment of Catalonia. Marbles carved at Genoa reached not only the east coast, but also the famous Casa de Pilatos in Seville. Italian sculptors in search of fame and fortune flocked to reconquered Andalusia and Castile. Lombards went to the castle of Calahorra. Domenico Fancelli left for Avila and Granada, Jacopo l'Indaco for Granada and Murcia. Torrigiani moved to Seville where he died miserably in prison for breaking a statue of the Virgin in a fury because his pay was so niggardly. The sites of major artistic projects formed a cosmopolitan milieu where Spaniards and foreigners worked side by side. These foreign artists enriched sculptural experience, and Gothic opulence became "Plateresque" exuberance when melted in the Spanish crucible.

In Aragon where the Gothic style of the sculptor Gil Morlans prevailed, the workshop of Damián Forment introduced the Renaissance. Active in Valencia, his native city, from 1504, he was then commissioned to complete the alabaster high altar of the church of El Pilar in Saragossa. Still under Gothic influence, he emphasized the plastic density of the figures and freedom of the decorative elements, among them the portraits of himself and his wife surrounded by foliage representing their patronyms, wheat and poplar. For the altarpiece of Huesca Cathedral

Damián Forment again incorporated Renaissance style figure sculpture within a Gothic architectural setting, in this case the sturdy figures of the Apostles and the expressive scenes of the Passion. He was converted to the Renaissance style of decoration around 1527, perhaps under the influence of Italian collaborators, when he worked on the massive alabaster altarpiece of the Catalan monastery of Poblet. The composition is gigantic. On the first register niches house scenes of the Passion, above which statues surround a monumental Virgin and Child. On the third register, the joyous mysteries of the Rosary unfold, surmounted by a large Christ accompanied by an apostolic procession. Finally the Crucifixion is the crowning feature. The influence of Alonso Berruguete and Renaissance inspiration began to have a wider effect and dominated Forment's last great altarpiece, this time in the Castilian church of Santo Domingo de la Calzada (1537–1540) in which the painted gilt wood enlivened by secular decorations in the antique manner helps to soften the figures animated by a curvilinear rhythm.

Damián Forment (c. 1480–1540):
Altarpiece (detail) of the Poblet church, c. 1527–1531.
Alabaster.
Santa María de Poblet, near Tarragona.

Felipe Vigarny (Philippe de Bourgogne, c. 1470-1543)
and Diego de Siloé (c. 1495-1563):
Altarpiece with the Presentation in the Temple (detail), 1523-1526.
Painted wood.
Capilla del Condestable, Burgos Cathedral.

Bartolomé Ordóñez (c. 1475/80-1520):
Tomb of Philip I the Handsome and Joanna the Mad (detail), 1519.
Marble.
Capilla Real, Granada.

Castile, which was dominated at the end of the fifteenth century by Gil de Siloé's workshop, favoured gigantic altarpieces with regular compositions teeming with hundreds of figures of various sizes expressing the increase of religious feeling. A transit zone, it welcomed foreign sculptors, one of whom, Felipe Vigarny (or Biguerny), a native of Langres, presided over the gradual transition from Gothic to the Renaissance. His collaboration with Alonso Berruguete in 1519 on the Saragossa altarpiece and then in Granada drew him definitively towards the Renaissance. The polychrome wood altarpiece in the Capilla Real, punctuated by columns, emphasizes the fullness of the figures. Renaissance forms melt into the Gothic tradition in a realist, sometimes anecdotal art. Vigarny returned to Castile to work with Diego de Siloé on the altarpiece of the Chapel of the Constable in Burgos Cathedral (1523-1526) into which his collaborator breathed a more impetuous movement with more vivid accents, as in the scene of the Presentation at the Temple. Ultimately he competed with Berruguete, carving the upper part of the choir stalls in Toledo Cathedral where he softened his silhouettes even more (1538).

Three younger artists were the protagonists in the Castilian Renaissance: Juan de Balmaseda, Bartolomé Ordóñez and Diego de Siloé. Ordóñez, who is known to have been in Naples in 1517 and died at Carrara in 1520, was a shooting star of the sculptural world. The stalls of Barcelona Cathedral, the tombs of Charles V's parents in the Capilla Real at Granada, of Cardinal Cisneros at Alcalá de Henares and the Fonsecas at Coca reveal the lessons learnt from Michelangelo, apart from the influence of Fancelli with whom he collaborated. A precocious Mannerism twists his bodies into elliptical curves, adapting them in a new spatial geometry to bring out their expression.

121

SPANISH EXPRESSION:
ALONSO BERRUGUETE, JUAN DE JUNI

Alonso Berruguete (c. 1489-1561):
The Transfiguration of Christ,
1543-1548.
Alabaster.
Choir of Toledo Cathedral.

Son of the celebrated painter Pedro Berruguete, Alonso was born at Paredes de Nava near Palencia about 1489 and was brought up in contact with a changing cosmopolitan environment. He was already a painter and sculptor when he left for Italy in 1512, following his uncle, who had influence at the court in Rome. There he steeped himself in the work of Michelangelo and the great antiques, especially the *Laocoön* which he copied.

On his return to Spain in 1518 Alonso Berruguete entered the service of Charles V as a painter at Saragossa, at the same time forming an artistic partnership with Felipe Vigarny that lasted four years. Life at the court resulted, in addition to excellent revenues, in a commission for projects in the Capilla Real at Granada where he worked, incidentally, in vain.

When he found that Charles V was not a lavish patron, he had to fall back on an ecclesiastical clientele. After obtaining various commissions, he settled in Valladolid and set up an international workshop there composed of Spaniards and foreigners capable of fulfilling important church contracts.

Berruguete's first commission, the altarpiece for the monastery of La Mejorada at Olmedo (Valladolid Museum) begun in 1524 in collaboration with Vasco de la

Zarza, who died soon afterwards, enabled him to assert his personality. There he outstripped his early teaching in an insatiable search for dynamism, creating a new canon of bodies, elongating and deforming them at his will to magnify expression and effect, suggest the inner drama and define a passionate atmosphere.

Berruguete reached the full breadth of his style in the huge altarpiece of San Benito el Royal at Valladolid, today in the museum of that city. The detailed contract (1527) stipulated that the master would personally execute the paintings, sculptures and their polychromy, and that when the work was completed the altarpiece would be assessed by two experts, one for each party. But in 1532 the experts saw fit to call in a third assessor, Felipe Vigarny, who, incidentally, had known Berruguete well in Saragossa. Whether from professional jealousy or a clash of styles, the work was harshly criticized. There were complaints about the absence of a preparatory design, errors of installation, and tastelessness in the central part portraying St. Benedict (Benito). Nevertheless Berruguete won the day and the monastery accepted the finished altarpiece, thronged with painted and gilded wood figures.

Berruguete returned to a less frenetic style in the choir of Toledo Cathedral (1539). Responsible for half the stalls

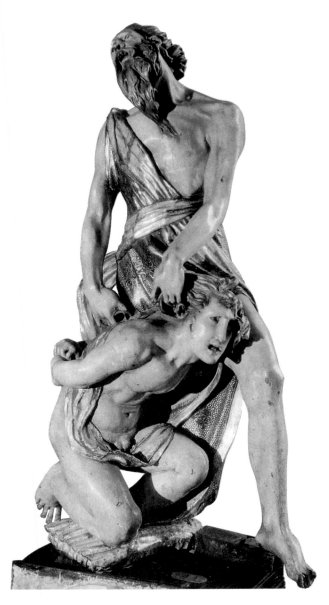

Alonso Berruguete (c. 1489-1561):
The Sacrifice of Abraham, 1526-1532.
Wood with traces of painting, height 33½″.

(Vigarny executed the other half), and the alabaster figures surmounting them, he varied their serpentine attitudes. He gave *Eve*'s body a voluptuous opulence, distinguishing the two intersecting planes of the female body offset to the right and the Tree of Knowledge, with a gnarled stunted trunk passing between her legs. His *Baptist* with thin legs and arched muscular body is quite as celebrated for its vigour as the badly balanced *Moses* taking off his shoe in front of the burning bush irradiated by the divine fire. The polychromy and polish of the flesh further accentuate the departure from classicism.

Berruguete finished his participation in the choir of Toledo by sculpting the archiepiscopal throne and the alabaster group of the *Transfiguration* surmounting it. In the Ubeda altarpiece he was to revert to this unusual theme of Christ's appearance at Mount Tabor.

Berruguete's atelier was the workplace of many artists. It included collaborators on major works, creators of minor altarpieces, such as Jean of Cambrai and Cornelisz of Holland responsible for the six contorted alabaster figures of San Benito el Real (Valladolid Museum), and artists who completed posthumous works such as the tomb of Cardinal Tavera in Toledo and the *gisants* of the Constables of Castile at Burgos. Isidore of Villoldo at Avila and later at Seville, Francisco Giralte at Palencia and Madrid,

Manuel Alvarez and Gregorio Vigarny at Toledo and Burgos, and the brothers Villalpando at Palencia were good examples of the vitality of Castilian religious art.

The man who gave definition to the realist style, basing himself on Berruguete's experience, was a foreigner, possibly a native of Joigny (Yonne). Juan de Juní appeared in Castile in 1536. He settled in Valladolid in 1541 and set up a busy workshop there until his death in 1577. Admired by Berruguete, who nominated him as his expert to assess the Toledo *Transfiguration*, he and his Spanish, French, Flemish and German collaborators formed the link between the harsh vehemence of the late Middle Ages and Baroque violence. His first work at Valladolid, the *Entombment* in the monastery of San Francisco (Valladolid Museum) begun in 1541 expresses a powerful theatricality. The polychrome wood figures with gold highlights in their clothing and furrowed, seamed faces express their drama with alternating exuberance and reticence, varying the expression of emotion so that realism and idealism are amazingly balanced.

Alonso Berruguete (c. 1489-1561):
Eve, 1539-1542.
Walnut.
Choir stall, Toledo Cathedral.

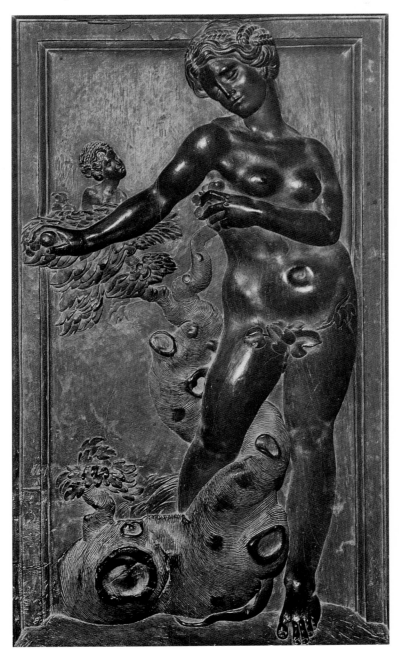

CENTRES AND MASTERS

TUSCANY:
CLASSICAL TEMPTATION, SERPENTINE INFLECTION

FLORENCE AFTER MICHELANGELO (AROUND 1530)

Pierino da Vinci (c. 1530-1553):
River God, 1548?
Marble, height 53".

The Florentine revolution, the shortlived, unsuccessful Republic and the re-establishment of the Medici inaugurated a new era. When Michelangelo had finished his last Florentine sculptures, the figures for the Medici tomb in the church of San Lorenzo, he moved from his birthplace to Rome (1534), leaving it wide open to his eternal, bitter and luckless rival, Baccio Bandinelli. From that time on two currents were opposed, the somewhat restricted classicism of the latter and the legacy of Michelangelo, adopted more in its form than its spirit.

Vilified by the critics, mocked by Cellini, despised by Vasari, Bandinelli was harshly treated. Nevertheless, he was a connoisseur of the Antique, the conscientious executor of a copy of the Belvedere *Laocoön* (1525) and the respectable creator of statuettes and dramatic reliefs of limited dimensions, such as the *Deposition* in London and the *Descent from the Cross* in the Louvre. His artistic pride drove him to undertake monumental works for which he lacked both the inspiration and a mastery of proportions,

and in which his desire to vie with Michelangelo accentuated the calm of his compositions to the point of inexpressiveness and their stability to the point of unwieldiness. Bandinelli failed lamentably with his gigantic group of *Hercules and Cacus* erected in front of the Palazzo Vecchio in 1534. The anatomy of the figures in this heavy static caricature of a combat was so over-simplified that Cellini's waspish tongue compared the shoulders "to the two sides of a donkey's pack," the chest "to a wretched sack of melons" and the back "to a sack of gourds."

A hidebound sculptor, Bandinelli remained faithful to a disembodied antiquity. His *Orpheus* (c. 1519), sculpted for the Medici, is merely another *Apollo Belvedere* with a Cerberus by his side. The austere statue of Giovanni de' Medici known as *Giovanni delle Bande Nere* (1540) erected in the square outside San Lorenzo and the statues of *Adam* and *Eve* intended for the choir of the Duomo in Florence are too redolent of the antique model and restrictive to the point of naivety. On the other hand, the choir screen be-

Baccio Bandinelli (1488/93-1560):
Orpheus, c. 1519.
Marble.
Palazzo Medici, Florence.

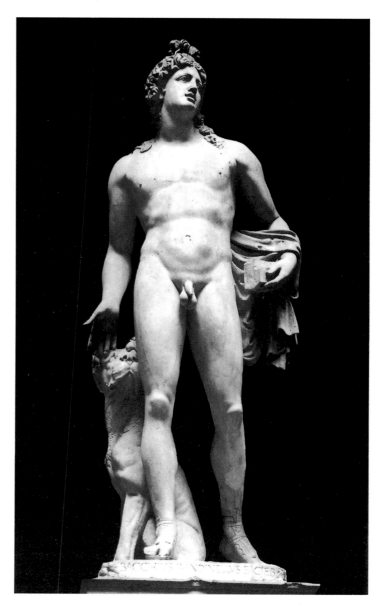

gun by Bandinelli in 1547 and finished much later by his pupil Giovanni Bandini exhibits a brilliant series of reliefs in which the rectangular framework of each marble panel contains the figure of a clothed or naked prophet, seen alternately from the front, the back or in profile. Overflowing the rigid architectural frame, these reliefs with their subtle modelling present every facet of human representation. Admittedly, we sense the influence of academic research in this collection of draperies and anatomies, but the clearly defined lines, encapsulating a fluid relief, reconcile formal elegance, the volume given to the bodies, stability and movement.

Unlike Bandinelli, Niccolò Tribolo sought for dynamic effect, using curve and counter-curve, and the contrast of volumes. As master of works of the Medici Gardens at Castello, he built a grotto in which bronze animals added a further note of fantasy to the already fanciful ambience and two fountains, one of *Hercules*, completed later with a cast by Ammanati, and the other of *Florence* on which Giambologna placed the allegorical figure of the city in the guise of Venus wringing the water out of her hair, probably inspired by a model of Tribolo's. Helped by his pupil Pierino da Vinci, Tribolo worked out a new aesthetic of garden sculpture animated by a grain of folly with marble and bronze *putti* twirling and dancing among a fantastic decoration of grotesque masks and marine monsters, an ornamental repertory borrowed from antiquity, but remodelled to suit his imagination. This introduction of a new movement with a breathless rhythm recurs in the bronze statuette of *Pan*, which also owes its originality to Paduan creations (Florence, Bargello).

Pierino da Vinci, a nephew of Leonardo and a disciple of Tribolo, did more than merely apply the formulas of his masters. His brief career, cut short by his untimely death at the age of twenty-three, was marked by some major creations. The marble *River God*, arched in melancholy and distractedly holding an urn supported by laughing *putti* similar to those on the Fountain of Hercules in the Castello Gardens, has the meditative face that Michelangelo gave his *Genius of Victory* in the Palazzo Vecchio. This Michelangelesque connection was also apparent in the bronze of *Samson and a Philistine* (Bargello), derived from the sketch that Michelangelo modelled in clay for *Hercules and Cacus*, and in the marble of the same subject (Palazzo Vecchio), a product of the *Victory*. Exceeding this reference to the master's *maniera*, Pierino created twisting silhouettes which blossom out from the base, although their energy vanishes in the face of the muted agitation emanating from a composition brutally interrupted by the contrasting diagonals. Thus the reliefs of the *Death of Count Ugolino and his Sons* (Vatican) and *Cosimo I Expelling the Vices of Pisa* (London) favour expressivity of line, subduing realism to the artist's intellectual vision.

During this period, other Florentines travelled through Italy, exporting new forms in which the example of Michelangelo was modified by reminiscences of antiquity. Jacopo Sansovino freed himself from Tuscan lessons to create classical Venetian sculpture. Giovanni Angiolo Montorsoli, Michelangelo's collaborator at San Lorenzo, where he executed a *St. Cosimo* in the guise of a repentant St. Peter, succeeded in combining classical respect and expressive tension in the works he completed at Naples, Genoa and Messina.

Bartolomeo Ammanati, equally aware of the lessons to be drawn from Bandinelli and Michelangelo, tempered with restraint the powerful figures he executed at Padua for his patron, Bernardo Benavides. His *Hercules*, *Jupiter* and *Apollo* for the Palazzo Benavides were the best expression of this difficult compromise. From the style of Michelangelo, the bodies borrow the sense of volume, the muscles and the restrained energy, but movement is lacking and the antique reference is blatant in the head of *Apollo*, a copy of the antique statue in the Belvedere, like that of Bandinelli's *Orpheus*. Later, when he worked on the fountain in the Castello Gardens, Ammanati again contrasted, in the group of *Hercules and Antaeus*, the conquering hero, a mass of straining muscles, crushing his adversary in his arms, his own feet firmly braced on the ground, and the defeated Antaeus, held high in the air away from his mother, the Earth, struggling and suffocating in agony. This relentless combat between two destinies became the main feature of the fountain. The wrestlers exalted the formal beauty of the human body, the play of volumes in space, brutal force and triumphant vitality in a complex arrangement of diagonals and twisting lines.

Bartolomeo Ammanati (1511-1592):
Allegory of Victory, 1540?
Marble, height 8'7".

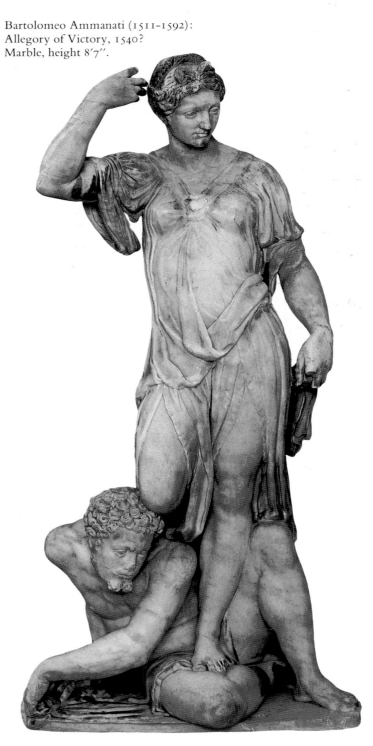

BENVENUTO CELLINI

Thief, liar, brawler, arrogant and spiteful, Benvenuto Cellini was a colourful personality. His autobiography, written at the end of his life, but not published until the eighteenth century, did a lot for his reputation, both good and bad, and added plenty of fuel to the controversies that surrounded him.

The Romantics, from Stendhal to Jakob Burckhardt, admired this sculptor-hero, "who can do everything, dares everything and has no limit to his capacities except inside himself," whereas the Positivists maliciously compiled all the examples of chicanery and hypocrisy in the text. Nevertheless, if we disregard Cellini's boundless self-satisfaction, the autobiography gives us a unique insight into the mind of a complete Renaissance man, who was goldsmith, medallist, sculptor, designer and writer.

A Florentine, Benvenuto was still young when he joined a goldsmith's workshop to learn the craft, studying design at the same time. Family quarrels often forced him to flee to Pisa and Rome, and this enlarged his experience to include the techniques of producing jewellery and medals. After his involvement in a serious brawl, he eluded Florentine justice and settled in Rome, so beginning a series of stays in the pontifical city interrupted by flights resulting from his bloody quarrels. He took advantage of this exile to visit Mantua, Naples, Florence, Venice and in 1537 France, where he solicited Francis I for work, but in vain. On his return to Rome, the incorrigible Benvenuto was imprisoned in Castel Sant'Angelo for murder and the misappropriation of jewels while taking the Pope's gems from their settings and melting down the gold during the Sack of Rome in 1527. He made an incredible escape, but unfortunately he was recaptured. Now he chose the mystic path. He had visions, wrote inspired verses, became an ascetic and finally managed to get himself released.

Providence placed him under the protection of Ippolito d'Este, Cardinal of Ferrara, who commissioned him to make the model of a silver saltcellar ornamented with the figures of Earth and Sea, and took him to the court of France, where the Cardinal resided. On his patron's recommendation, Francis I took the goldsmith into his service and installed him in the Hôtel du Petit Nesle in Paris, even granting him letters of naturalization. The era of great royal commissions had finally arrived: twelve silver torches depicting the gods of Olympus (he began the work with Jupiter) and the gold saltcellar, the model of which he had made at Rome. "To represent the Sea embracing the Earth," he wrote, "I modelled two large figures. They were… sitting with their legs entwined in the same way as certain long branches of the sea cut into the land. In the hand of the male figure, the Sea, I put a very richly ornamented ship that could easily and conveniently take a good quantity of salt; underneath him I positioned the four sea-horses, and I placed the trident in his right hand. I represented the Earth by a woman, whose beauty of form was such that it demanded all my skill and knowledge."

Benvenuto Cellini (1500-1571):
Saltcellar of Francis I, 1540-1543.
Gold partly enamelled and ebony, height 10¼", length 13¼".

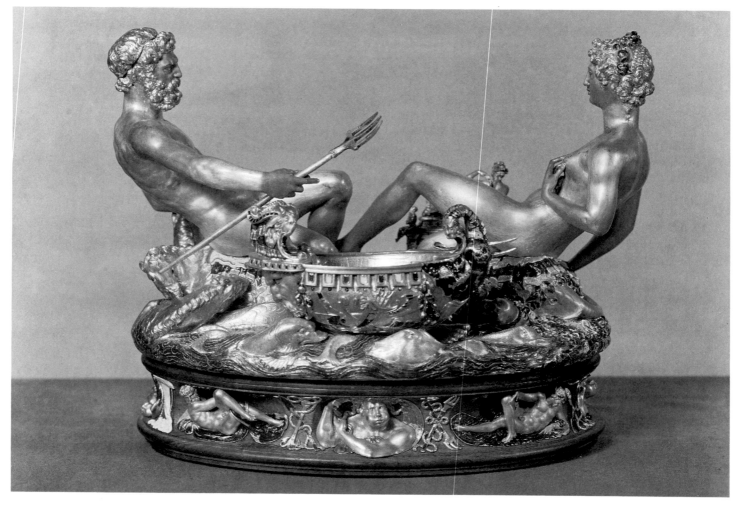

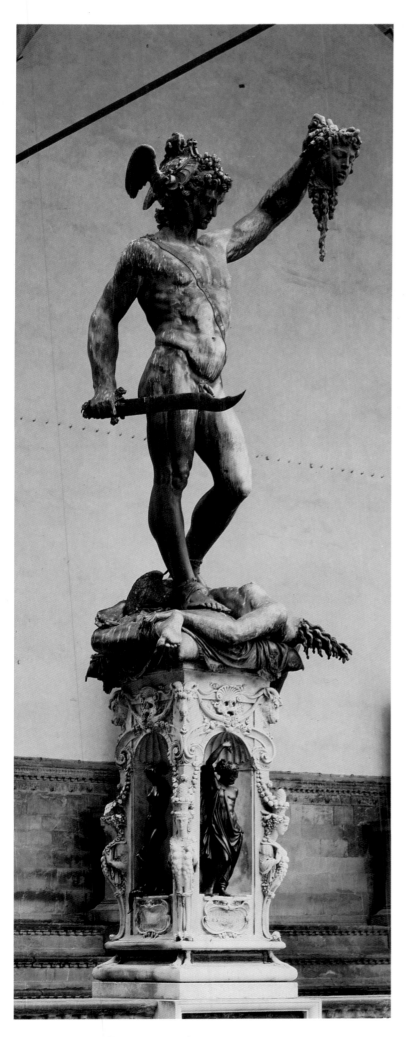

Benvenuto Cellini (1500-1571):
Perseus, 1553.
Bronze, height of figure 10′6″.
Loggia dei Lanzi, Piazza della Signoria, Florence.

Her hand rested on a richly ornamented temple which held the pepper. On the base, *Night, Day, Twilight* and *Dawn* are shown in the same attitude as Michelangelo's figures on the tombs in the Medici Chapel. The elongation of the forms, the limbs and the fingers and the precarious balance of the figures facing each other at either end of the oval combined with the precious material, the variety of the enamels and the delicate execution, make this salt-cellar (Kunsthistorisches Museum, Vienna) one of the most significant works of European Mannerism.

At the same time, the goldsmith determined to add bronze casting to his abilities. With the help of a team of specialists he cast two busts, a pedestal for the silver Jupiter and, most importantly, a large lunette for the Château of Fontainebleau (Louvre). It was the goldsmith's first great sculpture and he was helped by a group of sculptors and chasers (including Pierre Bontemps) who put the finishing touches to the waxes before casting and chased the bronze afterwards. It represented the eponymous nymph of the princely residence reclining near her source, surrounded by hounds and wild animals. Owing to her unnatural position on her side, showing body and legs frontally and not in profile, the gigantic monumental naked figure contrasts with the naturalism of the animals.

But Cellini never installed his *Nymph*, which ended up at the Château d'Anet. Perhaps with some money he had stolen, he left for Florence, where Cosimo de' Medici commissioned his own bust and a bronze statue of Perseus from him in 1545. The bust of Cosimo, cast after a prudent flight to Venice to avoid being accused of sodomy, has a tense face of brutal, almost terrifying authority, with staring eyes, tight lips, flaring nostrils and prominent cheek bones. The frontal cuirass contrasts with the head, which is slightly turned to the one side, by its goldsmith's decoration of festoons, lambrequins, ornamental foliage and masks.

This contrast between expression and ornament recurs in the *Perseus*. The subject was probably chosen by Cosimo to drive home the parallel between his pacific policy and the murder of the monster by Perseus. The Greek hero consciously competes with Michelangelo's *David* and Donatello's *Judith* in the Piazza della Signoria. Brandishing the bleeding head of the Medusa, whose panting body he tramples underfoot, he belongs to the line of young Renaissance heroes, victorious and serene. Here the hero's calmness and repose are such as to suggest complete detachment and indifference in the presence of the horrible spectacle of blood pouring from the Medusa's neck and the vipers writhing around her mask, were it not for an imperceptible contraction of the eyebrows and nostrils which expresses the repressed emotion of the hero dominating his feelings. Everything exalts the beauty of the body at rest with smooth flesh which throws into relief the deeply carved luxuriant curly hair. The balance of the body contracts on the right side, while on the left the composition opens upwards with the outstretched arm and towards the rear with an accentuated *contrapposto*, which allows the bronze to twist majestically in space, offering the eight views that Cellini looked on as an ideal in his treatise on sculpture. The pedestal supporting the monumental group is ornamented with a varied selection from the goldsmith's repertory: garlands, caryatids, masks and bucrania. A bas-relief, *Andromeda Chained to the Rock*, and four statuettes, *Danaë, Jupiter, Minerva* and *Mercury*, provide further evidence of Cellini's researches.

THE TRIUMPH OF MANNERISM AT FLORENCE

1555-1575

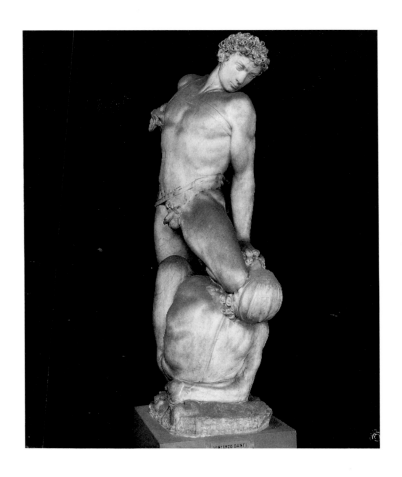

The deaths of Bandinelli (1560) and Michelangelo (1564), marked by the official funerals at Florence and the erection of his tomb in Santa Croce, and the decline of Cellini, who saw Bandinelli's bust of Cosimo chosen in preference to his own, were the milestones marking the entry of a new generation of sculptors. Ammanati, the oldest, returned to Florence in 1555; Vincenzo Danti arrived from Perugia in 1557, preceding Stoldo Lorenzi, Valerio Cioli and Giambologna who appeared in 1560.

Ammanati asserted his position with the Fountain of Juno, whose elements, now either in the Boboli Gardens or the Bargello, *Juno, Ceres,* the *Arno* and *Parnassus,* the *Earth* and *Florence,* represented the first grouping of balanced figures in a rhythm that was alternately calm and powerful.

At the same time, Vincenzo Danti, in his *Honour Triumphant Over Falsehood* (c. 1562, Bargello), displayed a care for supreme elegance, in which the legacy of Michelangelo's and Pierino da Vinci's *Victories* admittedly domi-

Vincenzo Danti (1530-1576):
Honour Triumphant Over Falsehood, c. 1562.
Marble.

Bartolomeo Ammanati (1511-1592):
Neptune Fountain, 1560-1575.
Marble and bronze.
Piazza della Signoria, Florence.

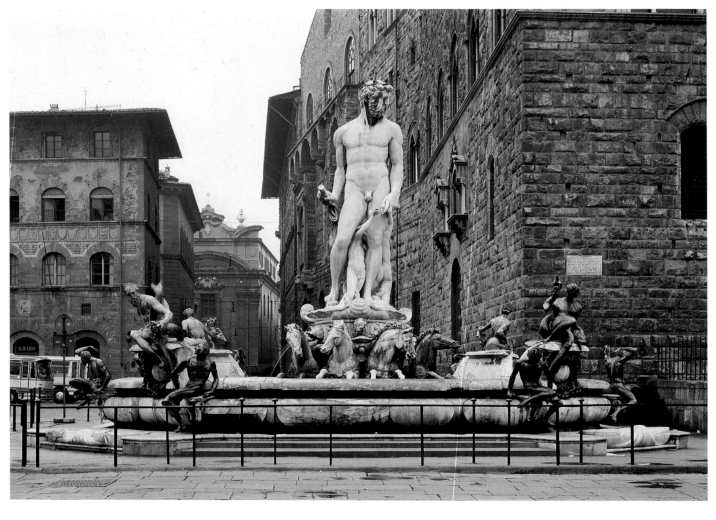

The Studiolo of Francesco I de' Medici, 1570-1573.
Palazzo Vecchio, Florence.

Thus a coherent whole is formed, in which the monumentality of the composition is united with the contrasting movement of the bodies. All future fountain-makers, whether Mannerist or, later, Baroque, looked to it as their source and point of reference.

Far from the hubbub of the public square, in the innermost recesses of the Palazzo Vecchio, the Studiolo of Francesco de' Medici was the retreat of the dilettante and collector. For its decoration, the scholar Vincenzo Borghini, assisted by Giorgio Vasari who designed the projects, produced a complicated iconographical programme, in which the riches of natural and industrial products were grouped according to the four elements. Although painting formed the major part of the decoration of ceiling and walls, the niches housed eight bronze statuettes representing the elements. These were Fire (*Apollo* by Giambologna and *Vulcan* by Vincenzo de' Rossi), Earth (*Pluto* by Domenico Poggini and *Ops* by Ammanati), Air (*Juno* by Bandini and *Zephyr* by Elia Candido from Bruges) and Water (*Galatea* by Stoldo Lorenzi and *Venus* by Vincenzo Danti). If the attributions are correct (they sometimes vary), these great statuettes express the diversity of Florentine art in which a triumphant Mannerism imposed the rhythm and ductility of the forms that sometimes remained classical, as in Bandini's *Juno*, and sometimes twisted in serpentine spirals, as in the works of the northern sculptors Candido-De Witte and Giambologna.

Bartolomeo Ammanati (1511-1592):
Ops, Goddess of Abundance, 1572.
Bronze, height 37½″.
Studiolo of Francesco I de' Medici, Palazzo Vecchio, Florence.

nates, though he laid more emphasis on plastic beauty which is identified with moral values than on inner tension. The bronze relief of *Moses and the Brazen Serpent* intended for the chapel of the Palazzo Vecchio (1561, Bargello) stresses the spiritual force of Moses treated as a bronze flame standing out against a barely adumbrated ground from which ecstatic faces and serpentine silhouettes emerge.

Two major artistic commissions coined the new artistic vocabulary, the Neptune Fountain in the Piazza della Signoria and the Studiolo of Duke Francesco. To tell the truth, the fountain was a legacy from the ageing Bandinelli who had decided on the model. On his death a competition was won by Ammanati over aspirants as famous as Cellini, Vincenzo Danti and Giambologna. Ammanati was also forced to use the block of marble chosen by Bandinelli for the central figure and his *Neptune*, unveiled in 1565, was no more than the archaizing heir of a misunderstood classicism, a clumsy colossus, jokingly nicknamed *il biancone*, the big white thing. During the next decade, however, Ammanati, assisted by the best sculptors and casters in Florence, placed around the fountain's octagonal basin a circle of male and female river gods reclining at their ease, framed by laughing satyrs, while sea-horses emerged from the foam in the centre. The bronze contrasts with the marble and the shimmering water. It brings out the dynamic expression of the figures, the mettlesomeness of the sea-horses and the bantering whimsy of the satyrs.

GIAMBOLOGNA

Born at Douai in the Flanders of Charles V, Jean Bologne (to use his original name) left to train at Mons under Jacques Dubroeucq, the architect and sculptor of the roodscreen in St. Waudru. Following his master's example, he travelled to Italy about 1550 to discover the world of Antiquity. In Rome, this experience enabled him to build up a body of references which informed his subsequent work, such as the group *Lion Devouring a Bull*. He also met Michelangelo, who passed on to him his feeling for creation. When the young Fleming handed the ageing master a meticulous smooth wax model, the master retouched it with his own hands to endow it with liveliness and freedom. This was a lesson in sculpture that Jean Bologne made good use of later in his vivacious clay and wax *bozzetti*, such as those now in the Victoria and Albert Museum, London.

The artist who became Giambologna when Italianized settled in Florence by chance. There he met Bernardo Vecchietti, an art connoisseur and his first protector, and took part in the competition for the Neptune Fountain. Introduced to Duke Francesco de' Medici, he obtained his first commissions and gradually became sculptor to the Tuscan court. The group of *Samson and a Philistine* (Victoria and Albert Museum) still reflects his early work in Florence, marked by the influence of epic combats, developed by Pierino da Vinci following Michelangelo.

Attributed to Giambologna (1529-1608):
Monkey, c. 1570.
Bronze, height 16″.

Giambologna (1529-1608):
Christ Before Caiaphas, after 1579.
Red wax on wooden ground, 19″ × 29″.

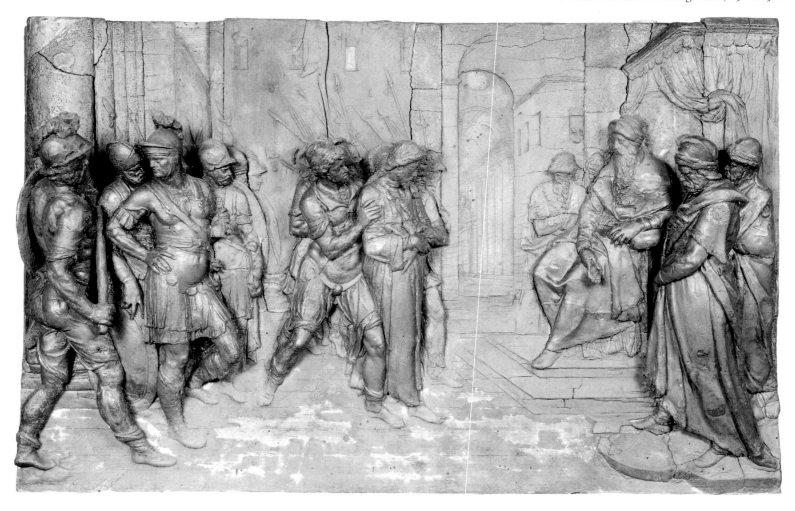

A stay in Bologna in 1563 to erect the Neptune Fountain enabled him to compete successfully with Ammanati, who was still dependent on the projects of Bandinelli and Montorsoli. The central *Neptune* was better articulated with the pyramidal pedestal, which was enlivened by *putti*, delicately balanced at the corners, and fantastic sirens at the foot. A set piece of fantasy, the monumental fountain had a height quite in keeping with its urban setting and Giambologna's pupils later copied its structure for the Mannerist fountains of Augsburg.

At the same period, Giambologna conceived the flying figure of Mercury, messenger of the gods, pointing his finger to the heavens that sent him forth. Subsequently cast many times, with variations, this precariously balanced image, standing on tiptoe, is the perfect embodiment of the Mannerist conception of effect. As Cellini wished, the figure is apprehended by the observer from all angles, but the chilly rhythm of Cellini's *Perseus* was replaced here by a changing vision which gives the appearance of a movement breaking up as one walks around the work. To technical virtuosity Giambologna added a new dimension of the dynamism of forms, the very source of the Baroque art which came later.

On his return to Florence, the sculptor occupied a pre-eminent position. Artist of the political allegory showing *Florence Triumphant over Pisa* (Bargello), in which he was competing with Michelangelo's *Victory*, he perfected a way of showing the main figure twisting around a fixed pivot, the leg. Known as the "serpentine line" by the critics, this sinuous spiral was used to enliven the bodies of statues and became the favourite arrangement for the small bronzes produced in large numbers by Giambologna, assisted by a permanent workshop. The skilful play of diagonals formed by bent limbs, the often sensual curve of bodies with the weight on one leg, the elongated forms of necks, fingers and feet, and deeply carved long or curly hair helped to animate figures in repose, the *Apollo* in the Studiolo, the seated *Geometry* and *Astronomy*. Sometimes, however, a powerful movement twists the bodies, as in *Nessus and Deianira* and fights between animals.

The *Rape of a Sabine*, which marks the summit of Giambologna's artistic career, is indicative of the sculptor's desire to innovate in the field of movement. At first he conceived a bronze group representing a rape which he sent to Ottavio Farnese, Duke of Parma, in 1579. The iconography is lacking. There are no accessories, no conventional signs, just a naked man, his arms bent with the effort, carrying off a woman, also naked, who seems to call the gods to witness. It is not a fight, it is not a drama. The woman does not struggle. It is a ballet opposing two contrasting movements. Basing himself on this composition, Giambologna carved the monumental marble which was inaugurated in the Loggia dei Lanzi in Florence in 1583. To give the group a better foundation, since he was limited by the need to preserve the full solidity of the marble block at its base, the sculptor placed a third figure curved inwards towards the ground. Now three interlocking figures play in space: the vanquished man on the ground, with legs bent back, the fiery Roman, standing with arched back, and the Sabine woman trying to free herself with a violent jerk. The geometry of lines of force, the contrast of expressions and the variety of volumes which contract downwards, then open out, all combine to make the *Rape* not only a technical *tour de force*, but also a milestone in aesthetic reflection on the relation of forms to space. The

Giambologna (1529-1608):
The Flying Mercury, 1564-1565.
Bronze.

Baroque artists realized this clearly. Bernini used the composition again, by adding violence where there had been only intellectual movement. And the Versailles classicists, including Girardon in his *Rape of Proserpine*, merely added a more settled equilibrium.

Giambologna (1529-1608):
Rape of a Sabine.
Bronze, height 38⅝″.

a strange image of a humanity that no longer measured itself by the yardstick of beauty, but by dreams of the fantastic.

And yet Giambologna was also a religious sculptor. It is true that he only came late to this genre, when Catholic reform became more restrictive in 1577. An altar at Lucca and especially the Grimaldi Chapel at Genoa allowed him to work on spiritual scenes. Without anecdotes or emphasis, the wax model for *Christ Before Caiaphas* for the Grimaldi Chapel shows that Giambologna, imbued with Donatello's compositions, could take an interest in perspective, abandon movement for reflection, individual serpentine twistings for group effects and renew his style according to the requirements of his commission.

Vying with his great predecessors, he also made his mark with the equestrian statue, such as the Medici felt called upon to commission. The figure of Cosimo I in the Piazza della Signoria may be a calmer version of the Marcus Aurelius in the Capitol, but it clearly reveals the hand of Giambologna. One has only to look at the snorting horse, with open mouth and tossing mane, and the austere serene duke imposing his will on it.

Giambologna's artistic importance is due to the variety of his experiences, the renovating role he played in Florence by forging the definitive link between the artistic creations of North and South, and especially to the profound effect his art had throughout Europe. The leading exponent of a tendency, he was also the master of the principal sculptors of the next generation who were trained under him. By his teaching, through his models which were diffused by his Florentine pupils, Pietro Tacca and Susini, through his emulators who propagated Mannerism, men like Franqueville, De Vries, Gerhard and possibly Lesueur, he laid the foundations of the European sources of Baroque art.

▷ Giambologna (1529-1608):
The Rape of the Sabine, 1582.
Marble, height 13′5½″.
Loggia dei Lanzi, Piazza della Signoria, Florence.

Giambologna (1529-1608):
The Rape of the Sabines, detail of the bas-relief on the base of the marble group of the Rape of the Sabine, 1582.
Bronze, 29½″ × 35½″.
Loggia dei Lanzi, Piazza della Signoria, Florence.

A bas-relief (similar, incidentally, to the one Cellini had placed beneath his *Perseus*) gives the key to the iconography. The rape is repeated in a more pictorial form, surrounded by other rapes, in a geometrical architecture in which form becomes silhouette and the serpentine line is inscribed in the centre of an architectural perspective.

At the same time, Giambologna was also a sculptor of fantasies. He filled the Medici Gardens with serpentine figures, such as *Florence*, and also with animals, birds, a turkey (still an exotic bird) with ruffled feathers and rough-haired monkeys on the Fountain of Samson (Berlin, Louvre). He modelled the strange dwarf Morgante, the duke's buffoon, the same figure that the sculptor Valerio Cioli had perched on a barrel in the Boboli Gardens. The monstrous and the eccentric combined to give

VENETIAN RHYTHMS:
CLASSICAL BALANCE, MANNERIST INTRUSIONS

Jacopo Sansovino (1486–1570):
Apollo, 1540–1545.
Bronze, height 58¾".
Loggetta, Piazza San Marco, Venice.

Jacopo Sansovino (1486-1570):
Mars (left) and Neptune (right), 1554-1567.
Marble.
Giants' Staircase, Ducal Palace, Venice.

For Venice, the century of Lepanto was not solely the golden age of painting (Titian, Tintoretto and Veronese) and the architecture of Jacopo Sansovino, Sanmicheli and Palladio, because sculpture also had its place in their works. Victories in the spandrels of arches, statues, reliefs and *putti* playing with garlands, enlivened the Loggetta of the Campanile (1537) and the Library of St. Mark, major works by Sansovino. Statues on balustrades and in niches, and interior stucco-work, gave a lighter, rhythmic note to Palladio's buildings.

Jacopo Tatti, a Florentine who adopted the surname of his master Andrea Sansovino, held a central place in the Venetian Renaissance from his arrival after the Sack of Rome (1527) until his death in 1570. A self-possessed person himself, he preferred tranquil forms. His bas-reliefs for the basilica of the Santo at Padua (1535-1536), like the later ones depicting the legend of St. Mark in Venice (1537-1544), were wholly in keeping with Florentine tradition. They comprise a barely adumbrated architectural background against which figures in high relief stand out, forming compact groups whose heads are arranged so that they are on the same level. *Contrapposto* is used with discretion to add flexibility to the calm, well-balanced figures.

An unobtrusive rhythm breathes life into the bronze statues for the Loggetta, *Apollo* (so close to its antique Belvedere counterpart), *Peace*, *Minerva* wearing helmet and armour, and *Mercury*. A solemn artist in his great tombs in which the forceful architecture dominates the rare figures expressed in powerful volumes, Sansovino obviously inherited something of Michelangelo's sense of the monumental.

The solid meditative marble colossi of *Mars* and *Neptune* that he placed at the head of the Giants' Staircase in the Ducal Palace (1554-1567) are vitalized by an epic inspiration, in spite of occasional indexterities, somewhat laboured anatomy and overmodest drapery.

Sansovino's heirs accentuated the vibrant luminosity of the material, the contrasts, expressions and liveliness of figures. Danese Cattaneo, a poet admired by Aretino, elongated the canon of bodies and gave his faces a barely perceptible smile. That fluent and sometimes facile artist, Alessandro Vittoria, filled the Doges' Palace, the villas on Terra Firma and the churches with stucco-work and statues. His two statues of *St. Jerome*, one in Santi Giovanni e Paolo, kneeling and ascetic, the other in the Frari, vigorous and athletic, have their heads, with Roman noses and unkempt beards, turned to one side. Penitents shown beating their breast with a stone, they exemplify passionate devotion rather than mortification of the flesh. Vittoria often makes the head pivot on a body that is shown frontally. St. Sebastian is twisting round, St. John turns his imploring gaze to heaven and the Atlantes look for help in every direction.

An outstanding specialist in the bronze, marble and terracotta portrait bust, Vittoria's main preoccupation was to achieve a realistic face and catch its expression, like the Venetian painters. He gave his numerous portraits of Venetian personalities, among them some Doges, a heroic aspect by ample clothing, sometimes draped, sometimes imitating damask velvet. He also strove to endow with a physical presence the severe, powerful, often wrinkled and bearded faces, whose eyes gaze out from deeply carved sockets.

Danese Cattaneo (1509-1573):
Allegory of Fortune, 1540.
Bronze, height 19¾″.

135

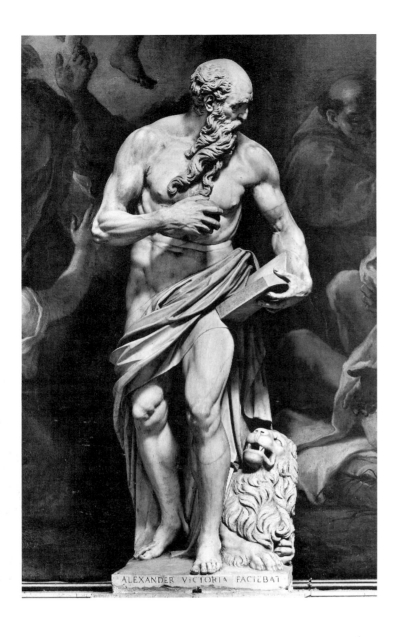

The next generation, Girolamo Campagna, a pupil of Cattaneo, and the Paduan Tiziano Aspetti laid more emphasis on movement, and Mannerist tendencies appeared. Figures became undulant and agile. Aspetti makes his statuettes of *St. Paul* and *Moses* for the high altar of San Francesco della Vigna and those of *Justice* and *Abundance* for the Grimani Chapel (1592) pivot around the axis of one leg. The small bronzes, which were a traditional Venetian speciality, were given a sprightly dancing bearing and flying drapery. The high altar of San Giorgio Maggiore was the setting for a good example of Mannerist confusion and agitation. It was the work of Girolamo Campagna, who, helped by his brother, installed a grandiose celestial globe, with God the Father on its summit, supported by bowed down Evangelists striving to straighten up, a superhuman effort hampered by the wind swelling their draperies.

The door was open to every kind of contortion. The Genoese Niccolò Roccatagliata, trained by the examples of Giambologna, presided over the transition from Mannerism to Baroque. His cursive style was applied to candelabra, figurines and the altar of San Moisè in Venice (1633), a bronze bas-relief in which clouds and cherubs flutter and figures crowd around the dead Christ. This capricious vivacious composition is both strange and contradictory, like a sculptured reflection of Tintoretto's restless tension.

Alessandro Vittoria (1524-1608):
St. Jerome, c. 1565.
Marble, height 6′3″.
Church of Santa Maria dei Frari, Venice.

Niccolò and Sebastiano Roccatagliata (late 16th – early 17th century):
Altar Frontal with Christ borne to the Tomb by Angels, 1633.
Bronze relief.
Church of San Moisè, Venice.

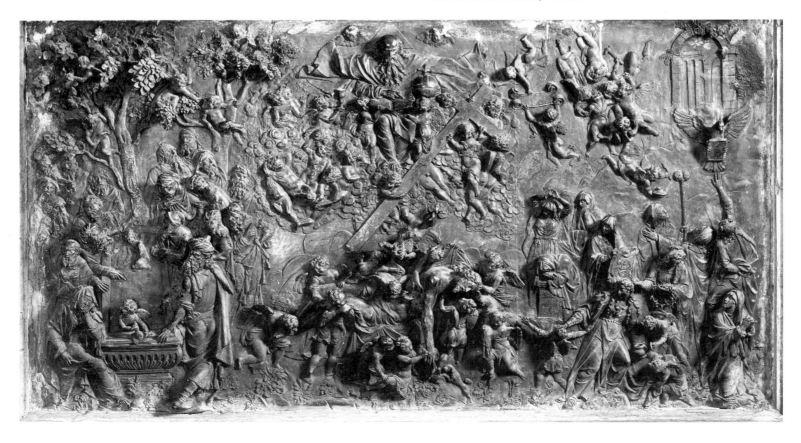

MILAN AND ROME:
TWO CAPITALS IN SEARCH OF A STYLE

After the departure of Leonardo and Bramante, Milan could not recapture its role as an artistic capital. While the endless work on the cathedral took its inexorable course, Leone Leoni dominated sculpture in the second half of the sixteenth century. Like Cellini, with whom he had squabbled in his youth, he was a goldsmith and medallist before devoting himself to sculpture late in life, often in collaboration with his son Pompeo. Taken into the service of Charles V in 1549, he produced busts and medallions in large numbers, mostly of bronze, but sometimes of marble, in which portraits of the emperor and his close relations were shown to advantage on small pedestals or in fantastic frames wrought in the goldsmith's technique in which figures and motifs were mixed. The series of imperial statues was more ambitious, *Charles V Restraining Fury* (1550-1553), the *Infante Philip*, the *Empress Isabella* and *Mary of Austria, Queen of Hungary*. Whereas the royal family was in court dress, the empress erect in her lavishly carved robe and her sister-in-law austere in her widow's weeds with flattened folds, the emperor was sculpted nude, in the antique manner, although he did wear a contemporary removable cuirass which compounded mythical heroization with decency. The composition formed by the emperor leaning on his lance, and trampling the struggling fury underfoot, reveals Leoni's desire to produce history sculpture of a teeming and lofty character. He used the same attitude later at Guastalla for the statue of *Ferrante Gonzaga*, Governor of Milan, crushing a satyr and a hydra.

Few of Leoni's works were executed except under imperial patronage. Nevertheless, he made the tomb of Vespasiano Gonzaga at Sabbioneta and, for Pope Pius IV, the tomb of his brother, Gian Giacomo de' Medici, Marquis of Marignano, in Milan Cathedral (1560-1563). Homage to Michelangelo is revealed in the architecture, the iconography and the pent-up force of the bronze statue of the deceased flanked by solid virtues.

Consequently we might think that Leoni was the pure product of court art, scrupulous and obsequious, a skilful metal chaser rather than a creative artist. Yet in his secret garden, the Casa degli Omenoni at Milan, he collected copies of antiques, including plaster casts made in Rome by Primaticcio, and ornamented the façade with eight stone Atlantes which gave the house its name. Only the naked pair in the centre bow under the weight of the consoles. The others, like antique barbarian captives, gaze out, mournful herms of various ages, giving concrete expression to the dream of a sculptor entranced by force and expression, a reminiscence of Michelangelo's slaves on the tomb of Julius II.

Papal Rome also sought its style in the shadow of Michelangelo, subjected to the architectural eclecticism of Vignola and Pirro Ligorio. The mixture of genres was completed in the Roman crucible which welcomed in turn the Florentines Ammanati and Vincenzo De' Rossi and later Landini, the Lombard families of Della Porta and Cassignola, before the arrival of the masters from Como, good craftsmen but poor creators, Vasoldo, Silla Longhi, Ippolito Buzio, Stefano Maderno, some northern immigrants, the Fleming Gilles de la Rivière, Nicolas Pippi from Arras, Nicolas Cordier of Saint-Mihiel and

Leone Leoni (1509-1590):
Barbarian Captives.
Limestone.
Casa degli Omenoni, Milan.

Simon Drouin, both from Lorraine, Camillo Mariani from Vicenza and a few Romans, Pier Paolo Olivieri, Cristoforo Stati and Flaminio Vacca.

Sculpture became architectural in the papal "follies" (the Villa of Julius III which Ammanati decorated with a circle of powerful caryatids and the Casina of Pius IV in the Vatican Gardens) and the retreats of the cardinals (Villa d'Este, Villa Lante, Caprarola Palace).

Great Roman sculpture blossomed in the funerary monuments of cardinals and courtesans. *Gisants* supported on one elbow and realistic busts fitted into architecture of a wholly classical vigour. The most famous was the tomb of Pope Paul III Farnese, commissioned in 1549 by the College of Cardinals from Guglielmo Della Porta and finished in 1579. The prototype of the Baroque monuments in St. Peter's, Rome, it still refers back to the Medici tombs in San Lorenzo by its triangular arrangement dominated by the statue of the seated pontiff. Michelangelo himself would have approved of the composition, fitted into a tall niche lined with coloured marbles, integrating the bronze statue above and the recumbent white marble figures of the two Virtues, *Justice* and *Prudence*, at the base. They were the remnants of an ambitious programme that included two more Virtues, *Peace* and *Abundance* (Farnese

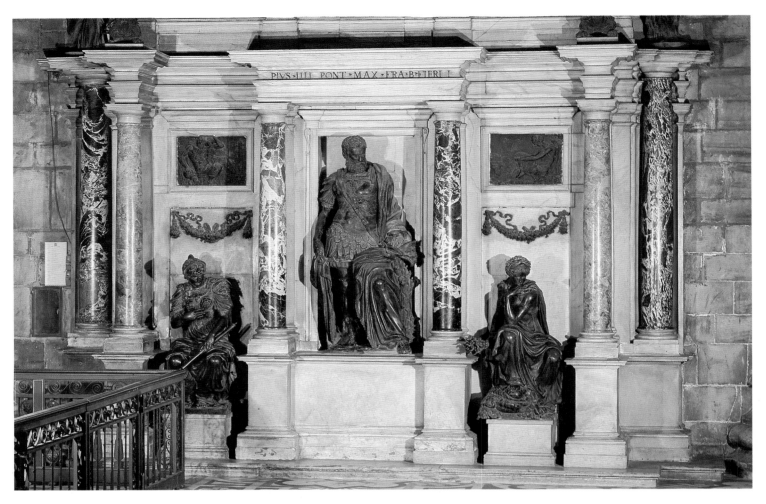

Leone Leoni (1509-1590):
Monument to Gian Giacomo de' Medici,
Marquis of Marignano, 1560-1563.
Milan Cathedral.

Pietro Bernini (1562-1629):
The Assumption of the Virgin, 1606-1610.
Marble.
Cappella Paolina, Santa Maria Maggiore, Rome.

Palace), and four allegories. The richness of the poly-
chromy of the coloured marbles and bronzes with gold
highlights animates the rigorous composition, as do
strange details, a winged grotesque mask, a wing-shaped
pediment, bronze volutes bestridden by cherubs, which
begin with a ram's head and terminate in a Bacchic mask.
The perfection of the bronze chasing which delineates the
least details, the geometric orphreys and allegorical medal-
lions on the cape, brings out the classical force of the fig-
ures: the pope in the act of benediction, *Prudence*, a realistic
old woman, and *Justice*, whose sinuous body was covered
in bronze drapery in 1595 at the behest of the prudish
Counter Reformation.

Another major scene of artistic work was Santa Maria
Maggiore where the Sistine Chapel with the tombs of
Pius V and Sixtus V and the Pauline Chapel with the
tombs of Clement VIII and Paul V were adorned with
marble altarpieces. All the sculptors then resident in Rome
played their part, even the late-comers, Maderno, Cordier
and Pietro Bernini. The ecstatic faces and the vibrant lumi-
nosity of the relief of the *Assumption*, executed by Bernini
for the Pauline Chapel (1606), demonstrated a new desire
for religious exaltation.

Thus we observe the progressive transition from a nar-
rative and naively robust style to the early stages of Ba-
roque, mainly evinced in isolated figures, *St. Sylvia* by
Cordier and *St. Cecilia* by Maderno. Cristoforo Stati's
dishevelled *Mary Magdalene* is an answer to the inspired
St. John the Baptist by Pietro Bernini in the Barberini
Chapel of Sant'Andrea della Valle (1616).

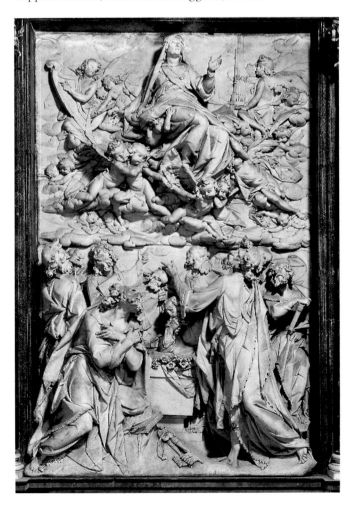

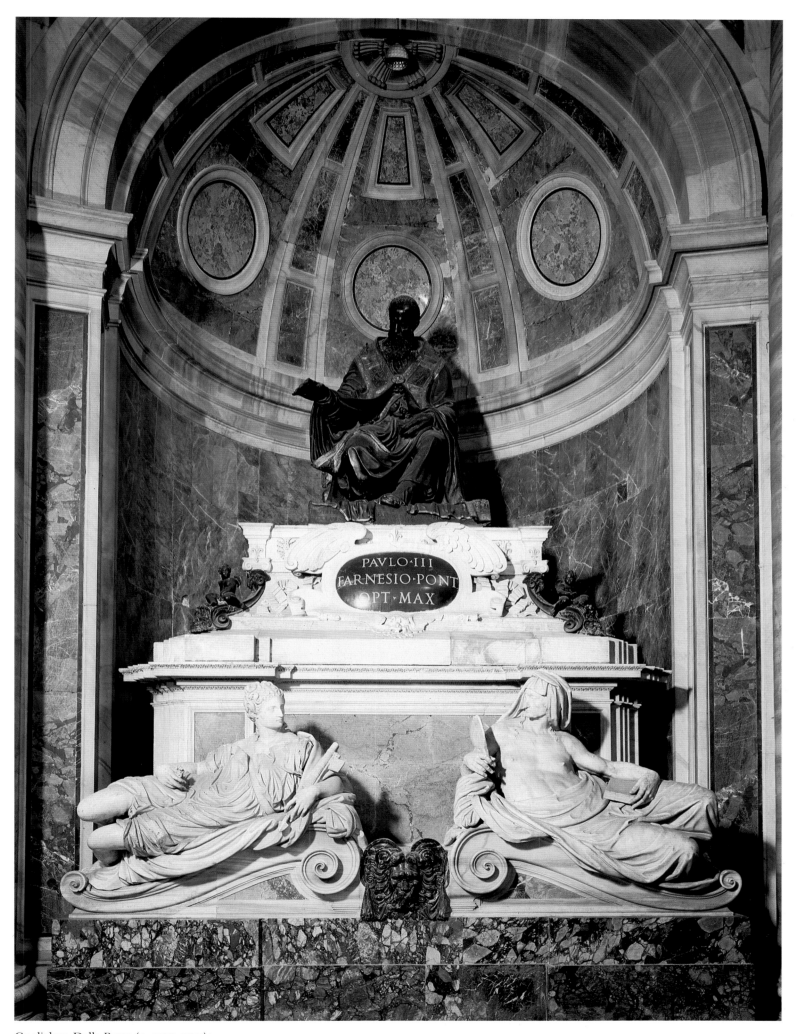

Guglielmo Della Porta (c. 1500–1577):
Tomb of Pope Paul III Farnese, 1549–1579.
White and coloured marble, bronze.
St. Peter's, Vatican, Rome.

THE SHOCK OF MANNERISM IN FRANCE

Pierre Bontemps (1507-1570):
Urn for the Heart of Francis I (detail), 1550-1556.

On his return from captivity, Francis I was engrossed in the construction of his new residences. Although the building of Chambord continued, preference was given to the châteaux of the Ile-de-France: Madrid, Villers-Cotterêt, Saint-Germain, and especially Fontainebleau, before work began on the Louvre (1541). The French masters of works were subject to the antique theory strengthened by the presence in France of Serlio and Vignola in 1540, and which culminated in the French classicism of three architects, Pierre Lescot, Philibert Delorme and Jean Goujon, preceding Jean Bullant.

The shock of Mannerism overturned the artistic panorama with the arrival of Rosso and later Primaticcio, the cabinetmaker Scibec de Carpi and the sculptors Laurent Regnaudin and Dominique Florentin, who made the decorative Lombard prettiness of the preceding generation quite out of fashion. Imported works of art, Tribolo's *Nature* (Fontainebleau), Michelangelo's *Hercules* (since lost) and the plaster cast of the *Pietà*, as well as copies of antiques executed after casts brought from Rome by Primaticcio, orientated French art towards the opposite poles of the antique and Mannerism.

The first Mannerist ensembles were executed in the Château de Fontainebleau, a virtual laboratory of the new forms, which gave the new "School" its name. They included the stucco-works in the Gallery of Francis I, under the direction of Rosso, and those in the Salon of the Duchesse d'Etampes by Primaticcio. The two court painters orientated sculpture in two directions. The first was a new ornamental grammar of strapwork and festoons, garlands and children, grotesque masks and bucrania, the second a stylized definition of the human body, no longer realistic, but anti-natural, in which decorative values, elongated forms, elegant gestures and twisted serpentine postures did not exclude an expressive tension favoured by Rosso, a pupil of Michelangelo. This style was so deeply rooted in court art that one might ask whether, during his stay in Paris (1540-1545), Cellini (while introducing Roman

novelties and denigrating Primaticcio) did not modify his manner when executing the *Nymph of Fontainebleau*, a work thoroughly representative of the predominant aesthetic.

This Mannerist hegemony had different effects on the collaborators of Primaticcio, master of the art of the French court until his death in 1570. Dominique Florentin, dividing his activity between the Court and Troyes enriched the art of Champagne with the memory of Michelangelo. The remains of the tomb of the Duc de Guise at Joinville executed with Jean Picard (Louvre, Join-

Pierre Bontemps (1507-1570):
Urn for the Heart of Francis I, 1550-1556.
Marble, overall height 6'10½'', diameter of the urn 33½''.
Basilica of Saint-Denis, Paris.

ville, Museum of Chaumont) and those of the roodscreen of Saint-Etienne de Troyes (Bar-sur-Seine, Troyes) exhibit denser figures than at Fontainebleau, their bodies appearing beneath full softly rumpled drapery.

Trained under Rosso, a collaborator of Primaticcio's on the casts after the antique and Cellini for the *Nymph*, Bontemps seemed to limit himself to his masters' directives when working on the carved marble urn for the heart of Francis I for the Abbey of Haute-Bruyères between 1550 and 1556, under the authority of Philibert Delorme (Saint-Denis). The iconography of this exaltation of royal patronage represented by eight medallions of the Arts and the Muses, the decorative strapwork, the pictorial reliefs in which perspective is rendered by the background architecture or the form of tables and not by the gradation of planes and relief, the elongated figures, naked Muses and sturdy old men with powerful forms inherited from Rosso—all show a desire to rejoin the Italianizing manner, although at times it is clumsily expressed.

Yet at the same time Bontemps executed in 1552 the picturesque reliefs for the base of Francis I's tomb (Saint-Denis). Wearing contemporary as opposed to antique costume, the soldiers of the royal armies, artillery convoys, bivouacs and cavalry charges testify to a narrative feeling which owes nothing to the sometimes over-subtle refinement of the School of Fontainebleau. For Bontemps could be a realist. He was the creator of the kneeling statues and the *gisants* on the tomb of Francis I and, in 1556, of the sepulchre of Charles de Maigny, Captain of the King's Guards, depicted asleep on his seat, faithful to his post (Louvre). This image, with its powerful serenity, has led some scholars to credit him with other *gisants* supported on one elbow: Jean d'Humières (Louvre) and Guillaume du Bellay (Le Mans).

It is more difficult to understand the personality of Ponce Jacquiot of Rethel. The long period of esteem he

Attributed to Ponce Jacquiot (c. 1515-1572):
Diana the Huntress, from the Château d'Anet, c. 1550-1560.
Marble, height 6′11″, length 8′5½″.

Attributed to Ponce Jacquiot (c. 1515-1572):
Woman Removing a Thorn from her Foot, c. 1560-1570.
Terracotta, height 10¼″, length 8⅝″.

enjoyed before the Revolution has not helped his reputation, and since the nineteenth century he has been undeservedly neglected. Nevertheless he was known by Vasari and trained in Rome, where he was a member of the Academy of St. Luke in 1535. After travelling to Paris to decorate the Grotto of Meudon, Jacquiot returned to Rome to model the stucco-work of the Palazzo Sacchetti (1553-1556), before another trip to France to collaborate on the tombs of Francis I and Henry II from 1559 to 1572. His authenticated works, the funerary genii used again on the monument for the heart of Francis II (Saint-Denis), two Virtues on the tomb of Henry II and the works which are attributed to him, the bronze *gisant* of Blondel de Rocquencourt (Louvre) and the *Woman Removing a Thorn* (Louvre), rehabilitate the qualities of execution of an artist with a broad free technique, an adherent of a controlled calmer classicism and not a Mannerist style. The celebrated *Diana of Anet*, a marble fountain erected in the park of Diane de Poitiers (Louvre), sometimes wrongly attributed to Goujon or Pilon, could well be the work of this precociously Italianized artist, in whom we can discover affinities with the style of Ammanati whom he may have known in Rome.

141

JEAN GOUJON
AND THE FLUID RELIEF

Jean Goujon deliberately avoided the influence of Primaticcio, with whom he never collaborated. A mysterious figure whose dates of birth and death are unknown, he appeared at Rouen in 1540 as "image-maker and architect" and there executed the two fine Corinthian columns supporting the organ-loft of Saint-Maclou (1541). It was in the capacity of architect that he entered the service of the Constable Anne de Montmorency and was active at Ecouen as master of works, before producing in 1547 engravings and commentaries for the French translation of Vitruvius by Jean Martin, popularizer of the *Dream of Polyphilus* and of Alberti and Serlio. This architectural specificity, that may have been reinforced by a hypothetical stay in Italy, explains his originality. Master of his own design, he escaped the domination of painters and, respecting the basic values of architecture, confined his figures to functional frameworks, panels, spandrels, caryatids and voussoirs, without allowing the compositions to overflow like the Mannerists at Fontainebleau.

How much did he actually invent? From the period of his first Parisian works, Goujon was active on projects by the architect Pierre Lescot. Was this a happy collaboration between an architect and his favourite sculptor? Or a collaboration between an accomplished amateur architect and a sculptor-cum-architect, a professional man?

Goujon was a master of the bas-relief. Not the relief of the Florentine type in which perspective and a sense of space include personages treated in *schiacciato*, but a subtle fluid shallow relief in which the figures stand out of their own accord, carrying the third dimension within themselves. In the roodscreen of Saint-Germain-l'Auxerrois, in the *Mourning over the Body of Christ* and the four *Evangelists* (Louvre), he exhibits his figures encircled by a fine outline against a bare ground. He is not afraid to borrow silhouettes from pictorial compositions. Joseph of Arimathea is taken from a figure by Rosso, and reversed; the dead Christ has affinities with an engraving by Parmigianino; the Evangelists evoke the engravings of Marcantonio

Raimondi. Goujon seeks expression by stylization. The figures bend in angular diagonals and simple volumes. The spectacular foreshortenings play with the drapery placed on the body in tight narrow folds sometimes clinging, sometimes loose and light. In *Our Lady of Pity*, as the literature entitles the *Mourning*, grief is expressed without violence or movement. Calm dominates a silent scene. The fainting Virgin grieving in St. John's arms, the concentrated sadness of the bearers and the meditating holy women engrossed in their emotion form a passive ensemble that is only broken up by a single turning gaping face in the background. Jean Goujon was not the sculptor of reality or expression, he was the sculptor of the intelligence of line and forms, skilfully controlled by the architecture and formal beauty.

The Fountain of the Innocents, standing in Paris at a corner of the Rue Saint-Denis on the triumphal route of Henry II's entry in 1549, was an architectural tribune conceived as a triumphal arch in the antique manner, almost without water and with no statues. The sculpted decoration was composed exclusively of reliefs. They consist of five standing nymphs pouring imaginary water from their vases, seascapes where children and dolphins sport, victories in the spandrels of the arches and groups of reclining nymphs playing with Tritons (Louvre). The nymphs fully respect the law of the frame, but fit into it with variety and freedom to the rhythm of long undulating movements. Here again the sources of his inspiration are apparent. An engraving after Rosso for a nymph; an antique sarcophagus for a Triton holding a Nereid in a tight embrace; the Arch of Titus for the flying victories. But Goujon with his technical virtuosity transposes themes and lines into his own personal idiom.

His other Parisian decorations, the façades of the Hôtel de Ligneris (now the Musée Carnavalet), the *Twelve Months of the Year* for the Hôtel de Ville (casts, Musée Carnavalet), show fuller well-built personages beside female figures.

But it was the works on the new Louvre directed by Pierre Lescot which absorbed Goujon's activity from 1548 to 1562. The palace façade is a frontispiece, the royal (one might even say imperial) significance of which is expressed by the reliefs. On the attic pediments the eternal values,

Jean Goujon (c. 1510 – c. 1565):
Mourning over the Body of Christ, 1544,
from the Paris church of Saint-Germain-l'Auxerrois.
Marble, 26½″ × 71½″.

Jean Goujon (c. 1510–c. 1565):
Nymphs from the Fountain of the Innocents, c. 1547.
Stone.
Place des Innocents, Paris.

royal coats of arms born by figures of Fame, Abundance of Nature, Science, Religion and Justice, surmounted by great personages who explain their meaning. Lower down, the œil-de-bœuf windows are framed by female allegories (1548-1549) which, being close to the observer, are in light relief and have a more dancing movement than the *Nymphs* on the Fountain of the Innocents, which are heightened by subtler drapery. In contrast the upper parts (1553) in stronger relief respect the laws of perspective which, in the illustrations of Vitruvius, are in proportion to the distance of the spectator from what is portrayed and the angle of vision. The lintels of the windows (1552) with sturdy dogs lying down and the friezes of children playing with garlands enlivening the articulations of the façades contribute to this exemplary conception of the relations between architecture and reliefs, borrowed from antique triumphal arches.

Inside the palace of the Louvre the great ballroom was richly decorated. Four stone caryatids support the tribune (1550) and face the two figures on the mantelpiece of the "Tribunal" (1551). Goujon had to work to a model, probably a project of Lescot's inspired by antique caryatids that were still extant, such as those in the Vatican. Hieratic armless "women as columns," the *Caryatids* exhibit an impassive image, far indeed from the spirit of Fontainebleau. The frontal severity, the firm axis of the body emphasized by light symmetrical drapery articulated on the small breasts and the midriff, and especially the repetition of the formula, stress the architectural and intellectual aspect of the conception. Yet the woman shows through beneath the column and the clinging drapery allows us to see the body. Goujon's fundamental ambiguity, torn between the intellectualism of the line and the sensuality of the model, is apparent.

Goujon's art was shared by other artists working on the Louvre: Etienne Carmoy, Martin Lefort, the Lheureux brothers, who executed the vaults of the stairway (1553) and the façade. They continued Goujon's style after he left the project (1562), perhaps to escape the persecution of Reformists, and settled in Bologna. A Protestant, like Bontemps, Ligier Richier, Bernard Palissy, Barthélemy Prieur, Dupré and so many engravers and poets, Goujon belonged to the intellectual Reformation and his formal researches clearly indicate acceptance of the movement of return to the antique aesthetic and the respect for moral values which it implied.

GERMAIN PILON

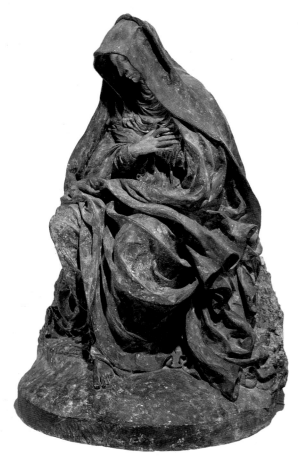

Germain Pilon (1528-1590):
Seated Virgin of Sorrows, model for the marble Virgin
of the Valois Chapel.
Painted terracotta, height 5′10″.

Germain Pilon, trained by his father, who was also a sculptor, could easily have settled for the accepted formulas of the paternal workshop, but being ambitious, he was constantly soliciting commissions and honours, and seeking alliances. In 1558 he appeared on the sites of royal projects, sculpting with Ponce Jacquiot eight "figures of fortune" for the tomb of Francis I that were never installed.

The ephemeral decorations of the Queen's garden at Fontainebleau and the arch of the bridge of Notre Dame, built for the royal entry of Charles IX, set the seal on Pilon's official career (1560). Catherine de' Medici gave him a succession of prestigious commissions to honour the memory of Henry II, "mausoleums" erected by the "new Artemisia" which, by association, equated her with the virtuous Queen of Caria who had the tomb of King Mausolos erected at Halicarnassus. The first was the monument for the heart of Henry II intended for the monastery of the Celestines (Louvre), a silent circle of three Graces holding hands, directly inspired by an incense-burner designed by Raphael and engraved by Marcantonio Raimondi. The group of caryatids supporting the gilt bronze funerary urn is stable and calm. The female bodies, depicted with decorum, even if a breast or leg is revealed here and there, have small heads, ample stomachs and long limbs. They are clothed in flowing draperies whose fluidity is interrupted by crumpled areas which catch the light (1563).

The Queen Mother then decided on the construction of a royal mausoleum at Saint-Denis, adding what is known

as the Valois Chapel to the apse of the abbey church, in imitation of the Medici Chapel at San Lorenzo in Florence. Primaticcio, who was in charge of the works, gave the designs to his collaborators. They were Ponce Jacquiot and Frémin Roussel, who made the model of the tomb, Girolamo della Robbia who prepared the recumbent effigy of the queen (Louvre) and Pilon, who finally became master of works (1565-1573). Except for the figures of two bronze Virtues modelled by Jacquiot, Pilon was responsible for all the sculpted decoration: two bronze cardinal *Virtues* as lissome as the Graces; four reliefs of theological *Virtues*, and one of *Religion*; the images of the deceased, both the two bronze pensive figures kneeling in prayer, wearing their consecration robes, a symbol of royal pow-

Germain Pilon (1528-1590):
Justice, corner figure of the Tomb of Henry II and Catherine
de' Medici, 1563-1572.
Basilica of Saint-Denis, Paris.

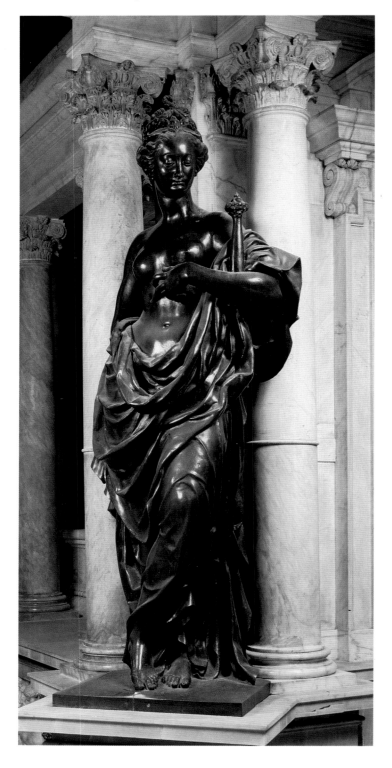

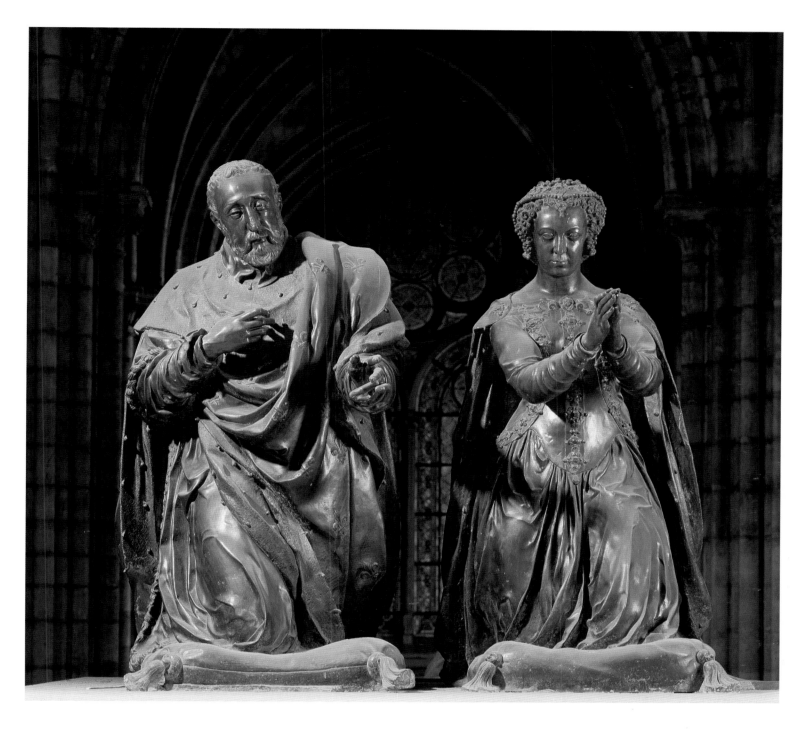

Germain Pilon (1528-1590):
Henry II and Catherine de' Medici Praying, detail of their tomb,
1563-1572.
Basilica of Saint-Denis, Paris.

er, and the marble *gisants*, poor naked recumbent effigies, poignantly expressive of the lifeless state, in which the sculptor contrasts the king's cadaverous rigidity with the supple female body of Catherine, her long hair framing a face dreaming for all eternity.

Ten years later, the Queen Mother commissioned two more *gisants* of the sovereigns in their consecration robes. Keeping to the tradition of the hieratic *gisant*, Pilon confined himself to making the portraits true to life and a painstaking attention to detail in the costumes.

Concurrently, from 1580 to 1586, three groups were commissioned for the Birague chapel: *St Francis in Ecstasy* with a grey marble robe and white marble flesh (Church of Saint-Jean-Saint-François, Paris), a *Resurrection* of Christ between two soldiers stricken with terror (Louvre) and a *Virgin of Sorrows*. Three facets of modern devotion were displayed. First Christ in the act of benediction, ten-

der and redemptory, but still inspiring religious awe; second the Virgin of the Passion, wrapped up in her grief, summing up the acceptance of human suffering even without the presence of Christ's tortured body and so asserting the Virgin's redeeming role rejected by the Protestants; thirdly St. Francis transfigured by mysticism, transcending the human condition to achieve ecstasy, communion with the divine through prayer.

These royal commissions did not prevent Pilon from executing many ecclesiastical works: statues of the *Virgin* and *Sts. Peter and Paul* for the church of La Couture at Le Mans, a triptych of *Christ on Gethsemane* and *Paul and Melchizedek* for Saint-Etienne du Mont (Louvre), the pulpit of the Grands Augustins (Louvre) and a relief of the *Mourning over the Body of Christ* cast in bronze for the Birague family memorial chapel in Sainte-Catherine de la Couture (Louvre). In these works he showed obvious borrowings from Italian Mannerism, e.g. the formal beauty noticeable in the figure of the dead Christ, or again in the composition and the variety of attitudes, the twisted bodies, elongated fingers and agitated draperies, sometimes flowing, sometimes crumpled in long arabesques.

MANNERISM IN THE NORTH

Under the direction of Alexander Colin (c. 1527/29-1612):
The Otto Heinrich Wing (Otto-Heinrichsbau) of
Heidelberg Castle, 1557-1566.

The fragile union between the Netherlands and the Empire ruled by Charles V did not preclude the clearcut individuality of towns and states. The fragmentation of ateliers which had marked Late Gothic and the Renaissance continued. Religious problems fractured the political and artistic scene although they did not stop a constant interchange of men and works of art. When Charles V abdicated (1556), the separation of the Empire from the patrimonial territories of the Netherlands ceded to Philip II of Spain did not bring about any particular change in the status of artists, who sought out the most stimulating centres and congregated at the courts which were the most lavish patrons. Regardless of frontiers, the Flemings had no hesitation in escaping from persecution and the Spanish wars.

The predominance of the three artistic capitals of Antwerp, Augsburg and Nuremberg, which were heirs of a tradition and centres of relations with Italy, is explained by their commercial and financial power. The craft workshops of those towns, which were organized into guilds and sent their products to wider markets, were matched at

the other end of the scale by the sites of political projects initiated by royal command. The long list of such places includes Mary of Hungary's Binche, in Hainaut, of which nothing remains; Heidelberg, capital of the humanist Otto Heinrich, whose palace was ornamented with sturdy caryatids and allegories; Munich, capital of the Electors of Bavaria William V and Maximilian; and Rudolf II's Prague. There were also England, which welcomed the Dutch sculptors Maximilian Colt and Nicholas Stone; Denmark which imported works of art; and Holland which, when peace was restored in 1609, kept its nationals at home and ensured the career of Hendrik De Keyser.

Two personalities made their mark in Antwerp. Cornelis Floris, a fertile decorator and artist of the tombs of the Dukes of Prussia at Königsberg and the Kings of Denmark, produced both overloaded structures such as the alabaster set piece of the Tabernacle of Léau (1550-1552) and classical ones, such as the roodscreen at Tournai (1570-1573), inspired by Sansovino. His subtle yet clustered reliefs and his stable (sometimes rigid) statuettes marked him out as Dubroeucq's successor. Van den

Anonymous Master:
Goose-Bearer Fountain (detail), c. 1550-1560.
Town Hall, Nuremberg.

Broecke, too, seems to be the heir of this early Renaissance and its tranquillity in certain alabaster reliefs such as his *Crucifixions* (Augsburg, Louvre). Nevertheless, this accomplished humanist with an inquiring mind produced one of the first *ecorchés* under the title of *St. Bartholomew*, and the first heroization of northern artists when he sculpted the faces of Van Eyck and Dürer as part of the decoration of a house in Antwerp. At a lower level, Jonghelinck, medallist and portrait sculptor, carefully followed the lessons of Leoni in his bust of the *Duke of Alba*.

Nuremberg was still the capital of metalworking. The Vischers' workshop was continued by Peter Flötner, a draughtsman, goldsmith, illustrator of Vitruvius and maker of plaquettes, mantelpieces and statuettes. His two journeys to Italy gave him a feeling for the clarity and authority of the human body which he expressed in his Apollo Fountain (1532). Inspired by one of Jacopo de' Barbari's engravings, this naked figure, shooting with a bow, combines a deep feeling for poetry and formal beauty. Later, the bronze founders of Nuremberg, the Lebenwolfs and Benedikt Wurzelbauer, interpreted the major Mannerist trends, monumental and elegant in the Fountain of the Virtues (1585-1589), popular in statuettes of peasants and hunters, and the anonymous fountain with a smiling down-to-earth figure holding two symmetrical geese spouting water. The craft of the goldsmith which was celebrated and active at Nuremberg became sculpture in the hands of Wenzel Jamnitzer, who, like Cellini, sometimes attained the monumental. In his lissome female statuettes of *The Seasons* at Vienna, he gave the precious metal a breath of classical Venetian elegance. This southern influence is also apparent in the work of Van der Schardt, a Dutchman, who mirrored the art of Vittoria in his bust

of *Willibald Imhof*. At Nuremberg he produced statuettes and plaquettes, and his fame won him the commission for a bronze *Mercury* for Tycho Brahe's Observatory, the Castle of Uranienborg financed by the King of Denmark (1577-1579, Stockholm Museum).

Augsburg was a long way behind Nuremberg until the Fuggers renewed their patronage of the arts around 1580. Their castle of Kirschheim was ornamented with an altar by Vittoria and especially by the works of Hubert Gerhard, a Dutchman. They comprised a mantelpiece, bronze ornaments for the fountain of *Mars and Venus* (1584-1594) and a dense bronze on a base bordered by fantastic terms (1590). He returns to the composition of Vincenzo de' Rossi's seated couple, emphasizing the sensual play of intertwined limbs, the slow rhythm of knotted curves and expressive passion. Next the city of Augsburg commissioned him to execute the Fountain of Augustus (1589), in which we sense the impact of Ammanati's fountain. But the seated, rather than reclining, figures and the firm solemn Augustus testify to a desire for sobriety, making Mannerist lessons subject to classical orderliness.

Hubert Gerhard (c. 1550-1622/23):
Venus and Mars with Cupid, 1584-1594.
Bronze, height 6'10½''.

The next arrival at Augsburg was Adriaen De Vries, also a Dutchman, who executed the fountains of *Mercury* (1596-1599) and *Hercules and the Hydra* (1602), allegories of Commerce and Virtue. The lightness of the former, inspired by Giambologna, contrasts with the powerful energy of the hero and the supple grace of the nymphs on the pedestal. Florentine influence was interpreted by a powerful temperament which stressed dynamic movement.

Away from the traditional centres, the courts attracted nomadic Dutch artists. Munich, where Pieter De Witte, an Italianized native of Bruges, worked as a painter, retained Hubert Gerhard who ensured the transition from Mannerism to Baroque until 1620. The religious creator of *St. Michael* and the *Virgin*, which was later placed on the central fountain, Gerhard executed the large bronze statues of kneeling knights which were intended to keep vigil over the tomb of William V and were placed at the corners of the tomb of the medieval emperor Louis. More Mannerist in his secular decorations, he cast the fountains for the Residence, *Perseus*, a variation of Cellini's work, the fountain of the Wittelsbachs and the massive *Tellus Bavarica*, bearing the symbols of abundance (oak leaves, antlers, a barrel of salt, a jar of wine). With her distant look, small breasts and ample stomach, she personifies opulence with a mysterious tranquillity.

International Mannerism found a centre at Prague in the court of Rudolf II (1576-1611), who was patron, collector, scholar (he protected Kepler and the astronomer Tycho Brahe) and astrologer—a mystical and authoritarian figure. As opposed to the strange intellectual painting of Spranger and Arcimboldo, sculpture was represented by a pupil of Giambologna, Hans Mont, and even more so by Adriaen De Vries. After training in Florence, De Vries arrived in Prague in 1593 and cast two groups of *Psyche* carried by cupids (Stockholm) and by Mercury (Louvre). To mark the flight of the Platonic soul, he developed the serpentine line and enhanced the effect of immaterial lightness inspired by the *Rape of a Sabine*. The supporting point, reduced to a minimum, makes possible a sensual lyric circle of entwined bodies. After his interim stay in Augsburg, De Vries settled in Prague (1602) and worked there for a long time, even after the Bohemian revolt and the Battle of the White Mountain. His forms enlarged in proportion to his development. The stucco *Adoration of the Magi* in Prague, statuettes and the large bronzes cast for the garden of Wallenstein were stages in an almost imperceptible transition from Mannerist elegance to Baroque force.

Hubert Gerhard (c. 1550-1622/23):
Personification of Bavaria ("Tellus Bavarica"), 1594.
Bronze, height 7½'.

△◁ Adriaen De Vries (c. 1560-1627):
Fountain of Hercules and the Hydra, 1602.
Bronze.
Maximilianstrasse, Augsburg.

◁ Pieter De Witte (Pietro Candido, 1540/48-1628),
Hubert Gerhard (c. 1550-1622/23)
and Hans Krumper (1570-1634):
Tomb of the Emperor Louis I of Bavaria, 1622.
Frauenkirche, Munich.

▷ Adriaen De Vries (c. 1560-1627):
Psyche with Pandora's Box, carried off to Olympus
by Three Cupids, 1593.
Bronze, 6'1½".

THE SECOND SCHOOL OF FONTAINEBLEAU

Mathieu Jacquet (c. 1545 – c. 1611):
Child with the Royal Insignia of France, 1600-1601,
relief from the Belle Cheminée in the Château de Fontainebleau.
Marble, 10¼″ × 12½″.

The Wars of Religion left France anaemic and divided. Under a weakened monarchy, the arts had declined. The Pléiade had culminated in the desiccated hegemony of Ronsard. The School of Fontainebleau had dried up on the death of Primaticcio (1570). The only members to continue were Pilon, protected by the Catholic League, and Barthélemy Prieur, a Protestant, in the shadow of the "politicians," the pacifists Henri de Montmorency and J.A. de Thou, who commissioned the tombs of their respective fathers from him (Louvre).

Henry IV's accession to power (1589) produced the conditions for an artistic revival, although it was still attendant on the consolidation of his position by his coronation, religious pacification by the royal conversion (1593) and the Edict of Nantes (1598), and most of all the economic recovery achieved by Sully. The new court art is conventionally known as the Second School of Fontainebleau because of the desire to renew the age of Francis I's patronage, but the royal château was only one centre among others and much less important than the capital.

Henry IV resumed the decoration of the royal palaces, Saint-Germain, the Louvre and Fontainebleau. Of the great works of the Louvre (the hall of antiques, the King's room, the Pavillon de Flore, the waterside gallery), we still have the bas-reliefs by the brothers Lheureux, a frieze of cheerful *putti*, on the façade facing the Seine. At Fontainebleau, Jacquet carved the Belle Cheminée of marble, on which the equestrian figure of the king in relief surrounded by Virtues (Fontainebleau) surmounted a lintel with a succession of flying winged victories and dimpled *putti* holding the royal arms around a representation of the victory of Ivry (Louvre). The legacy of Pilon mixed with Mannerist torsion is clearly shown, although transposed with good-natured naivety. Outside, Italianate fountains were installed. All that remains of the Tiber

Fountain are four bronze vases by Bordoni, ornamented with crabs comparable to the creations of Fantuzzi. The Fountain of Diana (1613) still has its base cantoned by bloodhounds and stags' heads due to the very free naturalism of Pierre Biard who brought out the classicism of the *Diana* on the summit cast in bronze by Barthélemy Prieur after an antique in the royal collections.

The king also made use of sculpture for political ends, to popularize and affirm his image. We have seen that it was the central theme of the Belle Cheminée. Dupré produced medals in large numbers. Franqueville and Tremblay each carved a standing marble effigy of the king (Château de Pau). Tremblay produced a bust which was treated in marble (Versailles) and bronze (1604, Musée Jacquemart André, Paris). Barthélemy Prieur executed small bronzes, busts of the sovereigns, a figurine of the king on horseback trampling his enemies underfoot and statuettes of Jupiter and Juno with the royal features (Louvre). The equestrian statue by Biard, no longer extant, on the façade of the Hôtel de Ville in Paris, another by Tacca placed on the terrace of the Pont-Neuf after the

Pierre Biard the Elder (1559-1609):
Fame, 1597-1599, from the tomb of the Duc d'Epernon at Cadillac.
Bronze, height 52¾″.

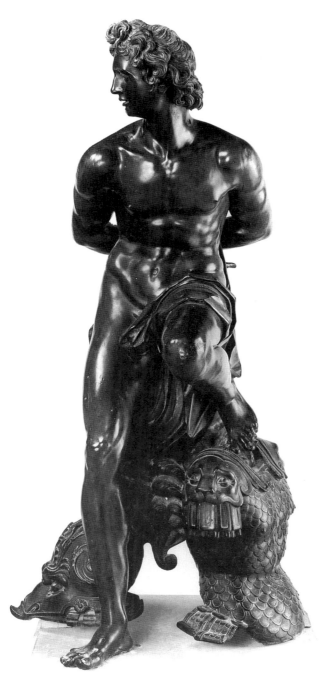

ous and realistic modelling with a balanced movement which shows the influence of Giambologna.

The fact is that the two currents of realism and Mannerism were tugging at the French style. To the first belonged Biard's *Dogs*, the statuettes of peasants by Prieur, some of the Avon terracottas, like the *Woman Suckling a Child*, and the art of the funerary portrait practised by Jacquet, Tremblay and Prieur. The role of Franqueville was decisive in the other direction. In the marble *David Slaying Goliath* (Louvre), he winds the swaying sinuous body round the giant's enormous sword. The group of *Time Carrying off Truth* (Pontchartrain) is an abduction involving three personages inspired by Giambologna. The four *Slaves* intended for the pedestal of the equestrian statue on the Pont-Neuf completed by Franqueville's son-in-law Bordoni (Louvre) are of purely Mannerist formation, with their delicate limbs and the serpentine line which builds the bodies posed on trophies of arms, one leg bent back, the other stretched. Biard, trained in Rome, and Jacquet were sensitive to this Mannerist inflection, whereas Prieur tried to resist it, clinging to more stable forms, while preserving the formulas of the First School of Fontainebleau. *Marie de' Medici as Juno* is a serene and generous figure with a swan-like neck and curly hair.

Barthélemy Prieur (1536-1611):
Marie de' Medici as Juno, early 1600s.
Bronze, height 27½″.

Pierre Franqueville (Pietro Francavilla, 1548-1615)
and Francesco Bordoni (1580-1654):
Young Slave, 1618, from the pedestal of the statue
of Henry IV on the Pont-Neuf, Paris.
Bronze, 61″.

king's death, and the bronze Henry IV cast by Cordier for St. John Lateran in Rome, of which the king was Canon (1608), formed the apogee of this royal statuary.

In parallel, the aristocracy called on sculpture for prestigious decorations and the indispensable immortality of the tomb. The Neufvilles of Villeroy employed Jacquet both for their châteaux, of which the mantelpiece of Villeroy still remains (Louvre) and their tombs, that of *Marguerite de Mandelot*, a dreamy repetition of Valentine Balbiani's figure, and those of Magny-en-Vexin with robust kneeling statues displaying a subtle melancholy. The Constable de Lesdiguières, governor of the Dauphiné, had his tomb and his statue as Hercules erected by Jacob Richier at Vizille. As for the Duke of Epernon, he turned his Château de Cadillac into an artistic centre where he employed the Richiers and Biard, author of the allegory of *Fame* which crowned the duke's tomb (Louvre). Standing on one foot, flying, the naked figure combines gener-

151

PLEASURES AND MYSTERIES OF THE GARDEN

The lovely medieval landscape consisted of neatly arranged vegetation enlivened by jets of water that were sometimes capricious. The Renaissance introduced a more architectural conception. Axial perspectives, rhythmic changes in level created by terraces and stairways, created a structured universe in which walls and balustrades stood out against borders of greenery, hedges and trellises, sometimes reflected in mirrors of water and animated by small cascades, waterfalls and jets. Monumental perspectives contrasted with shady groves, rustic grottoes, theatres and mazes. Sculpture gave an intellectual meaning to this domesticated nature. It emphasized the architecture, was reflected in the water, peopled the groves and added a strange enchantment to the grottoes.

After the sober Italian gardens ornamented with fountains which were exported to Amboise, Blois and Gaillon in France by Pacello da Mercogliano, fantasy was born with Tribolo in the Medici villas of Castello (1540) and Pratolino, and the Boboli gardens in Florence commissioned in 1550 by Eleonora of Toledo, wife of Cosimo I, later executed by Ammanati, alternating with the architect Buontalenti, who also renovated Pratolino and Petraia for Cardinal Ferdinando de' Medici.

The fashion for structured gardens spread. In Latium we find the gardens of the Villa d'Este, the Villa Giulia, Caprarola and the Villa Lante at Bagnaia; in Venetia, Palladio's gardens, such as the Villa Barbaro at Maser. France could boast of the decoration of the Garden of Pines at Fontainebleau and the gardens of Meudon laid out by Primaticcio, with their grotto, the park of Gaillon remodelled by the Cardinal of Bourbon, the Tuileries laid out for Catherine de' Medici by the Florentine Carnessecchi with a grotto by Palissy and a fountain by Ponce Jacquiot, the fountains of Fontainebleau under Henry IV and the grotto of Saint-Germain.

The different types of fountains multiplied. Tribolo's set piece of superimposed basins was replaced by centred motifs surrounded by expanses of water and balustrades. The water theatre (the Nymphaeum at the Villa Giulia, the basin of the Muses and Pegasus at the Villa Lante, the scenic wall at the Villa Barbaro, the amphitheatre of the Villa Aldobrandini at Frascati) offered an architectural vision in which sculpture merged with the walls. In contrast, isolated antique or false antique statues stood out against the foliage, white marble among the greenery.

Certain heraldic themes (the bear of the Orsinis at Bomarzo, the fountain of the Moors at Bagnaia, the dragon of Gregory XIII at the Villa d'Este) shared pride of place with a mythological world. Neptune reigned at Boboli with a statue by Stoldo Lorenzo (1565) and the basin of the Isolotto on which Giambologna surrounded Oceanus by the Nile, the Ganges and the Euphrates, symbols of the ages of man. Venus and Diana also had their place, as did the heroes, Hercules and Perseus, who were identified with the patrons who commissioned the work.

The garden was a dreamland of complicity with nature. At Pratolino, Giambologna erected the colossal stone *Apennine*, which is 46 feet high, even though seated. It merged with the rock like a concretion in human form. In the grottoes, the rustic and the sham natural created a dreamworld: Primaticcio's Atlantes on the façade of the Grotto of the Pines, Michelangelo's slaves re-used by Buontalenti at Boboli (1583), terms which look like fossils by Palissy in the Tuileries and stony sirens in the Residence at Munich. In the shade at Boboli *Paris and Helen* by Vincenzo de' Rossi and *Venus* by Giambologna suggested an erotic retreat. At Castello, Giambologna's bronze animals, at Saint-Germain Orpheus, Perseus and Neptune, and at the Villa d'Este Ovid's Metamorphoses transported the spectator into a theatre.

At Bomarzo Prince Valerio Orsini conceived his whole garden as a dream or a nightmare. He laid out an initiatory route where visitors were confronted with alarming images, a house with such sloping floors that they lost their balance, a monstrous siren, the mouth of Hell, a winged

Giambologna (1529-1608):
Giant Statue of the Apennine, 1569-1581.
Stone, height 46'.
Villa Demidoff, Pratolino, near Florence.

dragon and an elephant hurling a soldier to the ground. These gigantic monsters crudely carved out of the rock were so many ordeals, like those the soul had to face before merging with divine love. This quest, like the recurrence of the cave theme, translated the myths of Plato and Florentine Neoplatonism into images.

△◁ Giambologna (1529-1608):
Fountain of Oceanus, 1567-1570.
Boboli Gardens, Florence.

◁ Alessandro Vittoria (1524-1608):
Nymphaeum, second half
of the 16th century.
Villa Barbaro, Maser, near Treviso.

Anonymous Master:
Dragon fighting a Lion and Lioness, 1552.
Tufa rock.
▷ Castle park, Bomarzo, near Viterbo.

Ga La REYNE

Grande Reyne égale à ce Grand Roy, c'est par vous que reflorit le Lys si vostre belle Florence chérit tant vostre belle Fleur, de grace ne desdaignez ce croyan portrait du portrait de l'vnicque chef-de vostre Ame: son vous a esté denné, l'autre vous est deub, car autre que vous n'en est capable. Le bronze eternisera bien sa memoire dans les siecles, mais il ne peut le faire voir plus long que son pourpris: Le papier n'a autres bornes que l'Vnivers, il portera son Image par tout ou son Nom est ouy.

SCULPTURE AND POWER

Melchior Tavernier (1594-1641):
Equestrian Statue of Henry IV on its Pedestal, Pont-Neuf, Paris.
Print.

Patronage is a pleasure, but art is the favourite instrument of power. A sign of wealth, it becomes a political symbol. In funerary art, the desire to go one better gave rise to inflated monuments, the triumphal arches of the Venetian Doges, the tiered monuments at Saint-Denis, Westminster, Roskilde and Amsterdam, Medici chapels, papal tabernacles and imperial processions. Allegories and narrative reliefs extolled the virtues and the lofty deeds of the deceased.

Like the creations of Frederick II, the public monument, city gate, palace of Justice, town hall (and sometimes private monuments), proclaimed the strength of power. Historical narrative was rare. Long after the triumph of Alfonso of Aragon at Naples, the Cardinal d'Amboise decorated his château of Gaillon with a relief by Antonio Giusti depicting the entry of the French into Milan and later Guillaume de Bourgtheroulde displayed the pomp of the Field of the Cloth of Gold on his private house at Rouen. Allegory predominated on façades. Figures of Fame insinuated themselves into spandrels; the Virtues, unobtrusive in the early French Renaissance (Gaillon, Montal), were placed side by side in pairs on Italian pediments. On the model of royal entries, elaborate programmes, like the one on the façade of the Louvre, were constructed. Heraldry was reinforced by emblems, ciphers, symbolical animals and devices. In deference to royalty, the French seigneurs sprinkled their creations with porcupines and salamanders, crescents and entwined H's. The king's image was displayed on private châteaux (Louis XII at Gaillon, Francis I at Albi and Moret, Habsburgs on the Bishop's Palace at Brixen, James I at Hatfield House).

The dedicatory monument erected in honour of a citizen existed from the medieval period (*Virgil* at Mantua, the *Podestà* at Bologna). The first equestrian statues to heroize defunct *condottieri*, *Gattamelata* and *Colleone*, were born of this civic trend. Gradually popular gratitude was shown to the living. Admiral Andrea Doria met with opposition when he wanted to erect a marble statue showing him crushing the Turks outside the civic palace of Genoa, and it was twenty years before it was actually executed by Montorsoli (1528-1548), whereas the people of Messina commissioned from Calamecca a bronze statue of *Don Juan of Austria*, the victor of Lepanto, in a wave of enthusiasm for the fleet which had set sail from their town (1572). During their lifetime the Popes accepted the honour of seated statues in the act of benediction from the communities of papal states. Examples were Julius III by Vincenzo Danti at Perugia (1553-1556), Gregory XIII at Ascoli (1574-1576) and Bologna (1575-1580), Sixtus V at Loreto, Camerino and the Palazzo dei Conservatori in Rome (1587), and Paul V by Cordier at Rimini.

The "modern" dynastic centralized states adopted the civic monument for their own benefit. Hitherto the royal statue had been reserved for votive or funerary purposes, while busts and medals were the favourite genre for political portraits. The royal portrait emerged from the obscurity of churches and palaces into the sunlight. Possibly inspired by Leonardo's project for an equestrian monument to Francesco Sforza, Maximiliar I vainly attempted to have an equestrian statue, which was to have stood outside St. Ulrich at Augsburg (1500-1502), cast by Gregor Erhart. The kings of France also continued a fruitless

Giambologna (1529-1608):
Equestrian Statue of Cosimo I de' Medici, Grand Duke of Tuscany, 1581-1594.
Bronze, height 14′9″.
Piazza della Signoria, Florence.

Pietro Tacca (1577-1640):
Equestrian Statue of Philip IV, 1640.
Plaza de Oriente, Madrid.

Francesco Mochi (1580-1654):
Equestrian Statue of Ranuccio Farnese, 1612-1620.
Bronze.
Piazza dei Cavalli, Piacenza.

search. Guido Mazzoni sculpted an equestrian statue of Louis XII on the façade of the Château of Blois, an architectural decoration destroyed during the Revolution; Francis I summoned Rustici to cast a horse which was never finished; Henry II sought out Michelangelo who referred him to Daniele da Volterra, who cast only one horse which was brought to France under Louis XIII, long after the Duke of Tuscany had refused Catherine de' Medici's wish to have the effigy cast by Giambologna (1567).

The Emperor Charles V was sensitive about his political image. The Bruges mantelpiece on which he is surrounded by his grandparents is evidence of this. Admittedly the project for an equestrian statue by Leoni in 1546 came to nothing, but the group of *Charles V Restraining Fury*, once in the Alcazar at Toledo, inaugurated a type of allegorical monument based on the theme of St. Michael and the dragon, used again by Leoni for Ferrante Gonzaga at Guastalla and in France under Louis XIV.

The Florentines were the masters of political art. Cosimo de' Medici manipulated iconology to his own advantage. The groups of *Victories*, *Perseus* and *The Labours of Hercules* were so many references to his deeds. He commissioned Pierino da Vinci to depict him expelling the vices. A statue of him in the antique manner by Vincenzo Danti stands in front of the Uffizi (1567-1568) and he accumulated effigies of the Medici family in the great Salone dei Cinquecento in the Palazzo Vecchio. But it was after his death that his successor had his equestrian statue (cast by Giambologna, 1587-1594) erected in the Piazza della Signoria. It links up with the fifteenth-century *condottieri*, inspired by the statue of Marcus Aurelius which Michelangelo had placed in the centre of the Campidoglio in Rome (1538-1539). Ferdinando de' Medici increased the number of statues of himself with a standing marble figure by Franqueville at Arezzo (1594) and Pisa, and by Bandini at Leghorn (1595-1597). He is also honoured by the equestrian statue in the Piazza della Annunziata (1603-1608), cast by Pietro Tacca after a model by Giambologna. Afterwards Tacca, a specialist in royal statues, executed the effigy of Henry IV, commissioned from Giambologna (1604) and cast after the sovereign's death (1611), then a statue of Philip III for Madrid (1607-1616), followed by that of Philip IV on a rearing horse, which is already Baroque. Meanwhile at Piacenza, Francesco Mochi had cast the equestrian monuments of Ranuccio Farnese (1612-1620) and Alexander (1620-1633). Based on the Florentine model, the equestrian statue became an indispensable state requirement, even though Republics disdained them and other forms, such as the marble statues of the kings in the Quattro Cantoni of Palermo (1608-1620), continued to be made.

Leone Leoni (1509-1590):
The Emperor Charles V Restraining Fury, 1550-1553.
Bronze, height 5′8½″.

IMAGES OF REALITY: FACE AND BODY

Alessandro Vittoria (1524-1608):
Bust of Francesco Duodo, c. 1570-1580.
Marble.
Ca' d'Oro, Venice.

In an artistic world so marked by philosophy, reality was not the faithful reproduction of nature. It strove to represent not only the outer envelope, but also the inner truth connected with Platonic ideas and forms. In order to capture the external image with the utmost accuracy, sculptors could resort to casts. That was the technique of the Paduan casters, of Flötner and Jamnitzer, and Bernard Palissy, who moulded small animals such as lizards and frogs, and even large ones, since recent excavations have unearthed a seal moulded by Palissy not far from the Tuileries. Death masks were also made after death when funerals were held. This practice, which was common to French and English ceremonial, helped in the execution of the royal figure who presided symbolically over the obsequies. Then the original cast was reworked to provide an ideal "lifelikeness." Henry II's mask, executed by Clouet, the court painter, was modified in this way. The terracotta which proves this shows no traces of the eye wound that caused the king's death (Louvre).

Another means of knowledge, not of the external form, but of the inside of the body was anatomy, in the original sense of dissection. It was indispensable to a sculptor's training and formed part of the disciplines of the Florence Academy. In spite of the religious ban on the dissection of human bodies, doctors and artists had no hesitation in disregarding it in the age of triumphant humanism. The Belgian Andreas Vesalius laid the foundations of modern anatomy when he published his manual *De humani corporis fabrica* in 1543. It circulated rapidly in Germany and Italy where he taught in the anatomy theatres of Padua and Pisa. During the decades that followed, his successors published one manual after another that gradually improved knowledge of the human body. They included Guido Guidi (1544), the Frenchman Charles Estienne (1545), the Italians Realdo Colombo (1553) and Gabriele Fallopio (1562), and the Spaniard Juan Valverde (1556). Specialized chairs were created, among them the chair of anatomy at the new Collège de France in Paris where Francis I installed the Florentine Guido Guidi, nephew of Ghirlandaio and a relation of Cellini's. Although anatomists concentrated on the human body, they sometimes dissected animals. Fallopio, for example, studied the lions in Cosimo I's menagerie in Florence.

The great leap taken by anatomy was also made possible by the collaboration of artists who produced the plates illustrating manuals, among them Salviati, who collaborated with Guidi, and Gaspar Becerra with Valverde. In addition to their descriptive value, their plates also present an artistic vision of the human body in a wide variety of positions.

The result was that artists discovered in anatomy the reality concealed in the body. According to Vasari, Michelangelo had already practised dissection to learn about the hidden springs of the body, and the Florence Academy continued this practice, as Allori's drawings and Vincenzo Danti's *Treatise on Proportions* (1567) demonstrate. It was a question of achieving a knowledge of perfect proportions, of the harmony which produces beauty, founded not on external mathematical standards, but on intrinsic nature as conceived by God. For the human body, an image of the divine, contained a small part of divinity and hence of beauty.

This search for the divine ideal through knowledge of the real is clearly expressed by Franqueville, who wrote an anatomical treatise unambiguously entitled *Il Microcosmo*. He executed anatomical models, and *écorchés*, in various positions displaying the play of tensed and relaxed muscles. The success of his figurines (two small bronzes are still extant in Cracow) is attested by the study that designers and sculptors made of them. From that time the *écorché*

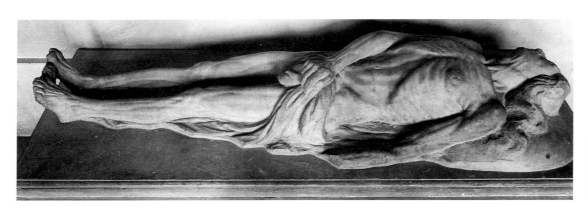

Girolamo della Robbia (1488-1566):
Sketch Model
for the Recumbent Effigy
of Catherine de' Medici, c. 1565.
Marble, length 6'4½".

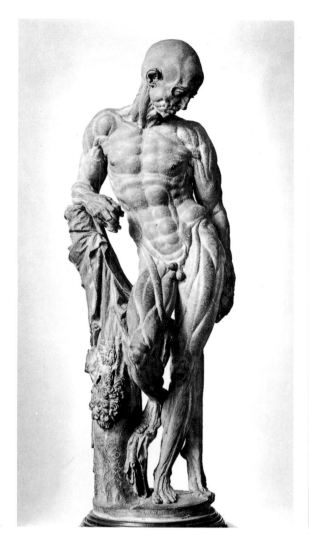

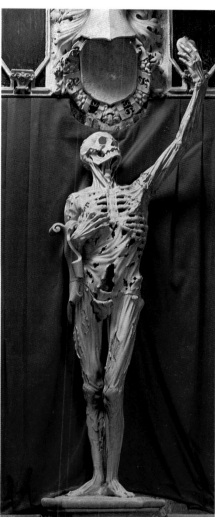

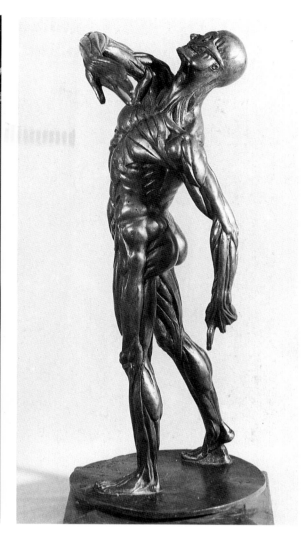

Willem van den Broecke,
known as Paludano (1530-1580):
St. Bartholomew, 1569.
Terracotta, height 22″.

Ligier Richier (c. 1500-1567):
Skeleton on the Tomb
of René de Châlons, c. 1550.
Stone, height 5′8½″.
Church of Saint-Pierre, Bar-le-Duc.

Pierre Franqueville
(Pietro Francavilla, 1548-1615):
Ecorché in Outstretched Pose.
Bronze, height 16½″.
Jagellon Library, Cracow.

became an aid to study: waxes by Andrea Commodi (Victoria and Albert Museum, London) and Lodovico Cardi, known as Il Cigoli (Bargello, Florence). It was sometimes transformed into a religious representation as in *St. Bartholomew* by Van den Broecke, which Girardon later added to his collection. From this point of view, the work of art is never a simple photographic reflection, realism is charged with meaning. Vittoria's portraits, for example, reconcile the representation of appearance (physical resemblance) with the moral value given by the composition, the costume and the sitter's look which tells us about his inner self. In contrast, northern art, in line with Metsys and Holbein, preferred concrete figurations which introduced an action and a context. Thus Van der Schardt shows the collector Willibald Imhof (Berlin Museum) deep in contemplation of a ring.

Funerary art also posed the question of reality. The *transi* (the recumbent figure of a naked corpse) appeared in France and Germany at the end of the fourteenth century. It was usually marked by the stigmata of death. The dual funerary image of the living and the *transi* became a necessary adjunct of royal tombs (Louis XII, Francis I, Henry II, Christian III of Denmark) and aristocratic ones (Margaret of Austria and Philibert of Savoy, Cardinal Duprat, Duc de Brézé, Valentine Balbiani). Described as "anatomy" in Conrad Meit's contract for Brou, the naked recumbent figure might be serene and tranquil or macabre and hideous, showing the scars left by the embalming stitches, like the figure of Louis XII. Some scholars have wrongly seen this as a sign of fear of death and love of life during a happy period. This conception was not held by the religious sixteenth century. But neither was it an ascetic look cast at a wretched body, a hopeless derelict confronting eternity, which would have run counter to belief in the resurrection of the body. The two figurations of the deceased were two facets of the same reality, the reality of man. The physical body is the same in terrestrial and eternal life; it is the living body. It experiences a moment of transition, death, which transforms it into a *transi*. This transient figure also has its divine value, that which the sculptors disclosed in anatomy. Pilon represented Valentine Balbiani as emaciated and terrifying (Louvre) and Girolamo della Robbia sculpted Catherine de' Medici in such a rigid and stylized way that the queen was shocked by it. Ligier Richier expressed this exaltation of macabre beauty. On the tomb for the heart of René de Châlons at Bar-le-Duc stands a skeleton partly stripped of its flesh and holding a heart up to heaven. The anatomical accuracy is not perfect in the eyes of science, but this allegory of the resurrection of the dead achieves beauty by the roundabout routes of *terribilità* and the disclosure of the interior of the body, a divine secret.

THE EVOLUTION OF RELIGIOUS SENTIMENT:
FROM THE MYSTIQUE OF THE PASSION TO THE RULINGS OF THE COUNCIL OF TRENT

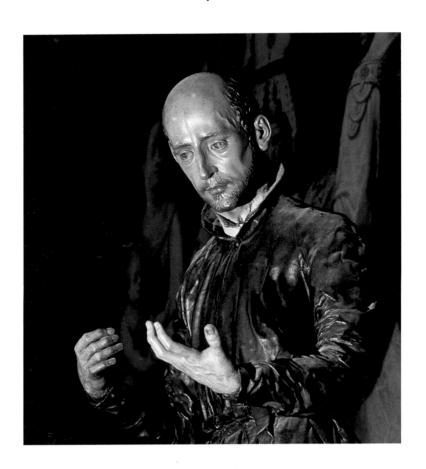

Producing a sacred image, God, Virgin or Saint, was not simply an aesthetic act, but a spiritual step. As the Church's doctrine developed and theological conceptions and devotional practices clashed, not only iconography, but also the way of sculpting could change. Certain themes enable us to follow these transformations.

The mystical and tragic spirituality of the Rhineland had insisted on the theme of the Entombment in the fifteenth century. Life-size sculptured groups of the Mourning over Christ on the Stone of Unction or the Deposition in the Sepulchre were numerous in the late fifteenth and during the sixteenth century: large figures crying aloud with grief modelled in terracotta by Guido Mazzoni in Italy, compact groups with a unified spirituality at Solesmes, Chaource and Biron in France, and realistic expression introduced by Juan de Juní in Spain. Ligier Richier, a convinced Protestant, never sculpted a statue of a saint, but did execute many groups of Christ on the cross and at Saint-Mihiel produced the heart-rending image of the dead Christ being carried away. A vision of suffering,

Juan Martínez Montañés (1568–1649):
St. Ignatius Loyola, 1610.
Painted woodcarving.
University Church, Seville.

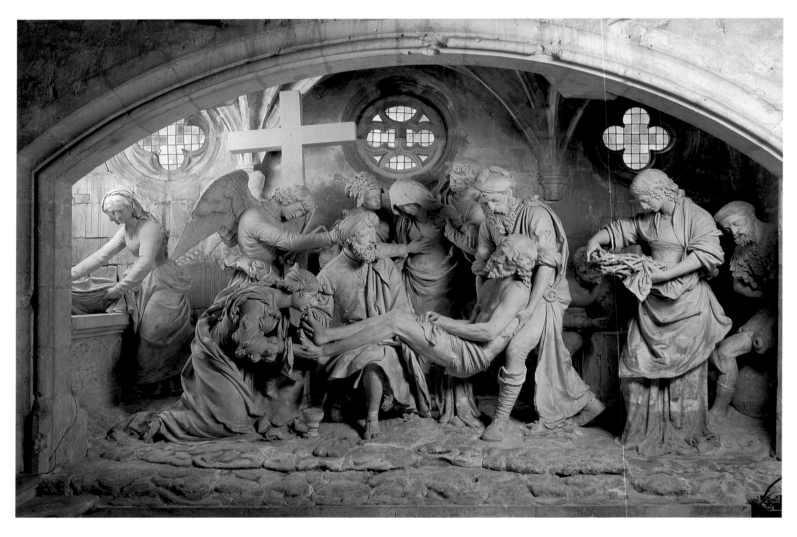

160

◁ Ligier Richier (c. 1500-1567):
The Entombment.
Stone.
Church of Saint-Etienne, Saint-Mihiel, near Bar-le-Duc.

Girolamo Campagna (c. 1550-1627):
God the Father on the Terrestrial Globe upheld by the Evangelists,
detail of the main altar, 1591-1593.
Bronze.
Church of San Giorgio Maggiore, Venice.

sometimes assimilated to the eucharistic body and thus bearing a sacramental spirituality, this figuration emphasizes the human drama of the Passion, of earthly suffering, effacing the divine nature, triumph over death, and apocalyptic apotheosis. Although Entombment groups were still sculpted at the end of the fifteenth and during the sixteenth century, especially the large terracottas from Poitiers and Le Mans, they became rare and finally disappeared altogether. Passionate and personal devotion, visible to only a few of the faithful in the dim light of chapels, the Entombment gave way to more organized official cults aligned along lateral altars. The rotunda of the Valois Chapel at Saint-Denis already presents a triumphant innovatory iconography. Our Lady of Sorrows is alone without the presence of the dead Christ, whereas the group of the Resurrection shows the resuscitated body.

Pilon also introduced into the Valois Chapel the figure of St. Francis in ecstasy, a theme of the stigmata well known since Giotto, but rare in sculpture. The Council of Trent called for a new way of making images of the cult of saints, with individualized features and realistic clothing. The hagiographic statue with unchanging attributes made way for the devotional statue already expressed by

Vittoria in his two figures of St. Jerome, for example. The emphasis was on religious feeling, prayer, penitence, offerings to God, ecstasy rendered in a living true way.

The great novelty of the Council of Trent (1545-1563) was the lively moral and theological reaction of the Church faced with the rise of Protestantism. The long discussions of the fathers of the Council subject to contradictory pressures culminated in the adoption of an arsenal of responses to the assertions of the Protestants, rather than in new devotions. This Catholic Reform laid its main emphasis on theology and the clergy. Sculptors were requisitioned to forge religious images accessible to everyone, images that spoke to the heart and brought them closer to the people. The movement towards preaching, moral conversion and reform, the "laboratory" for which was the Milanese diocese of St. Charles Borromeo, demanded legibility without flourishes, demonstrative simplicity. The high altar, visible to everybody, became the support for the *mise en scène*. Theatrical groups like Girolamo Campagna's in San Giorgio Maggiore at Venice and the monumental altarpieces, based on forms elaborated in the sixteenth century, which were widely diffused, are examples of this.

Rome: aerial view of St. Peter's, with Bernini's Colonnade, 1656–1667.

BAROQUE by Maurizio Fagiolo dell'Arco

Charles Le Brun (1619–1690):
Allegory: Sculpture Working on the King's Bust.
Chalk drawing, 41¾″ × 46″.

This essay makes no claim to investigate the complex history of European sculpture in all its many ramifications, stylistic, historical and allegorical.

It begins with an introduction to the problem, an attempt to trace the origins of Baroque and the moment when the first signs of the new century can be identified. More will be said about individual works than about the personality of the men who made them. Over and above the study of forms, we shall aim at a synthesis of the ideas which these sculptors set in motion.

In a succinct overview we shall then examine the sculpture produced at the Italian courts, beginning with the triumphant Rome of the popes, and then go on to its various manifestations in France and Spain, in Central Europe, and finally in the New World.

The second part of this essay, more closely connected with the pictures, will offer an interpretation of some works considered as outstanding examples of their kind: First, Mochi's *St. Veronica*, whose dynamism seems to open the century of Baroque; then Gian Lorenzo Bernini, the grand master of Baroque. He will be studied by way of three works: an early one (*Apollo and Daphne*), one of his maturity (the *Ecstasy of St. Teresa*), and a late one (the Vatican *Constantine*). Then comes the more classical-minded Algardi, followed by Puget alongside Poussin, and Girardon alongside Coysevox, to indicate the other great pole of Baroque: the France of Louis XIV.

A third section will inquire into the structural components of the Baroque language. In other centuries, too, it may be a mistake to isolate one technique from the others; but in the Baroque period above all sculpture formed an integral part of a wider system of signs, of what may properly be termed an aesthetic cosmology.

One series of chapters will consider how the artist came to grips with the problems of his craft: his technical resources (the urge towards virtuosity, indeed an overwrought virtuosity), his use of various materials to achieve a probable polyphony, his interaction with other forms of expression (painting, architecture), and his opportunities for experiment (ephemeral and festival works).

A second series of chapters will dwell on the relation between sculpture and nature: the true problem of the century. For sculpture set itself to vie with the volatility of the elements, arriving at an active fusion of light, water and air.

A third series of chapters will, it is hoped, offer some insights into Baroque man. The idea of the face is contrasted with the concreteness of the body, while an unexpected existential warmth is attached to the conception of mysticism and the inevitability of death.

This essay, then, can amount to no more than an introduction to the motivations behind Baroque, with examples from the work done at the courts of Italy and Europe. It has no pretension to completeness, but does attempt to point out the problems involved, leaving the issues open in all their fascination and reality.

THE CONCEPT OF BAROQUE SCULPTURE

THE FUNCTION OF SCULPTURE

Today we have largely lost the historical sense of what was meant in the seventeenth century by that many-sided phenomenon which we now simply call sculpture. Even so unusual a treatment of the subject as the volume on technique issued by the Ministry of Culture in France seems to underestimate this situation. It may be that the time is past when only the masterpieces were looked at, when only the protagonists were the object of study. In any case, one great problem remains open: that of the Baroque worksite.

What such a worksite implied may be seen from the chronicle of an ephemeral ceremony in 1626. In that year Cardinal Ludovisi laid the foundation stone of the church of Sant'Ignazio in Rome, which was destined to become the driving power behind the Jesuit policy of propaganda by means of images. Then, in procession, the cardinal went round the site of the church, embellished for the occasion with allegorical figures of the Arts which would contribute to beautifying the building ("as if the Arts were vying with each other to offer the Cardinal their work," reads one record of that day). Of those arts or techniques, nine, no less, come under the heading of what today, in brief, we describe as sculpture. Sculpture in the proper sense was flanked by Statuary; alongside Incrustation (polychrome inlays) was Niello-Work; alongside Chiselling (low-relief carving) were various techniques such as Casting, Iron-work and Woodcarving. Finally there was Modelling, which (as we read in the records of that occasion) "is the mother, as the Ancients called it, of the three arts, Statuary, Sculpture and Chiselling." So many were the different arts that went to the making of a given work that the memory of them has almost been lost. Among them is still another which Cardinal Ludovisi is known to have come into contact with that day: the statue of Fragrance, one of the more elusive arts of the Baroque world (and indeed a sculptural one, in the sense of being a smell that extends into space).

All these techniques, or distinct arts, entered together into triumphal works like the *Chair of St. Peter*, designed by Bernini for the apse of St. Peter's; and during the seventeenth century we find them being used together in an organized concourse *ad maiorem Dei gloriam*. Unless one understands how complex a set of techniques were brought to bear, one cannot understand the why and wherefore of a single piece of seventeenth-century sculpture.

Sculpture at that time had an almost triumphal role because it occupied a rhetorical position in the philosophy of the century. Already at the close of the sixteenth century, the theorists of the New Science laid it down that the centre of every operation is man. In his treatise *De sensu rerum et magia* (1620) Tommaso Campanella writes: "Man is the epilogue of the whole World. The World is statue and image. It is the living Temple of God, where he has depicted his acts and written out his ideas. He adorned it with living statues, simple in heaven, mixed and feeble on earth: but from all of them goes the way to God." In short,

God created the world by means of the three great arts: sculpture (because it is statuary), painting (because it is image) and architecture (because it is a Temple). Men are thus seen as "living statues," as sculptures in motion.

Daniello Bartoli, the great Jesuit writer of the seventeenth century, says in his *Life of St. Francis Borgia*: "As soon as he arrived in Barcelona, he turned to the machine of his great body, no otherwise than a sculptor who from too big a block of stone should wish to shape the lean and spare statue of Penitence, and he began the work by removing great chips from it with great blows. The first chisel he took up for this purpose was the chisel of abstinence." The relation between creator, man and sculpture could hardly be made more explicit.

RELIGION AND IDEOLOGY

One of the first steps in the new papal policy was to organize the Congregatio de Propaganda Fide (1622), in order to coordinate missionary activities; and this was done in a spirit closely connected with that of the Jesuits. "Propaganda" (that is, the spreading of the Faith) was the order of the day also for the Baroque sculptor. At every step of his work he had to think not only of his technique, but also of the message that he was conveying, a message destined to become ever more universal and "rhetorical"—that is, persuasive.

Other events of moment in the seventeenth century were the growth of the Inquisition (chiefly in Spain), the confirmation of the legislation arising out of the Council of Trent, and the open struggle against the Jansenists in France. Standing at the centre of power, the religious spirit was ardent and tormented, as in Borromini and Mochi (faithful to the stark vision of the Bible), or visionary and rich, as in the early Bernini and in Puget, or mystical to the point of morbidness, as in Bernini's last period.

The Jansenist view of the world, austere and uncompromising to the point of tragedy, ended in rubble and ashes, when by order of Louis XIV Port Royal was razed to the ground in 1664, a year before Bernini's arrival in France. But the spiritual renewal spearheaded by the Jansenists is present throughout the century, in a variety of forms, from the *esprit de géométrie* of Descartes to the *esprit de finesse* of Pascal.

A synthesis may be discerned in a late sculpture of Bernini's, the *Salvator Mundi* in half-length (Chrysler Museum, Norfolk, Virginia). Here the triumphal expression of the apotheosis (the base recalls the bust of Commodus, and also the project for the base of the bust of Louis XIV) is combined with a tormented expression of religion (the visions of Maria Maddalena de' Pazzi, and also the mysticism verging on heresy of Miguel de Molinos, as well as St. Catherine and St. Teresa of Avila) in order to emphasize the vision of death, understood as the first breath of the resurrection, of the new life beyond the grave.

Gian Lorenzo Bernini
(1598-1680):
Baldachin over the High
Altar of St. Peter's,
1624-1633.
Bronze and gold,
height 95′.
Vatican, Rome.

The idea of persuasion through images impelled the intellectuals of the period (followed by their friends the sculptors, painters and architects) to rediscover the power and resources of Rhetoric (a subject to which Aristotle had devoted a treatise). The whole act of artistic creation could be viewed in a particular way through the lenses of the "Aristotelian telescope" (the title of a treatise on rhetoric by Emanuele Tesauro); viewed, that is, in terms of such rhetorical devices as antithesis, anastrophe, metonymy, ellipsis, hyperbole, oxymoron and, above all, metaphor.

Metaphor is defined as follows by Tesauro: "Of the figures of rhetoric, it is the most acute and ingenious, the most novel and wonderful, the most appealing and useful, the most fertile and eloquent fruit of the human mind."

Gian Lorenzo Bernini (1598-1680):
The Fountain of the Four Rivers, 1648-1651.
Marble and travertine.
Piazza Navona, Rome.

This view was echoed by Baltasar Gracián, the acute Spanish thinker, who defined it as "a singular turn of speech which swiftly indicates one object by means of another."

The mind, in short, is thereby acted upon so effectively that it is carried from one image to another by the workings of the imagination. A Baroque sculpture almost always conceals this rhetorical device. The very transformation of allegories into real figures or animals, together with the way the subjects are used, and the ability (in Tesauro's words) to "find similarity in dissimilar things," made for the triumph of the "rhetorical figure."

Two other devices often resorted to are hyperbole and oxymoron. Hyperbole consists in exaggerating an idea in order to obtain, through overemphasis, the complicity of the spectator. Sculptors indulged in hyperbole by distorting proportions, stressing the materials, refining the quality of their technique to the point of preciosity, adding decorative elements of often contrasting import, and by a purposeful heightening of energy. The oxymoron is often

present in poetry. It lies in combining two contradictory terms, to gain a more expressive effect: "When not far away / he heard the fountain murmuring / with a raucous roar" (G.B. Marino). The sculptors, too, practised something of this kind: a calculated casualness, a controlled chaos, a pent-up dynamism.

DYNAMISM AND METAMORPHOSIS

Dynamism is created by the plastic and organic modulation of the materials. We have a symbol of the new century in the twisted, almost writhing columns in the Baldachin raised over St. Peter's tomb by Gian Lorenzo Bernini, who took the idea from painting (from an altarpiece by Rubens in a Roman church) and turned it into sculptured architecture. It was Bernini who demonstrated how centrifugal

and centripetal forces could co-exist in the same marble, how every figure group could be placed on the borderline between appearance and disappearance, on the theatrical threshold of truth, fiction and verisimilitude, so effectively as to make even Death seem alive and dynamic.

Baroque art answers unquestionably to a changed conception of the world. Rome had quickly been made aware of the new views put forward by Copernicus who, in opposition to Ptolemy, saw the earth as only one of the components of a far larger cosmos. Man stood now on a smaller footing, a somewhat bewildered contemplator of nature and divinity. Giordano Bruno had already summarized the meaning of this vision of the infinitely great which reduced man to the infinitely small. Tommaso Campanella had already related this severe scientific vision to the existential measure of earthly life: "The world is a great and perfect animal, a statue of God that God praises and resembles."

It was the new focus on Nature, and new insight into it, that prompted artists to take over its most characteristic principle: change and ceaseless dynamism. In this period of continual experiment, sculpture became almost a second Nature, moving away from set methods and designs and exulting in the untrammelled freedom of metamorphosis. Any piece of sculpture that one may consider from this time on illustrates this attitude, which has its "manifesto" in Bernini's group of *Apollo and Daphne*–the very allegory of metamorphosis.

Three related phases of this gathering dynamism may be singled out in the new interest for anamorphosis, the unexpected creation of carriages, and the passage from architecture to sculpture.

Anamorphosis is an image which, from a distance, produces one effect and from close at hand another. A typical example is the large corridor decoration at Trinità dei Monti, in Rome, where the complicated landscape sheltering a hermit is seen, from close up, to be a maze of signs and colours.

In carriages or coaches we have the authentic allegory of movement. They are referred to here because many sculptors competed in designing them, from Gian Lorenzo Bernini, who designed a quite extraordinary one for Philip IV of Spain, to Alessandro Algardi and Ercole Ferrata. Consulting the records of the period, one is surprised to find that a carriage of this kind (of which many still exist in an unusual museum in Lisbon) was the combined handiwork of a whole group of specialized craftsmen, a team of artists whose only equivalent is to be found in the architectural worksites and in ephemeral festivities or pageantry. As the moving and suggestive image of Time, the carriage must be seen, not as the precursor of the motorcar, but as the apt allegory of dynamism and metamorphosis.

Organic life and forms entered also into the space of the city, even though it was thought of as unmoving and timeless. Artists like Bernini, Borromini and Pietro da Cortona included simulated rocks and plants in their façades; into the Louvre and Sant'Ivo alla Sapienza, into the Palace of Montecitorio and the Fountain of Trevi, they introduced the fleeting instead of the eternal, movement instead of stability. The Palace of Montecitorio in Rome became a living sculpture (with rocks in the pilasters and window sills, and artfully contrived plants), putting into practice the principle laid down by Zanni, a character in one of Bernini's comedies: "Where you have naturalness you have artifice."

Workshop of Gian Lorenzo Bernini (1598-1680):
Design for a Carriage for Philip IV of Spain.
Drawing.

Johann Paul Schor (1615-1674):
Gilt wooden bed and precious fabrics for the birth of the first child of Maria Mancini Colonna, 1663.
Print by Pietro Santo Bartoli.

SCULPTURE AS TOTAL ART

Sculpture was always thought of in connection with the other arts. The great sculptor was expected to contribute to the church or palace, on condition that he was supported by a larger team of image makers. His specialized language thus became part of a wider discourse.

The role of sculpture may also be triumphal, as shown by many examples in Europe. The amazing Karlskirche (church of St. Charles Borromeo) erected in Vienna by Fischer von Erlach is based on a Borrominian design (typified by Sant'Agnese in Piazza Navona, Rome) and enriched with two mighty columns, whose spiralling reliefs illustrate the events of the saint's life. These two added features, with their unfolding and (in a sense) film-like reliefs, are intended to enhance the architecture with a continuous narration; they bring to mind the historiated columns of ancient Rome.

It was Bernini who had realized that the limits of sculpture were too narrow. It was he who, in his early works (*Apollo and Daphne, Rape of Proserpine, David*), had risen to the height of virtuosity and so perfectly illustrated the specific character of that elaborate carving technique which he had learned from his father as he learned to speak. Now, as he worked out his complicated chapels or his halls designed as moving pageants, what he offered was a synthesis of techniques and media. His idea is described (by his biographers Baldinucci and Domenico Bernini) as "a fine compound" or "a marvellous compound."

Yet, to use the words of Shakespeare, there was method in this apparent madness. When Descartes (*Discourse on Method,* 1637) and Bacon (*Novum Organum,* 1620) set forth the necessity of a method which should override the particularity of individual disciplines, then we have already reached the heart of the problem of the interchange of techniques, with the resulting ambitious project of recomposing them in new structures. All this to guide worldly efforts into the learned channels of the New Science, while for Bernini and his followers it was a question of arriving at a sculpture which should be at once spectacle and magic.

An awareness of the New Science is noticeable in the antirational structures of Baroque art, tending towards a cosmic inclusiveness; in a style of modelling pressed on to a continually heightened dynamism; in paintings which carry illusionism to the point of redoubling the space of church or palace; in stage designs that cancel out any difference between stage and auditorium (and one remembers that Bernini, who was also a man of the theatre, contrived to carry fire and water into the auditorium, as living elements).

Artifice triumphed, then, and being presented as a harmonious reconciliation of opposites it can be seen as the most widely diffused attitude of the century. It is referred to again and again by artists and theorists, like the Florentine Carlo Ridolfi ("To find again an easy, unlaboured manner, concealing so far as possible the underlying difficulties"), or another Florentine writer on art, Raffaello Borghini ("To nature may then be added Artifice"), as also in the emblematic statement made by Gian Lorenzo

Johann Bernhard Fischer von Erlach (1656-1723):
Façade and Columns of the
Church of St. Charles Borromeo
(Karlskirche), 1716-1737.
Vienna.

FASCINATION OF THE ANTIQUE

Gian Lorenzo Bernini (1598-1680):
Bacchanal: A Faun Teased by Children (Allegory of Life), c. 1616-1618.
Marble, height 52″.

Bernini ("Where you have naturalness you have artifice").

This harmony between the materials employed recurs in all Roman Baroque (typical being Bernini's church of Sant'Andrea al Quirinale where the saint's statue stands out among coloured marbles and altars with apparitions), in the Naples of the Spanish viceroys (one high point being the Sansevero Chapel, articulated between the apparition of the Virtues and the triumph of Death), in Grand Ducal Florence (the Corsini Chapel in Santa Maria del Carmine, a polychrome kaleidoscope of materials), in Spain as in Central Europe (from the crowded theatricality of the Spanish *retablo* to Asam's spectacular altars), and even in Latin America (where the materials and forms seem to be in continual levitation, in keeping with the size of those new lands and the memory of the transocean passage).

Inevitably, when a sculptor took up his chisel, he was haunted by thoughts of Phidias or Praxiteles or the virtuoso achievements of the Greeks. The fundamental problem of Italian art at all periods would seem to lie in the alternation between different choices within the limits of a standard classicism. Art as mimesis and art as idea are the two classic positions which, at the beginning of the seventeenth century, were represented in painting by Caravaggio and Annibale Carracci respectively.

Bernini, as it happened, represented both: the first in his earlier work, the second in his maturity. The point may be clarified by some passages from his conversations with Chantelou in Paris.

On 5 September 1665 Chantelou records Bernini's views of the Academy: "In his opinion it is necessary for the Academy to possess plaster casts of all the best statues, bas-reliefs and busts of antiquity, for the schooling of young artists... To put these students from the outset face to face with life figures, he said, is as good as leading them astray, because if their imagination is filled only with that, they will never be able to produce anything that partakes of the beautiful and the great; for neither the one nor the other is to be found in life figures." On 25 June, when asked whether Trajan's Column was really a fine work, Bernini "answered that it was the work of the greatest men there had ever been." On 5 September he confessed that "when he was young he often drew from the antique, and in the first figure that he made, whenever he had any doubts, he would go and consult the Antinoüs as his oracle." And so on.

The connection with the classical world was maintained by the constant practice of restoring ancient sculptures (a practice amounting, all too often, to an arbitrary reworking of them). Pietro Bernini and Nicolas Cordier were primarily "restorers," just as were Gian Lorenzo Bernini and Algardi. What the sculptors of triumphant Baroque (Gian Lorenzo Bernini and Algardi) proposed at Villa Borghese or Villa Doria Pamphily were almost archaeological edifices embellished with recently excavated statues. Hellenism was preferred by Bernini, a severe classicism by Algardi, a languid Praxiteleanism by Duquesnoy. Beside the latter worked Nicolas Poussin, the Apelles of the seventeenth century, who in Casa Barberini left the finest statement of this classical revival (the *Death of Germanicus*, now in Minneapolis) and entered the basilica of St. Peter's to paint the *Martyrdom of St. Erasmus* under the guidance of the most Baroque of sculptors—"*arbitrio equitis Bernini*," as we read in the records.

If we turn to specific instances, it seems obvious that the Apollo pursuing Daphne in Bernini's wonderful group derives from the *Apollo Belvedere* (a standard model at least till the time of Winckelmann); that the oratory of San Filippo Neri sculpted by Algardi refers back to a Demosthenes; that the many draped maidens (Duquesnoy's *St. Susanna* or Bernini's *St. Bibiana*) are variations on ancient Vestals. In architecture, too, classicism provided a frame of reference, and even the most "heretical" manipulators like Borromini looked (as he himself expressly says) to the tombs in the Roman Campagna, to Hellenistic shrines, to the exoticism of Hadrian's Villa at Tivoli.

One of the closest ties between Rome and Paris lies in their joint reliance on the theory of classicism. G.P. Bellori

Antonio Gherardi (1644-1702):
Stuccowork in the Chapel of St. Cecilia, 1692-1700.
Church of San Carlo ai Catinari, Rome.

helped things to move in this direction with his discourse of 1664, entitled "The idea of the painter, sculptor and architect, chosen from natural beauties, is superior to nature." Bellori was a friend and admirer of Poussin, and exchanged ideas with Bernini (who during his stay in Paris, in the conversations recorded by Chantelou, might almost be speaking with the voice of Bellori). Not surprisingly, Bellori dedicated this discourse to Colbert. And it was at Colbert's prompting that the Académie de France was founded in Rome in 1666, at the Villa Medici, for the purpose of schooling young French artists in *le bon goût*.

SCULPTURE AND ILLUSION

"The poet's be-all and end-all is wonder": such was the motto of Giovan Battista Marino. And the stated aim of his rival poet Gabriello Chiabrera was not so very dif-

ferent: "Poetry is bound to make you raise your eyebrows." In the mouth of Graziano, a character in one of his comedies, Gian Lorenzo Bernini puts these words, amounting to a programme: "Ingenuity and design are the magical art whereby one contrives to deceive the eye and arouse amazement." Wonder, then, may be achieved by the "deception of the eyes" (title of an artists' manual of the period), induced by the perfect attunement of a bright idea with a flawless realization of it.

True, false, likely: in various combinations these categories run through the artistic theories of the day. "Art lies in making what is feigned seem true," wrote the art historian Filippo Baldinucci. "The poet avails himself of whatever is likely or true or false... He makes his poems as much on the basis of truth as on that of lies," wrote Agostino Mascardi, a friend of the Barberini family.

Art as artifice had its appointed place in pageantry, entertainments, performances. In festivities first of all. Being called in to provide for these, the great sculptors found here an opportunity for trial and experiment with ideas which they afterwards embodied in the lasting form of marble or bronze. And then the stage, where artists found an outlet for some of their most fascinating discoveries.

Art as artifice always had some connection with literature and rhetoric. One favoured medium of communication was wit, acuteness of insight, *agudeza* (as the Spaniards say). Its effect is thus described by Emanuele Tesauro in the mid-seventeenth century: "By the miracle it works, mute things are made to speak, senseless ones to live, lifeless ones to rise again: Tombs, Marbles, Statues, receiving voice, spirit and movement from this enchantress of minds, are made to discourse ingeniously with ingenious men." Symptomatic is this vision of speaking sculpture in vivid relation with man and divinity.

Two examples may be cited in the domain of spectacular sculpture, to illustrate the interchange of roles with the theatre, while the worshipper acts as spectator.

The chapel of St. Cecilia in San Carlo ai Catinari, Rome, was done in the late seventeenth century by Antonio Gherardi, with a blending of architecture, painting and sculpture. The lower level is rich in fabrics, paintings, movement. Above, the elliptical dome opens over a white setting in which, in contact with the large window illuminating the chapel, stand music-making angels. In other words, what we have on this upper level is a chamber of light with four angels, which suggests a mystical staircase mounting to the large window framed by palms symbolizing the palm crown of martyrdom. The key to this interpretation lies in the underside of an arch where, on a large shell, an angel has written a eulogy of St. Cecilia which breaks off in the middle of a word: DOM... This chapel of the Congregation of Musicians is like a small stage conceived as an apotheosis of the ephemeral, with the added, mysterious suggestion of interrupted music.

Though executed in the first decade of the eighteenth century, the monument to Pope Gregory XV and Cardinal Ludovisi belongs by right to the high Baroque period. With its sumptuous display of coloured marbles, it is the work of Pierre Legros the Younger and Pierre-Etienne Monnot (who also executed the triumphal altar in the church of Sant'Ignazio, designed by Pozzo at the end of the previous century). The billowing of coloured fabrics evokes the mystery of sculpture ranging beyond the limits of its usual language, intent on the spells of wonder and optical illusionism.

Pierre-Etienne Monnot (1657-1733) and Pierre Legros the Younger (1666-1719):
Tomb of Gregory XV, after 1697.
Marble.
Church of Sant'Ignazio, Rome.

THE CENTRES OF BAROQUE ART

Gian Lorenzo Bernini (1598-1680):
Bust of Cardinal Scipione Borghese, 1632.
Marble, height 30¾".

ROME, THE "GREAT THEATRE OF THE WORLD"

Paul V and Gregory XV came of the two great Roman families of Borghese and Ludovisi respectively. It was these two popes who, in the first two decades of the seventeenth century, created what may be aptly called triumphant Rome. Work on the still unfinished basilica of St. Peter's continued with encouragement and commissions from Cardinal Scipione Borghese, the pope's powerful nephew, who turned his Villa Borghese into a prestigious museum. The sculptors of the first Baroque generation competed with each other in the Pauline Chapel of Santa Maria Maggiore. There, between 1608 and 1615, working alongside Lombards like Peracca da Valsoldo, we find Pietro Bernini, Nicolas Cordier, Cristoforo Stati and Camillo Mariani. With the great manifesto-tombs of Clement VIII and Paul V, this chapel became a colossal Salon, representing the moment of contact be-

tween the specialism of the Lombards and the innovations of men like Mochi and Pietro Bernini.

The part played by this transitional generation has only recently become clear. The work of Nicolas Cordier (1567-1612) is that of a gifted restorer, while Cristoforo Stati (1556-1619) may be described as a sensual-minded virtuoso. The work of Stefano Maderno (1576-1636) was pursued beyond his masterly statue of *St. Cecilia* in a series of dynamic, small-scale bronzes. As for the Venetian Camillo Mariani (c. 1565-1611), his luminous statues in San Bernardo alle Terme (done with his pupil Francesco Mochi), with their abundant folds and emphatic modelling, mark the real start of Baroque sculpture.

A place apart is occupied by Francesco Mochi (1580-1654) and Pietro Bernini (1562-1629). Mochi has been rightly recognized, not as the last sculptor of Mannerism, but rather as the first of Baroque. His *Annunciation* has a piercing and sensual vehemence; his portraits are convincing in their psychological insight; his figures of saints (typical being the *Veronica* in the transept of St. Peter's) are imbued with a dynamic pathos; and his equestrian monu-

Francesco Mochi (1580-1654):
The Virgin of the Annunciation, c. 1608.
Marble, height 6'10".

Francesco Mochi (1580-1654):
The Angel of the Annunciation, 1605-1608.
Marble, 6'9".

ments in Piacenza renew an old theme going back to antiquity. An austere and scorbutic personage, Mochi is the *alter ego* of the triumphant Gian Lorenzo Bernini. The latter's father and master, Pietro Bernini, is unjustly overshadowed by his famous son. His *Assumption* in Santa Maria Maggiore offers a lively reinterpretation of classicism, in its working out of a new formal structure.

After Gregory XV came the Barberini pope Urban VIII (1623-1644), the Pamphily pope Innocent X (1644-1655) and the Chigi pope Alexander VII (1655-1667). The churches and palaces erected by them and their influential Roman families were the stimulus for many works by Gian Lorenzo Bernini. His biographers dwell on his precociousness and Bernini himself saw to it that this myth gained currency; he told Paul Fréart de Chantelou, who looked after him in Paris, that he had carved his *Apollo and Daphne* at the age of eighteen, while the records show that he was actually between twenty-four and twenty-seven years old. His early efforts were made rather on "Greek" lines, from the recently discovered *Seasons* for Villa Aldobrandini to *St. Lawrence* and the *Rape of Proserpine*.

During the pontificate of Urban VIII much work was done by Bernini in St. Peter's, from the Baldachin (1624-1633) to the Loggia of Relics (1629-1633), where he carved the figure of *Longinus* and left the other sculptures to Mochi, Duquesnoy and Bolgi. To understand the power and respect Bernini commanded at that time, it is enough to recall that the Baldachin alone cost the Papal

State one-tenth of its annual revenue. It was now that he arrived at a new type of funerary monument (*Tomb of Urban VIII* in St. Peter's) and of portraiture (the series of *Urban VIII* at different ages, *Scipione Borghese, Costanza Buonarelli, Thomas Baker*).

Under Pope Innocent X, after a brief eclipse, Bernini was again in favour, with his admirable portraits (that of the pope can bear comparison with Velazquez' painting of him) and a fresh elaboration of new types, from the public fountain conceived as an allegorical monument (Fountain of the Four Rivers, 1648-1651) to the figure group as a theatrical vision (*St. Teresa*, 1647-1652).

Under Pope Alexander VII, Bernini busied himself with architecture: the Sala Ducale and the Scala Regia in the Vatican Palace, Sant'Andrea al Quirinale, Santa Maria dell'Assunzione at Ariccia, the Colonnade in front of St. Peter's, the Chair of St. Peter inside—all works in which sculpture is everywhere present. Among Bernini's finest groups of this period are the *Constantine* in St. Peter's, *Daniel* and *Habakkuk* (Chigi Chapel in Santa Maria del Popolo), *Mary Magdalene* and *St. Jerome* (Chigi Chapel in Siena Cathedral). During his "diplomatic" sojourn in France at the court of Louis XIV (1665) he did the imperious portrait bust of the Sun King. To the later years belong sculptures like the angels of the Ponte Sant'Angelo in Rome (in which his efficient studio assistants took part), the reclining figure of *Ludovica Albertoni*, and the *Salvator Mundi*, works testifying to a deep and heartfelt devoutness.

Antonio Raggi (1624-1686) and Gian Lorenzo Bernini (1598-1680):
Stuccoes in Sant'Andrea al Quirinale, Rome, 1662-1665.

putti, beginning with the *Bacchanal* (Spada Gallery) and the *Sacred and Profane Love* (Doria Gallery), as in the ethereal portraits, as also in the funerary monuments in Santa Maria dell'Anima (a revival of antique schemes, with a modern sense of Hellenism), Duquesnoy stood forth as the opposite pole to Bernini. In monumental statues like *St. Susanna* (his *St. Andrew* in St. Peter's was done at Bernini's request), he even seems to depend on Bernini, the predominating master of Baroque sculpture. Settling permanently in Rome, Duquesnoy died at Leghorn in 1643, on the first stage of an unrealized journey to France at the invitation of Louis XIII. He is one of the foremost exponents of the new style, which held its own till the advent of Rococo in the following century.

Working alongside Bernini in the first half of the seventeenth century were Giuliano Finelli (1601-1653) and Andrea Bolgi (1606-1656), both natives of Carrara and both active also in Naples. Finelli acted as Bernini's expert assistant in such masterpieces as *Apollo and Daphne* and the Baldachin in St. Peter's. In his portraits (*Michelangelo as a Young Man*, Florence; *Francesco Bracciolini*, Victoria and

Alessandro Algardi (1595-1654):
Attila.
Terracotta study for "Pope Leo the Great Driving Attila from Rome" in St. Peter's, Rome.

In the period when Baroque was fully asserting itself, in the first half of the seventeenth century, two other sculptors stand out, one Italian, the other Flemish, both working in Italy: Alessandro Algardi (1595-1654) and François Duquesnoy (1597-1643).

One of the most successful artists of his time, Algardi is often thought of as contrasting with Bernini through his more "classicizing" style (derived from his schooling with the Carracci in Bologna and his contacts with Reni and Sacchi in Rome). In reality his work is distinctively Baroque (as is, one may add, that of Nicolas Poussin). After the early period in his native Bologna, Algardi settled in Rome in 1625, during the pontificate of the Barberini pope Urban VIII. He was friendly with Domenichino and did statues in stucco and portraits of noblemen. From the 1630s date several masterpieces: *St. Philip Neri and the Angel* (sacristy of Santa Maria in Vallicella), the *Martyrdom of St. Paul* (San Paolo, Bologna) and the *Tomb of Pope Leo XI* (St. Peter's). Under the Pamphily pope Innocent X, from 1644 (that is, over the last decade of his life), Algardi reached the height of his powers and enjoyed the full confidence of his patrons. As architect and stucco-worker in the Villa Doria Pamphily, he revived a forgotten mode of treating myth in sculpture. In his monumental sculpture in St. Peter's, *Pope Leo the Great Driving Attila from Rome*, he succeeded in combining bas-relief with figures in the round, agitation with dignity, dynamic contrasts with composure. Of his portraits of the Pamphily family, that of *Donna Olimpia* is unforgettable for its psychological insight and its proud sense of Roman dignity. Here he proves himself a Van Dyck or Velazquez of sculpture.

François or Frans Duquesnoy, of Brussels, was in Rome by 1618, at the age of twenty-one. Already in 1624 we find him working alongside Poussin, in this moment of passionate admiration for Titian which gives a Dionysiac turn to his early style (as also to Poussin's) and adds a distinctive note to Baroque dynamism. In his small sculptures with

Pierre Legros the Younger (1666-1719):
Religion Driving out Heresy, 1695-1699.
Marble, height c. 10'.
Church of Gesù, Rome.

Albert Museum, London), Finelli shows psychological penetration of no uncommon kind, together with wonderful technical skill. Bolgi's sculpture is cooler and stiffer, as a result in part of his Tuscan schooling under Pietro Tacca. Bolgi collaborated with Bernini on many works, among them the Baldachin, the Loggia of Relics, the *St. Helena*, the *Countess Matilda* (all in St. Peter's) and the tombs in San Pietro in Montorio.

Three masters connected with Bernini, but independent spirits in their own right, are Ercole Ferrata (1610-1686), Antonio Raggi (1624-1686) and Domenico Guidi (1625-1701).

Ferrata was a Lombard, also active in Naples. He is best remembered for the masterly high reliefs in Sant'Agnese in Agone, the church of the Roman palace of the Pamphily family. Here the altar frontals are systematically replaced by his high reliefs in marble, which go to create a Temple of Sculpture. He also did some fine work on the façades of churches (like the extraordinary angel which seems to support the second order of Sant'Andrea della Valle in Rome).

A native of the Ticino, Raggi worked alongside Bernini on the stuccoes at Castelgandolfo and the Roman churches of Sant'Andrea al Quirinale and the Gesù, shaping with his modelling tool graceful women and lovable *putti*, martyrs

and garlands, youths and maidens, which bridge the gap between the elegance of Duquesnoy and the high Sicilian confectionery of Serpotta.

As for Domenico Guidi, also a leading figure, of uncertain allegiance between Bernini and Algardi, he gained a Europe-wide reputation, contributing a sculpture to Versailles and maintaining friendly relations with Lebrun.

From this point on, names become legion, demonstrating once again that in Rome sculpture was the major art of the seventeenth century. Among this host of artists a place apart is due to Melchior Gafà (1638-1667), of Malta, who in a short working life created several masterpieces, like his *St. Catherine in Glory* (Santa Maria in Magnanapoli, Rome). Prominent among Bernini's assistants (and his school now overlapped with those of Algardi and Ferrata) were Francesco Baratta, Paolo Naldini, Giulio Cartari, Lazzaro Morelli, the Fancelli, the Giorgetti, and the bronze founder Girolamo Lucenti. Among other sculptors of great skill are Francesco Cavallini, Michel Maille, Francesco Aprile and Giuseppe Mazzuoli. Many of these artists had a hand in group undertakings in Rome like the Fountain of the Four Rivers in Piazza Navona, the *Chair of St. Peter*, the *Monument to Alexander VII*, and the Ponte Sant'Angelo, this bridge allegorically closing the century of the great Berninian worksites. Around the painter and decorator Andrea Pozzo, in the Jesuit churches in Rome, Sant'Ignazio di Loyola and the Gesù, several remarkable sculptors were at work, Pierre Legros, G.B. Théodon, Pierre-Etienne Monnot, who had much to communicate to the new century at hand.

THE ITALIAN COURTS

"Italy was the most flourishing country in Europe, but not the most powerful": so said Voltaire, with admiration, as he looked back on the seventeenth century. In reality the Italian courts lived in tragic aloofness, both economically and politically, and even Rome failed to count for as much as it claimed to. France and Spain alternated in their domination of Italy. But foreign political domination was offset by Italy's continuing prestige as the home of the arts. The only independent state was Venice, though Venetian sculpture was the one least connected with the eloquence of Roman Baroque.

NAPLES

The absolute rule of the Spanish viceroy was hardly shaken by such events as the plague epidemic (1656) and the popular uprising led by Masaniello (1647). In addition to its dependence on Spain, the ties of Naples with Rome were of the closest. In architecture the new language was brought hither by Domenico Fontana, in sculpture by Pietro Bernini; in painting, Caravaggio's short working periods in Naples remained decisive for half a century.

Cosimo Fanzago (1591-1678):
St. Bruno, 1623-1630.
Marble.
Certosa di San Martino, Naples.

The leading sculptor was Cosimo Fanzago, a native of Bergamo. His culture was that of the Counter Reformation and his taste was all for decoration; from his school arose the plastic style of southern Italy, with fountains and pulpits, railings and altars, and polychrome inlays. His *Prophets* in the Gesù Vecchio are dynamic figures, with sharp-edged draperies and emotive plays of light; the *Virgin and Child* in the Certosa of San Martino (with Pietro Bernini) is contorted and richly worked; the large bronzes in the Cappella del Tesoro in the Duomo, from near the end of his career, celebrate San Gennaro (St. Januarius), the patron saint of the city. For thirty years Fanzago worked on the decoration of the Certosa (Carthusian monastery), where he produced his most highly wrought works. In spite of brief stays in Rome, his style is closer to the Counter Reformation trend of painters like Cerano and Morazzone than to the winning voice of Gian Lorenzo Bernini. Fanzago's school spread from southern Italy to Spain; a notable example is the elaborately carved altar in the church of the Descalzas Reales in Salamanca. The two great obelisks in Naples, one in the square of San Gennaro, the other in the square of San Domenico, carry decorative profusion to the point of extravagance; the Roman obelisks, in comparison, are like ephemeral holiday constructions.

Again from Rome came Bernini's message in the persons of Giuliano Finelli and then of Andrea Bolgi. Bernini's favourite pupil, Finelli came to Naples in 1634. In addition to his forcible sculptures in the Cappella del Tesoro, among them the full-length *San Gennaro*, he was successful with his portraits; some of them even reached the church of the Descalzas Reales in Salamanca. Bolgi, too, was an outstanding portraitist, and here he shows many links with contemporary painting. The schools of these two men further stimulated the taste for decoration, filling the city and its environs with elaborate inlays of polychrome marble, and reviving a Late Empire taste in the light of a new popular festiveness. The theme of the Nativity, centring on the Christmas crib or Presepio, gave rise to a wealth of decorative effects, at which sculptors like Celebrano and Vaccaro tried their hand. "Under the fine sky of Naples, this show is staged even on the terraces of private houses," noted Goethe.

EMILIA

United in part with the Papal State, this region witnessed in painting the splendours of the Carracci and their followers, down to the active schools of Guido Reni, Francesco Albani and Guercino, and on to Crespi. Their underlying classicism is reflected in the work of Alessandro Algardi; in Bologna he did one of his deceptive bas-relief groups, the *Martyrdom of St. Paul*. One of the leading figures was Giuseppe Maria Mazza, the son of a sculptor, and in his work closely akin to the painters. He produced some lively terracottas, but his finest things are the stuccoes he did for churches (the Corpus Domini) and also for palaces: their light, of a Venetian tone, also owes something to the teaching of the Romans.

FLORENCE

The power of the Medici was on the wane; their authoritarian rule was doomed in a context of political decline and came to an end in 1743. Here as elsewhere sculpture was regarded as an important *instrumentum regni*, and the First Sculptor of the Medici court took precedence over architects and painters. This rule was still observed in the Renaissance worksites, but the Baroque ardour was introduced to Florence by the illusionist painting of Pietro da Cortona and his pupil Ciro Ferri, then by Luca Giordano.

The most striking personality of the first generation was that of Pietro Tacca (though Francesco Mochi and Pietro Bernini were also Tuscans). In his monument to Ferdinando I de' Medici, at Leghorn, the *Four Turkish Slaves* stand out, with the exoticism of a cultivated academician. In the bronze monument to Philip IV, in Madrid, Tacca develops a theme which, from the designs of Leonardo da Vinci, goes on to Mochi's groups at Piacenza. Tacca's work was continued by his son Ferdinando.

Relations with Rome were actively encouraged by Cosimo III. In the Palazzo Madama he opened a school whose sculpture masters were Ferri and Ferrata; here were

Ferdinando Tacca (1619-1686):
Fountain of the Little Bacchus (detail).
Bronze.
Formerly Piazza del Municipio, Prato.

Alessandro Algardi (1595-1654):
The Martyrdom of St. Paul, c. 1643.
Marble, height of St. Paul 6'3", of executioner 9'3".
Church of San Paolo Maggiore, Bologna.

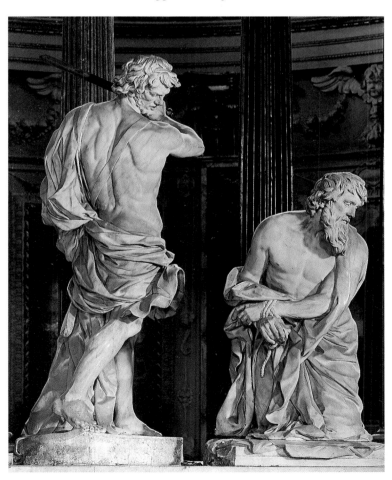

trained many new Florentine sculptors, among them Foggini and Soldani. Giovan Battista Foggini, who rose to become First Sculptor, was a remarkable portraitist; his busts of the Medici, languid and sullen, have the facial expressiveness of the Bourbons painted by Goya a century later. A work of some consequence for the spread of Baroque art is the *Chest of San Francesco Saverio* which Foggini sent out to Goa, in India.

The Florentines were particularly distinguished for their small bronzes. In this medium Antonio Susini and G.B. Foggini equalled the virtuosity of the ancients, as they catered to the taste for copies and at the same time pointed the way to Rococo. The wax figures of Gaetano Giulio Zumbo were also made with virtuoso skill: the celebration of an art which was not new, but pervaded by medieval terrors.

The principal monument of Florentine Baroque is the Corsini Chapel in the Carmine Church, as conceived or "stage-managed" by Giovan Battista Foggini. Under the dome painted by Luca Giordano, and together with the bronzes of the German artist Balthasar Permoser, Foggini gave full scope to his virtuosity. His ability to work with equal ease on a small or large scale led him to become a specialist in the field of the medal. After the middle of the century he also worked in Paris (at the court where Volterrano painted his *Triumph of the Sun King*), and Colbert was much pleased with his medal of Louis XIV.

GENOA

Aligned in politics with Spain and in its economy with France and Flanders, the city was assuming new features. Prosperity was ensured by its position as a hub of commerce throughout the Mediterranean, and its culture was the image of its wealth: the young Rubens had stopped there, and there his pupil Van Dyck painted some of his aristocratic portraits. Sculpture was introduced by the Frenchman Pierre Puget, who was in Genoa from 1661 to 1667 and often stopped there in later years. His *Immacolata* or *Blessed Virgin* in San Luca acted as a rhetorical prototype for nearly a century to come, while his *St. Sebastian* and other groups have obvious connections with local painting, from Castiglione to the De Ferraris and the Piolas. Filippo Parodi, who studied in Rome with Bernini, stands out as the founder of a school. One thinks of the figures of young girls in the Palazzo Reale, representing *Metamorphoses* with Rubensian languor. Parodi was also active in Venice and Padua where he worked on the elaborate front of the Chapel of the Treasure; most memorable is the figure of *Penitence* enveloped in brambles rendered with a virtuoso picturesqueness. From Parodi's workshop came a large amount of furniture and fittings; their carving, in the Roman manner and with reminiscences of Schor, is at once capricious and brilliant in its virtuosity. Works like the *Dressing Table* at Albisola are already fully Rococo in style.

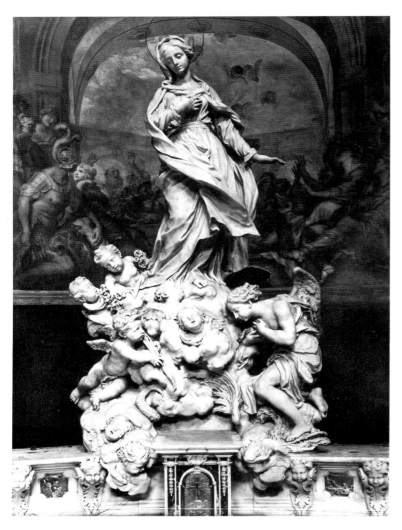

Filippo Parodi (1630-1702):
The Immaculate Conception, c. 1700.
Marble.
Church of San Luca, Genoa.

Melchior Barthel (1625-1672), Bernardo Falconi,
and Baldassarre Longhena (1598-1682):
Funeral Monument of Doge Giovanni Pesaro (detail), 1669.
Church of Santa Maria Gloriosa dei Frari, Venice.

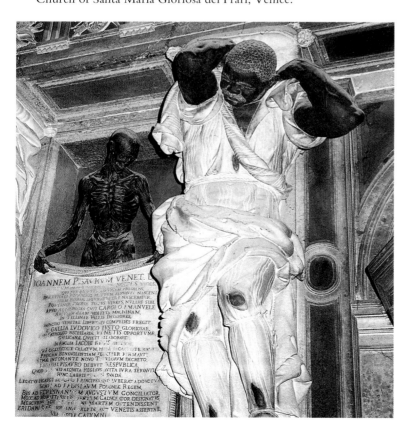

VENICE

A seaport like Genoa, Venice displays a pictorial manner largely its own, owing little to mature Roman Baroque. The new ideas arrived with Parodi of Genoa, Mazza of Bologna, the Frenchman Perrault, the German Melchior Barthel, and most of all with the Fleming Josse de Corte. The latter's imposing *Allegories of the Plague* in Santa Maria della Salute are handled in a northern and indeed almost Gothic manner, but are vivid and memorable, if rather overemphatic. Prominent among the Venetians was Onorio Marinali. Pictorial and picturesque at the same time, he is a sort of Giovan Battista Tiepolo who, in his "genre" sculptures, also reminds one of Gian Domenico Tiepolo. His decorative sculptures in countless villas on the Venetian mainland and his character heads (the finest being the seven heads of *Bravoes* in the Pinacoteca Querini Stampalia, Venice) have movements and attitudes all their own. A place apart must be accorded to Francesco Pianta, who did the sculptures of the altar frontals under Tintoretto's paintings in the Scuola di San Rocco; in addition to the vivid presentation of the figures (Mercury, for example, watching over Vices and Virtues in hermetic silence), one notes the technical proficiency of the carving. At the end of the seventeenth century, this type of artistic craftsmanship found a fresh and striking interpretation in the work of the Brustolon family, which made an original contribution to Rococo.

LOMBARDY

Regional culture here was strongly influenced by the religious impetus of the Counter Reformation, more compelling here than elsewhere thanks to the dedicated social labours of Carlo Borromeo. This culture found expression in two trends of sculpture, one popular, the other realistic. Lombardy produced many very skilful craftsmen and stone carvers, from the architect Francesco Borromini to the sculptors Ferrata and Raggi who worked in Rome, and Fanzago who became the First Sculptor of the Neapolitan court. The worksite of Milan Cathedral continued its activity in an obviously conservative sense, but the privileged theme of sculpture became the Monte Sacro or Sacred Mount. The personalities of the artists concerned are not always distinguishable (they range from Dionigi Bussola to Cristoforo Prestinari, from Francesco Silva to Martino Rezio), but this was perhaps inevitable, given the group-character of these works, governed as they are by the spirit of Counter Reformation Catholicism rather than that of sculptural practice. And so the roads into the

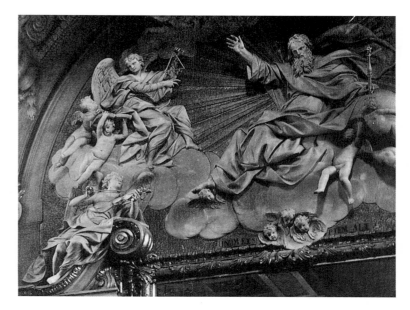

Giuseppe Maria Mazza (1653-1741):
Stucco decoration of the Main Altar, late 17th century.
Church of Corpus Domini, Bologna.

Gaudenzio Ferrari (1471/81-1546) and others:
The Condemnation of Christ, early 16th century.
Fresco and terracotta figures.
Church of the Sacro Monte, Varallo.

hill country of Orta and Varese, and also Domodossola, were marked by wayside shrines peopled with figure carvings whose meaning depends on a context of architecture, of fervent paintings and most of all an itinerary of salvation. The theme of the Sacred Mount, as the "New Jerusalem," is closely akin to the language of the sacred representation, but also to the spirit of the procession. Already a century ago these groups were much appreciated by Anglo-Saxon art lovers, such as Samuel Butler (who wrote about them in his *Ex Voto* of 1888), but it is only recently that scholars have arrived at their true interpretation. These hundreds of Lombard figure carvings, very similar to those done in neighbouring Piedmont, in a style that spread further in the eighteenth century, raise a problem that exceeds the limits of sculpture.

PIEDMONT

As the Dukes of Savoy consolidated their rule, Turin became a capital moulded on the French model. Culture was valued for its own sake and encouraged, and the arts followed the lead of architecture which, with Guarino Guarini in the late seventeenth century, celebrated the mystical marriage of mathematics and structure. Some very fine stuccoes are to be seen in the various residences of the ducal family (Venaria Reale, Rivoli, Castello del Valentino), and in Piedmont too figure carving flourished in the Sacred Mount groups (Varallo, Crea, Oropa). The artists' names are different, but they are at one in the moralizing group-character of their work: Giovanni Tabacchetti (the Fleming Jean de Wespin, known as Tabaguet), Giacomo Paracca da Valsolda, Giovanni d'Errico, the brother of Tanzio, the most curious and gifted of these sculptors. They were intent on a truthful rendering, in a popular and indeed rustic style; the colouring is theatrical and Hispanic; the pathos extends from anecdote to life experience, with the tactile use of actual materials (real necklaces and wigs of human hair).

THE FRANCE OF LOUIS XIV

Antoine Coysevox (1640-1720):
The Crossing of the Rhine, c. 1681-1683.
Stucco bas-relief, height 10'8".
Salon de la Guerre, Château de Versailles.

The "world capital": thus, in the mid-seventeenth century, was Paris proudly described by the Duc de Bouillon. It challenged Rome for the first place on the map of Europe. For thirty years France had gained steadily in prestige thanks to Cardinal Richelieu and his successor Mazarin, chief ministers governing with great political

skill under Louis XIII and the early reign of Louis XIV. Religious unity was sought by arms, while the growth of the bourgeoisie was encouraged as a counterweight to the old aristocracy.

In the field of culture the whole trend was classical; in other words, it was Italianizing. Lemercier and Mansart dominated French architecture. In painting, besides Simon Vouet, the great Philippe de Champaigne led the way: he proposed a synthesis between Flemish vision and Jansenist spirituality. In the field of thought, this was the transition from the method of Descartes to the scientific spirit of Pascal. In the theatre, Scaramouche (the Italian Tiberio Fiorilli) answered to the toga'd characters of Pierre Corneille. From afar (for they were working in Italy), Nicolas Poussin and Claude Lorrain pointed to the firmament of ideas and the truth of nature.

French sculptors too looked to Rome. One thinks of Jacques Sarrazin, who was trained under Mochi and Domenichino. On his return to Paris he carved the caryatids of the Pavillon de l'Horloge at the Louvre (1641) and then the monument to the Prince de Condé (now at Chantilly). He contrives to combine something of the Korai of the Erechtheum with the morbid sensibility of the School of Fontainebleau. An equally transitional position is occupied by the brothers François and Michel Anguier.

The Louvre and Versailles became the two focal points of French art under Louis XIV, the Sun King (it was he himself who spoke of the new interest for "the court and the town"). The economy as reorganized by Colbert was directed towards centralization, mercantilism and supremacy outside Europe (which involved colonial wars with the English), and culture was also taken into account. Great prestige attached to the Royal Academy of Painting and Sculpture, founded at Colbert's prompting in 1663. Its president for life was Charles Le Brun, the real creator of the Louis XIV style in the arts. A master decorator and interpreter of French grandeur, Le Brun had been in Rome in 1642 with Poussin on the latter's return from his stay in Paris. In 1660 Le Brun designed the decorative furnishings for the king's triumphal entry into Paris and was appointed First Painter to the King. He later worked at the Louvre (Galerie d'Apollon with stuccoes by Girardon) and at Versailles (Salon de la Guerre, with sculptures by Coysevox, and Galerie des Glaces).

In giving his first royal commandment to the members of the Academy ("I entrust you with the most precious thing in the world: my fame"), the king who said "L'Etat

François Girardon (1628-1715):
Nymphs Bathing (detail), late 17th century.
Marble bas-relief.
Gardens of the Château de Versailles.

Antoine Coysevox (1640-1720):
Bust of Louis XIV, 1686.
Marble, height 35″.

c'est moi" laid down the lines of an artistic undertaking whose primary aim was political. It was Colbert again, as Superintendent of Royal Buildings, who was responsible for the revival of the Gobelins tapestry factory, officially called the Royal Manufactory of Furniture for the Crown, while the Louvre and Versailles were intended as the twin glories of the new centralized kingdom. The competition for the Louvre mobilized several Italian architects (Pietro da Cortona, Carlo Rainaldi, Gian Lorenzo Bernini), and in 1665 the reluctant Bernini (then almost seventy) was summoned to Paris; he accepted for reasons of state.

During the six months he spent in Paris, Bernini made various designs (Chapelle Bourbon, altar of the Val de Grâce), carved his marble bust of Louis XIV, taught the French the technique of caricature, and witnessed the laying of the foundation stone of the New Louvre. As things turned out, his presence served no purpose. His project for the New Louvre was abandoned, a victim of the endless struggle between the *bon goût* and the *grand goût*, the grand style which Bernini represented. Nor was he any more successful with his fine *Equestrian Statue of Louis XIV*. Sent from Rome in 1684, it was relegated to a corner of the park at Versailles, after undergoing a change of personality at the hands of Girardon (who converted it into a *Marcus Curtius Leaping into the Flames*).

Bernini had an able and ideal follower in Pierre Puget. In a letter to Colbert of 1669, Girardon had been critical of

him: "In Genoa I have seen some of Puget's works. Of art there is much in what he does and the marble is well wrought. If one looks for any natural beauty and fine draperies, nothing of the sort is to be found. Nevertheless it makes a great effect." A native of Marseilles, Puget did his early work there and in Toulon, where his aggressive and anguished atlantes at the Town Hall date from 1656. From Paris he went south again and in Genoa produced a masterpiece instinct with the pictorial illusionism of Bernini: the *St. Sebastian* in Santa Maria di Carignano. "The marble quivers before me," he once said. Not till 1670 did he receive from Colbert a commission for the royal buildings: out of it came his masterpiece, *Milo of Crotona*, followed by *Alexander and Diogenes*. But with his violent and passionate temperament Puget was somewhat cramped by the requirements of the place and times. More freedom, even in minor official commissions, was enjoyed by his pupil Christophe Veyrier, who through his master rediscovered the (pre-Rococo) grace of Alexandrian Hellenism.

To come back to the cultural climate of the period. It was precisely the idea of an art conceived as ceremonial that led in France to a fully worked out theory of art. A strict and doctrinal *Cours d'Architecture* was published by François Blondel, while André Félibien in his *Entretiens* defined the laws of painting (giving precedence to design over colour). Jean Racine set his plays firmly within the

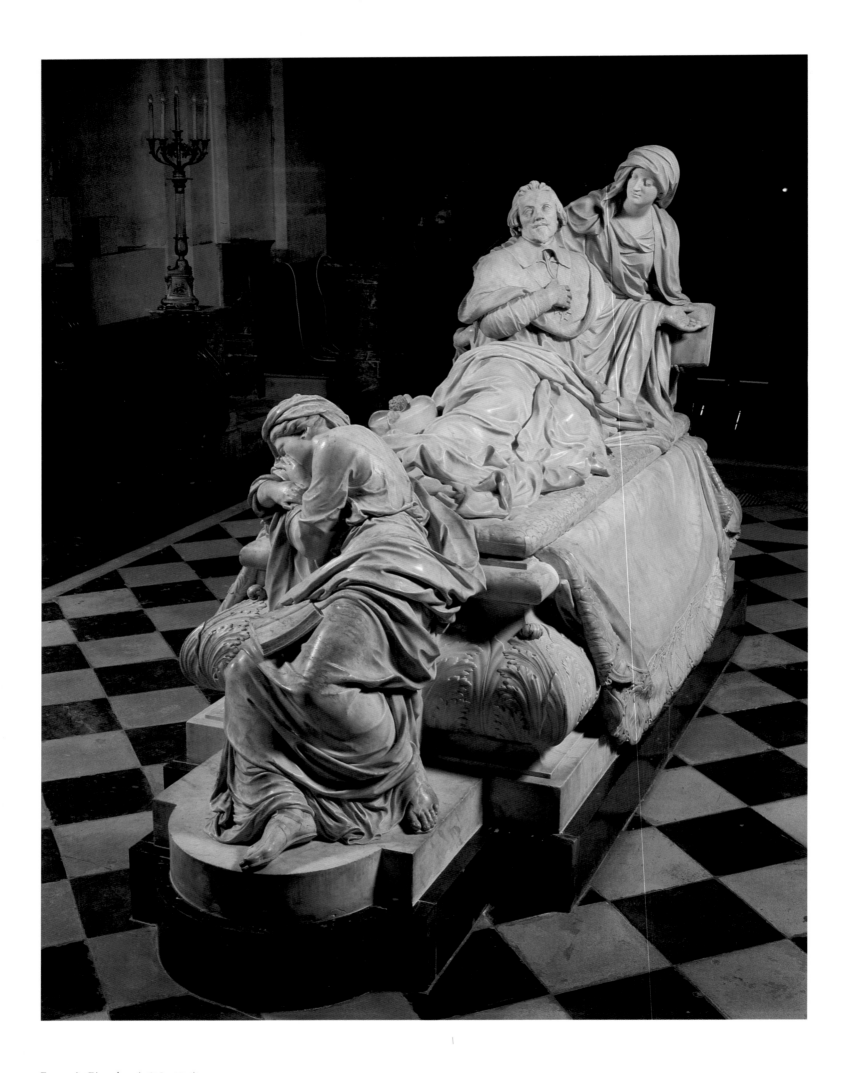

François Girardon (1628–1715):
Tomb of Cardinal Richelieu, 1694.
Marble.
Chapel of the Sorbonne, Paris.

rational scheme of the classic unities of time, place and action, while Nicolas Boileau in *L'art poétique* carefully limited the freedom of versification, just as Bossuet in his *Instruction sur les états d'oraison* prescribed the theory and methods of that new literary and gestural genre, the funeral oration. Some other men worked in a spirit that took no account of court etiquette: Molière, the master of biting and satirical comedy; La Rochefoucauld, the sceptical and pessimistic moralist; La Fontaine, who with his animals, fools and schemers mimicked the absurd ballet of court life. In the world of the theatre, the Comédie-Française was founded in 1677, and the Italian Commedia dell' Arte flourished in Paris, with its original cast of vivid and amusing characters.

The official sculptors of the period were François Girardon and Antoine Coysevox. It is not easy to characterize their style, even though Girardon kept to the rules laid down by Le Brun (with whom he collaborated) and seemed to comply with the Academy, while Coysevox seems to follow the example of Bernini. In reality their style was continually shaped by the taste of the court, as one can see so clearly in their funerary sculptures for the great ministers of state. Girardon did the *Tomb of Richelieu* at the Sorbonne, Coysevox the *Monument to Colbert* (Saint-Eustache) and the *Tomb of Mazarin* (now in the Louvre). In full length, with dignified gravity, Cardinal Richelieu lies on the sarcophagus, supported by the allegorical figure of Piety, while at his feet the figure of Christian Doctrine, in intricate mourning garments, closes the ideal triangle of sorrow. Here the epic strain of Bernini is tempered by the Attic equilibrium of Poussin. Cardinal Mazarin, on the other hand, is portrayed kneeling on his sarcophagus, with one hand pressed to his heart, and looking out at the spectator and (originally) the congregation. Beside him kneels an angel holding his emblem (lively and Rococo), while at the foot of the sarcophagus sit three bronze Virtues, nobly draped in noble attitudes. Fervent in its details, the sculpture loses force when seen as part of an overall ensemble.

Again at Versailles we witness the clash of two styles. Girardon's groups in the park stand opposed in their naturalism to the historical rhythm displayed by Coysevox in the Salon de la Guerre. For the Grotto of Thetis, Girardon carved a group of seven life-size figures, *Apollo Tended by the Nymphs*; to this apparition was originally to be added another, the *Horses of Apollo* (now in another part of the park). Though monumental and heroic, the Apollo group seems in its style to vie with more refined and delicately chiselled models, such as biscuit ware and ivories; it aims at and achieves decorative refinement.

It was also for Versailles that Girardon did his bas-relief of *Nymphs Bathing*. One is not surprised to find Renoir, in 1885, confessing to Ambroise Vollard that he had looked long and carefully at these alluring (and already eighteenth-century) nudes. As for Coysevox, mention must also be made of his portraits: the moving terracotta bust of *Le Brun* in the Wallace Collection, the one of *Louis XIV* at Versailles, and the more mature and authoritative *Louis XIV* at Dijon, with its deeper psychological insight.

FROM CENTRAL EUROPE...

Among the various countries contending for hegemony within the Empire, the cultural and political situation was not very different from one to another. The prevailing influence in art was Italian to begin with, then French. This was the period of the Thirty Years War (1618-1648). This costly struggle between Catholics and Protestants was brought to an end by the Peace of Westphalia, which sanctioned the existence of thirty-five small independent states in Germany. By the end of the seventeenth century Prussia stood out amongst them. Frederick II drew many states into an alliance extending to north and south. He was a despot, but an enlightened one, as vouched for by the reforms he carried out in economics and lawmaking (his civil code, his granting of freedom of the press and of worship), also in culture (he founded the Academy of Sciences in Berlin). One key to an understanding of the transition from Baroque to the eighteenth century is to be found in the work of Leibnitz, who from his early treatise *De arte combinatoria* went on to the discovery of infinitesimal calculus and the majestic synthesis of his New System of Nature, the theory of "pre-established harmony."

The language of art varied according to the religion of the country concerned. Among Catholics the lead was taken by Austria and Bavaria, among Protestants by Prussia and Saxony. After John Sobieski defeated the Turks at Vienna (1683), a certain unity took shape which was also reflected in the arts.

The state of culture was by no means stagnant in Central Europe. Several Academies of Fine Art were founded (Donner and Moll taught in Vienna, Schlüter in Berlin). Bach, born in 1685, gave music a new depth, richness and harmony. Architecture at the various courts was largely in Italian hands, and many of the painters and stage designers active there were also Italian.

Not many sculptors here were able to arrive at a language of their own, free of the stamp of French and Italian art. The only signs of novelty are to be seen in the internal and external decoration of churches and palaces, and it was largely craft work. The case of Andreas Schlüter is typical, in that he combined the professions of architect and sculptor, and we find that his sculpture (e.g. the equestrian statue of the Great Elector at Charlottenburg) is much more dynamic than his buildings.

The first generation was made up of Georg Petel, Matthias Rauchmiller and Balthasar Permoser. In such ivory carvings as his *St. Sebastian*, Petel gave new dignity to a minor technique; and into his larger sculptures (which may be described as Rubensian) he carried over from this experience a sense of preciosity. Rauchmiller was prominent in the growing Vienna of the mid-seventeenth century. In addition to his work on the *Plague Column* in the Graben, several of his Berninian or Rubensian statues are noteworthy: *Apollo and Daphne* and the *Rape of the Sabines*. Winckelmann admired him: "He surpassed the Greeks in the gracefulness of his figures." Balthasar Permoser learned the language of Bernini and was already elaborating on it in the Corsini Chapel in Florence and then in Venice. From his workshop came many figures in the Zwinger at Dresden (designed as a cosmic sculpture, the Zwinger was the emblematic building of the period). Permoser's statues and groups may be described as a development of ivory carving into monumental terms.

... TO THE NEW WORLD

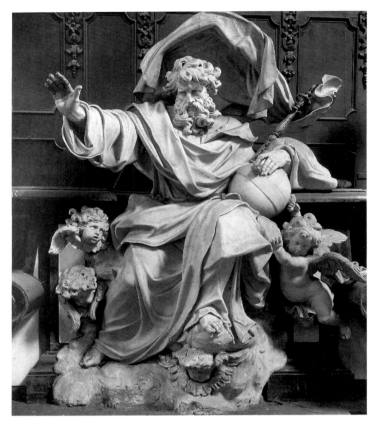

Artus Quellinus the Younger (1625-1700):
God the Father, 1676.
Marble.
Antwerp Cathedral.

The Low Countries present a sharp contrast. In the Protestant North (present-day Holland), where the urban bourgeoisie prevailed, sculpture never made its way into the Gothic space of the cathedrals. In the Catholic South (roughly corresponding to Belgium) Spanish influence imposed a court art and culture steeped in the spirit of Catholicism. The economy was flourishing. Amsterdam was the marketplace of Europe and Dutch cities were shaped by the first modern forms of town planning. Sculpture, however (and architecture too), receded into the background, leaving the field free to painting, stimulated here by the phenomenon of private collecting. The epic grandiloquence of Rubens stands in contrast with the Biblical pessimism of Rembrandt, while the prolific Flemish genre painters stand in contrast with the space-light painting of Vermeer.

Sculpture, then, had to compete with painting. The greatest Flemish sculptor of the period was François Duquesnoy, of Brussels, active in Rome during the first half of the seventeenth century; his father, Jerome Duquesnoy, was also a sculptor. In Antwerp worked the Verbruggen dynasty, from the great Pieter to his sons Hendrik and Pieter the Younger; in their saints and allegories they take inspiration from the more decorative side of Rubens' genius. While the Quellinus family peopled the churches of Antwerp with statues, a place apart is occupied by Lucas Faidherbe, who after training in Rubens' studio returned in 1641 to his native town of Malines and gave a new face

to various churches (Béguinage, Brussels; Jesuit Church, Louvain; Notre-Dame d'Hanswyck, Malines).

To understand the relation between such a sculptor and the great painting of the day, it is helpful to read the testimonial which Rubens gave him. From between the lines we gather two distinct facts: the close connection between the two arts and the need felt by the political authorities for the imagery supplied by artists. "I the undersigned hereby declare and attest that Lucas Faid'herbe has resided with me for over three years as my pupil, and that, in view of the relations existing between painting and sculpture, he has made the greatest progress in his art, with the help of my advice and through his own diligence and natural aptitude; and that he has executed for me various carvings in ivory, of finished workmanship and worthy of praise. In consequence whereof, I think it fitting for all town magistrates and lords to grant him favour and encourage him with dignities, franchises and privileges, that he may take up his abode among them and embellish their homes with his work."

England, considered in economic terms, was tantamount to an extension of the Low Countries. For a country which perhaps did not even have a "renaissance," the language of Baroque art seemed unthinkable, despite the early pointers in this direction of a Rubens or a Van Dyck. Baroque is only to be seen on the Elizabethan stage, and not only in Shakespeare, with the implied emphasis on metamorphosis, the interwoven culture of sensuality and morbidness, and the adroit use of the "play within the play." English empiricism thus manifested itself wholly in terms of culture (Bacon, Locke, Kepler, Newton, or the inductive method, toleration, the "new science").

In Spain it was the very absolutism of the monarchy which made it so easy for religion to be used as an *instrumentum regni*. The Inquisition was like a sacred institution. The economic driving force of the country came from the overseas colonies, but Spain was unable to fashion the raw material (gold) and already by the beginning of the seventeenth century was experiencing the phenomenon of growing inflation, which in time spread to the rest of Europe. Culture reflected the religious orientation; it also reflected the latent crisis. To the sacred theatre of Lope de Vega and Calderón was opposed the *Don Quixote* of Cervantes which ironically emphasized the cleavage between the nobility and the world of everyday life, marking the end of an epoch.

The masters of Spanish sculpture were Juan Martinez Montañés, Alonso Cano and Pedro de Mena. Their language was still bound up with Renaissance fixedness, even in their popular vein which found expression in polychrome figures. The most active centre was Seville, where the gold ships came in and whence the local sculptures were shipped out to the churches of Latin America. Here at the end of the century worked the Churriguera family, which multiplied ornament with growing extravagance, giving rise to the style known as Churrigueresque, which seems to anticipate the artfully contrived *bricolages* of Gaudí.

It was about the middle of the sixteenth century that began the Spanish colonization of Latin America, with all that such an endeavour implied in the way of economic exploitation and violence, for one civilization imposed itself on another by force. Both Spain and Portugal were characterized by bureaucratic and religious centralism. To the new world they transferred many religious orders

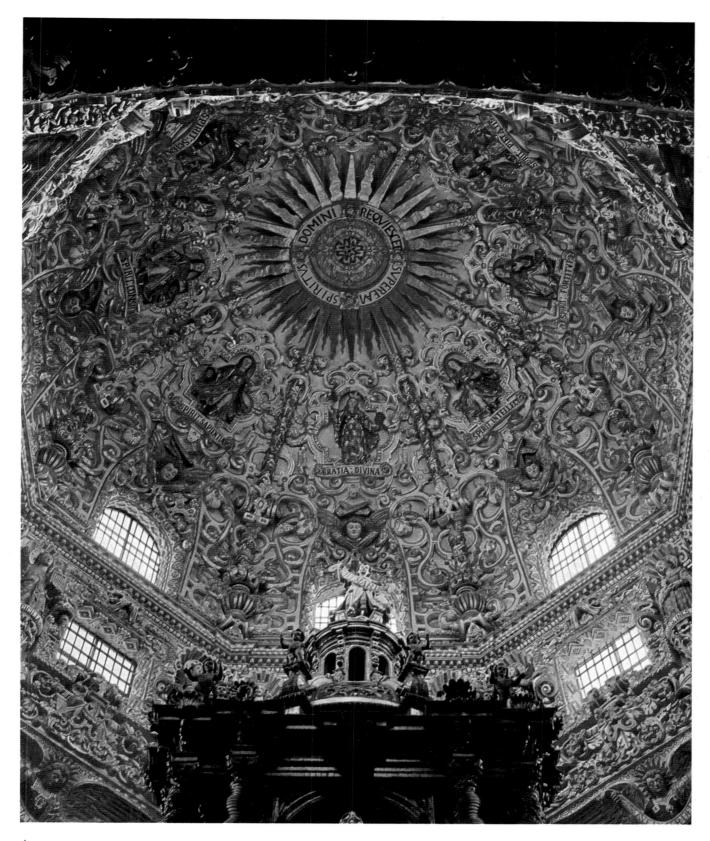

Anonymous:
Chapel of the Rosary, 1650–1690.
Church of Santa María del Rosario, Puebla, Mexico.

which, by the beginning of the seventeenth century, already numbered 70,000 churches and 500 monasteries. So it was only natural for this art to take, very largely, the form of religious propaganda. Asceticism and agony, ecstasy and triumph: these were the themes, typically Spanish themes, and Spanish too was the prevailing use of brightly coloured woodcarvings. The stylistic vocabulary of European art was taken over in Latin America, slowly distorted and given a new pathos deriving from popular reinterpretations. The dividing line between the colonial empires of Spain and Portugal was drawn by a pope: imagery and culture on both sides remained Catholic. Being an art for all, made by all (many of these works of sculpture are anonymous), it was lavishly decorated and comes like a glittering outburst of the last fires of European absolutism.

IMAGES AND FORMS OF BAROQUE

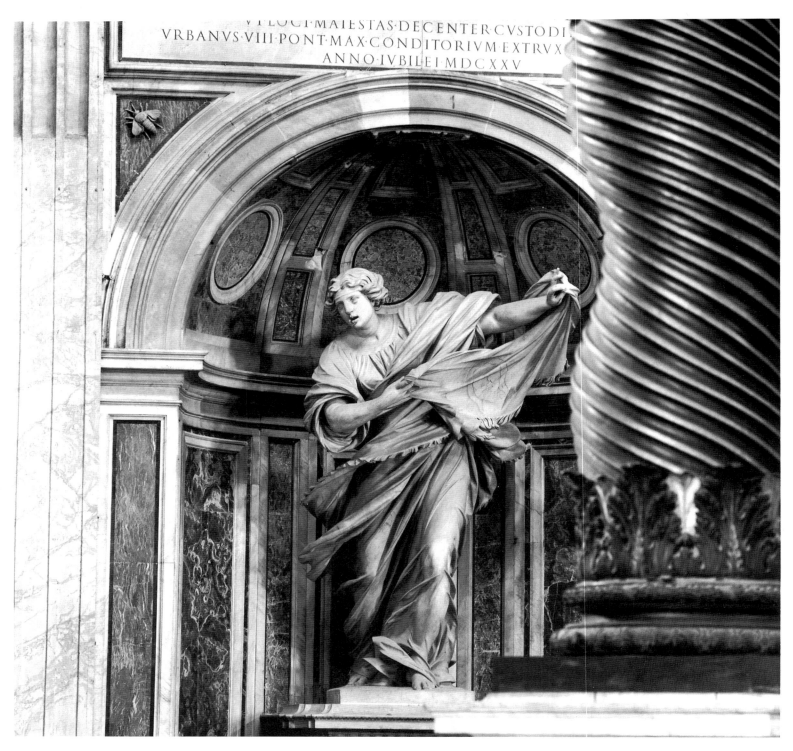

Francesco Mochi (1580-1654):
St. Veronica, 1646.
Marble, height 16½'.
St. Peter's, Rome.

FRANCESCO MOCHI: ST. VERONICA

Francesco Mochi's eloquent statue of St. Veronica stands in one of the four niches of the piers supporting the dome of St. Peter's; in one of the other three is the *Longinus* of his great rival, Gian Lorenzo Bernini. Mochi's marble figure still has certain Michelangelesque overtones, chiefly noticeable in the skilful mixture of violence and languor. While its folds are sharp and dry, the play of the drapery, and of the veil, conveys an impression of convulsive dynamism. The joins are schematic, but at the same time the artist invents the effective device of showing the hand en-

tangled in the miraculously fluttering veil. One is reminded of a similar instability tested out by Mochi in the footstool which, in his Orvieto *Annunciation*, slips from under the Virgin's knees.

This colossal figure of Veronica accordingly embodies a subtle dialectic between ancient and modern which was not understood in Rome; the influence of Bernini was then too overpowering. Mochi's austereness, served by great technical skill, may be compared with the ultra-religious specialism of Borromini.

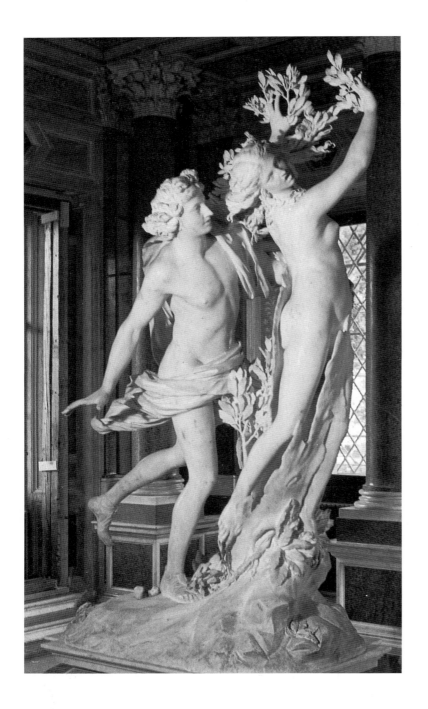

GIAN LORENZO BERNINI: APOLLO AND DAPHNE

One of the most successful of Bernini's early works, emblematic of the Baroque century. As in a poem by Marino, a man of the previous generation, the sentiments expressed are schematized choreographically in the dynamic allegory of metamorphosis. The classical myth of Apollo and Daphne, as here reinterpreted in a modern key, is also a moral allegory, or moral warning, formulated in the Latin couplet by Cardinal Maffeo Barberini (the future Urban VIII) inscribed on the sculpture: "Quisquis amans sequitur fugitivae gaudia formae/Fronde manus implet, baccas seu carpit amaras" (The lover intent on the pleasures of fleeting beauty fills his hands with leafage or plucks bitter fruit). The fable of Daphne, transformed into the laurel sacred to Apollo, also refers to poetry and to the Barberini family, whose armorial bearings include the laurel–which accordingly figures in other works done by Bernini for the same family (*Rape of Proserpine*, *St. Bibiana*, the Baldachin in St. Peter's).

The Apollo Belvedere here assumes its Catholic form (albeit a fleshly form), the female figure modestly conceals her nudity behind the upspringing laurel tree, and her fingers are turning into branches: a work of wonderful virtuosity which calls on painting for help and aspires to the energy of a fireworks display.

Gian Lorenzo Bernini (1598–1680):
Apollo and Daphne, 1623–1624.
Marble, height 8'.

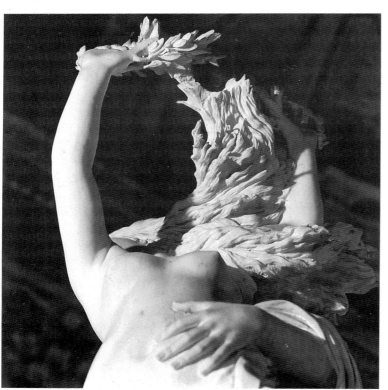

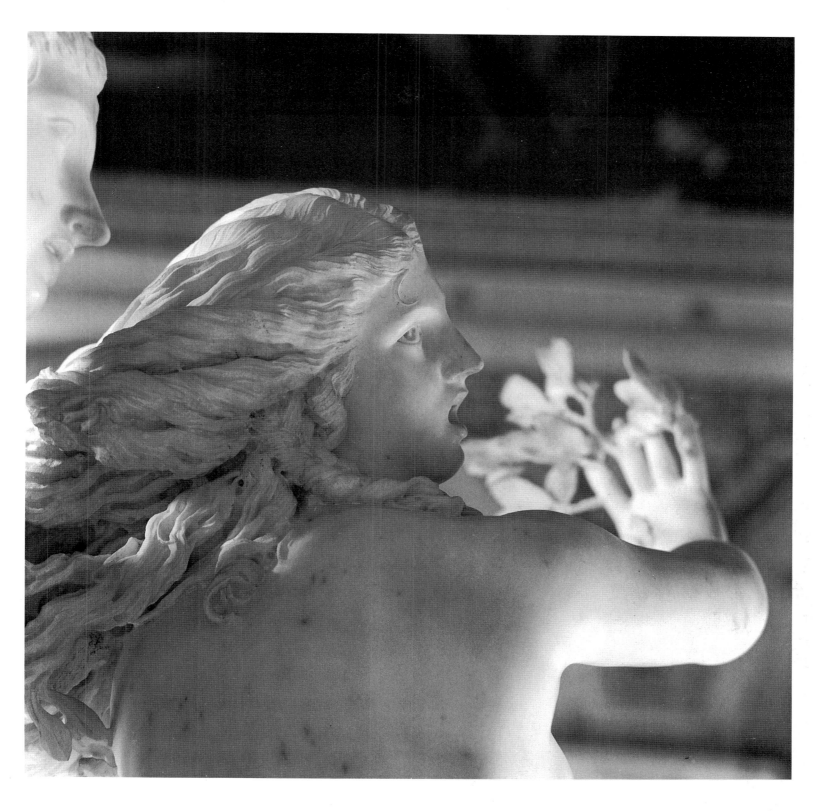

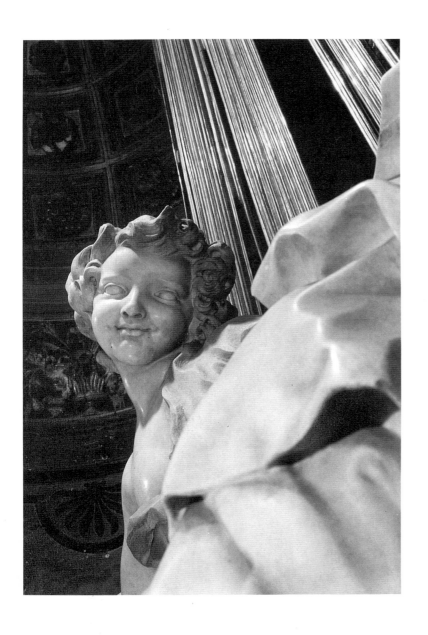

GIAN LORENZO BERNINI:
THE ECSTASY OF ST. TERESA

The setting of this group consists of a carefully articulated variety of stones retrieved from ancient ruins in Rome (some twenty different kinds, including jasper, breccia, alabaster, lapis lazuli, red marble from France and black from Belgium), which go to constitute a theatre of salvation. Here, twenty years after the group of *Apollo and Daphne* (and in a church restored by the same patron, Scipione Borghese), Bernini tackles a similar theme, as old as the tradition of the images: the female principle transmuted by the action of the male principle. The two figures are situated in space with a subtle displacement of their bodies. Almost indescribable is the gesture of the angel-satyr, shown as he draws the dart from the female body, caught in momentary abeyance before it falls back. The figures are brought to life before our eyes. The centre of gravity of this complex mass of marble is shifting: the saint is sinking down (her symbolic foot emerging), and the young satyr moves into the forefront. The focal point of the whole is in that flame-tipped arrow so vividly described by St. Teresa of Avila in her spiritual autobiography.

Gian Lorenzo Bernini (1598-1680):
The Ecstasy of St. Teresa, c. 1647-1652.
Marble and gilt bronze, height 11½'.
Cornaro Chapel, Santa Maria della Vittoria, Rome.

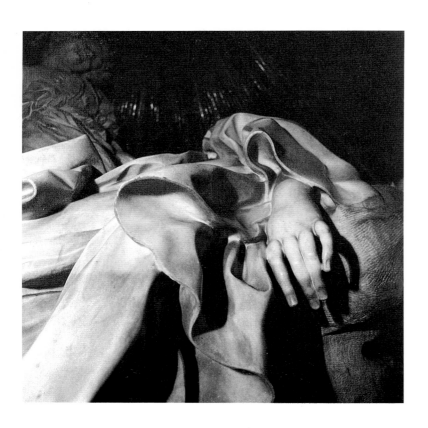

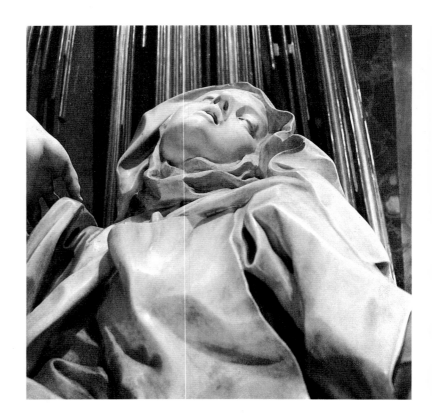

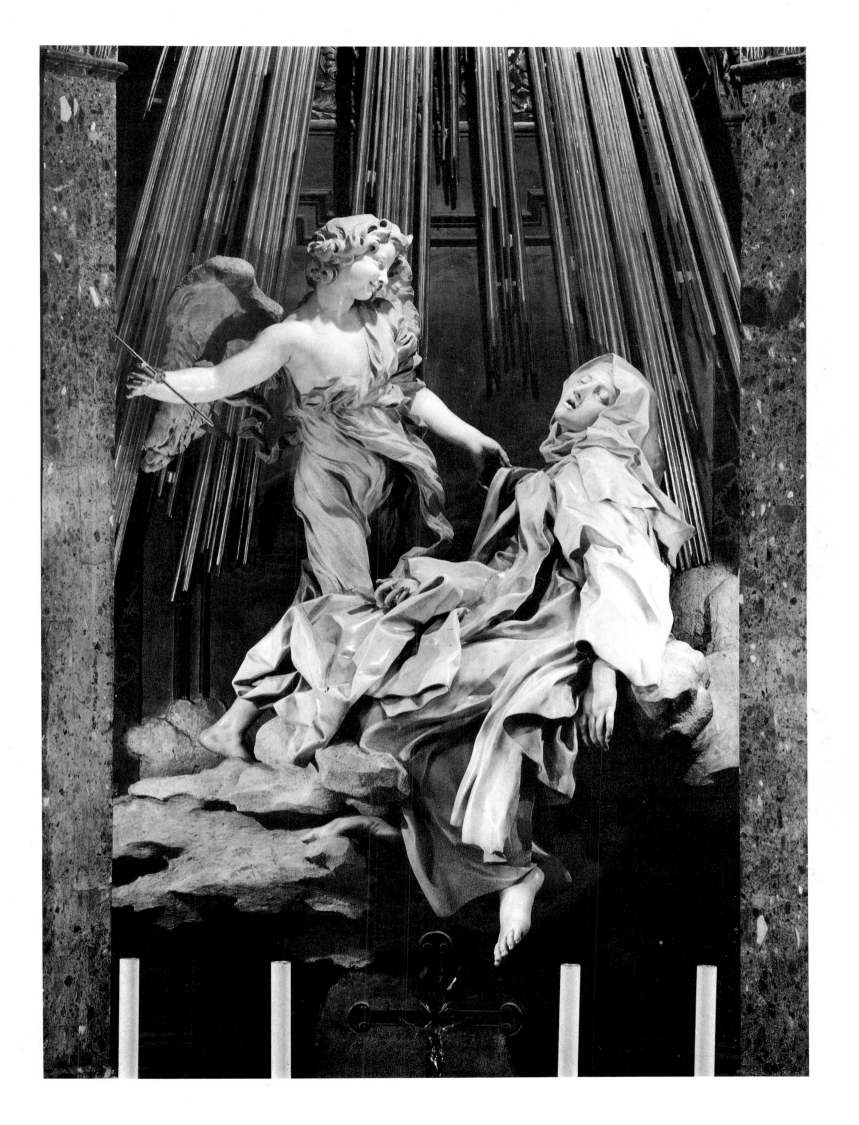

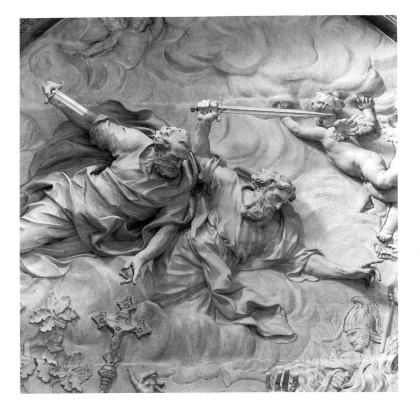

ALESSANDRO ALGARDI:
POPE LEO THE GREAT DRIVING
ATTILA FROM ROME

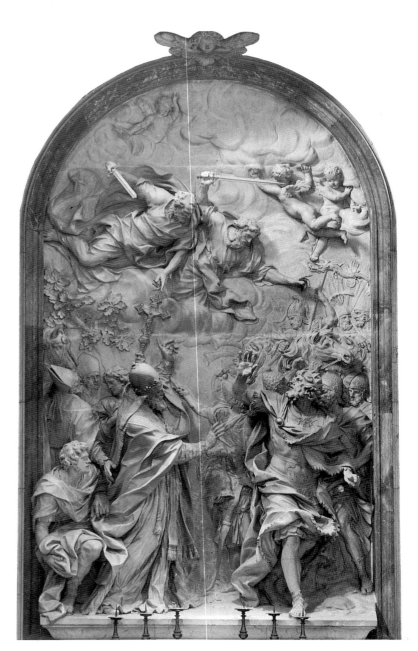

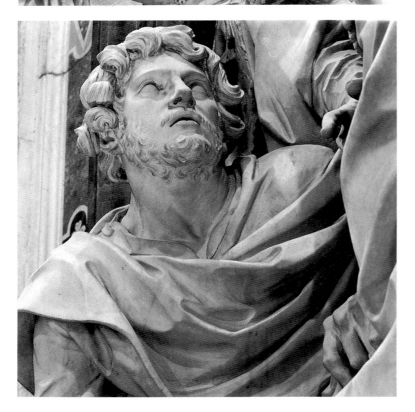

Alessandro Algardi (1595-1654):
Pope Leo the Great Driving Attila from Rome, 1646-1653.
Marble.
St. Peter's, Rome.

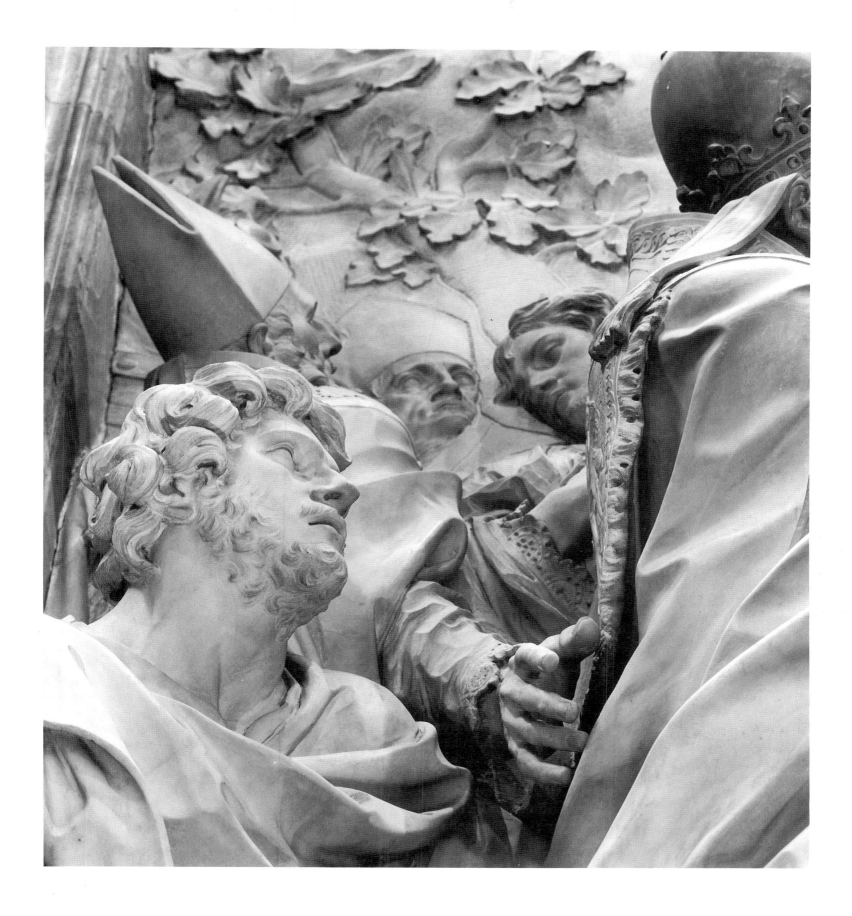

In the pontificate of Innocent X Pamphily, in the left transept of St. Peter's, a pope is shown meeting his opposite number (exemplifying barbarous violence): it was Alessandro Algardi, in the mid-seventeenth century, who worked out the balanced typology of this historical bas-relief. A strict classicist, Algardi succeeds in assembling on the white surface a "continuum" of emotions (as the theorists say) which refer back to each other: from the astonished trainbearer to the imperious pope, the awe-stricken barbarian, the apostles St. Peter and St. Paul threatening him with drawn swords from the stormy sky above. Rounded shapes and flattened relief are interwoven

in the subtle spatial architecture organized by an artist whose life, written by Bellori, is fittingly entitled "Algardi Sculptor and Architect."

The layout is classical and pictorial: the natural outcome of his early schooling (the academy of the Carracci in Bologna, the journey to Venice before settling in Rome), of his early Roman work (restoring ancient statues for Cardinal Ludovisi), of his fruitful encounters (with the sculptor Duquesnoy and the decorator Sacchi, also with the myth-loving Poussin and the theorist Bellori). The "tableau vivant" effect is even stronger in the life-size model of the relief (now in Borromini's Oratorio dei Filippini, Rome).

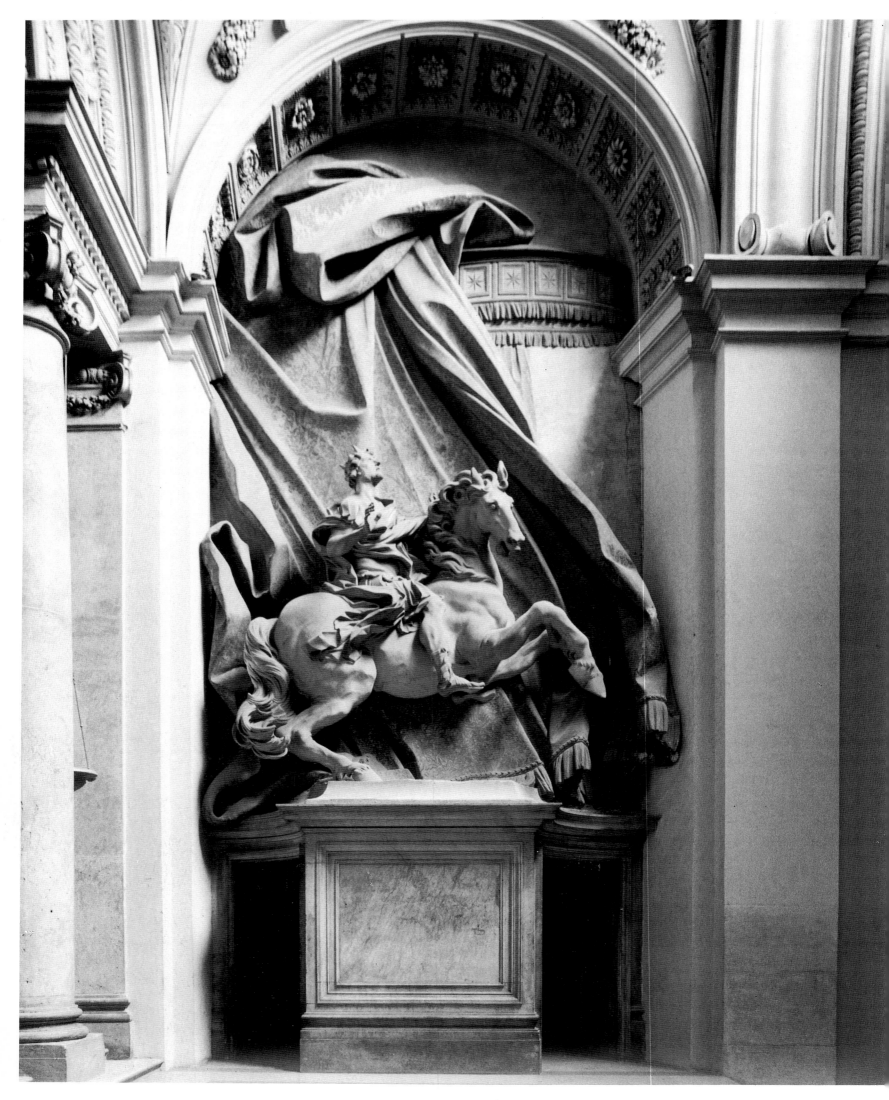

GIAN LORENZO BERNINI:
CONSTANTINE ON THE SCALA REGIA OF THE VATICAN

Bernini's statue represents the Roman emperor who first recognized the cross as the sign by which he would conquer, and accepted the Christian faith. Only natural, then, that Pope Alexander VII should wish it to stand at the entrance of the Vatican Palace, beside the grand staircase or Scala Regia. Here merge the two basic motives of the Baroque church: temporal power and spiritual sovereignty.

The emperor on horseback is set on a pedestal, with a drapery behind him fluttering in the wind: one cannot help being reminded of a stage curtain, for its quality is purely scenographic. In this it is rather like another of Bernini's equestrian statues, that of Louis XIV, which found no favour at the French court precisely because of this theatrical feature.

The ancient typology of the man on horseback, revived by the humanists of the Quattrocento, assumes in Bernini the triumphal assertiveness of a Late Antique monument. Then in its placing there is a subtle psychological tension, since the prancing horse expresses its own pent-up dynamism, while the curtain behind is shaken by the wind, in a representation which, in a sacred-profane setting, displays the quickening energy of nature.

Gian Lorenzo Bernini (1598-1680):
Constantine, c. 1663-1670.
Marble with painted stucco drapery.
Scala Regia, Vatican Palace, Rome.

Gian Lorenzo Bernini (1598-1680):
Project for a Monument to Constantine, 1654-1657.
Drawing.

195

PIERRE PUGET:
MILO OF CROTONA

Arising as an autonomous form, the statue developed into something more complicated in the Baroque age, being interlocked with other statues in order to draw the spectator into the plastic group. Pierre Puget, on the other hand, seems intent on reverting to the specific value of the figure and the specific quality of the bas-relief. In the centre he places a void, encircled in a centripetal rhythm by the tensed and twisted figure, with arm and legs outstretched towards the treetrunk and drapery. Reminiscences of Bernini (the tree of like quality to that of *Apollo and Daphne*, the tragic face similar to that of Pluto in the *Rape of Proserpine*) fail to disrupt the court style, which here is eminently "clear and distinct."

A different mythology and a nostalgic space can be divined behind this group of the Greek athlete attacked by a lion. His rival François Girardon, passing through Genoa (where Puget worked for some years), saw nothing in his sculpture of "natural beauty and fine draperies," but only "effect." And indeed the twisting dynamism of Bernini and the exuberant fleshiness of Rubens are turned here into a complicated pattern of forceful lines and planes, which shift the weights to the inside or the outside, in a reconciliation of centripetal with centrifugal movement.

Pierre Puget (1620-1694):
Milo of Crotona, 1672-1683.
Marble, height 8′10″.

Designed by Nicolas Poussin (1594–1665):
Termini or Boundary Figures: left to right, Faun, Flora, Pan.
Gardens of the Château de Versailles.

Charles Le Brun (1619-1690):
The Four Seasons, figures drawn as models
for the sculptors at work at Versailles.
Left to right:
Summer, Spring, Autumn, Winter.
Pencil and ink wash, 9″ × 19¼″.

The terminus or boundary stone protected the limits of a property or territory; in the seventeenth century it was much used as a decorative feature. Being half man and half post, it permitted the artist to express a classical vision, a suggestion of the theatre or an allusion to the wealth of nature or to whoever may have tamed it. Fourteen termini were ordered from Poussin by Nicolas Fouquet, superintendent of finance in France, for his château at Vaux-le-Vicomte. Poussin modelled them in clay and they were executed by a team of Roman stonecarvers. "I often saw him working the clay and modelling with great facility," wrote Bellori, his first biographer. In this series of rural personifications (Pan with his panpipes, Pallas and Ceres, Bacchus with ears of corn and grapes, nymphs with cornucopias), Poussin was trying to recover the pictorial value of two specific experiences: that of classical sculpture (which is always an adroit synthesis of the Apollonian and the Dionysiac) and that of the painting of the Carracci (whose ceiling painting in the Palazzo Farnese contains termini which seem almost human).

These termini by Poussin animated the grounds of Vaux-le-Vicomte with their panic presence (a compound of Classical and Baroque), surprising apparitions, almost like an emanation of nature.

Statues after the antique in the Gardens of Versailles:
Left to right, Callipygian Venus by Clérion, Silenus by Mazière, Belvedere Antinoüs by Legros, Mercury by Mélo, Dying Gladiator by Monier.

FRANÇOIS GIRARDON: APOLLO TENDED BY THE NYMPHS

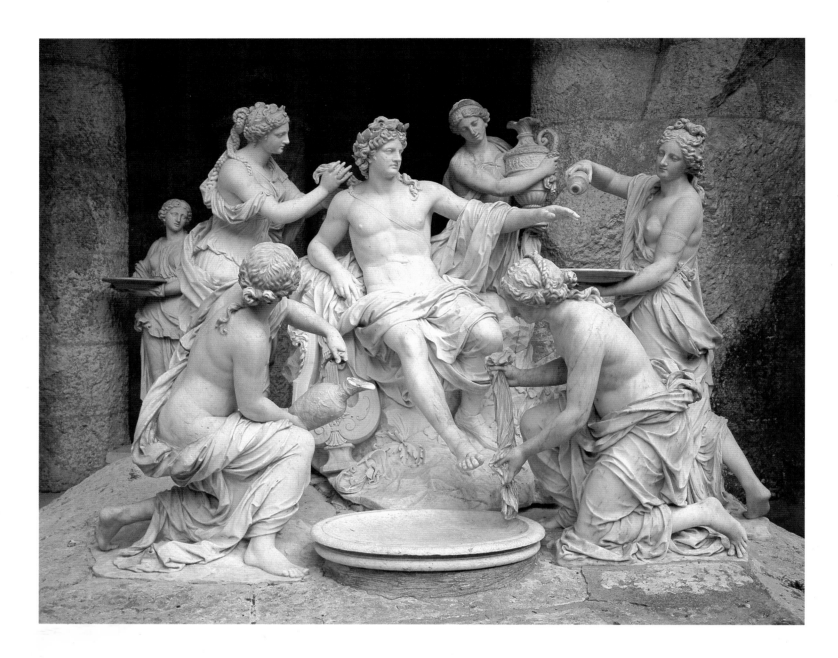

Girardon's style may be described as well-tempered Baroque: rule corrects emotion. It found scope at the royal palace of Versailles, where he combined and united in a "solar" project the town and the palace grounds, contriving to make even nature submit to the laws of court etiquette.

After his work in Paris, at the Louvre and the Tuileries, we find Girardon at Versailles in 1666. There he worked for the next seven years around this group of *Apollo Tended by the Nymphs* (which originally stood in the Grotto of Thetis, flanked by the horses of Apollo carved by Guérin and Marsy). The life-size figures are like a semblance, in mythological terms, of the King and his court ladies taken by surprise in a corner of the park. Undoubtedly of some importance was the journey to Italy made by Girardon while he was working on the group: the seven strictly isolated figures have Renaissance prototypes and even re-echo commemorative sculpture. The lively setting, animated by lifelike details done from nature (such as the amphora, so accurately rendered with all its relief carving), may readily be imagined as part of a ballet or opera with music by Lully.

François Girardon (1628-1715):
Apollo Tended by the Nymphs, 1666-1673.
The three nymphs at the back are by Thomas Regnaudin (1627-1706).
Marble, life-size.
Gardens of the Château de Versailles.

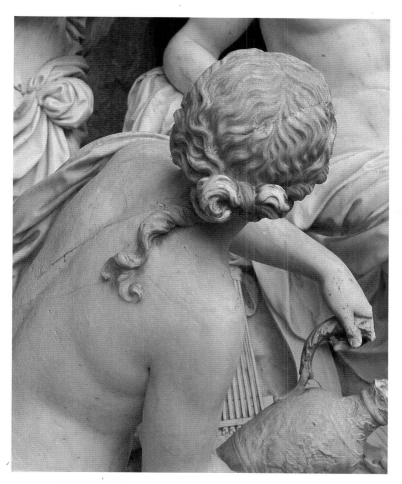

ANTOINE COYSEVOX: THE TOMB OF CARDINAL MAZARIN

The history of Baroque sculpture is summed up in the evolving typology of the funeral monument: from the Pauline mausoleum still characteristic of the Cinquecento to Bernini's Barberini monument (the triumph of Baroque), and on to the classical critique of Baroque implicit in Algardi's tomb of Leo XI, then on to the eloquent tombs done by French sculptors in Rome in the late seventeenth century. At the court of Louis XIV the tombs made for Richelieu, Colbert and Mazarin mark successive stages of the idea of death interpreted as a passage to the triumph of eternal power.

Here Coysevox took over certain patterns of his monument to Colbert in the Paris church of Saint-Eustache, building up a pyramid of grief: it moves from the three bronze figures (which are Virtues but also living presences), rises by way of the lifelike tomb, and ends at the top in the figure of the deceased, shown in action, with an angel holding up the emblem of the Mazarin family. The focal point of animation lies in the drapery, which symbolizes the true protagonist of this skilfully balanced combination of Classical and Baroque: Time and its ceaseless onward flow.

Antoine Coysevox (1640-1720):
Tomb of Cardinal Mazarin, 1689-1693.
Below, figures of Prudence, Peace (attributed to Jean-Baptiste Tuby, 1635-1700), and Fidelity.
Marble and bronze, height of the Cardinal 63″, of Prudence 63″, of Peace 55″, of Fidelity 55″.
Institut de France, Paris.

METHODS AND STRUCTURES
OF BAROQUE SCULPTURE

Gian Lorenzo Bernini (1598–1680):
Restoration of the Borghese Hermaphrodite, 1620.
Marble.

TECHNIQUE:
VIRTUOSITY AND ARTIFICE

Technical prowess in the Baroque period verges on the inexpressible. Sculptors showed the greatest skill and resourcefulness in rendering complex anatomies and conveying feelings and psychological attitudes through facial expression. Sculptors proved themselves goldsmiths and engravers as well, showing the unexpected power of giving body to a pile of leaves, to the flickering shapes of fire, to rising tears glistening in the eye. To represent the unrepresentable was one of their aims, but they were also intent on treating in different and apposite ways the very different parts that may go to make up a sculpture (flesh, drapery, jewelry, headdress).

In other words, they were virtuosos. The very word makes one think of another art, music, which was then by way of becoming almost entirely a problem of execution, and therefore of virtuosity. Poetry too, and not only the

Italian phenomenon of Marinism, witnessed the transformation of word handling into a kind of funambulation, an adroit and indeed learned play and metamorphosis of images, whose only precedent was the Hellenistic period, at the end of the ancient world.

It was precisely with this ancient period that the eighteen-year-old Gian Lorenzo Bernini set out to measure himself, when he left the workshop of his father Pietro, a sculptor of great skill who transmitted to his son an almost instinctive insight into the secrets of marble carving. Ancient sculpture, which had reached the highest levels of invention, also presented the problem of restoration. In the famous Borghese *Hermaphrodite*, young Bernini restored the ancient marble in the area of the feet and mattress. The tender extremities and the compact delicacy of the bed on which he lies, go to emphasize and enhance the morbidity of this mythical creature of flesh.

Bernini's friend and rival Alessandro Algardi practised a similar virtuosity in such works as the Borghese *Sleep*,

Pierre Puget (1620–1694):
The Assumption of the Virgin, 1664–1665.
Marble bas-relief, 49″ × 37¼″.

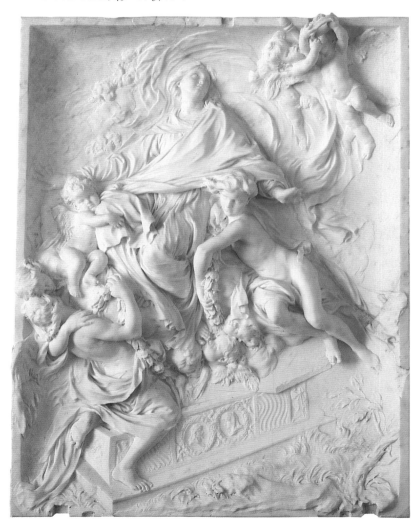

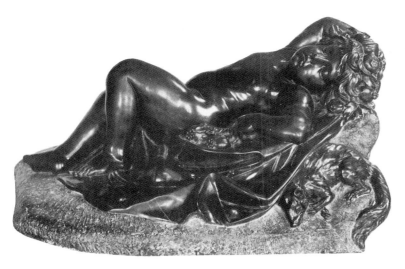

Alessandro Algardi (1595-1654):
Sleep, c. 1630.
Marble.

which was so close to the antique in spirit and handling that, as records testify, it was mistaken for an excavated statue. The stone, hard as diamond, is modelled with the easy fluency of wax. And here in addition occurs the usual Baroque transformation under our very eyes, as by way of his material Algardi evokes the idea of night.

The bas-reliefs of the period illustrate a kind of sculpture which, given sufficient technical skill, can be made to approach painting. One thinks immediately of the Roman church of Sant'Agnese in Agone, where everything is of marble, even the altarpieces being replaced by the plasticity of low and high reliefs. One outcome is Pierre Puget's *Assumption*. The tomb is placed diagonally, the groups of angels move upwards in three dimensions, and as they range from child angels to grown ones they provide a welcome

diversity of proportions within the same scene. The eye is caught up and follows the paths of movement, whether centripetal or centifugal. This early moment of plastic technique (the *stiacciato* or "flattening" of Quattrocento reliefs) was given a new lease of life in Baroque precisely by this virtuoso overlapping of techniques. The emerging figures and the flattened zones alternate within a whole which is no longer a matter of sculpture but of pictorial illusion (just as in other cases architecture becomes sculptural decoration, furniture is transformed into building, the fountain into symbolic architecture, just as painting varies between architectural illusionism and tapestry).

In Bernini's workshop was a gifted German sculptor, Johann Paul Schor (progenitor of a family of artists who led up to Rococo), and he had a hand in even the most purely Catholic allegories, to which he brought something of his "Gothic" uneasiness. One thinks of the *Chair of St. Peter*, standing as a focal point in the first basilica of Christendom: the most solemn sculpture of the seventeenth century, poised between the flood of true light and billowing clouds, hovering angels and stalwart Fathers of the Church, between the reliquary and a profusion of ornaments. On the chair of the first apostle appears a rich decoration of clustered shapes, the work of "Paolo Todesco," as Schor was called. In its sheer virtuosity it suggests comparison with the volutes of Art Nouveau and the forms of abstract art. The same fascination with decorative details is to be found in the sophisticated creations of Francesco Borromini, another artist whom Bernini himself had described as "Gothic." In short, we are in the presence here of the two types of salvation put forward by the art of the seventeenth century: on the one hand, religious conviction of mass appeal, conveyed by theatrical devices and the rhetoric of glittering materials; on the other, the intimist, individual ideal of self-improvement peculiar to northern artists. And these opposing conceptions of life are both expressed in terms of technical virtuosity.

Johann Paul Schor (1615-1674):
Detail of the lower part of Bernini's Chair
of St. Peter, 1657-1666.
Silver and gilt bronze.
St. Peter's, Rome.

205

THE HARMONIZATION
OF MATERIALS

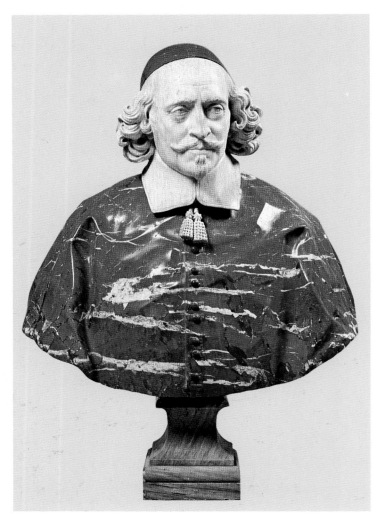

Antoine Coysevox (1640-1720):
Bust of Cardinal Mazarin.
Red and white marble.

The new sculptor was aware that, to achieve his purpose (i.e. to win over the believer by putting him in the position of spectator), he could also sacrifice his own specific language in order to make it answer to different motives. He might be prompted to use a free combination of techniques–what Bernini in his theorizing described in theatrical terms as the *mirabile composto* ("admirable mixture") of the arts. Sculpture was accordingly integrated into a spectacular context, wherein it had further to answer the requirements of the problem of the century for the Church, the spreading of Catholicism (*de propaganda fide*) in the face of the Protestant menace.

The artist was called upon to unify and at the same time transform and enhance his materials in those small show-houses that were the chapels of noble families—a secular space within the ecclesiastical world. Borromini may be credited with the Spada Chapel in San Girolamo della Carità, on the strength of a seventeenth-century guide-book to Rome written by the architect G.B. Mola: "The first chapel on the right hand with those unusual inlays and balustrade is the work of Francesco Borromini."

This chapel of the Spada family is like a room transferred from the family palace to the church. The damascened bands rising vertically are inset with six oval bust

portraits of deceased members of the family. Over the altar is a picture of the Virgin and Child, hanging from the gilt escutcheon plate above. On either side are framed portraits in relief, representing the patron saints Bonaventure and Francis, while below lie two members of the family on antique-style benches, looking towards the altar. The latter is flanked by two simulated urns supporting the inscriptions which tell us how to interpret this mystical space, explaining that two ancestors gave a tunic to the Poor Man of Assisi (i.e. St. Francis). This accounts for the banisters (carved by Antonio Giorgetti), which take the form of two angels holding up an altar cloth; it accounts for the pavement inlaid with a profusion of roses (the motif of the rose garden in which St. Francis is said to have rolled). The space devised by Borromini therefore excludes the *living* presence of death, choosing instead a complex tissue of symbols. Behind the apparent vitality, over and above the deceased evoked in pictures or portrayed in marble and bones, beyond the fiction of an actual room lined with pictures in good order, lurks the stark reality of death in cold disguise (very different from the gesticulating skeleton imagined by Bernini in the Cornaro Chapel of Santa Maria della Vittoria).

Even in smaller works we find this deliberate alternation of materials, handled with a virtuosity calculated to convey an overstrained allegory.

The bust portrait of *Cardinal Mazarin* by Antoine Coysevox, in red and white marble, is carved in the classical manner. In many ways it recalls the faces and gestures of the monument to Colbert in the church of Saint-Eustache in Paris. But the marble used here is characteristic of the new century. It is a so-called red marble of France, the same that was used (for example) for the plinth of the church of Saint-Sulpice in Paris. The unusual feature of this bust lies in the skill and insight with which the sculptor revives the Late Antique practice of using two kinds of marble in order to achieve lifelikeness, the red being employed in fact only for the cardinal's mozzetta and cap.

Orazio Mochi (?-1625) and Giovanni Biliverti (1576-1644),
after designs by Giulio Parigi (?-1635):
The Grand Duke Cosimo II de' Medici Praying, before 1630.
Hard stones and precious stones.

Pierre Legros the Younger (1666-1719):
St. Stanislas Kostka on his Deathbed, 1702-1703.
Polychrome marble and jasper.
Convent of Sant'Andrea al Quirinale, Rome.

The *Grand Duke Cosimo II Praying* is like a piece of goldsmith's work. Produced in the Florentine workshop known as the Opificio delle Pietre Dure, it is not only a superb representation of aristocratic dignity, but in the end resembles a fine collection of samples of precious materials. Carefully chose and analytically juxtaposed, these materials achieve what is in effect the portrait and allegory of a caste, the triumph of ermine and richness.

A variety of materials (apparently difficult to join together), such as stucco and marble, bronze and lapis lazuli, silver and carved wood, are combined to triumphant effect in the Roman churches. As regards the sculptural decoration in the Gesù e Maria church on the Corso, it seems pointless to deal separately with the figures of deceased members of the Bolognetti family which people the crowded space and were carved by Francesco Aprile, Michel Maille and Francesco Cavallini. For these figures are set within a complex structure (designed by Carlo Rainaldi as the central hall of a nobleman's palace). They stand on tablets rising from well-designed confessional boxes and make one with the superincumbent marble figures of Virtues, within a complicated alternation of coloured marbles, ranging from alabaster (from Sicily and the East) to *rosso antico* and lapis lazuli. The culminating point is the frescoed ceiling by Giacinto Brandi, surrounded by stuccoes. Always, even when at times it is used to admirable effect in "solo passages," Baroque sculpture enters fully into spaces and materials so compounded as to form a "pre-established harmony."

At the turn of the seventeenth and eighteenth centuries, virtuosity reached its peak in such a sculpture as *St. Stanislas Kostka on his Deathbed* by the Frenchman Pierre Legros the Younger. Standing in Sant'Andrea al Quirinale, the church of the Jesuit noviciate, it was described by a contemporary as "a dead man on the bier, between the dark and light, which arouses deep feelings of pity." It was customary for the bodies of martyrs to be seen in more or less macabre form, until Maderno, at the beginning of the seventeenth century, placed under the altar the miraculously undecayed body of the young St. Agnes. Now Legros introduces us, as if on tiptoe, into the bedchamber of a hero of the faith who has just breathed his last; it is as if we were being admitted on a farewell visit to the luxurious room where the body lies in state. The mattress and sheet, together with the saint's gown (all carved in jasper, yellow marble, and Belgian black marble), answer to the white marmoreal face which takes on the transparent consistency of a wax mask.

Francesco Borromini (1599-1667):
Spada Chapel in San Girolamo della Carità, Rome, 1662.
Polychrome marble, jasper, onyx.

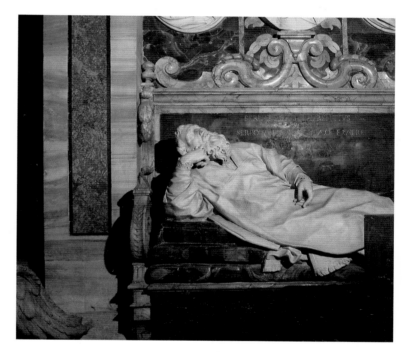

Pierre Legros the Younger (1666-1719):
St. Stanislas Kostka on his Deathbed, 1702-1703.
Polychrome marble and jasper.
Convent of Sant'Andrea al Quirinale, Rome.

The *Grand Duke Cosimo II Praying* is like a piece of goldsmith's work. Produced in the Florentine workshop known as the Opificio delle Pietre Dure, it is not only a superb representation of aristocratic dignity, but in the end resembles a fine collection of samples of precious materials. Carefully chose and analytically juxtaposed, these materials achieve what is in effect the portrait and allegory of a caste, the triumph of ermine and richness.

A variety of materials (apparently difficult to join together), such as stucco and marble, bronze and lapis lazuli, silver and carved wood, are combined to triumphant effect in the Roman churches. As regards the sculptural decoration in the Gesù e Maria church on the Corso, it seems pointless to deal separately with the figures of deceased members of the Bolognetti family which people the crowded space and were carved by Francesco Aprile, Michel Maille and Francesco Cavallini. For these figures are set within a complex structure (designed by Carlo Rainaldi as the central hall of a nobleman's palace). They stand on tablets rising from well-designed confessional boxes and make one with the superincumbent marble figures of Virtues, within a complicated alternation of coloured marbles, ranging from alabaster (from Sicily and the East) to *rosso antico* and lapis lazuli. The culminating

point is the frescoed ceiling by Giacinto Brandi, surrounded by stuccoes. Always, even when at times it is used to admirable effect in "solo passages," Baroque sculpture enters fully into spaces and materials so compounded as to form a "pre-established harmony."

At the turn of the seventeenth and eighteenth centuries, virtuosity reached its peak in such a sculpture as *St. Stanislas Kostka on his Deathbed* by the Frenchman Pierre Legros the Younger. Standing in Sant'Andrea al Quirinale, the church of the Jesuit noviciate, it was described by a contemporary as "a dead man on the bier, between the dark and light, which arouses deep feelings of pity." It was customary for the bodies of martyrs to be seen in more or less macabre form, until Maderno, at the beginning of the seventeenth century, placed under the altar the miraculously undecayed body of the young St. Agnes. Now Legros introduces us, as if on tiptoe, into the bedchamber of a hero of the faith who has just breathed his last; it is as if we were being admitted on a farewell visit to the luxurious room where the body lies in state. The mattress and sheet, together with the saint's gown (all carved in jasper, yellow marble, and Belgian black marble), answer to the white marmoreal face which takes on the transparent consistency of a wax mask.

SCULPTURE AND PAINTING: METAMORPHOSIS OF TECHNIQUES

Sir Anthony van Dyck (1599-1641):
Three Heads of Charles I, c. 1635, painted as a guide
to Bernini in carving his marble bust of the King.
Oil on canvas, 33¼" × 39¼".
Buckingham Palace, London.

Gian Lorenzo Bernini (1598-1680):
Marble Bust of Charles I, 1636 (destroyed
in the fire at Whitehall Palace in 1698).
Print by Robert van Voerst.

Sculpture in the seventeenth century seems to tend towards comparison with painting, especially when the standard vision prevails–that is, the rule of classicism.

At least in one case painting acts as the handmaid of sculpture. And that is when the sculptor, unable to obtain a sitting from an illustrious model, is provided with a triple portrait of the sitter, showing his features from the three fundamental viewpoints. Thus there exists, for example, a triple portrait of Cardinal Richelieu, painted by Philippe de Champaigne (National Gallery, London) and sent to Francesco Mochi as a model for the marble carving. For the execution of his *Bust of Charles I*, the English court supplied Gian Lorenzo Bernini in 1636 with a triple portrait of the king painted by Van Dyck. The sculptor could thus perform his task of "ambassador" without leaving Rome.

But the relation is normally more structural than the one indicated in this extreme case. Philippe de Champaigne's painting is deliberately sculptural, because it is this medium "aere perennius" that is best suited to recording a dignified countenance. So it is that Champaigne's portraits of Richelieu or of the municipal magistrates of Paris look as if they were inlaid with hard stones, nielloed in a meticulous bas-relief, or cut in bronze. The sculpture of a Duquesnoy or a Puget appears on the contrary pictorial, both in its aims and effects.

Peculiar to itself is the art of François Duquesnoy. Working in the epic Rome of Bernini and Algardi, he practised a languidly Praxitelean form of sculpture, more akin to the precious object than to the monumental group. His training may already be described as "pictorial," for he spent his early years copying the painting of Titian. Bellori writes of Duquesnoy: "He set himself to studying the *putti*

of Titian, for in the Ludovisi Garden was then the famous picture of the Cupids at play, throwing apples at each other, which was afterwards given to the king of Spain. Charmed by them, Francesco rendered them in various groups in medium relief, and with him Nicolas Poussin modelled them in clay... And then he studied children from the life, seeking out the youngest, even infants in swaddling clothes, to such effect that he seemed to soften the hardness of marble. The children he carved were more milky than stony." Poussin was his closest friend in Rome, and Duquesnoy always sought to carry over into his sculpture a certain delicacy of shading. In the tombs at Santa Maria dell'Anima, the *putti* entangled in drapery take on a transparency like that of worked wax. His reliefs (like those on the altar of the Filomarino Chapel in Naples designed by Borromini) include *putti* which seem to have been carved in ivory. His portraits (*Cesarini* in the Campidoglio, *John Barclay* in Sant'Onofrio) aspire to the colouring of his friend Van Dyck, who has left us an eloquent portrait of Duquesnoy.

Likewise with Pierre Puget: his sculpture can only be understood from a pictorial point of view. During his second stay in Rome, this sculptor from Marseilles entered the workshop of Pietro da Cortona, who set him to work in the Palazzo Pitti in Florence on the fine gilt stuccoes which mark the high point of court decoration in the mid-seventeenth century. Alongside the supple and vivid paintings of Cortona, Puget proposes his lithe and ephemeral-seeming sculpture. To Mansart in 1688 he said: "I work in a way that bears comparison only with Algardi and Bernini." But apart from his work as a painter (recently revalorized), the true orbit of Puget's sculpture lies in the painterly circle of Pietro da Cortona, in addition to its

Antonio Raggi (1624–1686):
Vault decorations (detail), Church of Gesù, Rome, 1674–1679.
Gilt stucco.

connection with the Berninian language of a Baciccio or a Borgognone.

For the interior decoration of Roman churches, another type of sculptural ornament proved an ideal medium: stucco, more or less coloured. One of the leading practitioners was Antonio Raggi, master of a languid, pre-Rococo style.

Illusionist painting, with its carefully planned system of simulated architecture and sculpture, had been successfully practised in Rome by the Carracci in the Palazzo Farnese. Now it triumphed in Pietro da Cortona's ceiling fresco in the Palazzo Barberini. The starting point and peak of the Baroque style, it was inaugurated in 1639, the year when Tommaso Campanella died, the philosopher who occupied a position of importance at the court of the Barberini pope, in spite of his unorthodox views. In the cornice of Cortona's ceiling the caryatids turn with a twisting movement and break free from the inanimate mass, not in an existential sense as in the Sistine Chapel or a decorative sense as in the Carracci's paintings in the Palazzo Farnese, but with a forceful display of energy. These painted caryatids are like sculptured figures, so vigorously do they take part in the allegorical scenes handled like animated tapestries. "De sensu rerum et magia": so, in the words of Tommaso Campanella, might one define the meaning of Pietro da Cortona's ceiling. The embrace of heaven and earth, the panic sense of the "great theatre of the world," the transmutation of the arts into a mythical "city of the sun," such were the motives of the philosopher and the practice of the painter, who did not shrink from painting plastic, fully rounded figures alongside a simulated plastic decoration of stucco, as a token of metamorphosis.

In the church of Gesù, Baciccio's ceiling painting of the *Triumph of the Name of Jesus* is set off by Antonio Raggi's sensitive and luminous stuccoes. It was Bernini who proposed the theme and conception of this ceiling, in which triumphs not only the Church but also the "admirable mixture" of the arts. A figural precedent is only to be

Pietro da Cortona (1596-1669):
The Triumph of Divine Providence (detail), 1633-1639.
Fresco and stucco.
Palazzo Barberini, Rome.

found in the *Chair of St. Peter* set up in the apse of St. Peter's between 1657 and 1666. In the Gesù the celestial power pervades the church with the visible allegory of light, but mediation is conveyed precisely by Raggi's figures, shaped with all the plastic skill of the master stucco-worker. For thirteen years he worked at them on the scaf- folding, contriving to vie with painting in his bold coun- ter-movements and emphatic draperies, his languid poses and sentimental responses, all in so many *tableaux vivants* which seem to anticipate the Rococo graces of Giacomo Serpotta's highly refined (and distinctly Berninian) stuccoes.

SCULPTURE AND ARCHITECTURE: SPEAKING CONSTRUCTIONS

Francesco Borromini (1599-1667):
The Angel Cage (detail), after 1653.
Stucco.
Belltower of Sant'Andrea delle Fratte, Rome.

Three outstanding sculptors of the seventeenth century, Bernini, Borromini and Gherardi, were all practising architects as well. Borromini began his prodigious career as a stone-cutter in the workyard of Milan Cathedral. In his early days in Rome he worked alongside Bernini, on a railing in the Palazzo Barberini, on armorial bearings with figures in the Baldachin of St. Peter's, on the angel in the pediment of Algardi's high relief. Sometimes timidly, sometimes spiritedly, Borromini limited himself to laying emphasis on certain salient features as if to enlarge upon them. The fact remains that his churches and palaces are always endowed with an underlying humanity. The columns of the small dome in Sant'Andrea delle Fratte, for example, are turned into winged cherubs in various attitudes, with sad or smiling faces. A revival of ancient caryatids or the Korai of the Erechtheum, in keeping with Baroque metamorphosis.

This is more or less what happens in the doorway of the Town Hall at Toulon, done by Pierre Puget. In France of course there were different precedents for such work, ranging from Jean Goujon's caryatids (now in the Louvre) to Jacques Sarrazin's caryatids for the Louvre–two examples of an almost Alexandrian gracefulness. Puget adds the emotional and technical complication of pathos, both figures expressing anguish. The sense of strain in these two atlantes becomes an allegory for the place where they stand, where the destinies of the city were decided.

Just as in other cases sculpture was transmuted into painting, so here we see sculpture transmuted into architecture, with a fanciful redesigning that recalls theatrical or festival effects. It is above all a painter, Antonio Gherardi, who offers us two great examples of "sculptural theatre" in the Chapel of St. Cecilia in San Carlo ai Catinari and the Avila Chapel in Santa Maria in Trastevere. Through gaps and successive openings (in the side walls with tombs which become spatial shrines, in the altar wall, and in the lantern turret), the architecture breathes like a plastic organism and appears to multiply by spontaneous generation. The solution adopted for the Avila Chapel ceiling is both sculptural and pictorial. Unique in Baroque architecture, four flying angels (outside or within the chapel?) uphold a lantern-turret/shrine aglow with the influx of light. There are various iconographic precedents for this apparition. One such would be the antique medallions in the Ravenna mosaics, in which the apparition of the Virgin or Christ is replaced by the triumph of light. Another would be those painted lantern turrets which appear at the highest point of the pageant-filled heavens depicted by Pietro da Cortona or by Baciccio. A more likely precedent would be some sort of Holy House of Loreto represented during its translation at the hands of angels.

Within an architectural setting, then, carved and transparent angels were used to convey that sense of dynamism, that power of metamorphosis, which flows like an undercurrent through the century of Baroque.

Pierre Puget (1620-1694):
Atlas supporting a Balcony, 1656-1657.
Calissanne stone.
Door of the Town Hall, Toulon.

Antonio Gherardi (1644–1702):
Cupola decoration in the Avila Chapel,
Santa Maria in Trastevere, Rome, 1680.
Stucco.

FESTIVAL DECORATION: THE EPHEMERAL CRYSTALLIZED

Gian Lorenzo Bernini (1598-1680):
The Elephant: Fireworks for the Birth
of the Infanta of Spain, 1651.
Print.

Frequent and characteristic of the seventeenth century were the great festivities with ephemeral sculptures and architecture, and always with astonishing contrivances for the play of water and fire. Here was ample room for experimental design, and this indeed may be said to constitute the true connective tissue of the artistic ideas of the century. A typical example is Bernini's *Elephant with Obelisk*. Fifteen years before raising this symbolic monument in honour of the "wisdom" of Pope Alexander VII (identified with the obelisk and therefore with the Sun, like the king of France), Bernini had experimented with this theme in a festival display of fireworks to celebrate the birth of the Infanta of Spain (1651), of which there remain a commemorative print and several descriptions. It was a fanciful construction over twenty-five feet high, with an elephant spitting fire from its trunk and a towered castle on its back, the whole symbolizing royal might.

Keeping to Bernini's work, one may say that even the Baldachin in St. Peter's originated (when set up for the Jubilee of 1625) as an ephemeral contrivance, made of stucco, wood and fabrics. Even his mature sculpture includes some works deriving from a temporary structure which he designed at the end of 1621, the catafalque of Pope Paul V in Santa Maria Maggiore: the Veritas figure here was the prototype of his *Truth Revealed by Time* now in the Borghese Gallery, the Misericordia anticipates his *Charity* in the tomb of Urban VIII in St. Peter's, and so on. The young Bernini of 1621, with a career of only seven years behind him, found on this occasion (forty days to carve sixteen allegorical statues and twenty angels) an opportunity to publicize his own work.

A similar transition from a temporary device to sculpture can be observed in many squares in Rome, at the corner of noblemen's palaces, in shrines supported by angels as in processions fixed in marble and stucco. In the Naples of the Spanish viceroys, on the other hand, we find the phenomenon of the obelisks, like that of San Gennaro and that of San Domenico, which give the impression of small-size festival works enlarged and made permanent.

In other latitudes, too, one may observe this transition from the temporary to urban monuments and ordinary church fittings. Two examples may be mentioned in Vienna and Flanders.

The imposing monument of the *Plague Column* in Vienna, in the Graben, was designed by the architect Johann Bernhard Fischer von Erlach. Trained in Rome, in the workyard of Bernini, he began his career in Vienna with two temporary structures, triumphal arches and a wooden column in honour of Joseph I, which seem to anticipate his Karlskirche in Vienna, designed as a triumph of sculpture. Not by chance, his collaborator was Ludovico Burnacini, the scenery designer from Mantua and Venice. The sculptures of the *Plague Column* were done by Matthias Rauchmiller, Johann Bendl and Paul Strudel: consisting of graceful clouds, spirited *putti* and allegorical female figures, they clearly mark a shift of focus from Bernini to Rococo. This

Gian Lorenzo Bernini (1598-1680) and Ercole Ferrata (1610-1686):
Elephant with Obelisk, 1665-1667.
Marble elephant, Egyptian obelisk.
Piazza della Minerva, Rome.

Hendrik Verbruggen (c. 1655–1724):
Pulpit, 1699.
Church of Sts. Michael and Gudule, Brussels.

Column, with its artful build–up of cloud shapes, may also be described as the scenic materialization of a *deus ex machina* or of fireworks.

In Brussels, in the church of Saints–Michel–et–Gudule, we find an extraordinary pulpit done by Hendrik Verbruggen, a member of a large family of Flemish artists. The group of Adam and Eve expelled from the garden of Eden takes on the proportions of a *tableau vivant*, while the draped cloth of the baldachin and the vegetation, together with the other symbols of nature, make the work seem like a piece of festival machinery perpetuated in the hard materials of sculpture. It recalls the showy contrivances designed by Rubens a few decades earlier for solemn entries and august ceremonies.

Johann Bernhard Fischer von Erlach (1658–1723),
with Matthias Rauchmiller (1645–1686) and others:
The Plague Column, 1682–1694.
Graben, Vienna.

215

NATURE INTO SCULPTURE

Athanasius Kircher (1601-1680):
Garden in the form of a Bearded Head.
Drawing from his *Ars magna lucis
et umbrae in mundo*, Rome, 1646.

One of the abiding aims of seventeenth-century sculpture was to celebrate nature, and it sometimes did so in paroxysmal forms. The arts arise from natural events (the tangible truthfulness of the elements); they then aspire to take over from nature its organic rhythms (metamorphosis being one of the principal instruments to this end); finally, at the conclusion of the cycle, they arrive inevitably at a condition which may be described as naturalness.

In the code of oddities that make up Mannerism, one can single out the clues to many new ideas. The Jesuit scholar and philosopher Athanasius Kircher, a friend of Bernini's (and even his collaborator in Piazza Navona, Rome), followed up similar lines of research, which appear to run from Arcimboldo to Salvador Dali's "double image." Thus the human face is taken and transformed into a built-up and reshaped landscape, illustrating the interaction of the arts. Kircher thereby suggests that man's task may be that of metamorphosing even the appointed place of the metamorphosis–that is, nature.

Nature is ever present in that abstract field of imagery: emblems. The armorial bearings of the Chigi family, for example, represent an oak. When Bernini set about restoring the Roman church of Santa Maria del Popolo, at the behest of the Chigi pope, Alexander VII, he proceeded to design an oak on the two organs on either side of the main altar. And here came into play the mechanism of *agudeza*, of pointed wit: connecting music with the primal myth of birdsong, he placed the organ-pipes amidst the leafy branches of the oak-tree, thus transforming the emblem into vital nature by the artifice of sculpture.

Workshop of Gian Lorenzo Bernini (1598-1680):
Design for the organs of Santa Maria del Popolo
turning into the oak emblem of the Chigi family, c. 1655.
Drawing.

Jean-Baptiste Tuby (1635-1700):
The Chariot of the Sun, 1668-1670.
Gilt lead.
Basin of Apollo, gardens of the Château de Versailles.

"The whole world, then, is sensation, life, soul and body, a statue to the Almighty, raised to his glory, with power, wisdom and love": such was the conception put forward at the beginning of the seventeenth century by the philosopher Tommaso Campanella. This vision of a creation joined plastically to its creator also implied a renewed panic sense of life. Thus Giordano Bruno, when expounding his concept of the infinite, started always from the evidence of nature. The seventeenth-century sculptor shared this climate of thought, and not only when he was called upon to work in the actual field of nature, in gardens, parks and villas.

It was at the palace of Versailles that the marriage of nature and sculpture was celebrated, and it was thought of as a happy and indissoluble union. It is a further fact, and a singular one, that the historical dignity of the Sun King apparently had to be sanctioned by comparison with the perennity of nature. The many fountains combine with the architecture and sculpture, with the hedges, shrubbery and tree-lined avenues, in a polyphonic harmony of green achieved by the genius of André Le Nôtre.

Before undertaking his gigantic task at Versailles, Le Nôtre gave a foretaste of what he could do by redesigning the gardens of the Tuileries in the centre of Paris, beside the Louvre. Work here had begun a century before, with (not by chance) the guidance and counsel of an Italian, Carnesecchi. Then, between 1630 and 1660, with his love of botany and skill as a modeller, Le Nôtre had designed many sites in the "royal paradise" of the Tuileries. Trees shaped as figures, waters as festival apparitions, hedges as side curtains, it was all organized like a court theatre. He

at once went on to Versailles, and in a few years' time the hunting lodge of Louis XIII had been transformed into the most palatial country home of the century. "Genius and good taste are God-given. How is one to transmit them to others?" said Le Nôtre, asserting his ambition to be the new artificer and creator of nature. Making the most of accidental features of the ground, he created his terraced and perspective parkscapes with the combined skills of sculptor, architect and botanist. Under his prompting, nature seemed to become even more natural.

Israël Silvestre (1621-1691):
Fireworks over the Gardens and Canal at Versailles during the Festival of the "Pleasures of the Enchanted Isle" in May 1664 (fifth day).
Print, after 1679.

REPRESENTATION
OF THE ELEMENTS

Francesco Mochi (1580-1654):
The Bridge across the Scheldt, detail from the base of
the Equestrian Monument of Ranuccio Farnese, 1620-1625.
Bronze relief.
Piazza dei Cavalli, Piacenza.

Nature triumphed in the metamorphoses of Rococo, from the Piedmontese villas to the Royal Palace of Caserta (where the waterfall culminates in the metamorphosis of Acteon). But nature also had its place in Baroque. We have to remember that it was in Rome, in 1690, that the Arcadia was founded, an academy conceived in the circle of Chris-

tina of Sweden. With its bucolic statutes, it was meant to be a public institution modelled in the image and likeness of nature. These intellectuals aspired to provide themselves with a structure (and an instrument of power) which should be, no longer historical like the earlier academies of Florence and Rome, but strictly natural.

Philosophy and poetry were also called in to second the idea of the life-giving vitality of the elements. Two quotations by way of illustration: the first from the *Nova de Universis Philosophia* (1591) by the Neoplatonist philosopher Francesco Patrizzi; the second from the epic poem *Adone* (1623) by Giambattista Marino, the great wizard of metamorphosis.

"Not only the heavens are constituent parts, but all the elements too, however many they be. Each of them singly, though yet not separate from the whole, has its own being. If the elements had no such indwelling spirit, the substance of none would have any existence."

"Beyond the fixed boundary to leeward / Swells the sea as if with pride and surges. / Into the sea comes down the buffeting rain, / And sea with sky and sky with sea are mingled. / In new style, in unwonted fashion, / The bird learns to swim, the fish to fly. / Elements stand opposed to elements, / Clouds to clouds, waters to waters, and winds to winds."

Bernini was the first to introduce fire into sculpture; he did so in such a statue as his *Martyrdom of St. Lawrence*–Lorenzo, in Italian–a work of particular importance to him, for it represented his patron saint, bearing his own name. Bernini also made much of water, not only in his works but in explicit statements, as when he said to Chantelou in Paris: "I am a great friend of water." In the middle years of the century, in Piazza Navona, he gave his interpretation of the fountain as monument. An inscription reads: "Innocent X laid the stone adorned with Nilotic riddles over the Rivers that flow hereunder, in order to provide with magnificence a salutary amenity for the passerby, drink for the thirsty, occasions for whoever wishes to meditate." In the centre of the "court" of the ruling pope, he placed a four-faced arch formed by rocks

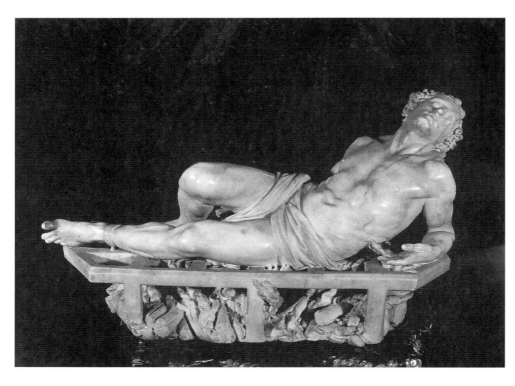

Gian Lorenzo Bernini (1598-1680):
St. Lawrence Being Roasted on a Gridiron, 1616.
Marble, 26″ × 42½″.

Gian Lorenzo Bernini (1598-1680):
Details of the Fountain of the Four Rivers, 1648-1651.
Marble and travertine.
Piazza Navona, Rome.

on which he placed the Rivers (equated with the four continents, the four temperaments, the four elements) and an obelisk, while European and exotic animals move about and the palmtree is shaken by the wind. This scheme was taken over from the festival machinery designed for the coronation of the Pamphily pope, Innocent X, on the theme of Noah's ark on Mount Ararat and the four con-

tinents. The dove is that of the Pamphily armorial bearings as well as that of the Holy Ghost; it is also the dove that marked the end of the deluge. The exotic sign of Egypt is placed like the mythical ark on the symbolical Ararat which anticipates the *rocailles* of the next century. Nature triumphs here with all its elements: earth in the mount, air in the wind blowing through the palm, water in the bubbling fountain.

As for Bernini's classicist rival Francesco Mochi, active in Rome and Piacenza, he too, in the bas-reliefs under the equestrian statues of the Farnese, deliberately set out to imitate the aerial quality of a clouded sky or the stormy sea during a naval battle, with an almost pictorial illusionism.

Again in Rome, towards the end of his life, Bernini designed the angels on the Ponte Sant'Angelo, carried out by his extraordinary team of assistants: Antonio Raggi and Ercole Ferrata, Antonio Giorgetti and Domenico Guidi, Paolo Naldini and Cosimo Fancelli, Giulio Cartari and Lazzaro Morelli, were the faithful executors of his idea as "producer." The recital of the choir of the Passion takes place against the sky because the angels stand on high pedestals, and in conjunction with water because the parapets of the bridge are in open work, with railings formed of ropes of twisted bronze, so made to put the pilgrim in a new situation. Actors and public find themselves bound together like sin and salvation. The dance of the angels, immersed in the natural elements and in the historical setting (sky and dome of St. Peter's, water and Castel Sant'Angelo), becomes the crystallization of an ephemeral procession.

Gian Lorenzo Bernini (1598-1680):
Two Angels on the Ponte Sant'Angelo, Rome, 1667-1669.

ALLEGORIES OF WATER

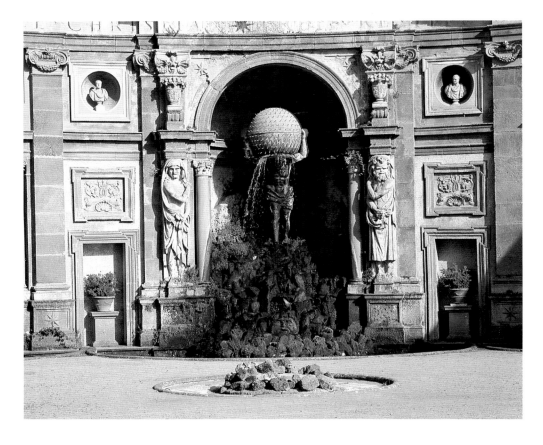

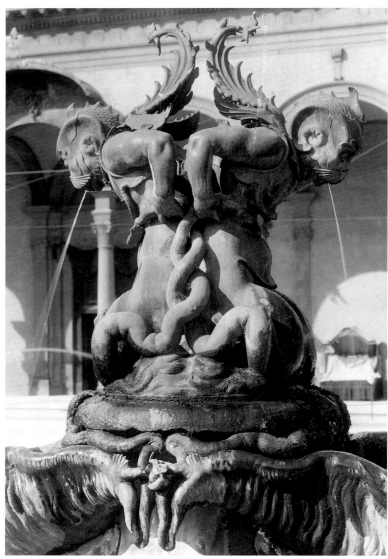

◁ Giacomo Della Porta (c. 1540-1602)
and Giovanni Fontana (1540-1614):
Atlas Figure, detail of the
Villa Aldobrandini Fountain, 1602.
Villa Aldobrandini, Frascati, near Rome.

▽ Pietro Tacca (1577-1640):
Fountain with Sea Monsters (detail), 1629.
Bronze.
Piazza dell'Annunziata, Florence.

Fountain sculpture was already present in Naples and Florence, the two homelands of Pietro Bernini, but it was his son Gian Lorenzo Bernini who brought this type of art from the villa to the city, from the natural to the social setting. In a work like the Atlas fountain at the Villa Aldobrandini, in Frascati, the water brought in by force has little connection with the mythological personage. Not so in Bernini's fountains. With him, the sculpture is conceived in relation to the water, to its ceaseless flow, to its shape and course, and it thus becomes one of the "symbolic forms" of Baroque.

In the Fountain of the Moor in Piazza Navona, the connection between figure and water is not so close. Here an action is taking place. The sea god or Triton is rising out of the water on his shell and has caught a dolphin which, squeezed between the god's legs, spews out the water contained within it. It is a combination of engineering and stage effects. (And indeed in one of the most fascinating shows that he staged, Bernini contrived to flood the pit.)

In a design for the Fountain of the Triton in Piazza Barberini, Bernini's sculpture is again closely connected with the water. Through a conch the Triton blows a great spurt of water into the air, and it cascades down into the large shells on either side. The gushing water thus takes the form of a lily, alluding to the arms of the royal house of France to which the Barberini were related. The sculptor, in short, constructed an emblem with water.

In Florence one of the foremost fountain designers was Pietro Tacca, who seemed intent on bringing some of the natural wonders of the Boboli Gardens into the city squares. In Piazza del Mercato Nuovo he set up a fat wild boar, wholly unexpected at that spot; his idea, and it proved an effective one, was to astonish the passerby and hold his attention. In Piazza dell'Annunziata he set up two

fountains conceived as fanciful "capriccios," but on an urban scale. With something of Gothic exuberance, two fantastic creatures support each other back to back, while the basins of the fountain swell out like organic forms. In the centre of the two shells Tacca carved a water-filled run-off which, being solid, is like an allegory of water. This "fiction within the fiction" is a device comparable to the "play within the play."

Though not actually completed till the eighteenth century, the Fountain of Trevi may be described as the apotheosis of the Baroque interpretation of the value of water. Issuing from articulated rocks full of living organisms, the flowing water unites the mythological theme (the Triumph of Neptune) with the transformation of a palace into monumental sculpture.

Poems of the "euphuistic" school of G.B. Marino come to mind, like the one by Gianfrancesco Maria Materdona describing a Roman fountain, whose water it transforms ideally into fire: "See how abundant the spume of this sea. / Even the frost seems to seethe, and smoke and sparks / Seem to arise even yet from the icy wave. / See how concordantly even the waterdrops, in harmony with this joyful moisture, / Dance in their hundreds and hundreds, their thousands and thousands."

Workshop of Gian Lorenzo Bernini (1598-1680):
Sketch for the Fountain of the Triton, with water in the form of the lily emblem of the Barberini family, 1642-1643.
Drawing.

Niccolò Salvi (1697-1751):
Fountain of Trevi (detail), 1732-1762.
Marble.
Piazza di Trevi, Rome.

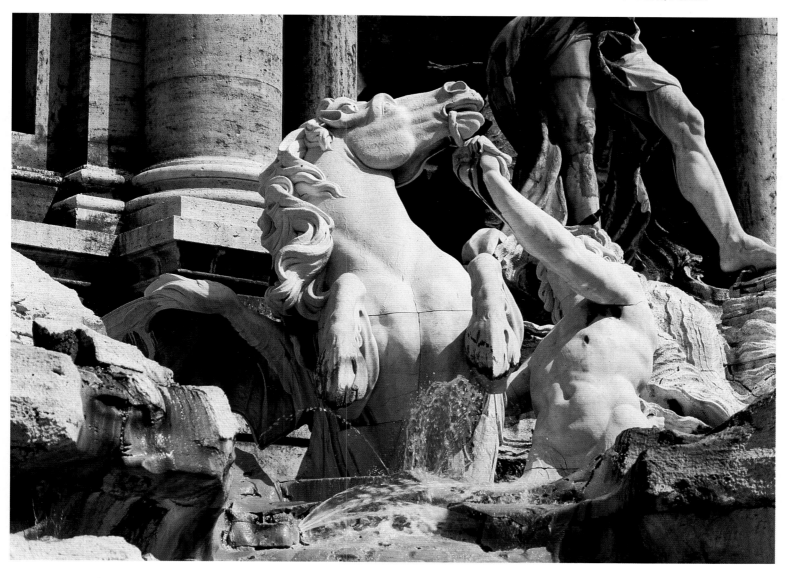

LIGHT, RADIANCE, INSPIRATION

Antonio Gherardi (1644-1702):
Ceiling of the St. Cecilia Chapel
in San Carlo ai Catinari, Rome, 1692-1700.
Stucco.

▽ Gian Lorenzo Bernini (1598-1680):
The Ecstasy of St. Teresa (detail), c. 1647-1652.
Marble and gilt bronze.
Cornaro Chapel, Santa Maria della Vittoria, Rome.

▷ Gian Lorenzo Bernini (1598-1680):
Alaleona Chapel in SS. Domenico e Sisto, Rome, 1649-1650.
Marble.

Again one has to familiarize oneself with the ideas of the period in order to understand the value which the Baroque sculptor attaches to this indispensable and ineffable element, as used by him to enhance and set off the virtuosity of his forms. For this purpose it is worth quoting the Neoplatonist philosopher Francesco Patrizzi (1529-1597), who saw light as the fundamental reality of things, the metaphysical atmosphere of the world, generating the "rays" which give life to the true and actual *lumen*: "Light is the image of God himself and of his goodness, which illuminates the whole supramundane realm, extends through all and permeates all. Permeating things, it forms them and makes them. It is all-vivifying, all-containing, all-sustaining; it unites and unifies all, and it singles out all. It turns towards itself all things that exist, or are brightened, or are warm, or live, or are begotten, or are fed, or grow, or are added to, or move. It purifies them, completes them, preserves them and keeps them from perishing. It is the number and measure of each and every thing. Of all things light is the purest, unaltered and unalterable, unmixed and unmixable, uncontrolled and uncontrollable. It lacks for nothing, it abounds in everything. Longed for by everyone, to everyone desirable. Ornament of the heavens and of each body, pride of the world, beauty of the world, joy of the world, laughter of the world. Nothing is more cheerful to the gaze, nothing more pleasing to the mind, nothing more soothing to life, nothing more important for knowledge, nothing more useful to action. Without it, all things would be sunk in darkness, inert to themselves and unknown to us."

The Baroque sculptor was familiar with the device of the camera lucida, with sidelighting and spotlighting. The fact is that in his complex elaborations he was much indebted to theatrical techniques (and indeed in Italian records of the period altars were referred to as "theatres"). In his hands the source of light was shaped and modulated, just as he shaped and modulated his marble or stucco. No more famous example of this than Bernini's *St. Teresa* in

Gian Lorenzo Bernini (1598-1680):
The Chair of St. Peter (detail), 1657-1666.
Bronze, polychrome marble, gilt stucco, height c. 60′.
Apse of St. Peter's, Rome.

the Cornaro Chapel of Santa Maria della Vittoria in Rome: in its *mise en scène* he experiments with every effect of light and shade that he can obtain.

Even sculptor-architects like Antonio Gherardi (as in the Chapel of St. Cecilia in San Carlo ai Catinari, Rome) contrive to build up an appropriate space for the illumination of angels, paradisiac palms and unforeseen apparitions. But it was Bernini who was most exact and thorough in recreating stage conditions. Thus in the Raymondi Chapel at San Pietro in Montorio, two windows open on either side of the sculpture group: unseen by anyone stand-

ing inside the chapel, they produce an intense effect of raking light over the bas-relief (carved by his pupil Francesco Baratta). The figure of the saint borne heavenwards seems to hover in the air. In the Alaleona Chapel at SS. Domenico e Sisto, the bright light pouring in from above produces effects of backlighting, leaving the group of Christ and the woman of Samaria in the ambiguity of a small living theatre.

But it is the *Chair of St. Peter* that embodies the triumph of light in all its manifestations (and the effect produced here was to be repeated in the *Transparente* by Narciso Tomé in Toledo Cathedral). In records of the time this complex work is described as the "splendour," and the dazzling vision of it spreads and expands from the actual daylight pouring in from the stained glass windows to the multitude of gilded rays (varying in thickness precisely in order to heighten the light vibrations) which are refracted into the clouds, curved like mirrors to multiply the illumination.

THE PORTRAIT: MASK OR FACE

In the early seventeenth century sculptors like Stefano Maderno, Nicolas Cordier and Pietro Bernini offer a fixed and frozen portrayal of their sitters. Pietro Bernini's *Bust of Antonio Coppola* was modelled on an ancient toga'd figure on a funerary bas-relief, while the sculptor's full attention was concentrated on the face. The gaunt cheeks, the thin line of the mouth drawn out into the final rictus, the sunken eyes: these details remind one of a deathmask. The portrait now, as in the ancient world, was expected to refer back to the penates; in other words, to death. In Central Europe, too, no other interpretation was expected. Thus the *Bust of Leopold I* presents a solid and almost funereal image; by deliberate intention there is no tremor of life, because power could also be represented as an image outside time.

It fell to Gian Lorenzo Bernini, in the 1630s, to bring forward and define a new, more living type of portraiture. In his *Scipione Borghese* and his *Costanza Buonarelli*, we find speaking likenesses, a dialogue with the world: the Roman cardinal and the sculptor's mistress move their face, and their lips are parted as in the act of speech. The suggested presence of an interlocutor takes us back in fact to a stage situation, characteristic of Bernini. His concern with mimicry and recitation comes out strongly in an avowal he made in France to Chantelou. To show the gesture he had in mind for a figure, Bernini would strike the attitude himself and have himself so portrayed by one of his pupils.

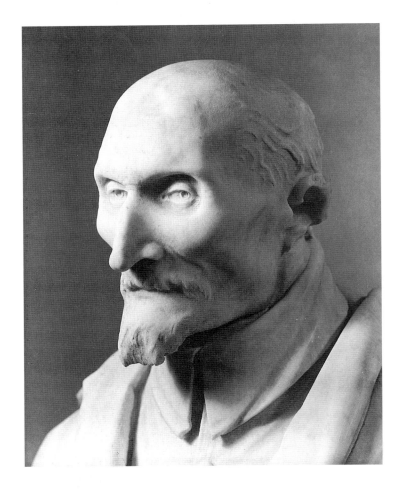

◁ Pietro Bernini (1562-1629):
Bust of Antonio Coppola, 1612.
Marble.
Church of San Giovanni dei Fiorentini, Rome.

Gian Lorenzo Bernini (1598-1680):
Bust of Louis XIV, 1665.
Marble, height 31½″.
Salon de Diane, Château de Versailles.

Anonymous:
Bust of the Emperor Leopold I, c. 1700.
Marble, height 34″.

224

Alessandro Algardi (1595-1654):
Bust of Donna Olimpia Maidalchini Pamphily, c. 1646.
Marble, 29".

From Bernini's workshop issued countless portraits of the speaking type, from that of the English gentleman *Thomas Baker* to those of various popes, from the majestic presence of the king of England (in this case Bernini acted as if he were a minister of foreign affairs) to his own features, portrayed as ever more worn and gaunt.

In the portraits by Alessandro Algardi and François Duquesnoy, other motivations appear. The dogmatic certainty of power, in the former; the art of delicate shading, in a pictorial and Venetian sense, in the latter. Soon known and looked to all over Europe, the artistic position of Bernini and Algardi was accepted like the two faces of a medal: in the latter, the mirror of dignity; in the former, theatrical dialogue.

It was Bernini who supplied a model for all Europe with his *Bust of Louis XIV*, still today at Versailles. The heroic note is set by the bust, no longer a truncated half-bust with funerary allusions, but vigorously alive and imperious.

Gian Lorenzo Bernini (1598-1680):
Bust of Costanza Buonarelli, c. 1635.
Marble, height 27½″.

The cloak is swept up, as if by a gust of wind, and the king turns with resolute composure in the direction of the wind, as if calmly facing a challenge (an allusion to the "wind" of the Fronde?). The base too is imagined as an allegorical complement; originally it must have included trophies of war and a globe, over which the Sun King's power allegorically shone.

A word, finally, about the courtly implications that may arise from such a detail, at once decorative and symbolic, as the sculptured base of the portrait bust. It is recorded by Chantelou that a cultured abbot, after seeing Bernini's *Bust of Louis XIV*, improvised this quatrain:

Bernini sank into deep thought
To make a support for the royal bust,
And said (finding none sufficiently august):

For such a king the world itself is a small base.

Bernini in turn, improvising an answer, explained the intellectual value of his allegory in a quatrain recorded by his son Domenico:

I can remember no such deep thought
Of making a worthy support for the King.
Useless would be the thought, for no such thing
Needs he who himself upholds the world.

That Bernini's message of life-giving allegory was not immediately understood, however, is shown by Antoine Coysevox's *Bust of Louis XIV*, which is still at Versailles. Having lost the advantage of the wind-filled cloak and the view of the haughty face from beneath, it remains a mere symbol, conveying nothing of Bernini's cosmic allegory.

THE ECSTASY OF THE FLESH

fruits which, if intact and well prepared, will be spoiled if they strike against each other. Water itself, however fresh in the vessel holding it, cannot long retain its freshness if touched by any earthly animal. So, Philothea, permit no one to touch you in an unladylike way, neither in fun nor in kindness, for though it may be that chastity is preserved amidst these actions more thoughtless than malicious, yet the freshness and bloom of chastity will always sustain some detriment and loss therefrom. But allow yourself to be touched in an immodest way, and the ruin of chastity will be complete. Chastity depends on the heart as its source, but concerns the body as its matter. This being so, it may be lost either through all the outward senses of the body or through the thoughts and desires of the heart."

Looking at an expressive nude by Bernini or Duquesnoy, Puget or his pupil Veyrier, one cannot help being reminded of some of the sensual poems of Góngora:

> Desnuda el brazo, el pecho descubierta,
> entre templada nieve
> evaporar contempla un fuego helado,
> y al esposo, en figura casi muerta,
> que el silencio le bebe
> del sueño con sudor solicitado.
> Dormid, que el Dios alado,
> de vuestras almas dueño,
> con el dedo en la boca os guarda el sueño.

François Duquesnoy (1597-1643):
Small Bacchus, after 1629.
Marble, height 23½".

Christophe Veyrier (1637-1689):
The Dying Achilles, 1683.
Marble, 41".

Sacred and profane love seem to flow in a subterranean course throughout the sixteenth century. In Titian's masterpiece the woman in fine clothes represents profane love, the languid nude sacred love: this interpretation was emphasized in the seventeenth century by an exaltation of the body, which now was no longer seen as merely appealing to the senses, but also as a vehicle of salvation.

The celebration of sensuality is to be found in the writings of Tommaso Campanella and Giordano Bruno, as it also informs the panic paintings of Pietro da Cortona: something of a subtle Epicureanism can be detected in the contention between man and his body. To understand the importance of this moment in the culture of the century, it is worth quoting a passage on chastity from the *Introduction to a Devout Life* (1609) by St. Francis of Sales:

"Human bodies are like crystal-glasses, which cannot be carried together because by thus being knocked against each other they run the risk of breaking. They are like

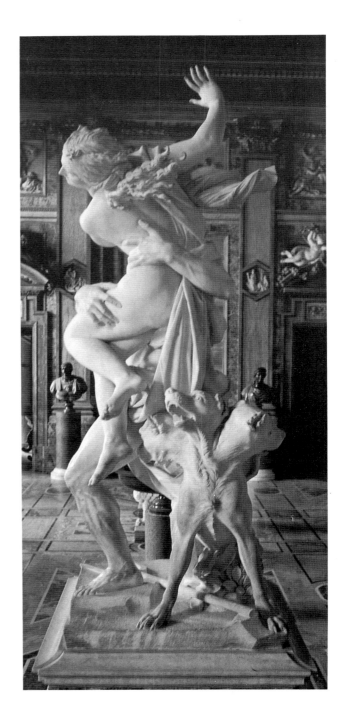

Gian Lorenzo Bernini (1598–1680):
The Rape of Proserpine, 1621–1622.
Marble, height 8'4".

Eros and Pathos are one and indivisible in the early work of Gian Lorenzo Bernini. The fruit of his meditations on Hellenistic sculpture is to be seen in virtuoso groups like *Apollo and Daphne* and the *Rape of Proserpine* (both in the Borghese Gallery, Rome). The plastic module is that of Mannerism (from Michelangelo to Giambologna), but the themes remained favourites of the fleshly-minded seventeenth century, from the classical fable of Rubens to the *danse macabre* of Rembrandt. The story of Proserpine clearly has universal implications, for the Eleusinian myth alludes to the perpetual renewal of life. But Bernini emphasizes the melancholy side of the story. As Pluto seizes her, about to carry her off, his hand sinks into her soft flesh, with faintly indicated seams—a deliberate reference to antiquity (in the manner of Scopas) within a sensual interpretation that is highly modern.

Sculptors relied on the softness and translucence of their material for the full effect of their "virtuoso operations" (as François Duquesnoy called them). And they found a precedent in Praxiteles for the vital exaltation of the body in a languishing *contrapposto*. The *Small Bacchus* of Duquesnoy (Doria Pamphily Gallery, Rome) takes over the modelling of a figure by Poussin, but with a heightened emphasis on light and shade; it recalls the figure of Antinoüs, the beautiful youth beloved of the Emperor Hadrian, who was also represented in the guise of Bacchus. This nude by Duquesnoy was a real curiosity in the collection of a worldly Roman cardinal.

Pierre Puget, too, emphasized the fleshly side of his strained and anguished figures, ranging from the monumental group to the trophy of flesh. His pupil Christophe Veyrier, in a work like the *Dying Achilles*, also emphasizes its sensual appeal. The heel, pierced by the fatal arrow, is pointed to by a simpering *putto*, while the youthful Achilles, with the outspread arms of an ancient martyr, offers not only a pathetic drama of gestures but even seems to move in a languid dance step.

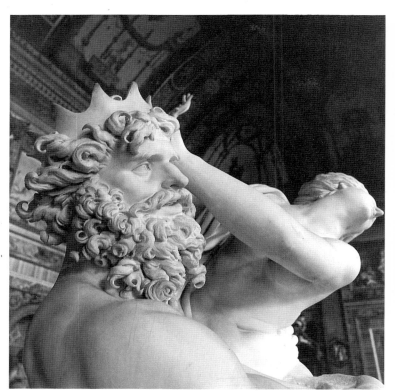

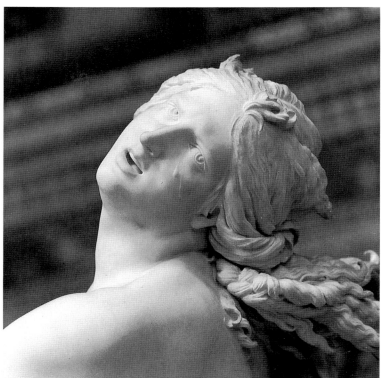

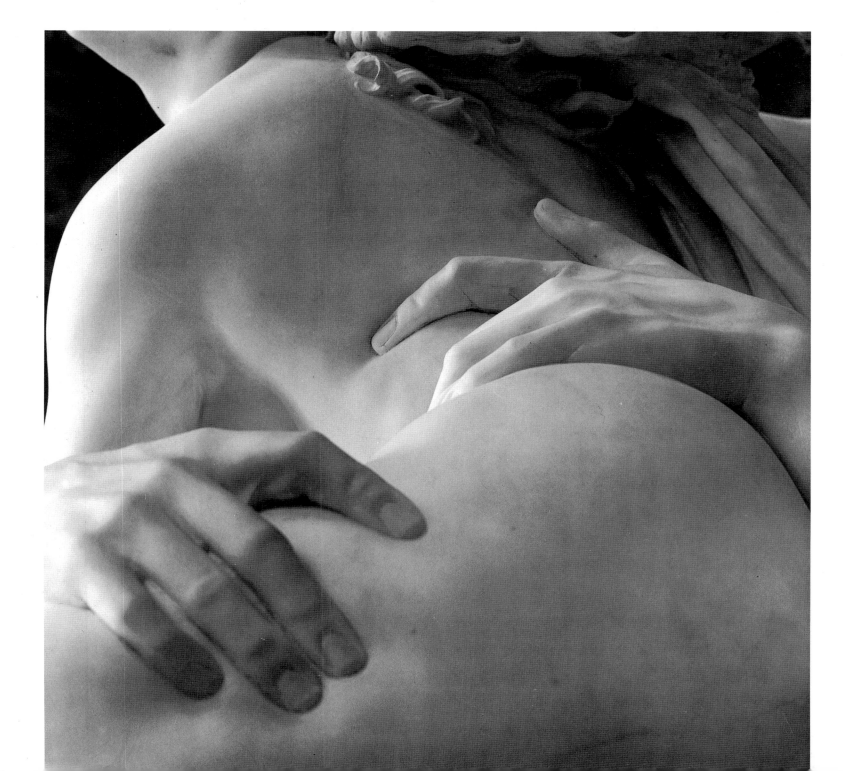

MYSTICAL RAPTURE

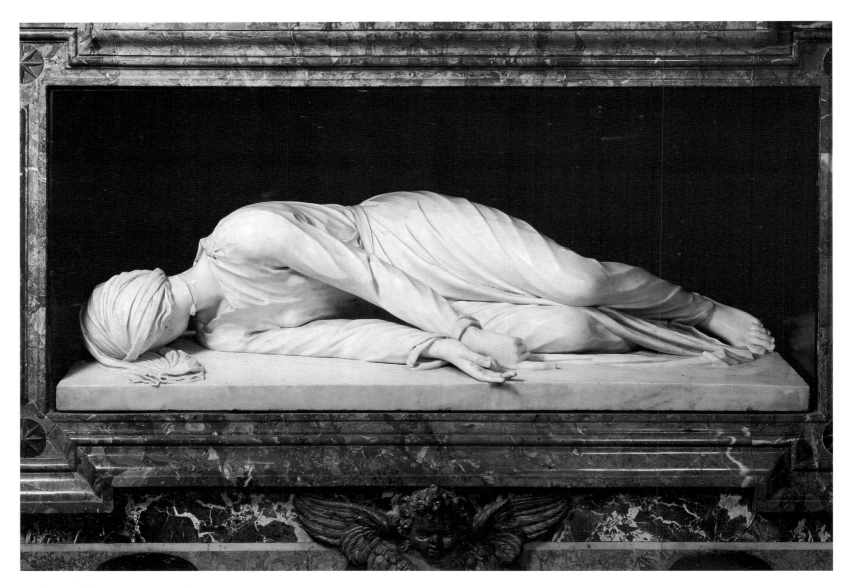

Stefano Maderno (1576–1636):
The Virgin Martyr St. Cecilia, 1600.
Marble, length 40″.
Church of Santa Cecilia in Trastevere, Rome.

Something will be said here not only about mysticism as represented in sculpture, but also about the sculptor's deliberate attempt to create in the believer a mood of mysticism and ecstasy. Sculpture thus became the mirror and indicator of a state of mind or deportment which was considered to open the way to salvation.

Obviously two different moods are induced by a chaste figure like the *St. Cecilia* by Stefano Maderno and the more theatrical figure of Bernini's *Ludovica Albertoni*. Little different from the first, however, is the attitude of devoutness that arises from the concentrated splendour of coloured Spanish sculpture, as exemplified in the gilt and triumphant rapture invoked by Churriguera.

This moment of ecstasy corresponds to the self-annihilation spoken of and written about by all the mystics of the seventeenth century. Pierre de Bérulle starts from the stage of "spiritual death" which the soul has to pass through during the "time of trials" in order to attain to the "mystical marriage" with the Bridegroom. It is the Bridegroom who permeates the soul in the "abyss of greatness" and the "gulf of glory" in order to consummate the "spiritual marriage" (terms strangely reminiscent of the language of the old alchemists). A quotation from the period may help to show how readily the moment (the nocturnal moment) of mystical experience could be described in artistic terms:

When with cunning hand
The painter paints his picture,
Unmoving must the canvas be
To receive the strokes of his brush.
Thus it is not in a changing soul
That God can be portrayed.

According to another mystic of this period, Benoît de Canfeld, the Bride of God (that is, man's soul) "desires with all other creatures to be melted, liquified, consumed, and annihilated."

230

At the beginning of the seventeenth century Rome was faithful to a "primitive Christianity" promoted by the learned studies of the historian Giacomo Bosio on the catacombs and the early martyrs. The embrasure in which Maderno's figure of St. Cecilia lies, in the church bearing her name, is like an ancient Roman loculus rediscovered, while her recumbent pose is lifelike and modest, quite remote from the worldliness that religion as interpreted by sculpture so easily assumed, from the Rome of "propaganda fide" to absolutist France ("One king, one faith, one law"), from Bavaria to the lofty raptures of Spanish art.

In the output of Bernini himself, which covers a period of sixty years, mysticism of various kinds is to be met with. He moves from pantheism (reminiscent of Giordano Bruno) and contemplation (reminiscent of Ignatius of Loyola) to a dramatic mysticism rich in emotional overtones. In his last years his faith was that of the Jesuits (Father Oliva was one of his advisers), but also partook of Quietism (as represented by Miguel de Molinos, first counsellor of Christina of Sweden but later forced to abjure and imprisoned for life). With Bernini's astonishing *Ludovica Albertoni*, the believer is introduced as it were into the Blessed Lady's bedroom, and made a witness to her convulsions on the disordered bed, with its covering of blood-red jasper. It is not merely a statue, but more like a living, gesticulating actress. It is not only a morbidly realistic vision but a subtle venture into allegory. The iconography is connected with that of *Truth Revealed by Time*, and also with that of Danae visited by Zeus in a shower of gold.

Gian Lorenzo Bernini (1598-1680):
The Death of the Blessed Ludovica Albertoni (detail), 1671-1674.

Gian Lorenzo Bernini (1598-1680):
The Death of the Blessed Ludovica Albertoni, 1671-1674.
Marble and jasper, length 6′2″.
Church of San Francesco a Ripa, Rome.

231

Pedro Roldán (1624-1700):
The Entombment, detail of the high altar in the church, 1670-1673.
Painted and gilt woodcarving.
Hospicio de la Caridad, Seville.

José Benito de Churriguera (1665-1725):
Detail of the retro-choir,
New Cathedral, Salamanca.

In seventeenth-century Spain the economic crisis had the effect of intensifying religion and bringing it closer to the people. The liturgy of processional statues carried on the themes exalted by El Greco to the glory of the altar. Spanish sculpture of this period, nearly always in brightly coloured wood, treated the various figures of the Passion singly, in isolation, with the devoutness of a miracle play, thus bringing about an unexpected return to the cultural atmosphere of the Middle Ages.

Quite different is the mystical sensation which an altar designed and sculptured by Churriguera was intended to convey. The old retable peopled with devout figures was now combined with the modern reliquary resplendent with precious materials, in an elaborate combination of forms which recalls the *frons scaenae* of ancient theatres. Before it, in the vast church, stands the believer, enfolded by the acrid smell of the incense, and the purpose of this triumphant gallery of heroes of the faith passing in the procession of virtue, is to excite his feelings to the tormenting point of ecstasy. Thus was created a short circuit, comprehensible perhaps only to the modern mind, between worship, contemplation, rapture, vision and drug.

José Benito de Churriguera (1665–1725):
High Altar, church of San Esteban, Salamanca, 1693–1696.
Painted and gilt woodcarving.

THE MIRROR OF ETERNAL LIFE

Gian Lorenzo Bernini (1598-1680):
Skeleton in the Cornaro Chapel (detail), 1647-1652.
Inlaid marble pavement.
Church of Santa Maria della Vittoria, Rome.

The idea of death was anything but lugubrious to the men of this period. For the believing Christian (the "ready and willing man" of the Jesuit Bartoli), it was the beginning of the true life, and as such a matter for rejoicing. In one of the earliest operas, the *Sant'Alessio* (1631) of the future pope Clement IX, death is sung of in pre-Metastasian stanzas as "pleasing" and "sweet," a source of "delight and comfort."

The lugubrious view of death persisted in Spain and the countries of Central Europe. Blood, *rigor mortis*, the skeleton, the rictus, all this lingers on in the sculpture of men like Juan de Mesa and Andreas Schlüter. But in Bernini's interpretation (the pavement skeleton in the Cornaro Chapel of Santa Maria della Vittoria, where his *St. Teresa* also stands), the denizen of the other world is very much alive, coming forward with a strenuous gesture of prayer.

To situate this quickening (and indeed ironic and dialectical) sense of life within the main currents of thought of the period, it may be worthwhile quoting one of the dreams described in the *Sueños* (1627) of Francisco de Quevedo:

"At that moment entered a creature that appeared to be a well-grown woman, covered with crowns, sceptres, scythes, sandals, fine shoes, tiaras, hoods, mitres, caps, brocades, furs, silks, gold, cudgels, diamonds, baskets and crockery. She had one eye open and one closed. She was naked and clothed, and adorned with all colours. She was young on one hand and old on the other. She went slowly and briskly. She seemed far away and she seemed close by. And just as she seemed about to come in, then at one stroke I found her beside me.

"I stood as one who pointblank has just been asked what is this and what is that, at sight of so extravagant an appearance and outlandish attire. Yet I was not afraid. I only wondered at it, not without a certain impulse to laugh, because, once I had taken a good look (as one says in colloquial speech), I saw how comic a figure it was. At last I asked her who she was. And without a moment's thought she answered in a still small voice: I am Death.

"Death?"

This quickening vision was further developed and deepened in Bernini's work, even in what he did for the stage. In his comedy *I due Covielli* (for Bernini was also a writer of comedies), one of the two cowardly soldiers ("covielli") appears in the last act and declares that the real show has been, not on the stage, but in the nocturnal carriage ride of the audience on the way to the theatre; and then the curtain opens on just such a scene. But immediately after that Death appears on a lean horse, with her retinue of grooms dressed in mourning. Then one of the two soldiers in the title role comes forward to explain that death "ends and cuts short the thread spun by all comedies," and he calls for the curtain to be drawn so as not to sadden the audience. Scenes and doings which were, in fact, typical of the Italian *commedia dell'arte*.

The appointed places for the expression of death were two: the catafalque and the commemorative monument. Gradually the sense of the catafalque as a *castrum doloris* was lost. The sculptures designed for it took the symbolic form of *mors victa*, of death subdued and triumphed over; further, being only a temporary structure or decorated scaffolding intended for immediate destruction, it also represented a triumph of the ephemeral. Funerary monuments progressively lost the sense of otherworldliness, to become like stage displays, with a spirited, vitalizing *mise en scène*.

Juan de Mesa (1583-1627):
Severed Head of John the Baptist, c. 1625.
Sacristy, Seville Cathedral.

In the early seventeenth-century monuments for Sixtus V and Paul V, in Santa Maria Maggiore, all the sculptors of the period took part, from Maderno to Pietro Bernini, from Mochi to Cordier. The figures are set in a rigid architectonic framework, and the tomb becomes the cold announcement of death. But a few years later, in the *Tomb of Urban VIII* in St. Peter's, Bernini comes forward with a new interpretation. The bronze figure of the pope stands at the top of a kind of pyramid of melancholy, completed by two allegorical figures in marble (Justice and Charity), while in the centre appears a lively gesticulating skeleton. The latter is opening a book in which is written in letters of gold the name of the deceased pope–just as the figure of Fame may do at the end of one of the stage plays of the period.

In all these monuments, big and small (and one of the least known is illustrated here), Roman Baroque emphasizes, steps up, this quickening sense of life. Death becomes a sculpted figure or picture or an active memory, in combination with performing figures or smiling angels.

Andreas Schlüter (1664-1714):
Death Seizing an Angel, detail of the Monument
to David Männlich, 1700.
Church of St. Nicholas (Nikolaikirche), East Berlin.

Michel Maille (?-1700):
Bust of St. Peter of Alcantara held up by an Angel, 1682-1684.
Chapel of San Pietro d'Alcantara, Santa Maria in Aracoeli, Rome.

Johann Balthasar Neumann (1687–1753):
Episcopal Palace (Residenz), Würzburg.
Kaisersaal (Emperor's Hall), 1737.

Frescoes, 1752, by
Giambattista Tiepolo (1696–1770).

Stuccoes and statues, 1749–1751, by
Antonio Bossi (1700–1764).

ROCOCO by François Souchal

Some of the terms we use today to label the phases of art history were originally terms of disparagement. Indeed, negative connotations still cling to the word "Rococo." First used as an adjective to designate the tastelessly florid, it gradually gained respectability and was eventually adopted by art historians. In the period when Rococo flourished it was usually called the "*genre pittoresque*" and was somewhat summarily lumped together with "Rocaille." There is some disagreement about its geographical origins. The American scholar Fiske Kimball held that Rococo began in France towards the end of the reign of Louis XIV. Others view it as a degeneration of Baroque. As with Baroque, the strict sense of Rococo ended by acquiring a wider connotation embracing much of eighteenth-century art.

Is there such a thing as Rococo sculpture? Some scholars maintain that Rococo is a freakish style limited mainly to jewelry work and the fantasies of whimsical draughtsmen. The Rococo phenomenon has its roots in the changing tastes of a society emerging from the wars and moral conflicts of the seventeenth century, a society that was acquiring a renewed zest for life and demanding a refined, exuberant, light-hearted art in reaction to the stern, ceremonious, majestic art of the previous century. There was, to be sure, no sudden dramatic break. The old iconographic vocabulary remained unchanged. The old system of values and forms was not rejected outright but was applied with a lighter and freer touch. The monarchic culture evolved less rigid institutions and more alluring decorations. The tone was set, more than ever before, by court art. Versailles, with its magnificent buildings and grounds, became the envy of Europe's princes. At the outset, then, Rococo was a decorative art and sculpture naturally had a place in it. A vibrant, irrepressible art, it demanded relief, as well as light and colour.

As in Baroque art, the borderline between ornament and figure remained somewhat vague. Rococo aspired to the symphonic. Architectural innovations lent themselves to its outpouring of fancifulness and inventiveness, an inventiveness that no longer recoiled from asymmetry, startling effects, or the abstractness of lines that twist around one another and intersect with absurd convolutions. Thanks to differences of national and regional temperament, there was nothing monotonous about this art willing to court extreme artificiality in order to avoid the humdrum. Nor did Rococo evolve in quite the same way in every country. Its chronology is not uniform. Moreover its stylistic landscape was complicated, to an even greater extent than that of other periods, by the individual careers of its artists. French artists, frustrated from satisfying their personal ambitions by incompetence in the domain of public finance, found work abroad, and as a result French art was exported to a degree that was unprecedented. To repeat an old adage, in the Age of Enlightenment Europe was French. This is not strictly true in fact. For though the decorative arts that developed in Paris workshops reached as far as Würzburg, Amalienburg, and La Granja, Italian Baroque nevertheless continued to exert a powerful influence over large portions of Europe.

Nor did Rococo begin to decline at quite the same time in all countries. The Neoclassical reaction set in early in France, towards the middle of the eighteenth century, but it did not begin to have much impact until towards the end of the century. As late as the beginning of the nineteenth century, Rococo exuberance permeates the visionary works of the Brazilian artist Aleijadinho. Thanks to its whimsicalness, Rococo (an astonishingly untyrranical European idiom) produced an enormous variety of expressions, which reflected not only different artistic temperaments but also different social, economic, and political conditions. In trading nations like England and the Netherlands Rococo is more restrained than in South Germany with its monasteries that were veritable bastions of the Counter Reformation and where Baroque art had already prospered as an expression of triumphant Catholicism. But it would be specious to try and establish such clear-cut and distinct categories.

It may seem illogical that Rococo flourished under enlightened despotisms that ought by all rights to have been an ideal terrain for a rational Classicism inspired by antique sources. But artistic phenomena are never that simple, especially when they express a whole civilization. The civilization of the eighteenth century was essentially monarchical, and this at a time when, in spite of the *philosophes*, monarchies still rested on religion and the Church. One of the most debatable notions in art history, one that is still aired today, is that the religious art of the eighteenth century lacks sincerity. In point of fact, Rococo, especially in sculpture, was perhaps the last great sacred art of the Western world, a world that was still far from becoming secular and where a system of coherent values and principles connecting everyday life to the sacred was by and large still in force.

Take the episcopal palace at Würzburg, the seat of a prelate who was both a spiritual and temporal ruler and who, wishing to express a greatness that transcended his mere person, called on the best artists of the day, irrespective of their nationality (though all the same admitting to a special liking for whatever was Italian). The stucco work and the statues of pagan gods that were placed as a matter of course in niches in the Kaisersaal are the handiwork of the sculptor Bossi. They are in perfect harmony with Tiepolo's frescoes and the architecture of Johann Balthasar Neumann, who was deeply influenced by memories of his Italian sojourns. In fact, they pay tribute to the venerable episcopal see, as does the whole decorative system. The ballet-like gestures of the statues proclaim that this essentially aristocratic art is, first and foremost, a spectacle caught in a perpetual whirlwind of colours and forms. Antonio Bossi, a Swiss sculptor born at Lugano, carved this series of masterpieces towards the middle of the century (between 1749 and 1751). He is obviously indebted to the Baroque of Bernini; he nevertheless brings to his work a touch of gracefulness and gaiety that are characteristically Rococo. The medium he employs, stucco, was then producing its finest results, for its malleability accorded perfectly with the zest for life, movement, and the unexpected that was vital to the spirit of Rococo.

FROM ROCAILLE TO ROCOCO

Lambert-Sigisbert Adam (1700-1759):
History and Fame, 1735-1736.
Stuccoes in the Salon of the Prince de Soubise.
Hôtel de Soubise, Paris.

most salient examples of the fascination the palace of Versailles and its outbuildings were to exert on European rulers. But here in Bavaria it transcends the merely imitative. Its grace reflects the Rocaille of the Hôtel de Soubise with greater freedom and exuberance.

While the French influence dominated in Munich, the triumphant art of seventeenth-century Rome was the model for the Habsburg imperial palace in Vienna. The greatness of the Holy Roman emperors counterbalanced the grandeur of the popes in Rome. Here, in the Habsburg capital, Prince Eugene of Savoy, the famous general who led the imperial army that fought the French at Turin, favoured the solemn, dramatic imperial style. The hall of Atlantes in his Upper Belvedere palace impresses the visitor with its powerful vaults sustained by strong, heroically grimacing figures carved in marble, which the surveyor of works, Lukas von Hildebrandt, used as pillars. Hildebrandt learned to experiment with dramatic effects in the workshop of Carlo Fontana in Rome. In the ornamental sequence shown here, sculpture serves the ends of architecture, but in the final analysis it is the sculpture rather than the architecture which holds our attention. The great architects of this period understood full well the interaction of decorative and spatial volumes, and they allowed sculpture to play a leading role in the organization of space.

Johann Baptist Zimmermann (1680-1758):
Amphitrite (?), detail of the ceiling in the
central hall of the Amalienburg shooting-lodge, c. 1734-1737.
Stucco.
Park of Schloss Nymphenburg, Munich.

Stucco was the ideal medium for decorating the space above drawing and reception room cornices with high reliefs recounting numberless episodes from classical mythology and illustrating allegories, as in the saloon of the Hôtel de Soubise in Paris. Here the gods were brought to life by the magic wand of the surveyor of works Boffrand, who set the best sculptors and painters in Paris to work on what remains, to this day, the supreme example of an aristocratic town house (1732-1740). Among those who worked on this fortunately preserved jewel of the most exquisite French Rocaille were the Adam brothers, Lambert-Sigisbert and Nicolas-Sébastien, the sons of a sculptor from Lorraine, who received part of their training in Rome. They combine the dynamic lines of Italian art with the elegance and distinction that were the rule in Bourbon France, whether at the court of Versailles or in private town houses.

This art, which originated in Paris, was echoed at the court of France's ally, the Elector of Bavaria. The Rococo decorative system there reflects not only the personal tastes of the Elector Max Emmanuel, who spent many years as a refugee in France, but also the genius of François de Cuvilliés, a native of the province of Hainaut, who was trained by Blondel in Paris. This prolific draughtsman drew models that were copied by the stuccoists working under Johann Baptist Zimmermann who, between 1734 and 1737, transformed the reception rooms of the shooting-lodge of Amalienburg into an enchanting fantasy in silver and blue, a second Trianon in the neighbourhood of the great Nymphenburg palace. This is one of the

Johann Lukas von Hildebrandt (1668-1745):
Hall of Atlantes (detail), 1721-1722.
Marble.
Upper Belvedere Palace, Vienna.

THE TASTE FOR THE THEATRICAL

Johann Balthasar Neumann (1687-1753):
Grand Staircase in Schloss Augustusburg, at Brühl, near Cologne, 1740.

The most elaborate examples of Rococo decoration occur in staircases. These do more than simply connect two superposed levels; they are a meeting place, an effective setting for outward show and pomp. Balthasar Neumann satisfied this double requirement brilliantly when he designed the staircases in the Archbishop-Elector of Cologne's castle of Augustusburg at Brühl (1740). He placed a group of caryatids at the foot of each arm of the upper flight, and made the main flight lead up to a monumental symmetrical composition.

Here we clearly have a ceremonious art, an art of jubilation, which achieves spectacular effects with its polychrome stuccoes and the gilded lace work of its wrought iron railings. The Germans were the great virtuosos of this essentially aristocratic art. Their crowning achievement, sculptural architecture that might have been transplanted from an elaborate stage setting, was built for the Elector of Saxony. The sculpture-decorated pavilions of the Zwinger at Dresden, which was reconstructed after the bombings of the Second World War, served one purpose and one purpose only: they were a grandstand for court pageants. From 1711 to 1723, the architect Pöppelmann collaborated with the sculptor Balthasar Permoser and the teams of artisans working under him. Their joint creation overwhelms us with its gratuitousness, so lavish it seems unreal–and surely this too is one of the hallmarks of Rococo.

The treatment of palace façades embellished with sculpted figures and ornaments was generally more restrained in France. And yet the irresistible *élan* and gaiety of Rocaille are clearly in evidence in the high-relief of the mettlesome *Horses of the Sun* which Robert Le Lorrain executed for the façade of the stables at the Hôtel de Rohan in Paris. Horses were of vital importance then and deserved a palace of their own near the palace of the lavish Rohans. Le Lorrain played a leading role in the genesis of Rococo sculpture and this work, an astonishing accomplishment for an old man (for he was old when he executed it towards 1737-1740), is a genuine masterpiece.

Balthasar Permoser (1651-1732):
Atlantes, detail of the last pavilion of the Zwinger, Dresden, 1714-1718.
Stone.

Robert Le Lorrain (1666-1743):
The Horses of the Sun, 1737-1740.
Stone.
Façade of the stables, Hôtel de Rohan, Paris.

PALACE AND TOWN HOUSE FAÇADES

Ignacio de Vergara (1715-1776),
after designs by Hipólito Rovira (1693-1765):
Entrance of the Palace of the Marqués de Dos Aguas in Valencia, 1740-1744.
Marble.

Johann Baptist Zimmermann (1680-1758):
Portal of the Episcopal Palace, Munich, 1735-1737.
Stone and stucco.

family produced one of the finest Bavarian Rococo sculptors and one of the finest Rococo fresco painters–two brothers who worked together on some of the major decorative projects of the period. The façade of their house is covered with figures and motifs that celebrate the arts and evoke the swift passage of time in a series of lively scenes that spill over on the architecture's openings and alignments. The house even has its private chapel, dedicated to St. John Nepomuk.

Egid Quirin Asam (1692-1750):
Façade of the Asam Family House, c. 1733.
Stucco.
Sendlingerstrasse, Munich.

An impression of profusion rather than clarity is what one feels in front of the entrance to the Marquis de Dos Aguas' palace at Valencia, one of the outstanding examples of eighteenth-century Spanish sculpture, executed in marble by Ignacio de Vergara between 1740 and 1744, to the designs of Hipólito Rovira. The niche contains a statue of the Virgin and Child, and the pair of twisted figures flanking the entrance represent the two rivers of the owner's name. The sculptures are framed by a sinuous naturalistic composition. What the ensemble proclaims is piety and aristocratic pride.

The Episcopal Palace of Munich, originally the Holnstein Palace, was designed and built by François de Cuvilliés (1735-1737). The portal sculpted by Johann Baptist Zimmermann is a good example of the ornamental range of Rococo, displayed in the woodcarving of the door panels as well as in the stone sculptures of the pediment and the brackets supporting the balcony. Notice the typical Rocaille forms of the cartouche, the wavy elongated finial, the twisting shell and volutes, the exuberant palm motif. Petulant angels support the distinctly asymmetrical cartouche which contains a delicate, fluid low relief depicting a gracious, smiling Virgin Mary.

This style of lavish sculpture, mainly associated with palaces and important aristocratic residences, is also found on the private houses of some artists. The Adam house in Nancy, which is still extant, is one example; another is the Asam house in Munich, dated about 1733. The Asam

Matthias Braun (1684-1738):
Portal of the Clam-Gallas Palace,
Prague, with Atlantes, 1717-1719.

Right in the heart of Europe, in Bohemia, Prague is, with Vienna and Munich, one of the centres of Baroque and Rococo sculpture. As in Vienna, the aristocratic palaces of Prague reflect imperial grandeur (and indeed the same Baroque and Rococo masters often worked in both cities). Johann Bernhard Fischer von Erlach, the most eminent master to work for the Habsburgs, was given the job of supervising the construction of the Clam-Gallas Palace between 1717 and 1719. The sculpture work was entrusted to the most prolific artist in that part of the empire, Matthias Braun, a native of Tyrol, whose turgid, tormented forms (for example, the atlantes flanking the entrance) are Baroque, if not Manneristic, rather than truly Rococo.

The aristocratic town houses in Paris were generally less given to supererogatory pompousness. They tended to be adorned with reliefs depicting pleasant mythological motifs–preferably amorous–in keeping with the more relaxed mores under the Regency and in the early reign of Louis XV. This type of decoration was, more often than not, integrated informally into architecture as a series of tableaux in low-relief. The small *hôtel* of the farmer-general de la Boexière, on the Rue de Clichy, no longer survives, but Nicolas-Sébastien Adam's low reliefs in stone which used to ornament its façade have luckily been preserved. In a style characterized by ingenious arabesques, they depict the life and loves of Apollo. One of the reliefs, *Apollo and Coronis*, was exhibited at the Salon of 1753.

Nicolas-Sébastien Adam (1705-1778):
Apollo and Coronis, 1753.
Stone.
Pavillon de Bagatelle, Paris.

244

WATER, STONES, AND LIGHT

The tone was naturally less playful in the royal grounds of the King of France. Under Louis XV, the gardens at Marly lost some of the glamour they had had in earlier times; nevertheless several choice pieces of sculpture were erected there to replace Coysevox's *Mercury* and *Fame*, which had been moved to the Tuileries from their original location at either end of the basin where the king and his courtiers watered their horses. The sculptor, Guillaume Coustou, was commissioned to sculpt a pair of rearing steeds restrained with great difficulty by their grooms. Carved out of enormous blocks of marble, they in turn were transported to Paris during the Revolution–preserved by the painter David–and they survive as masterpieces of French sculpture and Rococo art (a Rococo whose splendid, fully mastered impetuousness transcends the boundaries of style to attain the universal). They are now housed in the Louvre, sheltered from pollution and the elements.

Ferdinand Dietz (1709-1777):
Pegasus, detail of Mount Parnassus, 1765-1768.
Gardens of the Episcopal Palace,
Veitshöchheim, near Würzburg.

Guillaume Coustou (1677-1746):
Rearing Horse from Marly, 1739-1745.
Marble, height c. 11½'.

In the Rococo period, gardens and parks were adorned more than ever before with statues, whose function was not primarily to deliver a message but to embellish, to surprise pleasantly, to inspire daydreams. These isolated figures and groups were often placed on fountains, in basins, near cascades that were the principal attractions on the grounds of palaces, country seats, and town houses. Polite social intercourse, with its games, balls, pageants, fireworks, seemed unthinkable without the presence of these mute onlookers carved in stone or marble. The park of Veitshöchheim near Würzburg, the country residence of the Prince-Bishop, is, with its muses, dragons, sphinxes, and smiling deities, one of the most enchanting Rococo gardens. Its central ornament is a spectacular *Pegasus* rearing atop an elaborate stone mound representing Mount Parnassus. It is the work of Ferdinand Dietz or Tietz, a highly imaginative sculptor who was a student of Matthias Braun.

The eighteenth century saw the rise of the house of Savoy, whose rulers dreamt of turning Turin into a European capital fit for a new royal crown. Great emphasis was placed on sculpture in the reign of Charles Emmanuel III, who founded a sculpture academy. Its leading figure was Simone Martinez, the son-in-law of the architect Juvarra. The fountain of the Palazzo Reale (Royal Palace), with its frolicsome tritons and water nymphs, is a good example of this sculptor's rather nonchalant, highly contrasting work permeated with the influence of Versailles and French sculpture.

The issue of the genesis of garden sculpture in Spain under Philip V does not arise, for this king, a Bourbon, was born at Versailles and imported artists from his native land to ornament the grounds of the royal palace of La Granja. This enclave of French art in the mountains of Old Castile is one of the most complete outdoors sculptural ensembles to come down to us. René Frémin, Jean Thierry, and Jacques Bousseau were the chief authors of the countless basins, groups, isolated statues, mythological gods, and allegorical figures, many of them executed in a lead alloy, as were most of the statues at Versailles. And, though they are more than mere copies, these works clearly show the influence of Versailles, and especially of Marly. This enormous project, begun in 1720 and completed in 1740, reflects its time; it is permeated with the gay turbulence of the Rocaille spirit–as can be seen from the wonderfully theatrical treatment of the basin of *Perseus and Andromeda*.

In the southern Italian peninsula, the architect Luigi Vanvitelli supervised the construction of the huge Palace of Caserta, designed as a second Versailles for the king of Naples, with a matching park of its own. Here jets of water, fountains, basins, and cascades orchestrate a series

Simone Martinez (?-1768):
Nereid and Tritons, c. 1750.
Marble.
Gardens of the Palazzo Reale, Turin.

Paolo Persico (1729-1796) and Tommaso Solari (?-1779):
The Fountain of Diana, 1770-1780.
Marble.
Gardens of the Palazzo Reale, Caserta, near Naples.

of startling scenes, prospects, and perspectives framed by marble statues freely inspired from Ovid and Pausanias. An imperious Diana stands in front of a man-made grotto at the foot of a cascade, giving orders to her band of scattered, gesturing nymphs. The sculptors, Solari and Persico, are far less well known than Vanvitelli, who supervised this project between 1770 and 1780.

France, which set an example for large-scale garden sculpture, seems to have been outshone by the efforts of neighbouring kingdoms to emulate its grandiose decorations. And yet, recall that Louis XV, eager to complete the unfinished landscaping at Versailles, had the large basin constructed which closes off the north end of the north-south perspective. The Basin of Neptune is an eighteenth century Rocaille addition to the Sun King's ensemble—and does not dishonour it by any means. The group in the centre, tumultuous yet not lacking in power, is the work of the two Adam brothers from the Lorraine, Lambert-Sigisbert and Nicolas-Sébastien. It shows the influence of Bernini and the Italian Baroque sculpture they had seen in Rome. With an acute sense for dramatic movement, they skilfully transposed this influence to the classical environment at Versailles, and they did so without a break in mood or manner. Neptune and Amphitrite, riding their chariot in majesty, are surrounded by a band of exultant sea creatures which evince a stunning wealth of imagination.

René Frémin (1672-1744), Hubert Dumandré (1701-1781) and Pierre Pitué (?-1761):
Fountain of Fame, between 1720 and 1740.
Lead.
Gardens of the Royal Palace of La Granja at San Ildefonso, near Segovia.

Lambert-Sigisbert Adam (1700-1759) and Nicolas-Sébastien Adam (1705-1778):
The Triumph of Neptune and Amphitrite, 1740.
Lead, height c. 16½'.
Central group, Basin of Neptune, Versailles.

SCULPTURE
AND TOWN PLANNING

More than ever, then, sculpture served to satisfy the hunger for prestige and pleasure of the ruling circles in a monarchic and aristocratic culture. But its social function grew as well, as towns and cities expanded and were embellished. The eighteenth century was the age of urbanism *par excellence*. New avenues, improved fluidity of movement, and more efficient public amenities provided occasions for beautifying and ornamenting. Here too we observe a close connection between water and sculpture. Water is the source of all living things; it is also an incomparable setting for sculpture, for it reflects and magnifies its forms.

In the centre of Vienna's old town the Neuer Markt, a traditional place of meeting and exchange, was given a new air of grandeur with the erection of the Fountain of Providence. This masterpiece by Raphael Donner dates from 1739. Allegorical figures of the four rivers of Austria adorn its sides, combining the harmony of classicism (with a distant echo of the Rivers of France in the gardens at Versailles) with the energy of Baroque art (and here Bernini's rivers in the Piazza Navona come to mind). But Donner brings to his work a Rococo grace that is entirely his own.

The Classical-Rocaille dialectics can be observed again in Paris; and, once again, it serves to create an impressive setting for water, life-giving water. Bouchardon's Fountain of the Seasons stands, not in the middle of a square, but in a street–the Rue de Grenelle–and it suffers from the fact that one cannot step back far enough for it to make its full

Georg Raphael Donner (1693-1741):
Fountain of Providence, 1739.
Lead.

Edme Bouchardon (1698-1762):
Fountain of the Seasons, central part:
The City of Paris between the Seine and the Marne, 1739-1745.
Marble, height of main statue c. 7′.
Rue de Grenelle, Paris.

effect. Its allegorical scheme is familiar by now: a serene, self-assured City of Paris, looking perhaps a little too much like a Roman matron, sits on her throne, with the rivers Seine and Marne lying recumbent at her feet. Into this solemn group carved in the round, flanking bas-reliefs of sporting *putti* in different seasons introduce a note of gaiety and create a pleasing contrast.

Rome's inhabitants, on the other hand, inclined to a wider, more epic vision of life. The *Acqua Vergine* cascading on the Piazza di Trevi is unquestionably a nobler stream of water than the miserable trickle running from the fountain in the Rue de Grenelle in Paris. And then too Bernini had set high standards in the city of the popes. The

Fontana di Trevi (1745-1762) is the work of some of the best sculptors of the age. They successfully linked a palace façade imitating a triumphal arch with an impressive, operatic decoration depicting an imperious *Neptune* (by Pietro Bracci) towering above groups of tritons and rearing sea-horses. Rarely has the theatrical flair of a people who have always had a special love for spectacles been stated so explicitly.

It is interesting to note that Lambert-Sigisbert Adam, when he was staying in Rome, came in first in the competition for the design of the Fontana di Trevi, but later lost the contract. No doubt he drew consolation from designing the Basin of Neptune at Versailles.

Nicola Salvi (1697-1751):
Fountain of Trevi, 1745-1762.
Marble.
Central niche statue of Neptune by Pietro Bracci (1700-1773).
Piazza di Trevi, Rome.

Even modest capitals hankered for splendid public decorations. The Duchy of Lorraine, soon to lose its independence, in fact independent in name only under the reign of Stanislas Leszczynski, the father-in-law of the king of France, boasted a decorative ensemble in its capital, Nancy, that was unique in Europe. It made this relatively small town one of the most attractive and palatial of the Rococo royal cities. There is real genius in the way Guibal's monumental fountains, which survive to this day, are framed by the gilt lacy architecture of Jean Lamour's grille. This weblike wrought iron masterpiece with its inexhaustible arabesques is a noble addition to the vigorous, though not excessively original, art of Barthélemy Guibal, who uses the old Neptune motif, standing the god on a Rocaille peak from the sides of which water cascades down.

Barthélemy Guibal (1699-1757):
Fountain of Amphitrite (above) and Fountain of Neptune (below), c. 1755.
Lead.
Gilt ironwork by Jean Lamour (1698-1771).
Place Stanislas, Nancy.

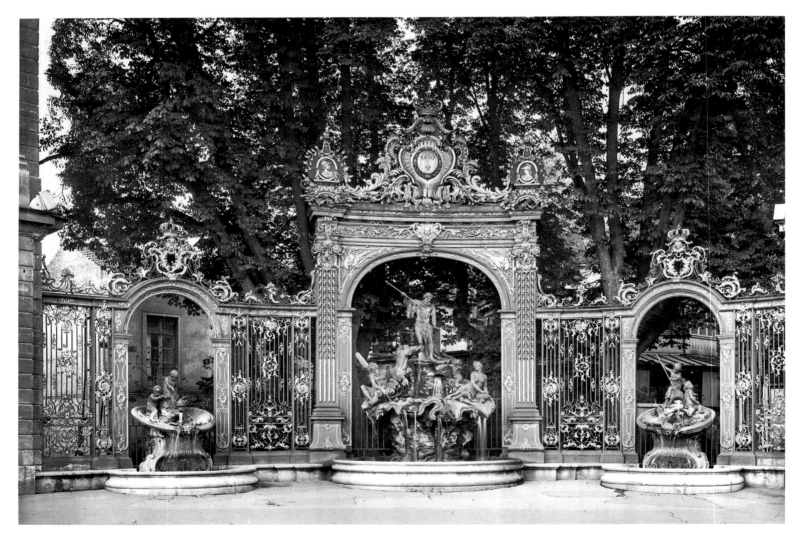

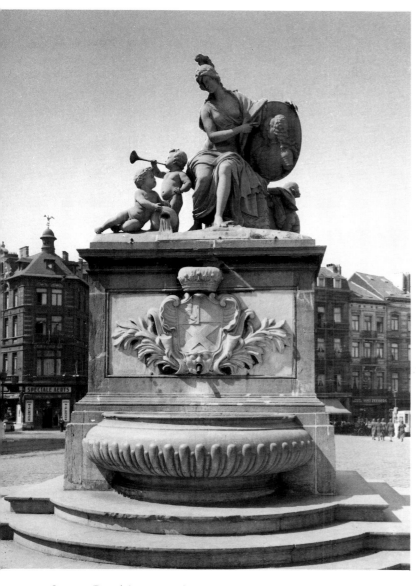

Jacques Bergé (1696-1756):
Fountain of Minerva, 1751.
Marble.
Place du Grand Sablon, Brussels.

Matthias Braun (1684-1738):
St. Luitgarda Embracing the Crucified Christ.
Stone.
Charles Bridge, Prague.

Not far from Nancy, in Brussels, the capital of the Austrian Netherlands, we find another ancient deity–Minerva–seated above a fountain erected (in 1751) in the middle of a square, the Place du Grand-Sablon. She is holding a medallion containing the portraits of the enlightened monarchs Maria Theresa and her husband, Francis of Lorraine. Once again allegory is made to serve the ends of political propaganda. The sculptor, Jacques Bergé, received part of his training in Paris in the workshop of Nicolas Coustou, one of the masters of Rocaille sculpture, and the French influence is clearly in evidence here.

The Italian influence continued to dominate in Central Europe. The heritage of the Eternal City, and of the Ponte Sant'Angelo in particular, can be clearly discerned in the splendid ensemble of the Charles Bridge in Prague. The patron saints and the protectors of Bohemia and its capital, flanking this triumphal avenue spanning the river and connecting the Old Town with the New Town, might almost have been brought there from the Rome of Bernini. Yet they are the work of some of the best artists of Central Europe–Jäckel, Braun, and Brokoff among them–artists who vied with one another in skill and inspiration. (Some of the statues are nineteenth-century work.)

THE SPECTACLE OF FAITH
SHRINES, ORATORIES, CHAPELS

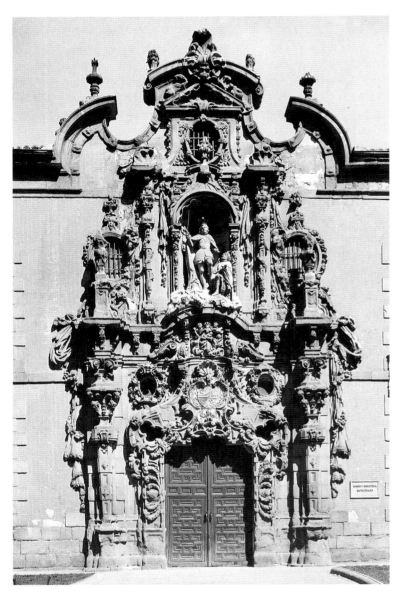

Pedro de Ribera (1681-1742):
Portal of the Hospicio de San Fernando, Madrid, 1722-1729.
Stone.

The secular sculpture of the eighteenth century expresses a worldliness refined almost to the point of being precious, within a rigidly hierarchical society whose standard of living was rising. The ruling class has been reproached for its "frivolity"; it is said to have been overly addicted to games and pleasures, and increasingly detached from religion. But this is a very incomplete view. The majority of the population of Europe continued to be deeply swayed by spiritual values; and the provocative behaviour of a few libertines hardly affected this popular faith. The Christian doctrine continued to inspire noteworthy monuments, but the language of these monuments was adapted to a new current of feeling, to new ways of worshipping, to new cults (for example the cult of the Sacred Heart, which began to sweep France as early as the middle of the seighteenth century).

The dynamic energy of Baroque art was ideal for conveying the triumphant accents of the Counter-Reformation. The eighteenth-century artists preserved the momentum of Baroque, disseminated it throughout Europe (and even beyond), and gave it inflections which were closer to the worldly accents of secular art. It has been said that the forms employed to decorate Rococo façades are essentially the same whether they adorn a palace, a church, or a monastery; that some Rococo chapels look more like drawing rooms; that some church choirs might well pass for opera scenery; that some eighteenth-century statues of saints resemble posturing actors. This is all true enough as far as it goes, but it does not prove conclusively that the religious feelings of the eighteenth-century artists and those who employed them were affected or tainted with passions that were less than religious.

The men of the eighteenth century were addicted to the theatre, the opera, and every kind of public spectacle; and for them religion too had its theatrical side. Their churches were sacred theatres, and the more impressive their scenery the more effective the perfectly sincere liturgical drama that was enacted in its midst. The Catholic Church had long outgrown the austereness of primitive Christianity; no expense was spared to ornament the House of God which was also a place of worship where rich and poor alike gazed in wonder at awe-inspiring liturgical spectacles. Like the art of this period, religion was more optimistic, more inclined to trust in God's infinite goodness and to surrender to the heart's outpourings. This plenitude of religious feeling was expressed as a rule in an ornamental profusion, especially a profusion of sculpted decoration. It had its privileged locations–notably façades, for the faithful have to be drawn to the church and made to feel welcome. This applied particularly to the ill and the infirm (in those days the business of the Church was the care of those in physical distress as well as the salvation of souls). The portal of the Hospital of San Fernando in Madrid is a case in point. Its sculpted composition (1722-1729), the work of Pedro de Ribera, borders on the delirious; it is a mad proliferation of festoons, finials, folds and falls of drapery, and it combines French, Italian, and native Spanish motifs to an almost indigestible degree. There is no attempt at achieving any coherence, yet one comes away with the impression that, frantic and uncontrolled as it seems, it nevertheless has a peculiar harmony of its own. Except for the statue in the niche, there is nothing particularly religious about its confused ornamental grammar. The entrance of the Marquis de Dos Aguas' palace at Valencia, which we have already seen, is at least as religious as the portal of the Hospital of San Fernando.

Rococo decorations are often most appealing in smaller chapels and sanctuaries, for the eighteenth century preferred spaces that were human in scale. Communion chapels and chapels dedicated to the Virgin were favourite sites for intimate Rococo decors. The axial chapel dedicated to the Virgin in the large parish church of Saint-Sulpice, Paris, was redecorated after the fire of the Marché Saint-Germain in 1762. As it stands now, it is a good example of a style of luxuriousness that sought to create effects of light and colour by contrasting materials, counterpointing architectural rhythms with figures carved in relief, and improvising a choreography of cherubs sporting with garlands. Pigalle's *Virgin* was installed only in 1776. A

Jean-Nicolas Servandoni (1698-1766)
and Charles de Wailly (1730-1798):
Chapel of the Virgin, 1729-1774.
Statue by Jean-Baptiste Pigalle (1714-1785).
Church of Saint-Sulpice, Paris.

concealed source of light, recalling Bernini, enhances the atmosphere of mystery.

French Rococo did not altogether abandon the phantasmagoria of Baroque, but by and large the French remained attached to a hierarchical conception of decoration and to a carefully gauged progression of effects that was, in essence, theatrical. Meanwhile, artists in other countries were inclined to juxtapose and accumulate optical effects, scattering the viewer's attention rather than trying to discipline it and train it on a single focal point. They experimented with new ways of integrating sculpture into architectural space; and in proportion to their different national sensibilities they derived different psychological benefits from these experiments. Stucco, for example, a medium that was particularly favoured by Italian artists, lent itself to startling tautological effects producing a sort of optical vertiginousness that seemed to permeate space.

With the great Sicilian sculptor Giacomo Serpotta this incantatory practice of charging every surface with excrescences virtually became a system. Under his hands the writhing, sinuous forms of the Rococo repertoire express the ancient phobia of empty surfaces that characterizes the overly ornate gilt altarpieces of the Iberian peninsula and Latin America. Serpotta, for his part, preferred to give his stucco work the false pallor of imitation marble. The

numerous oratories he decorated at Palermo and Messina are testimony to a talent that was able to invent endless variations. The Oratory of San Lorenzo at Palermo combines an indefatigable imagination with a gift for modelling and a keen sense of elegance that transforms female saints into great ladies of Palermo society.

It is in Germany that the most stunning achievements of Rococo sacred decoration are to be encountered. The case of the Asam brothers is exemplary. The younger, Egid Quirin, was a sculptor; the older, Cosmas Damian, a painter. Both travelled to Rome to perfect their training; they liked to work together, were both competent architects and masters at staging effects. Together they contrived impressive operatic (albeit religious) decorations. Using the magic of light, colours, and movement, their unbridled imaginations created unforgettable impressions of the miraculous and the supernatural.

At the Benedictine abbey church of Weltenburg, in Bavaria, the two brothers devised an elaborate decoration centred on an effigy of St. George on horseback. Riding straight towards us out of a golden, otherworldly glow, the knight-saint is clad in glittering armour; he has just plunged his sword into the twisting scaly neck of a hideous dragon silhouetted against the light. On his left a princess, her mouth open in a scream, recoils with a great

Cosmas Damian Asam (1686-1739) and Egid Quirin Asam (1692-1750):
High Altar with St. George and the Dragon, 1721-1724.
Gilt and painted stucco.
Abbey Church, Weltenburg, Bavaria.

Egid Quirin Asam (1692-1750):
High Altar with the Assumption of the Virgin (detail), 1722-1723.
Gilt and painted stucco.
Monastery Church, Rohr, Bavaria.

show of terror. Every scenic resource is utilized here, and to great effect. The horseman stands out against a luminous background, and the aura of mystery is heightened by the fact the the source of light is invisible. At the feet of the shadowy arch framing the saintly apparition two rather theatrical figures can be discerned–St. Martin and the founding abbot. Their rhetorical pose recalls the sculptures of the four great doctors of the Church supporting the reliquary containing the Chair of St. Peter at the Vatican; and the powerful influence of Bernini is further acknowledged by the twisted columns.

The decoration in the church of the Augustinian abbey at Rohr (again, Bavaria) is, if possible, even more unbridled. Here we have, not the fantastic imagery of a single combat between a brave knight and a dragon, but a relief in natural colours depicting one of the central mysteries of the Christian religion: the Assumption of the Virgin. The theme is treated on two levels. Below, the apostles behold the empty sarcophagus in amazement; above, the Virgin ascends to Heaven, carried by angels spreading their great wings. Wearing the flowing gown of a great lady, the Virgin stretches out her arms to celebrate the supernatural privilege being granted to her. Pouring down through a halo radiant among clouds and cherubs, a shaft of mystic light envelops her; and in the background a heavy, richly damasked curtain ripples in a mysterious draught. It seems impossible to push the symbiosis between sculpture and theatre any further. This masterpiece at Rohr transcends the very concepts of Baroque and Rococo.

To pinpoint the originality of the Asam brothers, we must fall back on the vocabulary of the theatre. They had a distinctly scenic conception of decoration; they modelled and painted and installed their decors; they were scene-shifters, stage-managers, animators. They were creators of genius, able to translate the mystical effusions of a passionate faith into optical effects. With a wave of their magic wands they created an atmosphere of miracles; they opened the gates of Paradise and gave the churchgoer a glimpse of the glories beyond. In its emphasis on the miraculous, Rococo shows itself the true successor of Baroque.

This tendency can be seen even in spaces of secondary importance–in sacristies, for example. Francisco Hurtado built the sacristy of the Carthusian monastery of Granada at the beginning of the eighteenth century, but the decoration itself dates from 1742-1747. Its lushness and profuseness have rarely been equalled. The walls disappear behind a froth of gilded excrescences that have vaguely vegetal forms and spill over everything, creating an overall pattern of stylized abstraction, and leaving no room, or almost none, for human figures. The effect is fairylike, precious; and the intention is perhaps to offset, by force of contrast, the statue of St. Bruno above the altar: an ascetic, emaciated saint in a plain monastic robe, meditating on a skull.

Giacomo Serpotta (1656-1732):
Interior Decoration, Oratory of
San Lorenzo, Palermo, 1707.
Stucco.

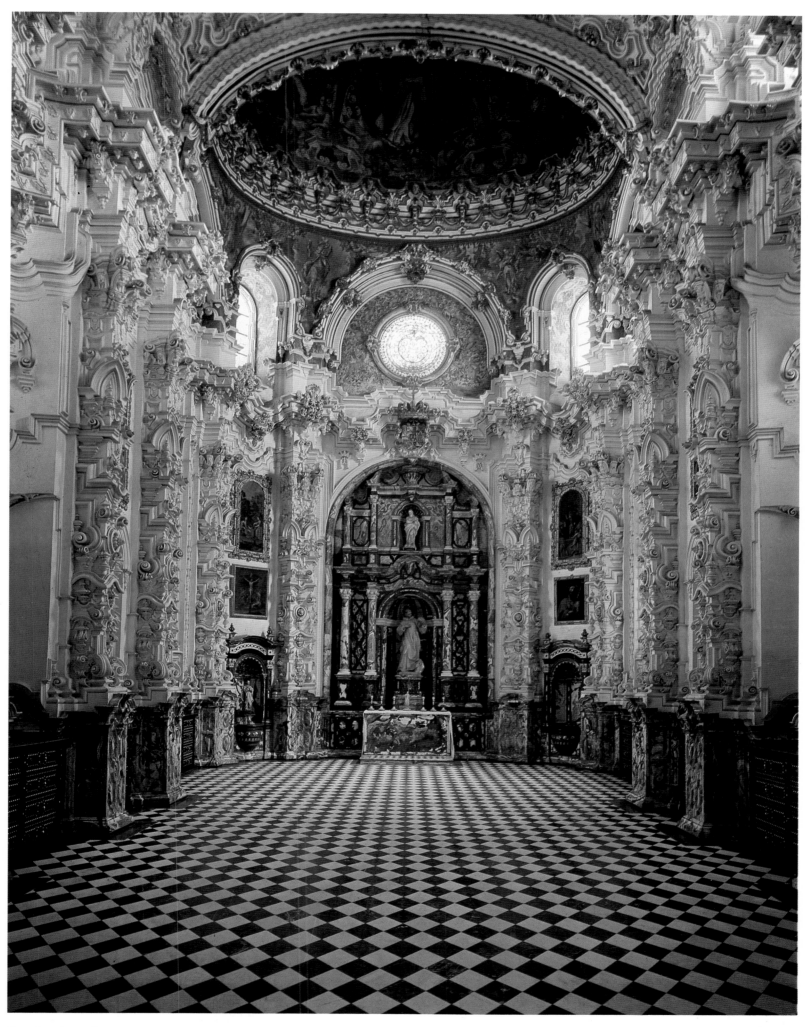

Francisco Hurtado (1669-1725):
Sacristy of the Carthusian Monastery (Cartuja) of Granada, early 18th century.
Interior Decoration, between 1742 and 1747.
Stucco.

ALTARS

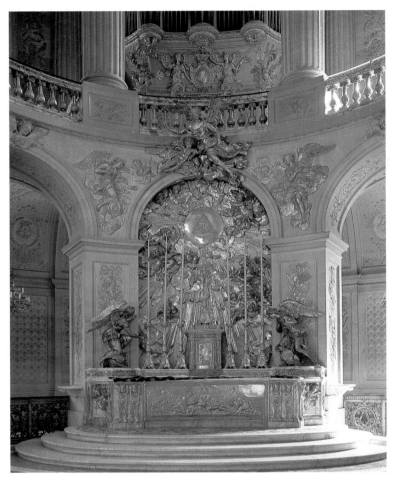

Jules Hardouin-Mansart (1646-1708)
and Robert de Cotte (1656-1735):
Royal Chapel at Versailles, 1699-1710,
with Glory, 1708-1709, over the main altar
by Corneille Van Cleve (1645-1732).
Gilt bronze.

In France, this style of tautological overstatement developed by the Hispanic artists was moderated by the Gallic taste for a more restrained art, as were the Bavarian artists' flights of fancy. French decoration was more sober and orderly than that of neighbouring countries. This did not prevent French artists, however, from modelling whole flocks of cherubs to create an atmosphere of religious ecstasy. Over the main altar in the Royal Chapel at Versailles, in a structure that is still classical in essence, Corneille Van Cleve devised a dazzling halo radiating from a theological triangle amid a flock of cherubs and angels floating in a mystical trance. The sources of this composition are obviously to be found in the Roman Baroque style. But the French sculptor brings a certain elegance to the modelling of his figures, a harmonious grace of gesture and expression that make it clear that, though the ageing Louis XIV was still alive, we are now in a new century (1708-1709).

Between 1721 and 1732 the Bishop of Toledo hired Narciso Tomé to execute a stunning monument to the Blessed Sacrament in one of the bays of the ambulatory behind the Cathedral's *capilla mayor*. The decoration combines polychrome marbles, gilt stucco work, and frescoes in an indescribable accumulation of ornamental details.

Scenes in low relief, statues, carved symbols are cunningly interspersed with openings through which sunlight, streaming in from the high rear windows, pours down. Hence the name "Transparente" given to this confused, disconcerting altar with its fluid, somewhat indefinite forms. By its very extravagance, it nonetheless exemplifies the Rococo spirit, especially that of the Hispanic Rococo with its insane accumulation and piling on of details. (It assumes such lavish proportions here that Tomé's work has been called the eighth wonder of the world.)

If there is one work that stands comparison with the Transparente, it is the Gnadenaltar in the church of the Vierzehnheiligen in Franconia, deep in the heart of Europe. Here we encounter another major religious phenomenon of the eighteenth century, one that inspired a number of remarkable monuments: the pilgrimages that drew vast throngs and required buildings of exceptional size, ease of movement, and magnificence to accommodate them. New churches had to be built to house altarpieces that were richer and more ornate than ever, not to mention the monuments containing the relics worshipped by the itinerant faithful. Designed by Balthasar Neumann, Vierzehnheiligen was dedicated to no fewer than fourteen interceding saints. In the very centre of the church, a sort of votive altar (the exact German word is Gnadenaltar) was erected in 1763, with statues of all fourteen saints. They are perched there, on top of that confection which does not contain a single straight line, some poised on the edges of the dais, others seated on the volutes of the but-

Johann Michael Feichtmayr (1709-1772)
and Johann Georg Üblhör (1700-1763):
Votive Altar with the Christchild and
Fourteen Interceding Saints, 1763.
Stucco.
Pilgrimage Church of Vierzehnheiligen,
near Lichtenfels, Franconia.

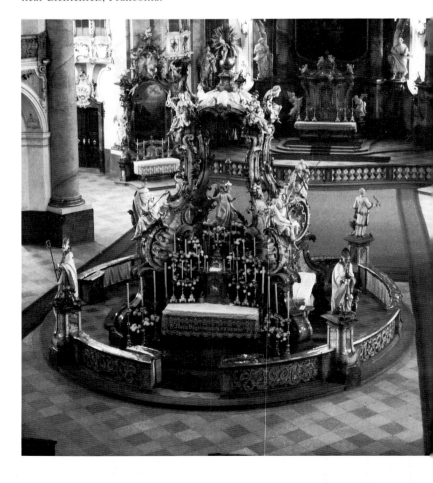

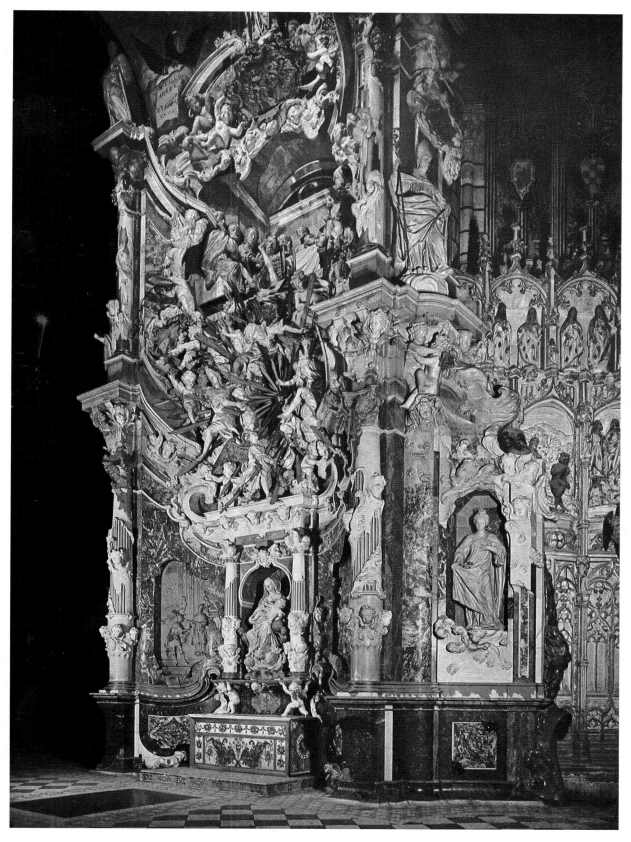

Narciso Tomé (1690-1742):
The Transparente Altar, 1721-1732.
Polychrome marble and gilt stucco.
Toledo Cathedral, Spain.

tresses, still others standing on the pedestals of the balu-strade. These figures, commissioned by Johann Michael Küchel, were executed in 1763 by two master stuccoists, Johann Michael Feichtmayr and Johann Georg Üblhör. Their work, jewelry work on a monumental scale, harmonizes perfectly with the church's sophisticated volumes. No great effort of the imagination is required to picture the processions of rustic worshippers circling ecstatically round the reliquary and imploring the aid of the saints—each according to his speciality—who stand there, surveying human misery with expressions that are utterly benign.

The art of the reredos goes back to well before the eighteenth century, but it was undoubtedly in that period when, abandoning itself to an excess of passion and ornateness, it had its fullest flowering. Excessive ornateness is especially characteristic of Portuguese altarpieces. So sculptural is their treatment, so free, so dispersed, that the underlying architecture is completely hidden, and even the figures, the saints and angels, are submerged by a flood of gilt details. One of the most beautiful Rococo altars stands in the apse of the church of Tibães, the principal Benedictine monastery in Portugal. The decoration, which dates from 1770, surges with an undulating movement. The tall pedestals of the columns begin to look like bells if you stare at them for a while; the area above the cornice, like a fierce dragon's face or an immense butterfly with ragged wings. In contrast to this ornamental frenzy, the statues with their sombre robes seem almost austere.

In the churches of Latin America, we encounter the same profusion of gold leaf as in Spanish and Portuguese art (which is to be expected), but with certain colonial and naive accents contributed by native sculptors who reflect the instinctive influence of their Precolumbian forbears.

PULPITS

Johann Baptist Zimmermann (1680–1758)
and Dominikus Zimmermann (1685–1766):
Pulpit, 1752–1754.
White, gilt and polychrome stucco.
Pilgrimage Church of Wies, near Steingaden, Bavaria.

José de Santo António Ferreira Vilaça (1731–1809):
High Altar, c. 1770.
Benedictine Monastery Church, Tibães, near Braga, Portugal.

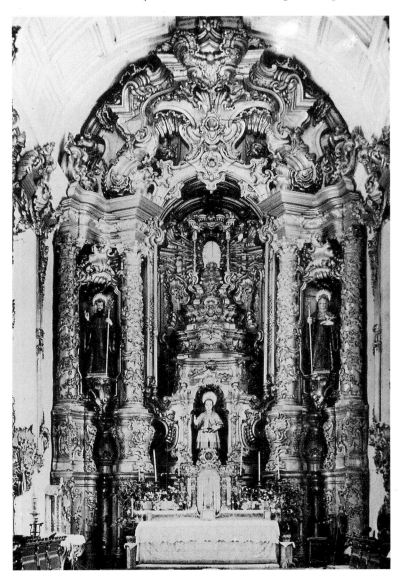

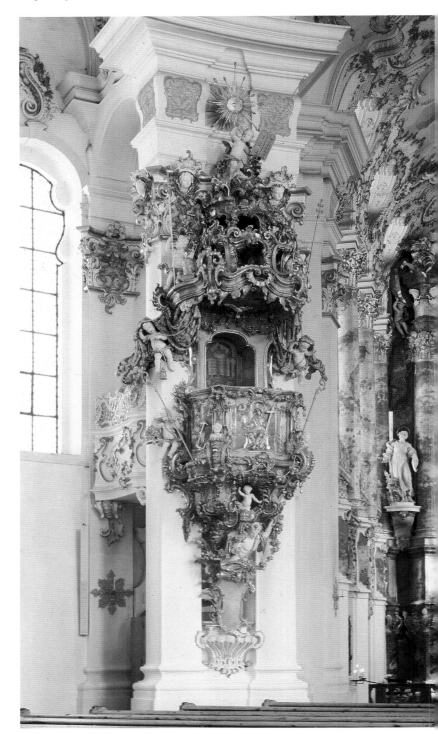

260

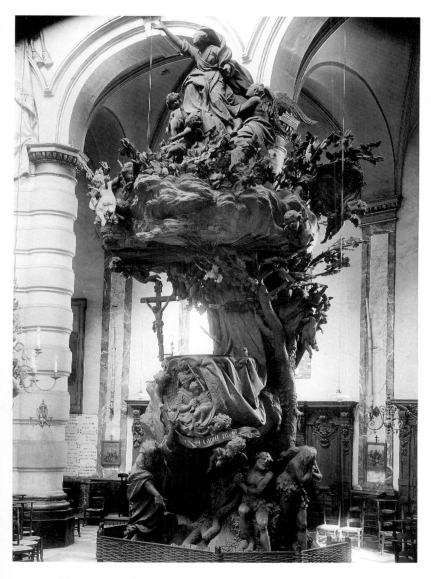

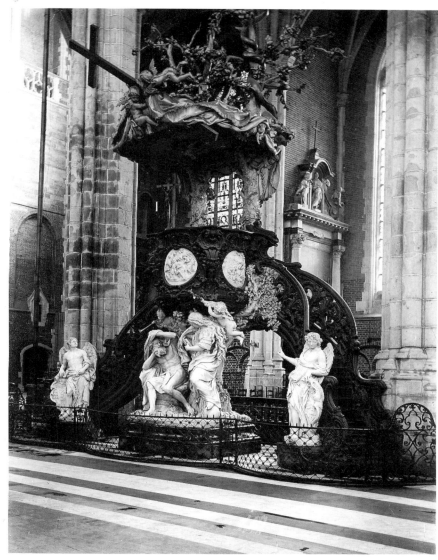

Theodore Verhaegen (1701-1759):
Pulpit, 1743-1746.
Wood.
Church of Notre-Dame d'Hanswyck, Malines, Belgium.

Laurent Delvaux (1696-1778):
Pulpit of Truth, 1745.
Wood.
Cathedral of St. Bavon, Ghent.

During the Counter Reformation, the Church laid great stress on preaching, on the spoken word. Pulpits were built in central positions in church naves, to give the faithful a clear view of the orator and to allow them to follow every inflection of his sermon. Thanks to the symbols and figures ornamenting them, the pulpits themselves were sermons in stone or wood. They were naturally penetrated with the same spirit of ostentatiousness that characterizes all of eighteenth-century religious art with its tendency to exteriorize passions and beliefs. In some places, they were even called "pulpits of truth," a term which aptly expresses the renewed confidence and spirit of proselytism that swept the Church during this period.

Take the church of Wies (1745-1754), another South German pilgrimage church and one of the leading examples of Bavarian Rococo. The architect, Dominikus Zimmermann, entrusted the sculpture to his brother Johann Baptist, and, once again, the cooperation of two brothers produced a miraculous degree of harmony. The pulpit, which is built against a large pillar, is an astonishing demonstration of the Rococo repertoire and its feverish reiterations–foliations, scrolls, garlands, bizarre asymmetrical plant motifs, concretions resembling stylized shells. The pyramidal treatment of the sounding-board canopy is particularly remarkable. And yet, despite its wealth of details, the pulpit has a programme, a theological coherence, as shown by the *putto* holding up the Tables of the Law in one hand and the Blessed Sacrament in the other.

In the southern Netherlands, the "pulpits of truth" offered a vast field for the fantastic realism of Flemish artists. This item of liturgical furniture was transformed into a tree with a twisted trunk and leafy canopy, into an ivy-covered grotto teeming with wild creatures. What is the reason for the presence of this unexpected flora and fauna? Only when we see the pulpit in the Church of Notre-Dame d'Hanswyck at Malines, carved by Theodore Verhaegen between 1743 and 1746, do we understand that the leafy tree sheltering the preacher is the tree of the knowledge of Good and Evil, that the grotto is the home of the serpent of original sin. To make the allegory complete, the sculptor has depicted God banishing Adam and Eve (who are bowed with the knowledge of their transgression) and pointing to a crucifix and a medallion containing an image of the Virgin and Child, unmistakable symbols of redemption. At Ghent, the symbolism of the Cathedral of St. Bavon is equally luxuriant but more hermetic. The sculptor, Laurent Delvaux, one of the foremost masters of this genre, has vividly rendered Truth holding up the

261

STALLS

Bible to an old man who is casting off a heavy veil—a symbol of awakening humanity. The skill of the Flemish artists seems particularly impressive when one recalls that they generally carved their visionary figures and decorations in wood.

Outstanding examples of woodcarving (which was sometimes coloured, for the eighteenth-century artists relied heavily on the magic of colours to create their marvellous illusions) can be cited for almost every item of church furniture. The sacrament of penance, one of the rites of individual salvation, inspired the decoration of innumerable confessionals. They were often adorned with statues of sinners famous for the enormity of their wickedness as well as for the vast fund of forgiveness which they earned—such as Mary Magdalene and the Prodigal Son—intended to encourage repentant Christians to come and kneel down and unburden themselves of their sins. Canons and monks did not hesitate to replace older choir stalls by new ones. In 1763-1770, two of the greatest masters of German Rococo, Johann Joseph Christian and Joseph Anton Feuchtmayer, carved the splendid set of choir stalls in the old abbey at St. Gall in northern Switzerland. The life of St. Benedict is depicted in a series of tableaux in delicately modelled relief. This richly detailed narrative sequence is rendered with a sharp feeling for expressive volumes and an inventive and unerring sense of composition. Unfortunately, this extremely refined piece of decoration lost some of its unity when the abbey church was remodelled and made into a cathedral.

◁▽ Johann Joseph Christian (1706-1777) and
Joseph Anton Feuchtmayer (1696-1770):
Choir Stalls with the Life of St. Benedict, 1763-1770.
Gilt wood.
St. Gall Cathedral, Switzerland.

Pedro Duque Cornejo (1678-1757):
Choir Stalls with Bible Scenes (detail), 1748-1757.
Wood.
Cordova Cathedral, Spain.

Johann Joseph Christian (1706-1777):
The Death of St. Benedict, 1755-1766.
Inlaid wooden panel with gilt reliefs and figures.
Stalls of the Benedictine Abbey of Ottobeuren, Bavaria.

Woodcarving of a truly dazzling technical virtuosity is found throughout Europe in this period. The Flemish artists achieved such a high level of mastery and became so renowned for their work that they were in demand everywhere, but they were not the only ones. In France, Spain, Germany, increasing numbers of lavishly ornamented church stalls were carved.

In Spain, Pedro Duque Cornejo carved the spirited reliefs of the choir stalls in Cordova Cathedral, which depict scenes from the Old and New Testaments (1748-1757). His work is an example of the whimsical, teeming style—a style full of excess and excrescences—that generally goes under the name Churrigueresque.

The Rococo forms derived from French Rocaille are relatively easy to identify in South German church furniture, thanks largely to the existence of printed pattern books that circulated in that part of Europe. One of the most perfectly preserved and unified ensembles is found in the abbey of Ottobeuren. Begun in 1755 and completed in 1766, it was carved by Johann Joseph Christian. It contains no fewer than eighteen large scenes in relief flanked by twenty-four herms. The gilt bas-reliefs depict, on one side, scenes from the Old Testament; on the other, scenes from the life of St. Benedict (for we are once again in a Benedictine monastery). The reliefs are carved with rare delicacy, and the sculptor has employed a variety of fantastic architectural motifs to produce an impression of depth. Clearly he has aimed for picturesque effects; in other words he has tried to rival the art of painting. Notice how small his figures seem in proportion to the background; and how many of them he has crowded into each scene.

THE REIGN OF ALLEGORY

Francesco Queirolo (1704-1762):
Count Antonio Sangro Casting Off Illusion
and Discovering Truth, 1757.
Marble.
Sansevero Chapel, also called
Santa Maria della Pietà dei Sangro, Naples.

The taste for, not to say the obsession with, technical virtuosity, sheer brilliance of manner, is another characteristic of this type of sculpture, whatever the material employed. And nearly always proficiency was associated with allegory. The vogue for this elaborate system of symbols was immense in the eighteenth century, not only in the area of sacred art but in the secular sphere as well. Convention required that the message of a work of art should not be immediately clear, but should be relayed by an image having certain stock attributes that lent itself to interpretations of varying degrees of complexity.

A bizarre work in the private chapel of Sansevero at Naples, carved shortly after 1750 by the Genoese sculptor Francesco Queirolo, represents a naked male figure draped in a net from which he is trying to extricate himself, aided, it seems, by an angel perched on a globe. Several large folios are balanced precariously on the edge of the cornice. The chapel contains the tombs of the Sangro family, and Queirolo's group is in fact an allegorical monument to one of the members of this Neapolitan family: Count Antonio Sangro, who took holy vows after his young wife died. The statue shows him throwing off the entangling net of worldly appearances and discovering Truth. What we

have here, then, is a symbol for spiritual deliverance achieved with the help of the Holy Spirit. The least one can say about this curious image is that it is spectacular, intriguing, and fascinating, if only by virtue of the sheer brilliance of the net carved out of solid marble. While displaying his technical skill, the sculptor has freely indulged an inclination for the bizarre, if not the morbid, that seems to have run through the Sangro family, whose members all had rather strange fates.

The morbid can easily turn into the macabre. Curiously enough, some eighteenth-century Rococo artists harked back to and indeed cultivated the old terrors of the Middle Ages. For example—to return to a German-speaking land and to yet another Benedictine monastery—consider the abbey of Admont in Austria and its justly famous library. This temple of theological learning is decorated with large figures carved in wood towards 1760 by Thaddäus Stammel. The sculptural ensemble is a harsh reminder of man's fate; its grim depictions of Death, of Hell, were intended to warn the monks of the mortal danger of yielding to sin. Death is a shivering skeleton menacing the onlooker with its sting and hourglass. The presence of several insouciant cherubs does little to alleviate this cheerless message. But once again we cannot help but admire the

Josef Thaddäus Stammel (1695-1765):
Death, from the group of the Four Last Things, c. 1760.
Wood.
Library of the Benedictine Abbey of Admont, Styria, Austria.

Giacomo Serpotta (1656–1732):
Allegory of Fortitude, 1714–1717.
White stucco and gilding.
Oratorio del Rosario di San Domenico, Palermo.

virtuosity with which an unsettling truth is displayed to our senses.

As a rule, though, religion was of a less sombre cast during the Age of Enlightenment; it inspired more appealing images in general, and because those images verge on the mundane at times, it has frequently been criticized for its frivolousness. Take the fashionable young lady in feathers, carved by Giacomo Serpotta between 1714 and 1717. Standing in a niche in the Oratory of the Rosary at Palermo, this statue represents, of all things, the cardinal virtue of Fortitude. At first glance, we see a coquette in a seduc-

tive pose, wearing flounces, lace, ostrich feathers, a flowing, artfully draped gown. But then, going a step beyond, we notice that her corselet bears a strange resemblance to an item of armour and that she is leaning against a pillar, two props which suggest a less obvious level of meaning. The artist has allowed himself a little joke of sorts: on the shaft of the pillar he has carved a lizard, one of those lizards that warm themselves in the Sicilian sun. He was evidently penetrated less by the gravity of the task of depicting a Christian virtue than by delight at modelling a pretty woman in a showy dress.

The stratagems of allegory can go far, so far that one begins to suspect that for the artist they are less a means than an end in itself. One of the skills that was applauded most loudly in the eighteenth century was the ability to render drapery, and few sculptors were able to resist succumbing to the temptation to surpass themselves in sheer technical brilliance. Now drapery is never so glamorous as when, instead of concealing forms, it hints at them, caresses them, subtly emphasizes them. Carving drapery easily becomes a pretext for an epicurean exercise in virtuosity. And no doubt the supreme skill is to veil not only the body but the face as well, and to do so without losing any of the latter's expressiveness.

Innocenzo Spinazzi worked in Rome and, chiefly, Florence where he was the court sculptor for the Grand Duke Leopold I. He carved a statue of *Faith* for the apse of the church of Santa Maria dei Pazzi. Traditionally, Faith is depicted as a soberly dressed young woman holding up a chalice and Bible. Spinazzi includes these props, but drapes a sheer veil over the figure's head. Beneath it we can discern an expression of mystical ecstasy illuminating the features of this curiously attired yet not inelegant cardinal virtue. The sculptor has in fact enriched the allegory with another level of meaning: Faith reveals itself in an inward gaze; it is God-given and transcends the mere senses. Yet how admirable is the mastery of those flowing, sensuous, harmonious forms beneath the damp ripples of drapery inspired by classical models!

Innocenzo Spinazzi (?-1798):
Faith.
Marble.
Apse of Santa Maria Maddalena dei Pazzi, Florence.

Antonio Corradini (1668-1752):
Modesty (Cecilia Gaetani, wife of
Count Antonio Sangro), 1749.
Marble.
Sansevero Chapel, also called
Santa Maria della Pietà dei Sangro, Naples.

Another statue of a veiled woman, apparently a kindred work, in that extraordinary museum of the morbid which we have already visited once, the chapel of Sansevero at Naples, inspires more mixed feelings. Here the figure, supposedly an allegory of *Modesty*, leans against a broken stela bearing an inscription in memory of Cecilia Gaetani. The sculptor is Antonio Corradini, an artist who travelled widely, going from Venice to Vienna and Dresden before returning to Rome and finally settling in Naples. There is no question about his skill at carving marble: wherever he went it was held in high esteem. But what an odd figure of Modesty! Under her mourning veil she expresses grief, to be sure, but the veil is so sheer as to be almost transparent; it unclothes rather than clothes her; it brings out the ripeness of her breasts; it even reveals the slight concavity of her navel. In short, it conceals none of the attractions of a rather fleshy young woman–or almost none, for the sculptor screens her modesty, so to speak, with a garland of roses. The overall effect is distinctly ambiguous, but then this type of ambiguity is one of the attractions of the eighteenth-century artists' cultivation of passionate feeling, their love of female beauty, and their surrender on occasion to the delicious appeal of the senses.

DEVOUTNESS AND DRAMATIZATION

Ignaz Günther (1725-1775):
The Annunciation, 1764.
Painted and gilt wood, height 63″.
Collegiate Church, Weyarn, near Miesbach, Bavaria.

The Virgin is the central female figure in the Christian religion and she has always been a favourite motif in sacred imagery. With its love for woman under all her aspects, the eighteenth century naturally paid tribute to the Mother of God, exalting her in her glorious as well as her sorrowful mysteries. It did so with a great deal of tenderness and, often, with poignant emotion.

Ignaz Günther was probably the greatest Rococo sculptor in the Germanic countries. His work has some of the freshness of popular art, yet his very sophisticated compositions possess a Manneristic and not unhumorous touch. His was an unusually rich and complex artistic personality. Like many artists of the period he revelled in painting carved wood and stucco with gaudy colours; he was a naturalist but his naturalism is only skin-deep. The *Annunciation* in the collegiate church at Weyarn is the supreme expression of his skill. One of his most ambitious and celebrated sculptures, it depicts an astonishing ballet of two figures on different axes, describing elaborate arabesques in space. Astonishing, too, are the falsely naive facial expressions. On first impression the Virgin is a sweet

Bavarian peasant girl; at second glance she is a grand lady with refined gestures. Rarely has ambiguity been pushed so far.

The Nativity inspired a type of sculpture that allowed the period's taste for the theatrical to vent itself freely, but on a miniature scale. This was the *crèche* or Nativity scene (*presepio* in Italian), an art that was virtually a Neapolitan monopoly. Neapolitan *crèches* were exported all over Europe. Some of them transcended mere artisanal ingenuity and were true works of art; indeed, some of them were modelled by sculptors who felt equally at ease carving on a monumental scale. This was manifestly the case with Giuseppe Sammartino, a Neapolitan who was deeply attached to his birthplace and who carved statues for many churches in Naples. The deftly modelled and painted terracotta figurines of the *crèche* shown here, now in Munich, are his handiwork. The grouping is masterly; the dynamic composition perfectly calculated to produce a dramatic effect, one strongly emphasized by the picturesque character of the setting. The shadows, familiar objects, and details are placed with an unerring touch.

Giuseppe Sammartino (1720-1793):
Nativity Figurines, later 18th century.
Coloured terracotta, maximum height of figures 11½″.

267

Naples maintained continuous artistic and political relations with Spain, and indeed Neapolitan art is strongly marked by the influence of Hispanic realism with its flair for the dramatic. A far from negligible branch of Spanish sculpture was the art of *pasos*, meaning groups of life-size statues which were painted to create the illusion of life (some of them even had real hair and clothes). They were carried–and in some cases they were large scenes with multiple figures–in the religious processions Spaniards are so fond of. Their realism ranged to an almost shocking degree of expressionism; nevertheless they answered the needs of religious style that exteriorized emotions with vehemence, that sought to stir with deep feeling, and that remembered what effects the Baroque artists had drawn from pathos. When these tendencies are brought together under the hand of a genuine artist, their very excessiveness can become moving and can transcend the ridicule of exaggeration.

This is certainly true of the works of the master sculptor Francisco Antonio Salzillo. He is famous in his native Murcia, where a museum devoted to his work contains an ensemble of eight *pasos* he carved from 1752 onwards for the Church of Jesus. With an undeniable feeling for religious drama, he modelled the Last Supper, Christ's betrayal and arrest in the Garden of Olives and other key episodes from the Passion. The figures are garishly coloured, their gestures are melodramatic, yet they have a rather irresistible "presence." Salzillo does not hesitate to place, in one of these groups intended as realistic reconstructions, a

◁ Francisco Antonio Salzillo (1707-1783):
Christ Praying in the Garden of Olives, after 1752.
Polychrome wood, height 61″.

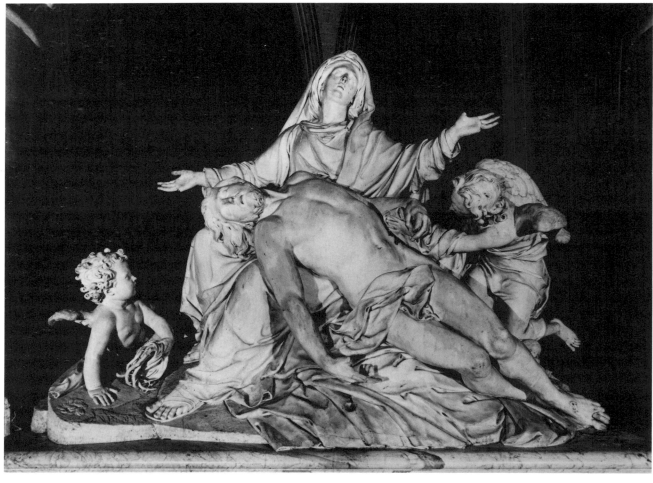

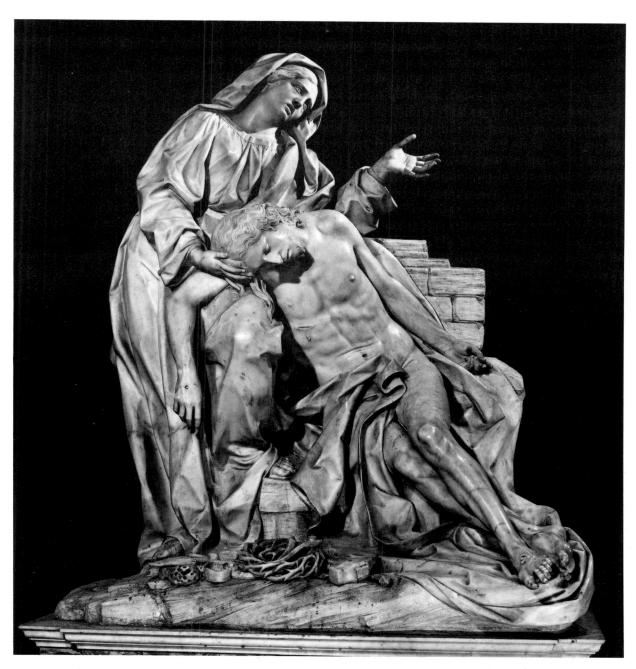

Antonio Montauti (? – after 1740):
Pietà, c. 1734.
Marble.
Crypt of the Corsini Chapel, St. John Lateran, Rome.

supernatural apparition beside the moving figure of Jesus deep in prayer on the eve of Judas's betrayal: an angel (depicted as a solemn handsome youth) who has been sent to support Christ in his hour of distress.

The Virgin Mary was often associated with Christ's Passion in an image of grieving sorrow that was designed to move worshippers deeply in an age when emotions flowed easily. Not surprisingly, this image, which combines the corpse of a tortured son with a mother calling on humanity to bear witness to her grief, harks back to the *pietà* motif that became popular in the late Middle Ages and has continued to flourish since. Shortly before his death Louis XIV undertook to honour a vow made by his father, who had dedicated the Kingdom of France to the

◁ Nicolas Coustou (1658–1733):
Pietà, central part of the Vow of Louis XIII, 1712–1723.
Marble, 90½″ × 110″.
Choir of Notre-Dame, Paris.

Virgin Mary; and the sculptor Nicolas Coustou was commissioned to carve a *Pietà* (which was erected, though only in the succeeding reign, at the rear of the choir of Notre-Dame Cathedral in Paris). This superbly modelled, genuinely poignant group is given a Rocaille note by the addition of two respectful cherubs who attend on the *mater dolorosa* with tender, graceful gestures. The calm grandeur of the Virgin's outstretched arms declaring her grief and inviting the onlooker to prayer expresses a human as well as a sacred drama. By an odd coincidence, we find the same gesture in a *Pietà* by the Florentine sculptor Montauti in the crypt of the Corsini chapel at St. John Lateran. The composition of this large marble group differs little from that of Coustou's work, but the effect is more dramatic. The same, essentially medieval theme inspired a number of German artists as well. There is a moving version by Ignaz Günther in the church of Nenningen, and another, by Raphael Donner, in the Cathedral of Gurk in the Austrian province of Carinthia.

INTERCEDING SAINTS

Anton Sturm (1690–1757):
St. Jerome, 1753–1754.
Polychrome wood.
Pilgrimage Church of Wies, near Steingaden, Bavaria.

Strengthened by the decisions of the Council of Trent, the ecclesiastical communities of the Counter Reformation erected statues of saints—those saints who were considered the Church's defenders and were constantly being called on to intercede on behalf of ailing humanity—on altars, against pillars, in short in every strategic spot. Eighteenth-century man entrusted the salvation of his soul, to a greater extent than any of his ancestors had done, to the saints who were seen now more than ever to have provided a bridge between the Church in its times of trouble and God; to the saints who had set an example; to those who had been patrons and founders of religious institutions. As one might expect with such a lively period, these saints were brought to life, were depicted in poses that emphasized their virtue, their struggles, their special areas of competence. Some of them stand apart, isolated in prayer or mystical ecstasy; others remind us by their clothes and gestures how deeply concerned they are with man's lot; mostly they seem to be on stage. It was a theatri-

cal period. Such figures, fault-finders claim, are no better than actors in an opera house. But what superb actors!

In the pilgrimage church of Wies in Bavaria a rigorous moral and theological programme surrounds the faithful and lifts them up to paradise. The four corners beneath the dome symbolize the four cornerstones of Christianity, and there, attired in formal, flowing liturgical vestments, stand four doctors of the Church keeping a lofty vigil on brackets placed midway between the worshippers and the heavenly realm of the elect. They are the work of Anton Sturm, a sculptor from the Tyrol. Sturm, who had his workshop in Füssen, emphasizes the distance between the ordinary churchgoer and these four raised figures; forgoing polychromy, he uses white stucco polished to imitate marble and simply gilds the saints' attributes (the golden fringes of the vestment, the hat, the pastoral cross). In sharp contrast with the polychromy of the surrounding decoration, this sobriety creates a powerful effect. *St. Jerome*, shown here, is deep in spiritual conversation with a skull resting on the Vulgate.

Quite different is Johann Joseph Christian's inspired *St. Jerome* on the main altar of the abbey church of Zwiefalten in Bavaria. Represented as he transcribes the prophecy of Isaiah (pictured on the other side of the altar), the saint is shown in the throes of the mystical vision announcing Christ's birth. In keeping with the Baroque aesthetic, the spectacular billowing of his ample robe expresses his inner turmoil.

Johann Joseph Christian (1706–1777):
St. Jerome, 1752–1756.
Stucco.
Main altar of the Abbey Church of Zwiefalten,
near Reutlingen, Baden-Württemberg.

To find an echo of the spiritual energy that surges through Christian's *Jerome* we must leap across the Atlantic and forward to the beginning of the nineteenth century. Latin America was, to a large extent, a province of Rococo art and like all remote provinces it lagged behind the times, which is why Rococo prospered there even beyond the eighteenth century. On the terrace in front of the sanctuary of Congonhas do Campo in Brazil, the prophets of the Old Testament, sculpted in blocks of rough native stone, sway in a majestic frozen choreography. The artist who carved these rough statues was a half-breed, the son of a Portuguese adventurer and a mulatto slave woman, named António Francisco Lisboa, otherwise known as Aleijadinho ("little cripple"). He infused his figures with an ardour, an impetuosity, at times a passionateness, that transfigures them and makes us forget how summarily they are executed. Aleijadinho was an architect as well as a sculptor; thanks to him the Rococo scenography continued to flourish in the New World at a time when European art was already turning to the static forms of Neoclassicism. His *Prophet Joel* stands in a pose of concentrated vitality and self-command, turning his head and gazing expectantly to his left. In one hand, his quill; in the other, a heavy parchment scroll, with his name inscribed on it.

Antonio Francisco Lisboa, known as Aleijadinho (c. 1738-1814):
The Prophet Joel, 1801-1805.
Stone.
Terrace of the Prophets, Bom Jesus, Congonhas do Campo,
Minas Gerais, Brazil.

Ignaz Günther (1725-1775):
The Empress Kunigunde, 1762.
Polychrome limewood, height 7½'.
Abbey Church, Rott am Inn, Bavaria.

The religious statuary of the eighteenth century often reflected the worldliness of court and drawing room. We have already seen one such work, Serpotta's *Fortitude*. But there are others. For example, the statue by the altar in the abbey church of Rott am Inn, again in Bavaria. It seems carved for a princely reception room rather than a church. A polychrome woodcarving of a haughty-looking empress in a ceremonial gown trimmed with lace, wearing necklaces and a crown and wielding a sceptre, she is the work of Ignaz Günther and represents the Empress Kunigunde—a canonized empress, at least according to tradition. Despite her finery and her rather theatrical pose, she belongs here, for she is said to have endowed this church in the Middle Ages. Her husband, the Emperor Henry II, stands, likewise in ceremonial dress, on the opposite end of the altar, making it perfectly plain that Rott am Inn is the royal couple's church. From mystical ecstasy to worldly pageantry, religious statuary runs the whole gamut and expresses every nuance in between.

THE PLEASURES
OF COLLECTING
DRAWING ROOM FIGURINES

Another phenomenon began to emerge during this period: that of the art lover, the collector, and his changing social status. Until now the privilege of collecting works of art had been restricted by and large to kings and to a few aristocratic patrons. But in the eighteenth century the bourgeoisie (mostly bankers and magistrates in the beginning) began to pride itself on its discernment, its willingness to protect artists, its ability to build private collections. And as a result a market for art began to emerge. Art works themselves began to lose their monumental dimensions; they began to be conceived for more intimate and comfortable settings than before. The range of subjects and materials began to diversify in response to the changing, increasingly diverse tastes of individual collectors. There was a demand not only for bronze figurines, a genre that harked back to Antiquity and had been popular in the Renaissance as well, but also for small marble pieces (often but not always reduced versions of monumental sculptures) which required a specific set of skills and a specific approach to sculpture.

Robert Le Lorrain (1666-1743): Galatea, 1701. Marble, height 29½".

Michel-Ange Slodtz (1705-1764): Diana and Endymion, c. 1740. Marble, height 33½".

Official art provided a sort of guarantee in this domain. As early as the beginning of the eighteenth century, the Royal Academy of painting and sculpture in Paris began to waive its policy of requiring candidates to submit a bas-relief on their admission and began to accept statuettes. On approval of a terracotta model, the artist was required to submit a finished marble figurine when he was formally received into the Academy.

Robert Le Lorrain's small *Galatea* dates from the year one of the century, yet its affected grace, which is already wholly Rocaille in spirit, and its subtly modelled forms demonstrate not only the artist's early mastery of marble work but also his ability to obtain exquisite effects on a very small scale appropriate for collector's items and objects for refined connoisseurs.

Works of this minutely detailed character became veritable *tours de force* when the sculptor combined the almost excessive preoccupation with details with an endeavour to keep up the "grand manner" on a reduced scale. Nicolas-Sébastien Adam spent two decades working on the presentation piece he submitted to the Royal Academy in 1762. Yet there is not a trace of weariness in his masterpiece (for that is surely what it is, a masterpiece in the root sense of the word as well as in the modern sense). It has a won-

derful verve, yet it is also wonderfully delicate, this miniature Prometheus on his rock having his liver devoured by a vulture. The treatment of the details, even peripheral ones like the torch smoking on the ground, is superb. There is no question that academic statuettes of this type were influential.

The sculptor Michel-Ange (René-Michel) Slodtz carved around 1740 for a private collector not just an isolated figure but a small group of four (counting the dog). The subject was a popular one, *Diana and Endymion*, and it allowed the artist to display his talent by contrasting the amorous goddess' eagerness with the torpor of the sleeping youth.

Nicolas-Sébastien Adam (1705-1778):
Prometheus, 1738-1762.
Marble, height 45¼".

273

COLLECTOR'S ITEMS

Franz Anton Bustelli (1723-1763):
Figures from the Italian Comedy, c. 1760.
Nymphenburg porcelain, height 6¾″ and 8″.

Jean-Baptiste Pigalle (1714-1785):
Child with Birdcage, 1749.
Marble, height 18½″.

Achieving such crispness of detail required an almost superhuman skill, so it is easy to understand why artists strove to invent new techniques, new ways to obtain results of this order with less effort and, mainly, at less cost. Works of art were now marketable items and this raised the issue of how to market them. Then too, as we have already seen, the eighteenth-century public wanted a colourful art, an art that imitated life and sustained a lifelike illusion.

Porcelain (which had been reinvented for tableware) thus came to be used as a medium for figurines. Though they were fragile, they had the advantage of possessing colours of permanent freshness. The Meissen manufactory in Germany is the oldest and most renowned of the eighteenth-century porcelain factories, but it was by no means the only one. Thanks to the work of Franz Anton Bustelli, the Nymphenburg manufactory near Munich enjoyed an excellent reputation as well. With a true sculptor's sensitivity and a keen eye for the whimsical, Bustelli contrived a multitude of small, witty, colourful figurines. He was especially fond of theatrical themes and, like Watteau, he found a rich source of inspiration in the *commedia dell'arte*; and he delighted in exaggerating the gesticulations of his little figures to the point of caricature. His figurines were immensely popular in Germany.

In France, on the other hand, the search for an ersatz marble resulted in the invention of a technique that was to become known as "biscuit." Biscuit figurines were produced in large quantities, especially at the Sèvres

Lambert-Sigisbert Adam (1700-1759):
Child Pinched by a Lobster, c. 1740.
Bronze, height 10".

manufactory. Many leading sculptors designed models for biscuit figurines or consented to have their statues reproduced in small biscuit copies.

Thus, after receiving considerable acclaim at the Salon of 1750 for his marble *Child with Birdcage*, Pigalle agreed to let the Sèvres manufactory publish a reduced and altered version in biscuit (the biscuit version shows two children, while the original only has one child). The biscuit was left uncoloured, for French collectors preferred a plain white finish, either matte or polished to look like marble.

Bronze figurines were of course more costly; they were also more resistant to blows. The technique for manufacturing them was similar to that employed for biscuit. At the same Salon where Pigalle exhibited his *Child with Birdcage*, Lambert-Sigisbert Adam presented his *Child Pinched by a Lobster*. What we have here, obviously, is a match between two rival artists belonging to the same generation; they both employ a theme that, because of its entirely natural and spontaneous expressivity, was a great favourite in the reign of Louis XV. Like Pigalle's statue, Adam's *Child* was reproduced in a small size, though in bronze rather than biscuit. And so the two works continue to invite comparison, even on a reduced scale. Our eye shuttles back and forth between the two *putti*, comparing their respective pouts, contrasting their adjuncts—the birdcage and the crustacean—perhaps noting how inappropriate these two objects seem, yet how perfectly they are integrated in their respective compositions.

After Jean-Baptiste Pigalle (1714-1785):
Child with Birdcage, after 1750.
Sèvres biscuit, height 18½".

Guillielmus de Grof (1676-1742):
Votive Statue of the Prince-Elector
Maximilian Joseph of Bavaria, 1737.
Chased silver, height 37″.
Pilgrimage Chapel, Altötting, Bavaria.

Matthias Steinl (1644-1727):
The Triumph of the Emperor Joseph I, c. 1710.
Ivory, 20″.

More rarely, sculptures were copied and cast (generally for a special purpose) in a costlier material. For example, the deeply moving one of the young prince of Bavaria was modelled and cast in silver by the Flemish sculptor Guillielmus de Grof. It was erected in the chapel of Altötting; and in fact it is an ex-voto to thank the Virgin for helping the pretender to the elector's throne to recover from a grave illness.

Ivory, which was prized for its softness and for the translucent sheen of its surface, was often employed for figurines in the Germanic countries. Rather paradoxically, it was in ivory that the highly gifted artist and architect Matthias Steinl carved a set of three equestrian statues of Holy Roman emperors for the court at Vienna. In addition to a meticulous accuracy of details, Steinl gave these pieces a fiery *élan* and a feeling of monumentality that are truly exceptional in statues of such small dimensions. Yet

Claude Michel,
known as Clodion
(1738–1814):
Satyr and Bacchante
(The Intoxication of Wine).
Terracotta, height 23¼″.

small as they are, the figurines are ostentatious expressions of the Habsburg monarchy's glory.

The favourite medium of eighteenth-century sculptors, however, was terracotta. The baked clay model or sketch (or *bozzetto*, as the Italians call it) was a vital preliminary in the creation of a statue; and connoisseurs would visit a sculptor's workshop in the hope of acquiring what was often nothing more than a rough draft. Yet despite its roughness it was prized because it seemed to contain the very heat of creation–a heat that was sometimes missing in the finished work.

Nevertheless this taste for the unfinished hardly explains the enormous success of terracotta sculptures. Many baked clay pieces that have come down to us are finished to the last detail. Obviously the medium's appeal lay to a great extent in the warm tones of the clays the eighteenth-century artists employed. These clays could be left matte,

given a patina, or coloured; moreover, no other medium allowed quite the same subtle modelling.

Claude Michel, otherwise known as Clodion, was a nephew of the Adam brothers. He became famous in his own right for small terracotta groups and statuettes. His renown rests partly on the subjects he depicted. In variations too numerous to count, he portrayed the amorous frolics of satyrs and bacchantes; nor was he excessively prudish. But his art is consummate and he has such a delicate sense of what is graceful and pretty that one easily forgives him his obsessive sensuality, a sensuality that has nothing morbid about it moreover.

It would be wrong to keep silent about the erotic side of the eighteenth century, an age which exhibited no systematic shyness about the vagaries of the mind, the heart, and the flesh; especially in sculpture where, as in literature, one knew how to speak elegantly about such matters.

Antoine Coysevox (1640–1720):
Marie-Adelaide of Savoy, Duchess of Burgundy,
as Diana, 1710.
Marble, height 6′4¾″.

278

TRAVESTIES OF MYTHOLOGY

are lowered and as she stands there, leaning against a shield adorned with a Medusa head, a cannon at her feet, one hand placed on her hip in a melodramatic *contrapposto*, she seems lost in a dream of some bloody battle. A grotesque, disturbing image of war, perhaps?

One can't help wondering too whether Marie Leszczynska, the peace-loving, kind-hearted queen of France really deserved to be depicted as Juno, the queen of Olympus, in Guillaume Coustou's portrait of her. It is a superb marble statue; the drapery is masterly; and Stanislas Leszczynski's daughter, who was no beauty in real life, is shown to her advantage. But how ill the peacock, that arrogant bird traditionally associated with Jupiter's shrewish wife, suits her! Coustou has added a touch of his own, a rather daring one for a statue of this kind: the queen stands on a bank of clouds, while a little familiar spirit floats weightlessly at her side playing sweetly with her crown and sceptre.

Ignaz Günther (1725-1775):
Bellona, c. 1772.
Limewood, height 6½'.

Guillaume Coustou (1677-1746):
Marie Leszczynska, Queen of France, as Juno, 1731.
Marble, height 6'4¾''.

Clodion belongs to the latter part of the century and his art is but moderately influenced by allegory, that system of symbols and images which served as a language for the whole period, as if reality absolutely had to be draped in a veil and disguised to some extent. And in fact the point often was to disguise, to dress up in stage costumes. A favourite royal pastime at the court of Versailles and elsewhere was to organize pageants freely inspired by classical mythology. Disguised as heroes and gods, courtiers, sometimes even the king himself, danced, sang, and play-acted.

So it is not surprising to see Coysevox depict the young Duchess of Burgundy, in his full-length portrait of her, as the light-footed, lightly clad goddess Diana accompanied by a playful greyhound bitch. No one, evidently, was shocked to see the future queen of France (as she would have become had the fates not decided otherwise) attired so succinctly; and certainly the role of Diana suited her.

The Rococo masters all employed mythology either to enhance a portrait or to express an idea, for classical trappings could be used to express character. What a fascinating figure Ignaz Günther's *Bellona* makes. Carved in wood around 1772, and originally probably painted and gilded, the goddess wears a plumed stage helmet; her sleepy lids

NOSTALGIA FOR THE ANTIQUE

Michel-Ange Slodtz (1705-1764):
Iphigenia, Priestess of Diana.
Marble, height 29½".

One cannot divide the eighteenth century into two periods of unequal length, one swept by the whimsicalness of Rococo, the other ruled by Neoclassicism. Nothing is ever that simple in the evolution of the arts. In fact, an almost constant nostalgia for Antiquity ran through the century (and, indeed, through the periods that preceded it). It is felt, with varying degrees of distinctness, in experiments and finished works that cannot be explained by artistic temperament alone.

The tranquil genius of a sculptor like Bouchardon tends to express itself in clean forms, calm and harmonious rhythms; and this makes him a precursor of the Neoclassical reaction. Yet these tendencies appear in the work of other artists as well, artists who wholeheartedly embraced the Rococo aesthetic.

The experiments, the sudden outbursts of a vaguely premonitory nostalgia, originated in Rome in circles that were permanently in contact with antiquities preserved in princely or pontifical collections, with archaeological finds, and with the restoration work on newly unearthed statues. This was a job entrusted to sculptors; and as the collectors of this period wanted works restored to their original state (or what was believed to be their original state), restoration often involved carving missing parts. And, shocking as it seems to our modern sensibility, this practice provided artists with a regular source of income and an opportunity to measure themselves against the sculptors of Antiquity. Inevitably this work left its mark on their style.

This was the case with Ignazio Collino, an artist from Turin in northern Italy and a protégé of King Charles Emmanuel III who sent him to Rome at his expense. Collino studied ancient marbles there, tried his hand at restoration, and became acquainted with French art (which exerted a strong influence in the city of the popes around the middle of the century). He made no secret of his classical leanings after he returned to his native city. Take the *Sacrificing Vestal* at the Accademia Albertina in Turin. Both in style and subject this amply draped female figure lighting or tending a flame on an altar bespeaks a fascination with the antique, notwithstanding its characteristically eighteenth-century elegance and fluidity of line.

In Rome Collino probably studied, as Canova was to do later, the work of a Frenchman who had been active in the Eternal City for almost twenty years, Michel-Ange Slodtz. Slodtz's work contains significant echoes of classical sculpture. His *Iphigenia, Priestess of Diana* has an enigmatic smile, a somewhat vacant look, and pure, smooth features that are obviously meant to be a resurrection of Attic sculpture. Yet both Slodtz and Collino are capable of conceiving large dynamic Baroque compositions. Their work, like that of a few other eighteenth-century artists, looks forward to the eclecticism of the nineteenth century.

Ignazio Collino (1724-1793):
Sacrificing Vestal, c. 1754.
Terracotta, 31½".

MYTHOLOGICAL IDYLLS

Augustin Pajou (1730–1809):
Psyche Abandoned, 1785–1790.
Marble, height 5'11".

rather superficial artist, kept the graceful manner of the reign of Louis XV alive right up to the beginning of the nineteenth century.

One wonders whether Pierre Julien was not inspired by *Psyche Abandoned* when he modelled his *Amalthaea (The Goat Girl)*, a figure that is almost contemporary with Pajou's and almost as naked (though she makes an effort to cover her breasts). The nymph is holding on a tether the goat that nursed the infant Jupiter, but her thoughts do not seem to be with her task. This group, a version of the motif of the Beauty and the Beast, was originally part of the decoration for the dairy at Rambouillet, which Julien sculpted for Louis XVI and Marie Antoinette on the eve of the French Revolution. It is stamped with a spirit of insouciance that hardly seems tragic, for what this appealing, falsely modest young girl expresses above all is the charm and the pseudo-rustic whimsicalness of the *ancien régime*.

Pierre Julien (1731–1804):
Amalthaea (The Goat Girl), 1787.
Marble, height 5'8".

The sculptors of the second half of the century were not slaves to doctrine. Before Canova, they sought chiefly to create pleasing images and they favoured an iconography and style which celebrated the feminine charms that had a high place in the flirtatious society of this age when women were often treated like queens. Thus the mythological pretexts employed in the earlier part of the century acquired a new lease of life. The idea was no longer to borrow the trappings of pagan gods and goddesses but to titillate with flirtatious, erotically suggestive scenes. Moreover, mythological motifs were in key with the period's growing reverence for Antiquity, though it sometimes seems as if they were merely an excuse for depicting delightfully sensual bodies in the nude. *Psyche Abandoned*, for example, shows Psyche without a stitch on her lamenting Cupid's disappearance; her flesh palpitates with distress; her despair gives her a languid pose which is not only touching but seductive. The sculptor, Augustin Pajou, a

THE CHARM OF CHILDREN

Insouciance is also the privilege of childhood, of youth. The children carved by Pigalle, Houdon and Vassé are natural and spontaneous. And even when they seem to suggest a not totally innocent sport (as with Pigalle's *Child with Birdcage*) they are delightfully appealing.

The *Child Stealing Honey* in the abbey church of Birnau on the shore of Lake Constance is a rascal caught red-handed in the act of helping himself to honey from the beehive he is clasping. Not exactly the type of figure one would expect to find in a church, but no doubt the sculptor, Feuchtmayer, intended to make a moral point—a point lost on the spectator who savours this scene of childish innocence in the same manner that the child is enjoying his stolen honey.

We enter a rather more ambiguous domain with Houdon's *La Frileuse*. The charm is still there, and so is the feeling of amusement and surprise, produced here by the little girl's efforts to shield herself from the cold by wrapping herself in a shawl large enough to cover her upper body but not her legs and bottom. As a method of keeping warm it leaves something to be desired, but the point of course (as with some of Balthus' pictures) is to rouse the viewer's prurience. The intention is admittedly a depraved one and the image of girlhood the sculptor gives us is degrading. But the eighteenth century was an age of contrasts; its art and literature are full of allusions to the weakness of the flesh, to its vagaries, and to the seduction of ingenuousness.

282

Franz Xaver Messerschmidt (1736-1783):
Character Head: A Lascivious Coxcomb, c. 1770.
Marble, height 17¾″.

what the artist's intention could possibly have been. What is the significance of the grimacing, slack-breasted hag dressed in rags and accompanied by a pig that Lorenzo Mattielli carved for the garden of the Schwarzenberg Palace in Vienna? We are a long way from aristocratic ladies in flounces; the statue seems to be the product of a sickly imagination fascinated with ugliness. In any case, it does not seem to bespeak a social conscience. The fact of the matter is simply that the artists of the eighteenth century were not interested only in the beautiful; there were shadowy zones in their idylls, blind spots in their refined worldliness, as proved by the dramatic events that brought the *ancien régime* to an end. But before the final cataclysm engulfed them, the patrons and artists of the period that ended with the French Revolution turned mockery and caricature and irony into an art.

It was after 1770 that Franz Xaver Messerschmidt, gripped by an obsession that was eventually to deprive him of his reason, began to produce his numerous "character heads," as they are called in Vienna; his busts of repulsively grimacing figures, derisive images of mankind on the verge of insanity. There is something both fascinating and disturbing about these systematic variations on a cracked theme.

There is nothing sickly, on the other hand, about the Venetian artist Antonio Bonazza who decorated the gardens of the Villa Widmann near Padua. These statues are an amusing parody of the society of the time. Their exaggerated or burlesque gestures and mimicry are governed by the laws of caricature, a genre which had an enthusiastic public then, especially in Italy and Germany; it was in fact a society game, a form of self-mockery–again a kind of theatre. With her sardonic smile and outstretched arm, the bizarrely accoutred *Sorceress* seems to be casting a spell. The artist, who was gifted with a lively critical imagination, pokes fun at the foibles of his age. One of the qualities of the eighteenth century is that it was not blind to its own shortcomings.

Antonio Bonazza (1698-1763):
The Sorceress, c. 1742.
Stone, height 6′1″.
Villa Widmann, Bagnoli di Sopra, near Padua.

BUSTS

And this brings us to the next subject of eighteenth-century art: the individual as he really was, with his psychological quirks and unique physique, not just the individual as an embodiment of a social function. The sculptors of the period have left us a gallery of unsurpassed portraits, even compared to contemporary painted portraits, for the third dimension adds the seal of truth. Busts were not intended as works for formal display, but as testimonials to friendship, as confidential glimpses, as striking portrayals.

Take Jean-Jacques Caffieri's bust of the Chanoine Pingré, carved in the year before the outbreak of the French Revolution. With his jowls and his pout, his look of a somewhat sceptical bonhomie, the old scholar-priest, a renowned astronomer in his day, comes to life before our eyes.

Jean-Jacques Caffieri (1725-1792):
The Astronomer Chanoine Pingré, 1788.
Terracotta, height without stand 18½″.

Michael Rysbrack (1694-1770):
Alexander Pope, 1730.
Marble, height 20½″.

Jean-Baptiste Lemoyne II (1704-1778):
Mademoiselle Dangeville as Thalia, 1771.
Marble, height 28¼″.
Comédie-Française, Paris.

Jean-Baptiste Pigalle (1714–1785):
The Negro Paul, c. 1760.
Terracotta, height 63½″.

The English called on continental sculptors like the Frenchman Roubiliac and the Fleming Michael Rysbrack, to sculpt portraits of their famous men. Rysbrack's bust of Alexander Pope shows the satirist of London society as he really was: an austere, sullen-looking man.

Female portraits were luckily less austere as a rule, and the charms of court ladies, rich *bourgeoises*, and actresses inspired a large number of works. Jean-Baptiste II Lemoyne, one of the most prolific portraitists of the age, both at court and in town, modelled a series of exact likenesses of Louis XV at every age, but he also sculpted the frank witty features of *Mademoiselle Dangeville*, a well-known actress at the Comédie-Française. She is depicted as Thalia, the muse of comedy. Another Lemoyne bust portrays the famous actress Mademoiselle Clairon as Melpomene; and inevitably both actresses tend to pose. On the other hand, Pigalle's portrait of *The Negro Paul* is natural, unstudied, intimate. Paul was a manservant at the home of Pigalle's friend Desfriches where the sculptor was a regular visitor. The bust has a stunning vivacity that may owe something to the fact that it was done on the spot. The young black man (having a black servant was another snobbery) is got up in a braided uniform and pseudo-oriental turban; he gazes at us a little timidly and with a shade of resignation, with his thick lips and flattened nose, as real as life, a gift from one friend to another.

LAST COMMISSIONS OF THE ANCIEN REGIME
STATUES OF GREAT MEN

Balthasar Permoser (1651-1732):
The Apotheosis of Prince Eugene, 1718-1721.
Marble, height 7′6½″.

In 1738, Louis-François Roubiliac sculpted a portrait of Handel for the Vauxhall Gardens in London. The composer is fingering the strings of his lyre like another Apollo while a *putto* transcribes the notes at his feet; yet Handel is dressed in ordinary clothes and has even neglected to remove what appears to be his nightcap. There is of course a world of difference between a great general and a mere composer of oratorios.

Literature played an increasingly important role in the cultivated society of the period. Voltaire was received like a true king in the courts of the European monarchs. The Rococo century was after all the Age of Enlightenment, the century of the *philosophes*. Few kings, in fact, can boast as many statues as Voltaire. The question of how to depict this prince of letters produced a variety of responses which are incidentally stamped by changing aesthetic conventions. For Pigalle, the modern style seemed to be indicated. The sculptor went as far as to portray the writer nude in the heroic mode–the Antique was then the latest fashion

Louis-François Roubiliac (1702-1762):
George Frideric Handel, 1738.
Marble, 53½″.

The cult of great men by means of images is not special to the eighteenth century. To a greater or lesser extent, it is present in all periods, all civilizations. Still, the last hundred years of the *ancien régime* were not noticeably marked by modesty. Everyone hankered for fame, for immortality in marble or bronze. What preoccupied patrons and artists was how to state and to give prominence to the attainments on which reputation rested. What pose should the subject adopt? What costume should he wear? What attributes should he be given? In some cases the array could be very elaborate: for example, the *Apotheosis of Prince Eugene* (of Savoy, the vanquisher of the Turkish forces) by Balthasar Permoser. This tumultuous group contains so many figures that the protagonist tends to be upstaged by those surrounding him: a spirit brandishing a gleaming halo, a trampled Turk, a trumpeting herald, a *putto* clinging to Hercules' bludgeon. The prince himself seems a little overburdened by his Nemean lionskin and his role as a hero of mythology. As the century wore on this type of symbolism would get less ponderous.

Jean-Antoine Houdon (1741-1828):
Voltaire Seated, 1795.
Terracotta, height 46″.

Jean-Jacques Caffieri (1725-1792):
Pierre Corneille, 1778.
Terracotta, height 61½″.

—hardly the most attractive way of depicting an old man who was all skin and bones, and one that supplied an inexhaustible topic for lampoons. Houdon, on the other hand, adopted the more felicitous solution of draping Voltaire in a thinker's toga, which had the advantage of being both classical and kinder to the ageing philosopher's physique. In addition, it gave prominence to Voltaire's famous sardonic smile (which was due less to his outlook on life, perhaps, than to the fact that he had lost his teeth!). Houdon has him sitting quietly in an armchair: the relatively recent taste for comfortable furniture gave sculptors an excellent pretext for making seated portraits. Many of the subjects in the series of portraits commissioned by the Comte d'Angiviller in the last years of the monarchy are seated. This undertaking, one of the last of the *ancien régime*, announces the first stirrings of the feeling of patriotism; to it we can trace the modern practice of erecting on public squares statues to renowned (and less renowned) persons deserving the nation's gratitude.

As regards the famous men of the past, the eighteenth-century sculptors tended to portray scientists and men of letters rather than soldiers. This too was a sign of the times. The vogue for retrospective portraits flourished and would continue to do so for a long, long time. Caffieri was particularly proficient at this genre, as seen by his wonderfully lifelike statue of *Pierre Corneille*. He captures the dramatist searching for an appropriate rhyme or twist in plot, a goose quill in his hand and a number of folios lying scattered at his feet. The sculptor is careful to avoid any anachronisms and depicts him accurately in seventeenth-century dress, thus anticipating the historicism of the nineteenth-century artists. The composition reveals a remarkably harmonious sense of balance and it has an undeniable vivacity.

EQUESTRIAN STATUES

Edme Bouchardon (1698–1762):
Print showing his Equestrian Statue of Louis XV
on its pedestal (it was destroyed during the Revolution).

Absolute monarchies require symbols. Just as the period after 1685 saw an increase in the number of equestrian statues of Louis XIV, the cult for Louis XV the "well-beloved" inspired, beginning about 1750, a campaign of erecting standing and equestrian statues of the king in the centre of royal squares designed to receive them. The equestrian statue is a particularly imposing genre, the supreme expression of the art of sculpture. Unfortunately, the equestrian statues of the king were destined by their very nature to perish under the angry blows of the French Revolution. One has to look beyond the borders of France to find any surviving examples of them.

The purpose of the equestrian monument was to glorify the reigning monarch and, through him, the monarchic ideal. From century to century, though, we observe significant differences in the way this programme was carried out. Initially, the monarch was shown dominating a group of chained slaves or vanquished enemy soldiers; later the

emphasis shifted to the ruler's peace-time virtues, to the benefits of his sagacious government. In other words, war was out and reason was in. Thus the political statement made by the statue reflected changing intellectual currents, though not of course to the extent of calling the power structure into question. Undoubtedly some of the sculptors who worked on these monuments were "in tune" with the ideas of the *philosophes* and their circle.

At Reims, Pigalle placed his own portrait at the feet of Louis XV, identifying himself as a simple "citizen." Unlike the French monarchy, the term was to have a long career.

In Paris, Bouchardon was commissioned by the city to sculpt a royal effigy in the traditional attire of a Roman *imperator*. Draped female figures reflecting the sculptor's classicist tendencies adorned the base, and at the four corners graceful caryatids symbolizing virtues seemed to support the august rider and his horse. Later, when the ageing, once "well-beloved" king had fallen out of popular favour, a joke was made up that went: "The Virtues go on foot, Vice rides on horseback." Bouchardon, a particularly meticulous artist, has left us a series of splendid studies for

Edme Bouchardon (1698–1762):
Small-size bronze by Louis-Claude Vassé of his Equestrian Statue of Louis XV (inaugurated in 1763, destroyed during the Revolution).
Height of bronze 28″.

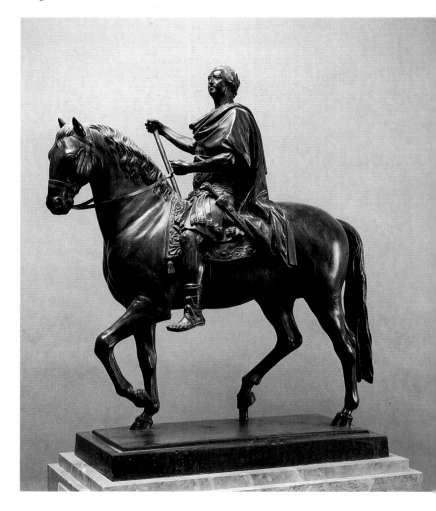

Edme Bouchardon (1698-1762):
Studies of horse and rider for the Equestrian Statue of Louis XV.
Left, first model: rider with coat, gaiters and wig, right hand
resting on a staff, in front view.
Red chalk, 33¼″ × 17½″.
Centre, first model in three-quarter view from the right.
Red chalk, 32″ × 25″.
Right, first model from behind.
Red chalk, 31¾″ × 18″.

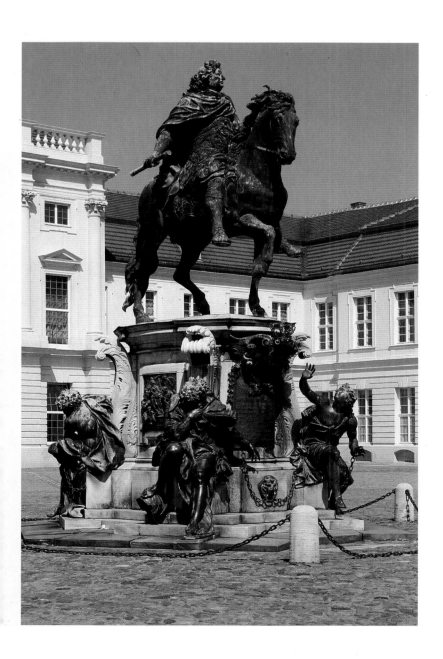

his monument, sketches in red chalk of horses and riders seen from every angle. He left nothing to chance or to improvisation. Luckily, a number of accurate reductions of the monument were cast in bronze, and these small collector's items have weathered the French Revolution while the original has not. The task of producing these figurines went to Bouchardon's pupil, Louis-Claude Vassé, and to Pigalle, who completed the monument after Bouchardon died leaving it unfinished. The statue was inaugurated in 1763. Less than thirty years later all that remained of it were the sketches, prints, and statuettes.

The same fate almost befell the equestrian statue of the Great Elector of Brandenburg, Frederick William I, which was erected in front of the royal palace in Berlin in 1708. The sculptor, Andreas Schlüter, still uses the martial iconography of the seventeenth century. Chained slaves, obviously reflecting the influence of Michelangelo and Pietro Tacca, are placed at the corners of the pedestal. During the Second World War the royal palace was destroyed, but miraculously the statue escaped destruction and it now stands in front of the Charlottenburg castle.

Andreas Schlüter (1664-1714):
Equestrian Statue of the Great Elector of Brandenburg,
Frederick William I, 1703-1708.
Bronze, height with pedestal 18′4″.
Schloss Charlottenburg, Berlin.

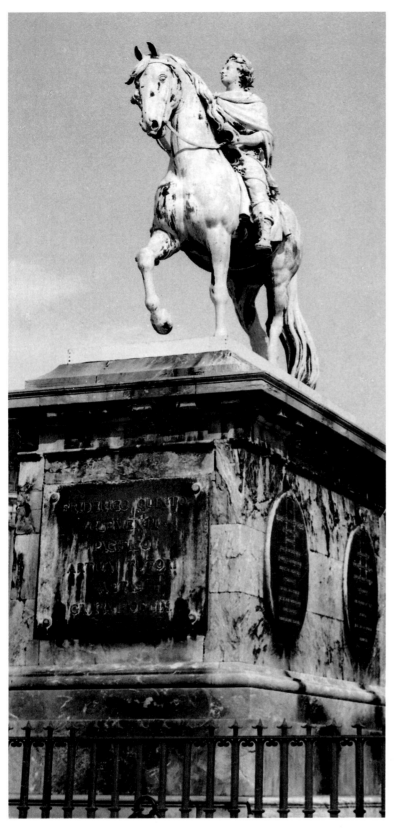

Schlüter was the best sculptor in Prussia in the early part of the century; Machado de Castro was the greatest sculptor in Portugal in the second half of the century. It was naturally to the latter that the job of carving an equestrian statue of the reigning monarch was given after the catastrophic earthquake of 1755. The monument stands in the midst of the Praça do Commercio in Lisbon, which is the centre of the modern reconstructed city. The king (Joseph I), an ineffectual ruler, looks rather clownish under his plumed helmet. A modest medallion on the unusually tall pedestal contains a portrait of the real ruler of the country, the redoubtable Marquis of Pombal.

The sheer number of equestrian statues in France and the unequalled reputation of French artists for sculpture in general and equestrian statues in particular explain why French sculptors were exported to other countries and why this was such a brilliant period for French art abroad. Jacques Saly was not one of the most famous French sculptors. Yet he had come to notice with a standing portrait of Louis XV in the main square at Valenciennes (which needless to say is no longer extant). On the strength of this work the king of Denmark hired him to sculpt an equestrian statue in bronze of Frederick V for the Amalienborg square in Copenhagen. The statue was unveiled in 1768. Saly's work, which is strongly influenced by Bouchardon's *Louis XV*, has fared better than that statue, for it is still in existence.

Jacques Saly (1717-1776):
King Frederick V of Denmark, 1768.
Bronze, height with pedestal c. 39′.
Amalienborg Square, Copenhagen.

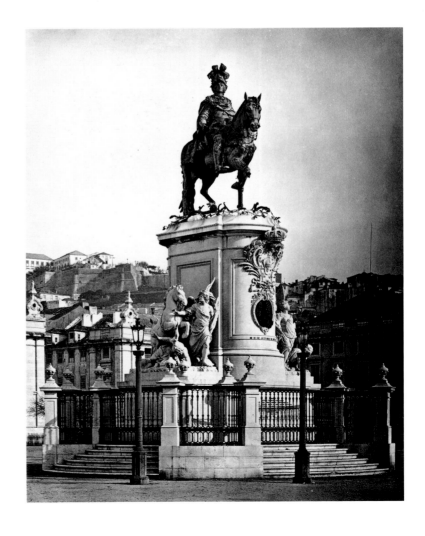

Joaquim Machado de Castro (1732-1822):
King Joseph I of Portugal, 1775.
Bronze.
Praça do Commercio ("Black Horse Square"), Lisbon.

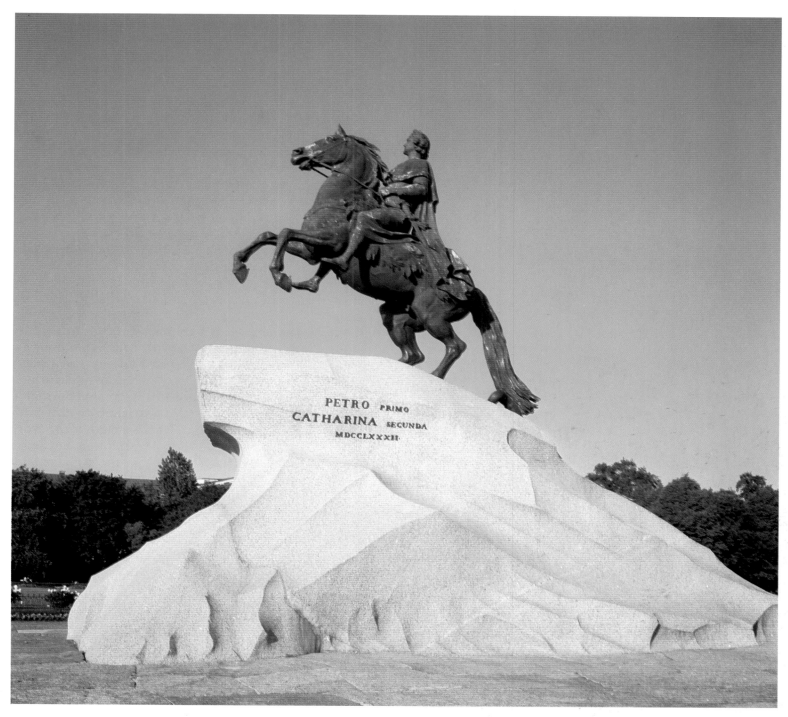

Etienne Falconet (1716-1791):
Equestrian Statue of Peter the Great, 1782.
Bronze.
Square of the Decembrists, Leningrad.

The finest equestrian monument of the period, and the most original, survives in the north-eastern corner of Europe. It is dedicated to a sovereign who was already a figure of legend in the eighteenth century: Peter the Great. It was commissioned by another great figure of Russian history, Catherine the Great, in what was an eminently political gesture; in the result, it has given us a work of truly epic magnitude. The artist, Etienne Falconet, was a Frenchman, and it made him famous. His idea is breathtaking. The czar is seated on a rearing horse atop an enormous block of granite by the river Neva which the mettlesome steed seems ready to clear in a spectacular leap. The monument is a powerful symbol of an imperious *élan* towards glory, a tribute from one autocrat to another. None of this appears to trouble the present rulers of Russia who respect works of art, unlike the narrow-minded French revolutionaries.

FUNERAL MONUMENTS

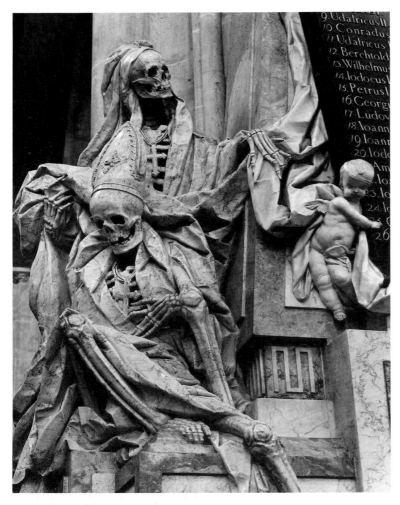

J.B. Wieland:
Death, detail of the Monument commemorating the Salem Abbots,
late 18th century.
Alabaster.
Abbey of Salem, near the Lake of Constance.

side chapels or collective monuments to a line of abbots or bishops.

At the abbey of Salem, near Lake Constance, the monument commemorating the monastery's abbots stands out as a kind of macabre hallucination in alabaster (it was erected towards the end of the century). A pair of skeletons draped in shrouds, one of them still wearing an abbot's mitre, are shown unveiling a black marble slab on which the names of past abbots are engraved. This is probably the work of one of Feuchtmayer's pupils, the sculptor J.B. Wieland who, in a style that is almost unbearably explicit, has given the figures of this *memento mori* the grandiloquent gestures of a medieval *danse macabre*.

One might expect a decline in this type of dire expressionism as the century drew to its end, for it seems out of key with the eighteenth-century delight in grace, the less austere religious practices, the more optimistic faith in

Louis-François Roubiliac (1702-1762):
Tomb of Lady Elizabeth Nightingale, 1760.
Marble.
Westminster Abbey, London.

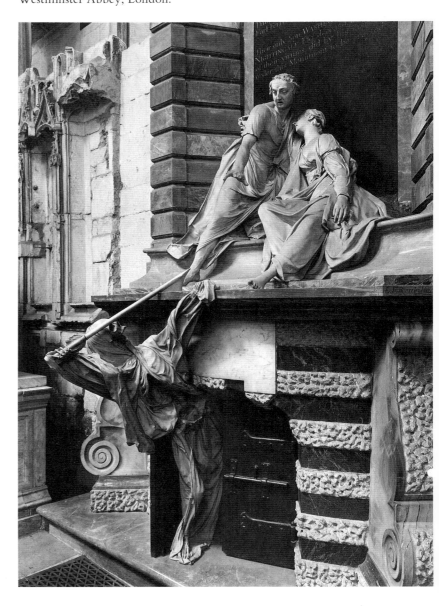

Another method of perpetuating fame for posterity was to erect a funeral monument. This was without doubt the most highly esteemed genre in the eighteenth century. It combined portraiture (when the effigy of the departed was included in the monument) with elaborate allegorical effects, a great diversity in the area of composition, colour in many cases, and, mainly, reflections on man's ultimate fate and on death itself (a theme that is of course common to all civilizations). It was an art that did not shrink from the spectacular, from staging death with all the pomp of funeral rites, with effects ranging from the grandiose to the maudlin, and at times the macabre. The magnificence of certain monuments, the sheer pride they exhibit, seems to accord ill with the teachings of Christian humility or the doctrine that all men are equal before death. But this contradiction worried no one; the point was to live on in man's memory. The belief in eternal life gave this a certain validity.

It was only towards the end of the century that these mausoleums were banished from overcrowded churches to cemeteries. They were not actually individual tombs in many cases, but family sepulchres in privately endowed

God's infinite mercy. Yet in fact threatening figures of death, sardonic skeletons, continued to be very much in evidence in France (e.g. the tomb of the *curé* of St. Sulpice by Slodtz, the Harcourt monument at Notre-Dame Cathedral by Pigalle) as well as in England. For the *Tomb of Lady Elizabeth Nightingale* at Westminster Abbey, Roubiliac composed a scene that was both moving and chilling. Lady Elizabeth is seen expiring in the arms of her husband, who is trying in vain to shield her from Death's cruel sting. The emotional impact of this scene of arrested action is heightened by the victim's youth and fragile beauty—it reminds us how short the life expectancy was then.

In Rome, Pietro Bracci employed other means to perpetuate the memory of another lady, the princess Maria Clementina Sobieska who was married to James Stuart, the Old Pretender, who was living in exile in Rome. Her crusade for the Catholic faith earned her the extreme honour, one usually reserved for popes, of being buried in St. Peter's at the Vatican. Bracci's work is a gaudy example of the Italian passion for polychromy and composite materials. The medallion contains a portrait of the defunct in

Pietro Bracci (1700-1773):
Charity, detail of the Tomb of Maria Clementina Sobieska, wife of the Old Pretender, 1739.
Polychrome marble, height 6'4½".
St. Peter's, Vatican, Rome.

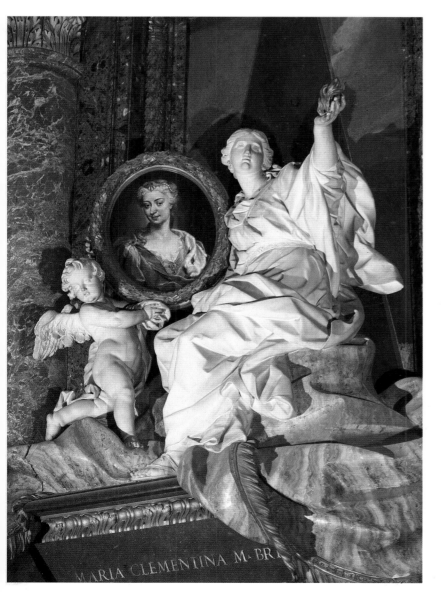

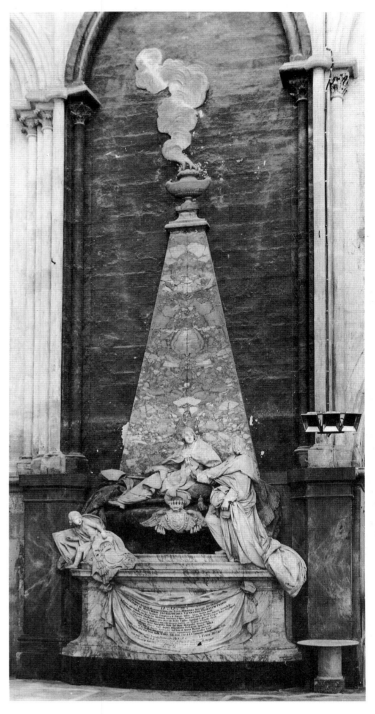

Michel-Ange Slodtz (1705-1764):
Mausoleum of the Archbishops of Vienne, 1740-1743.
Marble, height 33'.
Church of Saint-Maurice, Vienne (Isère), France.

mosaic; and in the midst of an orgy of coloured marbles, gilt bronze and stucco, the lovely figure of Charity (or the Love of God) holding a flaming heart in her hand is carved in pure white marble.

The vogue for polychromy was shared by foreign artists who lived for extended periods in Italy. Michel-Ange Slodtz, for example, sculpted an ambitious monument in Rome (though it was destined to be erected in the town of Vienne in France) memorializing two archbishops. In a kind of posthumous reunion celebrating their mutual understanding, the older beckons to the younger, Cardinal de La Tour d'Auvergne, to come and join him in the hereafter. In what is surely one of the masterpieces of eighteenth-century funeral sculpture, colour adds its glamour and appeal to the subtle modelling of the drapery and enhances the solemn spirituality of the scene.

Some funeral monuments were raised as tributes, expressions of public and official gratitude. To honour in the name of the entire nation the glorious memory of the marshal Maurice of Saxony who, notwithstanding his foreign birth, had led the royal army to victory, the king of France commissioned a suitably imposing funeral monument to be built. Maurice of Saxony was a Protestant, though, so there was no question of burying him in the royal basilica of Saint-Denis. It was decided to bury him in Strasbourg instead, in one of the Protestant churches of that city on the eastern border of the kingdom. Pigalle spent twenty years working on this project. With its flags and allegorical personifications, the monument has a profane rather than a religious character. Yet here too we see Death draped in a shroud. Brandishing an hourglass in one hand, it lifts the lid of a sarcophagus with the other. To render this grandiose entombment of a hero, who strides forth imperturbably to meet his fate, still more impressive, another hero, Hercules, is shown grieving at the head of the coffin. The days of the *ancien régime* were numbered, yet here, in one of its last flourishes, it spoke in epic accents. The monument, which was inaugurated in 1777, makes almost no concession to the rising Neoclassical trend which was soon to dominate the arts. There is not a trace of Canova's aesthetic in Pigalle's work. Maurice of Saxony appears here as the standard-bearer of a way of life that was soon to disappear. It is almost as if he were proclaiming that the old order knew how to die with panache.

For a long while, eighteenth-century art laid stress on free inspiration, on fancy, on the constantly renewed interaction of forms, volumes, shadows, even colours. It presented foremost a lively, joyous, occasionally solemn spectacle which mirrored the society of the time. It was quick to register passing fads and fashions; rejecting dogmatism, it devoted itself exclusively to the enjoyment of creativeness, a creativeness that sought chiefly to provide a suitable décor for the enjoyment of life. To some, there is something frivolous about this quest for a beauty and grace that were not without blemishes, however much they were disguised or ignored. Yet even in their most idyllic daydreams, the artists of the eighteenth century displayed strength and conviction: only, they chose to speak of serious topics as well as light ones in bantering terms and with an unsurpassed elegance.

What strikes us about eighteenth-century sculpture, then, beyond what is connoted by the term Rococo (which is not entirely coextensive with it), is how perfectly the principles which it embodied were in key with the society of the period; how faithfully its diversity reflected society's diversity while retaining certain common denominators: a preoccupation with technical skill, if not refinement; a striving after effect and vivacity which is clearly related to an unflagging fascination for spectacles (as a form of amusement, a reflection of the times, and a glitter-ing exchange of ideas and feelings); and an effort to achieve harmony with other modes of artistic expression. Sculpture attained its most satisfying expression in an architectural context, and that context in turn needed sculpture to realize its fullest effects. A similar relationship can easily be established with painting. Does this mean that sculpture lacked independence? The issue is a false one. Before the changes took place that transformed art into something doctrinaire and therefore a trifle boring, Rococo sculpture brilliantly answered sculpture's essential requirement of projecting forms into space, volumes that are both moving and full of movement, and doing so moreover without ceasing to adapt to new circumstances and thus to renew its inventiveness. Sculpture brought to the eighteenth century a vital, even incomparable portion of the beauty and charm that continue to captivate us to this day.

Jean-Baptiste Pigalle (1714-1785):
Marshal Maurice of Saxony Descending to the Grave and Immortality, 1753-1776.
White and coloured marbles.
Church of Saint-Thomas, Strasbourg.

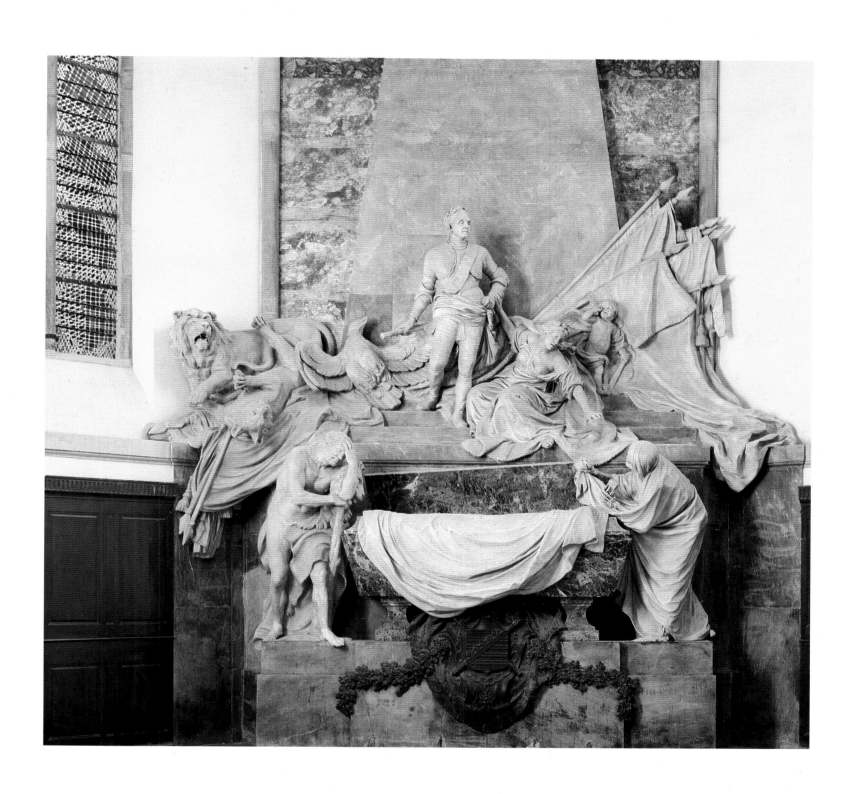

LIST OF ILLUSTRATIONS

PRODUCED BY THE TECHNICAL STAFF OF
EDITIONS D'ART ALBERT SKIRA S.A., GENEVA

EDITORIAL DIRECTORS:
JEAN-LUC DAVAL AND LAURO VENTURI

COLOUR AND BLACK AND WHITE,
FILMSETTING AND PRINTING BY
IRL IMPRIMERIES RÉUNIES LAUSANNE S.A.

BINDING BY H. + J. SCHUMACHER AG
SCHMITTEN (FRIBOURG)

Printed in Switzerland